SPECULATIVE TAXIDERMY

CRITICAL LIFE STUDIES

CRITICAL LIFE STUDIES

Jami Weinstein, Claire Colebrook, and Myra J. Hird, series editors

The core concept of critical life studies strikes at the heart of the dilemma that contemporary critical theory has been circling around: namely, the negotiation of the human, its residues, a priori configurations, the persistence of humanism in structures of thought, and the figure of life as a constitutive focus for ethical, political, ontological, and epistemological questions. Despite attempts to move quickly through humanism (and organicism) to more adequate theoretical concepts, such haste has impeded the analysis of how the humanist concept of life is preconfigured or immanent to the supposedly new conceptual leap. The Critical Life Studies series thus aims to destabilize critical theory's central figure, life—no longer should we rely upon it as the horizon of all constitutive meaning but instead begin with life as the problematic of critical theory and its reconceptualization as the condition of possibility for thought. By reframing the notion of life critically—outside the orbit and primacy of the human and subversive to its organic forms—the series aims to foster a more expansive, less parochial engagement with critical theory.

Luce Irigaray and Michael Marder, *Through Vegetal Being:
Two Philosophical Perspectives* (2016)

Jami Weinstein and Claire Colebrook, eds., *Posthumous Life:
Theorizing Beyond the Posthuman* (2017)

Penelope Deutscher, *Foucault's Futures:
A Critique of Reproductive Reason* (2017)

SPECULATIVE TAXIDERMY

NATURAL HISTORY, ANIMAL SURFACES, AND ART IN THE ANTHROPOCENE

GIOVANNI ALOI

Columbia University Press
New York

Columbia University Press
Publishers Since 1893
New York Chichester, West Sussex
cup.columbia.edu
Copyright © 2018 Giovanni Aloi
All rights reserved

Library of Congress Cataloging-in-Publication Data

Names: Aloi, Giovanni, author.
Title: Speculative taxidermy : natural history, animal surfaces,
and art in the anthropocene / Giovanni Aloi.
Description: New York : Columbia University Press, 2018. |
Series: Critical life studies | Includes bibliographical references and index.
Identifiers: LCCN 2017038409 | ISBN 9780231180719 (pbk. : alk. paper) |
ISBN 9780231180702 (cloth : alk. paper)
Subjects: LCSH: Dead animals in art. | Human-animal relationships in art. |
Art, Modern—21st century—Themes, motives. | Taxidermy—Social aspects.
Classification: LCC N7660 .A57 2018 | DDC 709.05—dc23
LC record available at https://lccn.loc.gov/2017038409

Columbia University Press books are printed on permanent
and durable acid-free paper.

Printed in the United States of America

Nandipha Mntambo, *Titfunti emkhatsini wetfu* (*The Shadows Between Us*),
2013 (*partial view, left*). Cow hide, resin. Photo by Jean-Baptiste Beranger.
Courtesy Andréhn-Schiptjenko, Stockholm.
The cover design is based on a concept provided by the author.

CONTENTS

ACKNOWLEDGMENTS

The research and writing in this book are the result of many years of exciting discussions with colleagues, students, artists, curators, and friends. Needless to say, I will not be able to mention everyone here because much of the ground research for this book dates back to 2010, when I embarked on my PhD on taxidermy in contemporary art under the supervision of Lynn Turner and Astrid Schmetterling at Goldsmiths University of London. Lynn's critical feedback, guidance, knowledge, and genuine enthusiasm for the philosophical "question of the animal" vastly expanded my own conception of the subject in an invaluable way. Astrid spurred me to start my academic career during my postgraduate studies in art history at Goldsmiths, and her influence on my work has been substantial. Other memorable and highly influential figures from my Goldsmiths years are Gavin Butt, Simon O'Sullivan, and Brendan Prendeville, who I thank for their thought-provoking seminars and invitations to think about realism and posthumanism from new and challenging perspectives. The first stage of this project is indebted to and informed by conversations with Steve Baker, Rod Bennison, Ron Broglio, Helen Bullard, Jonathan Burt, Mark Fairnington, Tessa Farmer, Diane Fox, Erica Fudge, Rikke Hansen, Garry Marvin, Susan McHugh, Austin McQueen, Marlena Novak and Jay Alan Yim, Cecilia Novero, Jennifer Parker-Starbucks, Nigel Rothfels, Bryndís Snæbjörnsdóttir and Mark Wilson, Jessica Ullrich, and Joe Zammit-Lucia. Perhaps most importantly, much of the

initial animal studies platform upon which the key arguments of this book stand was developed at the London meetings of the British Animal Studies Network held between 2007 and 2009, which I religiously attended. Many chapters featured in this book were presented at conferences in Europe and the United States. I therefore thank the scholars and graduate students who have helped me to fine-tune key arguments and ideas.

Despite its origin, this book is not an adapted PhD thesis. The end of my PhD studies felt like the beginning of something important, and thus I wanted to begin a new journey on the grounds of what I had learned through my research at Goldsmiths. The concept of speculative taxidermy emerged then. After I relocated to Chicago and found time to put Foucault on one side, I could focus on the emerging philosophies of object-oriented ontology and new materialism. This second stage of this project was substantially shaped by the reading materials and by those who attended the 2014 and 2015 incarnations of Following Nonhuman Kinds, a Chicago-based reading group organized by Rebecca Beachy, Caroline Picard, and Andrew Yang. From these meetings, friendships and important conversations on the subject of taxidermy and the nonhuman have also developed with, among others, artists Doug Fogelson, Jenny Kendler, Karsten Lund, and Claire Pentecost. I would like to mention the influence of the Animal/Nonhuman Workshop meetings held at the University of Chicago. Also important to the content of this book have been the conversations on nonhuman representation in digital media held at Digital Animalities, a project funded by the Social Sciences and Humanities Research Council involving a cohort of international animal studies scholars including, among others, Jody Berland, Matthew Brower, Robert McKay, Anat Pick, Nicole Shukin, and Tom Tyler. I also wish to thank the undergraduate students at the School of the Art Institute of Chicago who, every year, enroll in my class Surface Tensions: Taxidermy in Contemporary Art. Their insights, discussions, and motivation to get to the bottom of what taxidermy can bring to art practice keep my interest in this subject constant.

I am particularly grateful to all artists featured in this book for their kind collaboration and patience in answering my questions and helping with clearing permission rights for the use of their images. Most especially I would like to thank Robbi Siegel at Art Resource, Inc.; Sylvia Bandi and Julia Lenz at Hauser and Wirth; Gina C. Guy at the Robert Rauschenberg

Foundation; Sinazo Chiya at Stevenson Gallery; and Myungwon Kim at Tanya Bonakdar Gallery. The reproduction of images in this book has been made possible by a Faculty Enrichment Grant awarded by the School of the Art Institute of Chicago in April 2016.

Lastly, special thanks to everyone at Columbia University Press for supporting this project and especially to Wendy Lochner for her genuine enthusiasm, professionalism, and humor.

SPECULATIVE TAXIDERMY

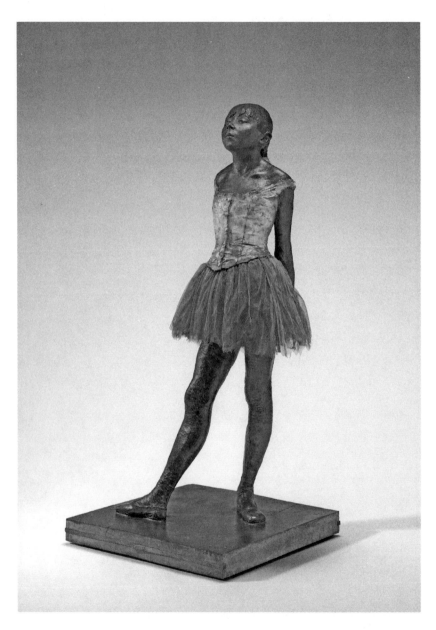

FIGURE P.1 Edgar Degas, *Little Dancer Aged Fourteen*, 1878–1881. Pigmented beeswax, clay, metal armature, rope, paintbrushes, human hair, silk and linen ribbon, cotton faille bodice, cotton and silk tutu, linen slippers, on wooden base. Overall without base: 38 15/16 × 13 11/16 × 13 7/8 in. (98.9 × 34.7 × 35.2 cm). Collection of Mr. and Mrs. Paul Mellon. Open-access image courtesy of the National Gallery of Art, Washington, DC.

PROLOGUE

The Carnal Immanence of Political Realism—
Realism, Materiality, and Agency

A key feature of the new materialism is its insistence on the recalcitrance and vitality of matter and thus on its role in constraining and engendering the ways it is understood and handled. Matter is recognized as having its own forces of resilience, resistance, and productivity.

—DIANE COOLE, "FROM WITHIN THE MIDST OF THINGS: NEW SENSIBILITY, NEW ALCHEMY, AND THE RENEWAL OF CRITICAL THEORY"

What I say instead is that artworks produce their own real objects, rather than imitating pre-existing ones.

—GRAHAM HARMAN, "ART AND OBJECTHOOD"

In April 1881, the Parisian artworld was rocked to its core by a work of art exhibited at the sixth impressionist exhibition. This one, like the first in 1874, was staged at the studio of renowned, pioneering photographer Nadar. The exhibition included works by Morisot, Cassatt, Gauguin, and Pissarro, among others, but Degas's *Little Dancer Aged Fourteen* (plate 1) captured more attention than any other work in the show. It was not a painting but, surprisingly for the established impressionist canon, a diminutive wax sculpture of a young girl. Today, the work has become one of the most recognizable and cherished pieces of impressionism. But its 1874 reception reveals a more complex picture. Upon its

unveiling, the sculpture quickly became the target of extremely negative commentaries, with critics labeling it "repulsive," "vicious," "frightful," and a "threat to society." Famously, art critic Elie de Mont said, "I don't ask that art should always be elegant, but I don't believe that its role is to champion the cause of ugliness," while a correspondent from the English journal *Artist* bluntly asked: "Can art descend lower?"[1] These surprising responses are indicative of the social role that sculpture was expected to play at the end of the nineteenth century in Europe and the United States. Needless to say, matters have changed a great deal since. After all, our generation is more or less at ease with the notion that a tipped-over urinal is the real conceptual matrix of much contemporary art. This is the universal premise upon which we can accept dead sharks in formaldehyde, an unmade bed surrounded with litter, and a photograph of a crucifix suspended in urine as art. The cuteness of Degas's little dancer is the result of our changed perspective. So, why did her appearance unsettle fin de siècle Parisians, and how could she be possibly relevant to the presence of taxidermy in contemporary art?

First of all, in popular culture, impressionism has been mollified to facilitate a consumptive mode of capitalist imaging that has stripped the movement of its political edge. Substantially castrated, impressionism has become the bourgeois mode of the "unproblematically pretty." The postcard, the calendar, and the chocolate box lid are its most readily available mechanical reproduction display formats. Yet, impressionism meant much more to the discourses and practices of classical art that dominated the nineteenth century. The movement's defiance of the classical canon was informed by the temporary rise to power of workers during the establishment of the socialist Paris Commune in 1871. Its ties to realism, the movement that in the 1850s brought artists to paint the present in which they lived, rather than idealized images of idealized pasts, is visible in Manet's influence on the group. Paintings like *Olympia* (1863) and *A Bar at the Folies-Bergère* (1882) deliberately and abruptly yanked the utopianism of classical art from within. *Olympia* assaulted classical art from a contextual standpoint: it lifted the veil of decorum to reveal the prostitute behind the Venus. The honesty and simplicity of this shocking operation upset Parisians because it exposed the hypocrisy embedded in the deep stratifications of naturalized gender and social hierarchies. *A Bar at the Folies-Bergère* (fig. P.2) mined the foundation of classical realism, chal-

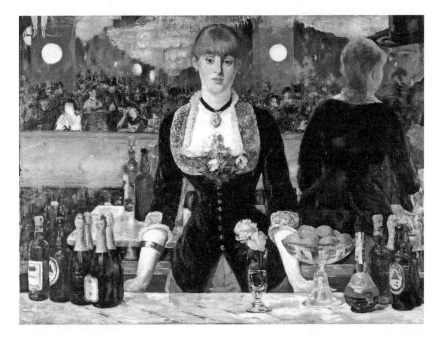

FIGURE P.2 Edouard Manet, *A Bar at the Folies-Bergère*, 1882. Oil on canvas. 96 × 130 cm. The Courtauld Gallery, London. The Samuel Courtauld Trust.

lenging the three-dimensional construction of space devised by optical perspective. Through an ambiguous play of reflections, Manet fragmented centuries of solid spatial representation on canvas, destabilizing the sovereignty of the viewer and at the same time exposing the grim social realities of alienation at the margin of the burgeoning entertainment industry in Paris. Manet made painting painful—he turned the classical tradition of representational affirmation on its head, reconfiguring the medium as a questioning entity. This is where modern art begins.

But not all impressionist artists assimilated Manet's lesson to the same extent. Of course, in a sense, impressionism *was* a bourgeois affair. Most of its exponents were of middle or upper-class extraction; with the exception of Mary Cassatt and Berthe Morisot, they were all white men; and some artists courted professional success by painting the everyday lives of those who could afford to pay for their works. Indeed, Monet's body of work, although groundbreaking in many other ways, never quite embodied

the political stance of Degas, who painted the working classes with a dignity and simplicity that assimilated the realism of Courbet and Daumier. And it was, in fact, a chance encounter with Manet, while copying paintings at the Louvre in 1864, that reportedly changed Degas's approach to painting. Then, the artist's work stylistically vacillated between the neoclassical rhetoric of Ingres and the darker romanticism of Delacroix. But in many ways, classical art loomed large in Degas's formation as a painter. Manet introduced Degas to his abrasively realist approach to painting and encouraged an interest in everyday life—one deeply shaped by Courbet's political desire to annoy, challenge, question, and shake up social stability. But if Courbet knew how to produce "annoying images" designed to reveal naturalized social structures, Manet knew how to make one look at them. He knew how to capture people's attention in order to grant resonance to his message. Well before Duchamp, Manet introduced controversy as the essential element of good art—art that makes people talk and share their views, art that makes people uncomfortable and that challenges preestablished norms: art with a pronounced agency capable of impacting social structures. In this context, *Little Dancer Aged Fourteen* emerges as a work of art that, as Charles Millard argued, functions as the "paradigm of the development of sculpture in nineteenth-century France, a resume of its statements and problems, its exploratory and modern strains."[2]

Degas's *Little Dancer* is therefore better understood through these influences. The sculpture was intentionally cast as a far cry from the elegant and idealized forms of the neoclassical works that dominated the Parisian art scene. The proportions of her body did not match those of a "first-class dancer," and Degas had deliberately altered her physiognomy to conform with popular scientific notions of what was then considered morphological degeneracy.[3] The artist, as he did in paintings of laundresses and prostitutes, chose not to immortalize the hero, not the *étoile* basking in the glory of an ovation, but what the French generally referred to as the *rat*.[4] Rats were the anonymous young dancers whose careers failed. Within the complex and harsh social structure of the *Opéra* in Paris, they were destined to round off their meager wages with prostitution. Through the second half of the nineteenth century, ballerinas were, most often, daughters of working class families. Like acting, the profession was not suited to aristocratic or upper-middle-class girls. But in that world,

opportunities for a good life were very real—successful ballerinas could substantially enrich their families, even surpassing the income of their own fathers. However, those who did not succeed would fall prey of wealthy patrons who could buy their way backstage. Exploited and degraded to worthlessness by their pest-animal label, these young dancers were effectively the by-product of Parisian desires, dreams, and drives. Unashamedly cast against this social background, *Little Dancer Aged Fourteen* simply confronted viewers with the dark side of the *Opéra* and forced them to face the inconvenient truth behind the glossy veneer of entertainment.

Degas admired perseverance in training. As someone who spent most of his time perfecting his practice, copying the work of classical masters and inventing new aesthetics through which to capture the ephemerality of modern life, he knew what struggling for one's art meant. For similar reasons, he also developed a fondness for horses (fig. P.3). Both horses and ballerinas began training at a very young age and worked with such intensity and focus that their bodies were effectively molded by the

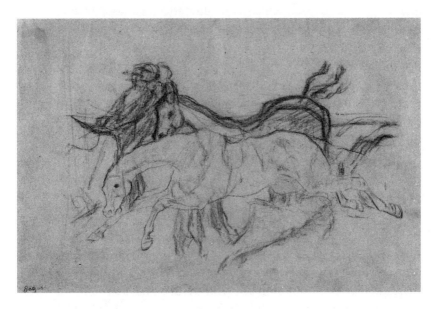

FIGURE P.3 Edgar Degas, *Racehorses* (study for *Scene from the Steeplechase: The Fallen Jockey*), c. 1881. Charcoal on light brown paper. Overall: 10 7/8 × 17 in. (27.6 × 43.2 cm). Collection of Mr. and Mrs. Paul Mellon. Open-access image courtesy of the National Gallery of Art, Washington, DC.

practice regime. They were both part of highly competitive environments defined by strict aesthetic standards, and both would see their career end prematurely with nothing else lined up for them thereafter. Both ballerinas and horses were in a sense the product of different but related unforgiving entertainment industries that similarly objectified human and animal bodies and then discarded them after use. Degas's images of horses and ballerinas in training thus bear a darker edge, one gesturing to the emerging capitalist economies of consumption and the vulnerability it imposed on its objects. The dark edge of training, whether of a ballerina or a racehorse, practically and metaphorically incorporated economies of domestication. Discipline was at the core of both training processes. Structures of power instilled submission in both horses and ballerinas. Methods of training were capable of "breaking the spirits" to accomplish the classical standard or create the ideal specimen, on stage as well as at the track.

This dark edge was exemplified in *Little Dancer* not simply through an emphasis on context—pushing unwanted sights into the view of bourgeois socialites had already been successfully accomplished by Courbet and Manet. But Degas's sculpture made matters far more uncomfortable by leveraging upon an unprecedented conception of materiality. The aesthetic essence of classical sculpture lay in a form of transubstantiation, according to which the varied materialities of objects should be synthesized into one by the dexterity of the artist. Flesh, hair, fur, horns, and so forth were all assimilated into the materiality of one medium, be it bronze, marble, or oil painting. The work of mimesis, which characterized neoclassical sculpture, always aimed at producing aesthetic models of perfection based on the Platonic ideal. Thus, classical sculpture situated itself as close as possible to optical visuality while simultaneously denying its realist ambition in favor of pure idealization. Nature must be perfected, Ingres advised Degas—"Young man, never work from nature. Always draw from memory or from engraving the masters," he said.[5] But, paradoxically, the frail-looking young *Little Dancer* was invested with the task of single-handedly assaulting the very tradition of classical sculpture by transgressing this most important rule on both accounts: form and matter.

But many might not be aware that the *Little Dancer* we have become used to encountering in museums around the world is not the original displayed by Degas in 1881.[6] Cast bronze multiples were authorized by Degas's descendants in the 1920s and have become more recognizable than

the original wax version. Structurally, the original 1881 sculpture bears substantial similarities to the taxidermy mounts made around that time. Inside the sculpture's wax model is a metal armature to which bits of wood, thread, rope, and other stuffing materials, including old paintbrushes, were secured. Wax was regularly used in taxidermy mounts for the modeling of fleshy animal parts that were not covered in fur. But in artistic circles at the time, this material was more often used by artists to produce maquettes rather than final works. And, rather importantly, wax was used by artists who worked with animal subjects. In this sense, it was a material predominantly associated with craft and genre scenes.[7] To complicate matters further, wax was also associated with religious effigies and anthropological displays in museums because it embodied a translucent quality evoking the consistency of human skin. This material choice infused *Little Dancer* with a vivid, illusive quality, one heightened by the implementation of a cotton and silk tutu, linen slippers, and a fabric ribbon in her hair. This unorthodox assault to classical taste and rules, one most likely inspired by African artifacts that the artist was familiar with, caught audiences and critics by surprise. Jules Claretie found the sculpture "strangely attractive, disturbing and [in possession of] unique Naturalism."[8] McNeil Whistler was so shocked by the work that he could apparently only utter short cries.[9] These surprising responses were triggered by Degas's tampering with the balance between realism and idealization typical of classical sculpture. Representation, the essence of taste, and the epistemic modality through which classical art had concealed the incongruities of everyday existence under a polished veneer of decorum were destabilized at once. But the strongest material challenge posed by Degas's work rested on the head of the sculpture—a wig of human hair.[10] This specific feature of *Little Dancer* is routinely underscrutinized in art historical accounts, yet I argue that, much more than the fabric tutu, this feature marks the most abrupt and radical departure from the discourses of classical art ever performed in the nineteenth century. This seemingly simple, yet utterly powerful gesture anticipated surrealist notions of the uncanny, the abject, and the object-assemblage by more than forty years. The abrasive realness of materiality shattered the screen of representational realism in order to reach further, to gesture toward a new level of political realism in which the undeniable materiality of "lived life" is no longer softened and edulcorated by ideological utopianism,

but incorporated in a state of carnal immanence—one that connects the representation networks of biopower relations that are contemporarily urgent. Suspended between life and death, the indexicality of human hair implicitly problematized authorial notions of artistic skills, labor, and creative genius. By leveraging the immediacy of its material essence, real human hair turned the ennobling into the grotesque, the fetishized into the abjected, and the realistic into the visceral.

Degas realized that rules and conventions in art bare an inscribed ideological root—they tend to sediment and naturalize. In the shock potential of materiality, he found a way to make representation *abrasive*. He could no longer simply allude to an existing social reality but instead opted to drag it in all its rawness into the exhibiting space for everyone to see. It was the viscerality of materiality in *Little Dancer* that brought bourgeois audiences face to face with the seamy side of the *Opéra*, its recklessly exploitative nature, its ethically questionable operations, the gender divide that limited social mobility, the unmanageability of underage prostitution, the burgeoning anxiety linked to venereal diseases, and the objectification of those who are deemed inferior and thus made vulnerable by the very social systems that construct them—by implication, to some, Degas's treatment of *Little Dancer* suggested that this girl was "born of a bad stock and subject to a corrupt environment."[11] As a commentator of the time noted: "No social being is less protected than the young Parisian girl—by laws, regulations, and social customs."[12] It is in this sense that *Little Dancer* constitutes a materialization of behavioral pathology in the classed society of fin-de-siècle Parisian culture.

To heighten the uncomfortable realness of his sculpture, Degas presented the 1881 version in a vitrine case. This was the first time in the history of art that an artist had presented work in such a way. The display modality emphasized the association of wax with anthropological and natural history models, prompting the viewer to consider the deliberate dislocation of institutional references to practices and discourses. Conceptually, the glass barrier erected by the artist also inscribed the effigy of the young girl within uncomfortable economies of desire—it connected the sculpture to the eroticized emergence of mannequins in shop windows, situating her as a commodity of the spectacle. Thus exhibited, *Little Dancer* posed as a natural history specimen. No longer an individual, she represented the multitude of faceless and failed ballerinas whose

bodies, beauty, and grace did not develop in accordance with the canon of classical ballet. Her posing as a specimen bore a claim of unprecedented veridicality in art—one supported by a pronounced indexicality that made this work of absolute importance to the series of artistic statements that would follow in its footsteps.

Adding to the political proposal of *Little Dancer* was its exhibition in Nadar's photographic studio, a site in which the indexicality of photography generated new economies of production and image consumption. Not quite art, but neither quite fragment of the real world, photography, during the nineteenth century, problematized previous histories of representation, largely contributing to the emergence of new realisms and enabling unprecedented forms of criticality to arise.

At this stage, one might wonder why realism should constitute a nodal point in the reception and assimilation of works of art. The history of realism in western art is intrinsically bound to opticality, perception, science, and philosophy. Optical realism has not been an essential component of nonwestern art. Closer to the west, Egyptian funerary art largely capitalized on symbolic synthesis. The Platonic conception of mimesis saw resemblance as a process generating inferior and deceptive copies that are progressively further removed from archetypal truths. And classical Greek sculpture (480–330 BCE) surely employed optical realism not only to tell universal truths but also to seduce the eye of the spectator while normalizing moral and ethical values—classical sculpture embodied an erotic/homoerotic essence according to which attention to detail and idealization of form became aesthetic parameters of paramount importance. Thereafter, during the Middle Ages, optical realism, or that which is also known as naturalism, dissipated. The hypersimplified flatness and hierarchical compositions of Gothic and Byzantine art privileged clarity, symbolism, and narrative structure over optical sensuality. This shift away from optical realism should not be understood as a lack of realism, but as the epistemic manifestation of a new and different register of realism—one that was substantially defined by the word of God and by the power/knowledge relations from which the works of art emerged. Thereafter, optical realism returned to occupy a prominent role in the Renaissance because of the revival of Greek philosophy and classical art and because of the increasing importance of patrons who commissioned works of art and who wanted to

recognize themselves immortalized in paintings. Renaissance realism was therefore defined by an erotic appeal shaped by socioeconomic and political forces. But most importantly, and despite appearances, realism has never equated to transparency, nor to objectivity—it has always been in one way or another an ideologically charged aesthetic tool designed to awaken the senses, trick the mind, attract attention, cause wonder, and narrate. Its overlaps with opticality are transitory—they come and go through the intersections of different histories of visibility and phenomenology.

But during the nineteenth century realism became a more complex agent. That which had been used to essentially please the gaze turned into an abrasive tool charged with renewed political values. The invention of photography in 1826, and its uncontainable popularity that followed the release of the daguerreotype in 1839, gave way to new ontologies of realism for the modern age. Photography freed representation from the rhetorical burdens of exclusivity that dominated painting, thus expanding the scope of representation itself. Simultaneously, the French Realist movement tampered with the classical canon by elevating the struggles of the working classes within the dramatic upheaval of the industrial revolution to the level of historical and religious representation. New registers of realism thus emerged from the heightened interest in opticality and the political criticality these new conceptions of reality inscribed. In this context, the realism of the mixed materiality of the *Little Dancer* embodies more than eroticism in its denunciation of a social actuality that involves not gods and heroes from the past but vulnerable groups who lived in specific socioeconomic milieus.

However, it is important to notice that no form of realism, not even the kinds that rely on material challenges to unravel new semantic structures, can reach, in Hegel's words, "a reality that lies beyond immediate sensation and the objects we see everyday."[13] What Degas's material register of realism effectively entails is a speculative dimension gesturing toward the possibility of surpassing the traditional constraints of human perception and enabling a political kind of agency to emerge from the encounter with works of art. It is therefore not much of a surprise, given the importance it plays in our conception of reality and in our ability to co-form reality along with the other co-agents, that today realism is again central to contemporary artistic and philosophical debates alike.

The materiality of objects in contemporary art, including taxidermy, should therefore not be understood as a site of truth of a higher kind but as a heightened register of realism that garners its semantic strength from the sociopolitical implications that have produced it. From this vantage point, realism acquires a carnality capable of inscribing past livingness, or vibrancy, that momentarily derails subject-forming linguistic structures—Whistler's reported inability to utter meaningful words in front of *Little Dancer* exemplifies this. So how does Degas's *Little Dancer Aged Fourteen* relate to what I call speculative taxidermy in contemporary art? There is something about the making visible, the mistrust for classical realism, the desire to make viewers uncomfortable, the investment in indexicality, the inclusion of organic matter, the embedded challenge posed to naturalized power relations, and the ability to unravel complex interlinks between humans, animals, social realities, discourses, and practices outlined in this prologue that will turn out to be essential to the aesthetic strategies and semantic capabilities of speculative taxidermy.

INTRODUCTION

New Taxidermy Surfaces in Contemporary Art

By the madness which interrupts it, a work of art opens a void, a moment of silence, a question without answer, provokes a breach without reconciliation where the world is forced to question itself.

<div align="right">—FOUCAULT, MADNESS AND CIVILIZATION</div>

I would like to blur the firm borders that we human beings, cocksure as we are, are inclined to erect around everything that is accessible to us. . . . I want to show that small can be large, and large small, it is just the standpoint from which we judge that changes, and every concept loses its validity, and all our human gestures lose their validity. I also want to show that there are millions and millions of other justifiable points of view beside yours and mine. Today I would portray the world from an ant's eye view and tomorrow, as the moon sees it, perhaps, and then as many other creatures may see it. I am a human being, but on the strength of my imagination—tied as it is—I can be a bridge.

<div align="right">—HANNAH HOCH, CATALOG FOREWORD TO HOCH'S FIRST SOLO EXHIBITION AT THE
KUNSTZAAL DE BRON, THE HAGUE</div>

THE RETURN OF TAXIDERMY

The events that took place on the night of February 1, 2008, on Paris's Rue du Bac would affect not only nearby streets or even the whole city. They would go on to impact popular culture and contemporary art on a global scale. 46 Rue du Bac was the home of Deyrolle, the oldest and most famous, still operating, taxidermy shop in the world.[1] The business had been trading since 1831. The owner, Jean-Baptiste Deyrolle, a renowned entomologist, passed it on to his son Achille, who expanded the scope of the collection through his interest in African megafauna. In 1888, Achille's son, Émile, relocated the business to Rue du Bac. It perhaps comes as no surprise that the rich history of Deyrolle closely mirrors the ups and downs of a complex and controversial craft: taxidermy. In its heyday, from the 1870s to the 1920s, Deyrolle employed more than 300 people, and its activities went well beyond mounting and trading specimens (fig. I.1).[2] Its educational programs, for instance, greatly contributed to its international fame. But in 1978, as taxidermy seemed to have completely lost its fashionable appeal, the shop entered a period of slow decline and was eventually sold.

Yet the beginning of the new millennium saw an unexpected change of fate for Deyrolle, as attitudes toward taxidermy appeared to shift once again. In an attempt to renew interest, its current owner, Prince Louis Albert de Broglie, reinvented the collection as an eccentric cabinet of curiosities, exhibited house-museum style. Taxidermy mounts of lions, tigers, llamas, zebras, bears, peacocks, and horses were displayed side by side, as if in one of Jan Brueghel's "paradise paintings" of the early Baroque period in Flanders. Visiting Deyrolle made for an overwhelming experience—a feast for the eye counterpointed by the uneasy appeal of death disguised as life. The walls were covered with glass cabinets, and entomological drawers manifested a deliberate disregard for scientific taxonomy. The rhythmic repetition of iridescent butterfly wings, next to the spiky bodies of locusts and the multicolored elytra of beetles, enthralled adults and children: the charm was Victorian in essence and the attraction seemingly irresistible in nature.

But at five o'clock in the morning on February 1, 2008, Deyrolle's displays made their appearance on the international news: a fire rapidly

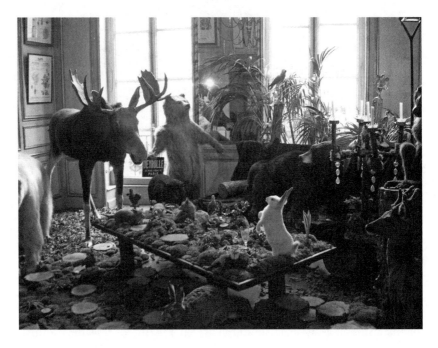

FIGURE I.1 Deyrolle, Paris, interior view, 2007. Photograph courtesy of Sara Goldsmiths, CC BY 2.0.

spread from the entomological cabinets and in a few hours had destroyed 90 percent of the collection. Louis Albert de Broglie, standing outside the building in the cold, amid the smoke and the fire trucks, told his wife: "It is all over—there are flames everywhere."[3] The picture was devastating, and news of Deyrolle's fire began to spread just as fast as the collection turned into ashes. TV and online news coverage from *National Geographic*, the *New York Times*, the *Telegraph*, *Le Figaro*, and even general interest publications like *Vanity Fair* and *W Magazine* captured audiences' imagination.[4] It was therefore no surprise that news of the fire also attracted the interest of many artists. Among others, Anselm Kiefer, Gérard Depardieu, Sophie Calle, Paul Smith, Huang Yong Ping, Karen Knorr, and Damien Hirst expressed their sympathy for the shop, while photographers Laurent Bochet, Pierre Assouline, Nan Goldin, and Martin d'Orgeval rushed to immortalize the charred remains of the few sur-

viving specimens to raise funds for the shop's refurbishment.[5] Overnight, taxidermy regained its cool. The celebrity endorsements, the media attention, the social media shares, and the tragic entanglements of life and death proposed by an event charged with filmic allure led to today's conspicuous abundance of taxidermy mounts in interior design magazines, fashion shops, and bars around Europe. In 2014, taxidermy courses, according to the *Evening Standard*, were a "sell-out hit" in London.[6] Meanwhile, in New York, taxidermy became the "new hipster hobby,"[7] as a *Sky News* headline read "Taxidermy: Art of Stuffing Animals Dead Trendy."[8] But besides the hype, the haunting photographs of burnt taxidermy mounts insistently grabbed my attention. A selection of these later appeared in two volumes, one by Pierre Assouline, titled *Deyrolle—Pour l'Avenir*; the other a collaboration between photographer Laurent Bochet and de Broglie, Deyrolle's owner, titled *1000 Degrees C. Deyrolle* (fig. I.1).[9]

Perhaps not surprisingly, these images generated romanticized responses contemplating the unavoidable completion of a cycle of decay that, thought arrested by science and craft, had been reclaimed to dust by fire.[10] Pointing at the aesthetic continuity between the charred architectural surroundings of the shop and the surviving specimens, Martin d'Orgeval said: "creation, conservation, and destruction have followed on from one another—a process completed and given closure by photography."[11] Despite the sublimity of rhetorical statements like these, what became intriguing was the aesthetics of ruination constructed by these photographs—an elusive quality that exacerbated the suspended life/death dichotomy that so much characterizes the realism of taxidermy. Observing many of these images revealed that the tension making these animal bodies so abrasively present pertained to internal economies of realism and abstraction specifically related to the representation of animal bodies in art. These images exposed an abrasive animal materiality capable of subverting photography's sometimes idiomatic inability to tell the living from the dead. They ultimately engaged in a new play of visibilities and invisibilities that ontologically problematized the intrinsic instability characterizing all taxidermy objects while simultaneously gesturing toward an intriguing critique of realism.

BEYOND POSTCOLONIAL CRITIQUE

The images from Deyrolle's fire brought me to reconsider certain notions of figuration and abstraction that had been central to early discussions in the field of animal studies and art and the need to more carefully consider certain representational issues that have thus far remained tangled (fig. I.2). Therefore, this book focuses entirely on the tensions just described—tensions pertaining to objects that employ realism in order to problematize notions of realism itself; tensions characterized by ambiguous approaches to figuration and abstraction, representation and iconoclasm, livingness and death, and, most importantly, by the preponderant value of materiality as an undeniable trace of what has been termed *naturecultures* in contemporary art.[12]

Despite the predominantly negative academic attention taxidermy has garnered over the past twenty years or so, I argue that the new and often uncanny presence of this medium in contemporary art can propose critically productive opportunities to rethink human/animal relations within a broader context than the artistic itself. I am aware that, from an animal studies perspective, this claim may sound at first controversial, if not intrinsically oxymoronic. Yet, the framework of this book relies on the refusal of generalizations and capitalizes on the analysis of specific examples in which taxidermy is adopted by artists as a deliberate destabilizer of anthropocentrism rather than as a tool of affirmation of man's superiority over nature. Therefore, its central argument focuses on the undeniable importance of representation in human/animal relations and takes new iconographies of animals in art as an opportunity to think inside the gallery space about what happens outside its physical confines.

The methodological approach is therefore underlined by a political proposal that links the current emergence of taxidermy in contemporary art to the ontological derailments initiated by postimpressionist artists and further explored by cubist, Dadaist, surrealist, neo-Dadaist, pop art, and postmodernist aesthetics. What was extremely important and powerful about these movements was their ability to connect the gallery space with the outside world in ways that had never been previously explored. They promoted modes of art making that nurtured criticality. Thus, by paying attention to the emergence of taxidermy in contemporary art as a phenomenon that inscribes much more than artistic trends and academic

FIGURE I.2 Laurent Bochet, *Lion, Panthera leo* (zoo specimen), February 1, 2008. Originally featured in *1000°C Deyrolle*. © Bochet.

theories, and by contextualizing it through a variety of lenses ranging from the biopolitical to the posthuman and the anthropogenic, this book aims to rethink our current relationship with animals, the environment, biopower, capitalism, and perception through art.

Whether we like it or not, taxidermy has the ability to grasp the viewer's attention in an artworld that is most regularly too distracted by shock tactics, sleek surfaces, and vacuous narcissism. And, by admission, some taxidermy art partakes in these very shallow economies of consumption too—but that is not the taxidermy this book focuses on. By the same

token, this book does not argue that a certain use of taxidermy in contemporary art might directly impact the environmental challenges we are currently facing. But I am, nonetheless, very sure that a taxidermy skin can at least draw the attention of those who don't usually think about animals and that it will bring them to consider some important conditions involved in human/animal relations. In a work of contemporary art, taxidermy constitutes a powerful semantic point of access, and if used critically, this power can bring positive change.

Although the celebrity endorsement that made Deyrolle's rebirth possible has contributed to taxidermy's renewed popularity, it surely has not won over its detractors. Taxidermy expert Pat Morris reminds us that the practice "went spectacularly out of fashion" in the years following the Second World War for "what had been a source of pride and stimulation for one generation was treated as dull and shameful by the next."[13] And in *The Breathless Zoo* Rachel Poliquin has shown that, paradoxically, European natural history museums have begun to find taxidermy unsuited to their current educational missions. Postcolonial, critical approaches to collecting and displaying have contextualized taxidermy as a difficult emblem of political and cultural imperialist pasts.[14] Some British institutions have been asked to publicly clarify their ethical stance on the subject, and, under pressure from funding bodies, some have sold or destroyed part or all of their taxidermy collections.[15] This turn of events has unfolded mainly because, to some, taxidermy has come to overtly signify "death on display"—the indelible reminder of a "gratuitous spoilage of nature" that cannot be reversed.[16] At the same time, according to others, the technological advancements in television and color photography have also rendered taxidermy's original function, that of making animals visible, substantially obsolete and redundant.[17]

As will be shown in chapter 1, the metanarrativizing history of taxidermy has its roots in the scientific innovations and colonialist practices of the seventeenth century. Thereafter, the craft gathered momentum as the industrial revolution relentlessly reconfigured the boundaries between city and countryside, nature and culture. In Europe, the increased distancing from the natural world imposed by modernization coincided with the rise in popularity of natural history museums and zoos as places of encounter between culturally encoded and rationalized notions of nature and audiences.[18] Back then, beyond its scientific purpose of enabling

taxonomic ordering, taxidermy functioned as the still and silent token of the exotic and marvelous life-forms inhabiting faraway lands—lands culturally admired and treasured as much as they were mystified and misunderstood.[19] On the surface, Victorian audiences, like those visiting Deyrolle, were fascinated by the unusual and colorful bodies of exotic animals that metonymically pinned the visual mapping of the far expanse of land incorporated into the British Empire.[20] Therefore, today, as Poliquin argues, taxidermy is understood by some as the emblem of the very values that drove the imperialist spirit: "dominion, courage, vigor, undaunted determination, triumph over the 'untamed,' and eventual victory" of patriarchal values.[21]

Further problematizing Poliquin's view with an emphasis on the new world, Pauline Wakeham argues that

if taxidermy denotes a material practice—the dissection, hollowing out, and restuffing of a corpse's epidermal shell—its connotative specters revive fantasies of white male supremacy in "the sporting crucible," of colonial mastery over nature, and of the conquest of time and mortality through the preservation of the semblance of life in death. In this context, taxidermy functions as a powerful nodal point in a matrix of racial and species discourses, narratives of disappearance and extinction, and tropes of aboriginality that have been crucial to the maintenance of colonial power in Canada and the United States from the beginning of the twentieth century to the present.[22]

Similarly, Mark Simpson's 1999 essay titled "Immaculate Trophies"[23] proposes a reading of wildlife conservation in western Canada in which taxidermy has played a conspicuous embodying role—a practice linked to the discourses of health in which "the protection of nature assures the fitness of white culture" and of which, ultimately, taxidermy represents the paradox affirming racial recreation.[24] In *The Empire of Nature*, John MacKenzie further exposes the connections between social class, gender, race, and big-game hunting that regularly perpetrated the search for perfect museum specimens.[25] Most notably, Donna Haraway's influential essay "Teddy Bear Patriarchy: Taxidermy in the Garden of Eden" firmly positions taxidermy as the quintessential tool of patriarchal identity construction in the United States. In her analysis of the technical and

metaphorical overlaps between shooting with a camera and shooting with a gun, Haraway configures the natural history museum as an epistemic site substantiating the dichotomic contrast between pristine nature represented in dioramas and the corruptive technological impact of early capitalist economies.[26] As the crucible of multiple natureculture unfoldings, taxidermy is here revealed as the embodiment of seemingly unrelated discourses and practices involving exhibitions, eugenics, and conservation. And even darker tones emerge in Jeffrey Niesel's "The Horror of Everyday Life: Taxidermy, Aesthetics, and Consumption in Horror Films,"[27] where taxidermy representationally embodies the morbid desires of the filmic serial killers in *Psycho*, *The Texas Chainsaw Massacre 2*, and *The Silence of the Lambs*.[28] As Niesel argues, "taxidermy, because it takes the fetish to its logical end (murder), exposes connections between consumerism, aesthetics, and patriarchy and shows how these systems contribute to creating relationships of violence particularly in the effort to render feminine subjectivity silent."[29] In this sense, taxidermy is configured as the tangible manifestation of the ways in which commodification constitutes our preponderant modality in the incorporation of the world— a trait that will become central to the examples discussed in this book.

TAXIDERMY IN CONTEMPORARY ART

Scientific taxidermy, the realist kind in natural history dioramas, was never accepted by the artistic canon as a legitimate form of high art. In a sense, the same is true today. However, over the past fifteen years, taxidermy has finally entered the exhibiting space, yet it has not done so in the way its Victorian supporters would have hoped for. It is not the realist accuracy conquered by the craft that has enabled the ontological shift from craft object to art object. Paradoxically, it is the very problematization of realism intrinsic to the medium that has finally enabled it to partake in artistic discourse. Many artists engaging with this medium have produced a very original and personal approach, contributing to the outlining of a richly fragmented and aesthetically challenging turn in contemporary art practice. Therefore, any attempt to map or exhaustively summarize this phenomenon would inevitably fail to do it justice. But it

might be useful to at least outline three substantially different and recurring approaches to the medium: the symbolic, the surrealist, and the political.

To some artists, taxidermy has provided an opportunity to crystallize the animal into pure symbolic form, thus reinvigorating classical traditions of representation based on objectification. It is worth noting that in the early works of Petah Coyne, Claire Morgan, Kate Clark, Cai Guo-Qiang, Maurizio Cattelan, and others,[30] taxidermy appears to ventriloquize human concerns extrinsic to human/animal relations: they essentially function as metaphors. Other artists have been more directly influenced by surrealist agendas, as in the case of Tessa Farmer, Sun Yuan and Peng Yu, Jan Fabre, the Idiots, Ghyslain Bertholon, and Polly Morgan. Here animal bodies re-propose a curiosity paradigm typical of the surrealist found-object. However, this familiar-made-strange gestures toward the possibility of reinventing ontologies, sometimes inscribing a political proposal that transcends lyrical aesthetics. Also inspired by surrealist aesthetics is the work of a number of contemporary photographers like Richard Ross, Karen Knorr, and Hiroshi Sugimoto who have invested time and energy in critically addressing the ambiguous life/death dichotomy of mounted animal skins through the lens of the camera.[31]

Lastly, a number of artists conceive taxidermy as a clear political statement—they exclusively adopt it to directly challenge, problematize, and question human/animal relations. Mark Dion, Steve Bishop, Wim Delvoye, Marcus Coates, Andrea Roe, Angela Singer, Thomas Grünfeld, Chloë Brown, Petrit Halilaj, Ali Kazma, Snæbjörnsdóttir/Wilson, and Art Orienté Objet have all distinguished themselves through the production of pieces in which taxidermy is implemented for the purpose of altering the viewer's conception of nature, environments, animals, and human/animal relations. At stake in their work is the possibility to think beyond the romanticized, affirmative, and comforting images of natural beauty that have historically pleased art audiences.[32] They directly address the ontological certainties of anthropocentrism, questioning the institutional writing of history, history's concealment of animals in the light of man's achievements, the histories of representation that have cemented man's exceptionalism, and the possibility of undoing such historiographies through a critical use of the very medium through which those histories were written in the first place.

However, as will be seen in the following chapters, these three approaches to taxidermy in contemporary art often overlap and intertwine, sometimes leading to the emergence of works of art that unexpectedly upturn objectifying tropes or productively incorporate symbolism in critical ways. But the emergence of taxidermy in contemporary art contributes to the current problematization of materiality, gender, ethics, and aesthetics emerging in the aftermath of postmodernism, while attempting to adequately address the ecopolitical crises that characterize the current phase of the Anthropocene.

BOTCHED AND SPECULATIVE TAXIDERMY

In 2000, Steve Baker, author of *The Postmodern Animal*, introduced the concept of *botched taxidermy* as part of his broader argument inviting serious consideration of the presence of animals in contemporary art.[33] The book has undeniably achieved its aim, situating artistic representation on the map of animal studies. However, it is important to acknowledge that botched taxidermy was intrinsically defined by postmodernist values and aesthetics that have now given way to new approaches and concerns. In itself, the term *botched taxidermy* inscribed the essence of the postmodern animal aesthetic. Baker acknowledged that the term was devised as a "clumsy catch-all phrase for a variety of contemporary art practice that engages with the animal at some level or another. In some cases, it involves taxidermy itself, but in all cases the animal, dead or alive, is present in all its awkward, pressing thingness."[34] Essentially, in botched taxidermy "things appear to have gone wrong with the animal," Baker argued.[35] And it is in this generic notion of wrongness that an important opportunity to differentiate between the semantic role played by animal skins and manmade surface has been overlooked.

Deliberately opposed to the sentimentalization of classical and romantic animal representations as heroic, comforting, exotic, or amusing, botched taxidermy proposed itself as "an awkward thing," "the product of postmodern human thought," a "strange being encountered and experienced, rather than rendered familiar through interpretation," essentially a questioning entity.[36] Its main role was that of confronting the

viewer with a fragmented, abrasive visibility, resisting and simultaneously displacing fixed cultural meanings.[37] Botchedness, therefore, was constructed as that which prevented man from possessing animals as objects, to metaphorically subjugate them in anthropocentric discourses and to make them work as moral/ethical blocks in the definition of man's finitude. Baker identified six predominant recurring modalities characterizing its aesthetics. The most common involved an awkward use of mixed materials, the replacement of taxidermy animals with stuffed animal toys, the production of hybrid form, the staging of "messy confrontations," the manipulation of taxidermy mounts, and an overall aesthetic of tattiness.[38] But though the term worked well with artworks that had nothing to do with the medium of taxidermy itself, the label "botched taxidermy" seemed reductive when applied to actual taxidermy objects—it just didn't quite capture the pressing complexities proposed by the materiality of the medium.

The concept of *speculative taxidermy* theorized in this book moves beyond botched taxidermy, providing a dedicated theoretical tool for articulating the new range of artistic concerns that taxidermy has brought to the fore. Speculative taxidermy is concerned with a more specific approach and with a much narrower range of works of art in which visible animal skin (or its representation) is critically adopted as a defining indexical relationship between animal presence and the medium of representation itself. Indexicality here is understood in C. S. Pierce's conception of a sign physically linked to its object by a strict relation, one that is inescapable and necessary. More specifically, in Morgan Marcyliena's conception,

> indexicality incorporates all aspects of the social and political context in order to construct referential systems of signs and symbolism—the core ingredients for ambiguity and indirection. It is the muscle that regulates the language and discourse of speech communities, and it enforces its boundaries. . . . Through indexicality we manage to understand what is being said within a contextual framework of the social, cultural, local, political, imagined and artistic world within which communication occurs.[39]

In this sense, indexicality can be understood to constitute the backbone of a certain realism; it is validation, the authenticating element that sets

such realistic register. In this context, indexicality is the tipping point that mobilizes semantic apparatuses inscribed in works of art. The focus on indexicality that characterizes speculative taxidermy is intrinsically bound to the new urgency gained by biopolitics in the context of the Anthropocene—the acknowledgment that a painting and photograph of the same animal occupy ontologically distinct dimensions despite their shared model, that such ontological distinction plays an active semantic role in the encounter with the work, and that the links between indexicality and realism constitute a central node of current preoccupations in contemporary art practice in a broader sense. It follows that speculative taxidermy is defined by a deeper investment in materiality and indexicality—an investment devoted to exploring shared physical and ontological vulnerabilities concealed by the naturalization of past human/animal institutionalized relationships. But furthermore, in speculative taxidermy, the mapping of these vulnerabilities takes place in a productive scope—the aim of speculative taxidermy, in opposition to botched taxidermy, is not simply to highlight a generic "wrongness" but to specifically address the biopolitical register as a fundamental natureculture site of production in human/animal relations.

The term *speculative taxidermy* therefore defines a category of actual taxidermy objects, or indexical representations of them, that first and foremost pose questions about what taxidermy may be or do in order to unravel complex interlinks between humans, animals, environments, discourses, and practices. The semantic ruptures proposed by the materiality of animal skin in speculative taxidermy, heightened by the manipulation of form, engage in speculation on the interconnectedness of networks that reflexively shape human/animal relations through specific biopolitical registers defined by sociopolitical and ecological frameworks.

In this context, the term *speculative* references the *speculative turn* that, since the 2006 publication of Quentin Meillassoux's *Après la Finitude*,[40] has revived enthusiasm in the tradition of western philosophy. The term implies the renewed investment in the materiality of objects that in speculative realism has been more concretely addressed by object-oriented ontology and new materialism.[41] The term expresses the deep unease and dissatisfaction with the limitation with which the term *taxidermy* connotes a vast range of animal-derived objects that have transhistorically

fixed, constant qualities—objects that can be easily categorized in taxonomies of stereotypical genres.

Although transcending the aesthetic concerns of botched taxidermy, to some extent, speculative taxidermy can still be understood as a "strange being encountered and experienced, rather than rendered familiar through interpretation." But, as will be seen, speculative taxidermy does not involve an aesthetic wrongness, and it is not defined by its "holding together."[42] These essentially were postmodernist values that are no longer preponderant in contemporary art. Most specifically, at times, the essence of botched taxidermy was haunting; at others, it was formally elusive. In both cases, the animal presence was, as expressed by Baker, "dumb"—a victim of generic human wrongdoings emerging from a traumatic past, unable to rest. As will be seen, speculative taxidermy is anything but dumb. Works of speculative taxidermy inscribe discourses and practices rendering the preserved animal skin into a charged interface tracing actual human/animal agential relationships: naturecultures. Boundaries between human and nonhuman are thus questioned through the consideration of a host of material/discursive forces constituting processes of materialization.[43] And, most importantly, speculative taxidermy does not present itself as an obstacle to meaning, like botched taxidermy did; rather, it provides tools to think with.

Most specifically, my theorization of speculative taxidermy bypasses the use of the terms *botched* and *wrongness* because of their intrinsic normative roots: the ways in which these terms somewhat imply that realism bears a model of (negative) *rightness*, and the intrinsic comparative/pejorative relativity that they imply. Speculative taxidermy is not concerned with notions of aesthetic wrongness, holding to form, or open-form, or messiness, but with interconnectedness, intra-action, materiality, and indexicality. It is concerned with the questions raised by the actual manipulation of animal skins (manual as well as mediatic) and the biopolitical registers inscribed in such operations; the discourses and practices that reciprocally shape humans, animals, and environments; the recovery of historical pasts of human/animal intra-actions that have sedimented in discourses and practices defining assemblages of political, geographical, and historical entanglements; and the possibility to envision alternative futures in the evidence of the ethical challenges that speculative taxidermy enables us to identify.[44]

SOME NOTES ON THE PHILOSOPHICAL FRAMEWORK OF THIS BOOK

This book originates from the frustration caused by the contextual simplifications of postcolonial approaches to taxidermy illustrated earlier and the lack of serious efforts on behalf of art historians to situate taxidermy as the manifestation of previous artistic discourses and practices. To be clear: the appearance of taxidermy in contemporary art is not simply a postmodernist "trick of the hat," and it can neither be reduced to the symptom of a wrongness between human and animal situated outside artistic discourses nor be grafted onto philosophical ones. It is for this reason that, to start, this book embarks on an ambitious and multidisciplinary genealogical recovery of multiple taxidermy pasts, intersecting material practices, parallel discursive formations, shared archives, and representative modalities.

That said, one of the most important challenges involved in writing about or with contemporary art involves the ability to switch among the increasing number of theoretical lenses at our disposal. When writing about animals, or specifically about taxidermy within an animal studies framework, certain disciplinary parameters appear to be intrinsically bound to ethical approaches. Keeping animals at the forefront of academic arguments while configuring their presence within multidisciplinary fields is not an easy task.

Over time, I have come to identify two types of discipline-specific blindness related to thinking and writing about art. Studying visual culture has made me aware that history of art can easily bury works of art under a carefully layered tapestry of biographical and comparative data. This operation ultimately fails to prioritize the very important connections that can be drawn between the art object and its role in today's discourses. It reduces the art object to historical evidence. On the other hand, history of art has made me aware that visual culture can be equally, but differently, blind. The reliance on philosophical texts as the ultimate key to access and problematize works of art can be guilty of using art as a pretext. Sometimes, in visual culture, the work of art figures as the soundboard for concepts that too quickly forget the work itself. In truth, I would argue that because of each work's originality and idiosyncratic relationship to materiality, performativity, and conceptualism, every

work of art could require the crafting of a new methodological approach, or at least might instill a desire to write with the work, rather than about it, or to engage in a shared flight rather than a dissection.

These subject-specific limitations brought me to reconsider Foucault's postphenomenological approaches to art. To some, this choice will seem odd, and to others, it might appear that my appropriation of Foucault's methodologies and ideas doesn't do justice to his broader body of work. These concerns might be legitimate, but focusing too much on this aspect of my work would mean to miss the point: philosophical concepts should be alternated, remodeled, expanded, picked up, and dropped in relation to the task and the productivities they bear in unraveling relevant discourses and practices inscribed in a work of art. Knowing when to switch tools is essential to the successful completion of the task, and crafting new tools in the process is a definite advantage. In this spirit, my tools of inquiry in this book also incorporate components of new philosophical movements, such as speculative realism, object-oriented ontology, and new materialism. The aim is not to test the frequently questioned applicability of these frameworks to artistic discourses but to appropriate aspects of their key arguments to find productivities in them.

These frameworks will be inscribed within the broader concept of the Anthropocene, the geological epoch in which the human impact on the earth's ecosystems is acknowledged as an undeniable and defining force.[45] The Anthropocene is well defined by the acknowledgment that, every year, humans exceeded by more than half the resources produced on the planet. In the Anthropocene, overconsumption is underpinned by a deep and general sense of unconnectedness with nature, which is compensated only representationally by the emergence of sublime-catastrophic visions of rising temperatures and sea levels. This is the lens through which the negative postcolonial connotation of taxidermy can be counterbalanced. Anthropogenic vantage points do not discard postcolonial perspectives altogether, but they problematize them through the ecocriticist acknowledgment that the human impact on the planet is also convolutional and productive, not simply and unilaterally destructive. Timothy Morton's theorization of dark ecology is the predominant modality that characterizes systems, entities, and thoughts in the context of the cultural, environmental, economic, and political crises we are currently traversing.[46] The proposal of dark ecology rests on the notion that engaging

with ecological thinking beyond the pure rhetorical level requires dabbling in irresolvable ambiguities, overlapping loops, and darkness.

> Dark ecology puts hesitation, uncertainty, irony, and thoughtfulness back into ecological thinking. The form of dark ecology is that of noir film. The noir narrator begins investigating a supposedly external situation, from a supposedly neutral point of view, only to discover that she or he is implicated in it. The point of view of the narrator herself becomes stained with desire. There is no metaposition from which we can make ecological pronouncements. Ironically, this applies in particular to the sunny, affirmative rhetoric of environmental ideology. A more honest ecological art would linger in the shadowy world of irony and difference. . . . The ecological thought includes negativity and irony, ugliness and horror.[47]

This is the backdrop against which speculative taxidermy emerges. Speculative taxidermy is always concerned with what Haraway calls the "knots of technocultural reinvented pastoral-tourist economies and ecologies," which raise questions of "who belongs where and what flourishing means for whom."[48] A more complex concept of "becoming with," one articulated in linguistic as well as carnal registers, quickly takes shape as the recurrent condition in current anthropogenic discourses.

Despite the controversy surrounding the genesis and uses of the term *Anthropocene*, this term focalizes the inconfutable impact of human activities on the webs of interconnectedness that characterize the biosphere. In a sense, it makes us all aware of a being-with that has not previously been central to the humanities. The era of climate change characterized by the pervasive and unpredictable impact of human activities on the planet has already demanded the crafting of new optics, methodologies, and concepts, and most importantly requires engagement with media and histories traditionally kept discrete. At this very point, a new relationship between philosophy and art comes to the fore. Philosophers, artists, art historians, and curators are today, more than ever, committed to notions of artistic production envisioning alternative historicities, rhizomatic notions of multispecies interconnectedness, previously uncharted registers of biopolitics, new materialist approaches, reconsideration of agential potentials, capitalogenic conceptions of production and con-

sumption, and a thoroughly nonanthropocentric determination to reconfigure past notions of identity, gender, and race. But most importantly, artistic parameters are also being shifted in the light of the undeniable awareness that contemporary art offers a unique opportunity to unhinge anthropocentric certainties within a productive, experimental, and inclusive space, one that transcends the limitations imposed by disciplinary boundaries.

These tendencies have become more visible since the 2012 edition of the quinquennial, trendsetting contemporary art exhibition dOCUMENTA, which placed speculative realism, new materialism, and object-oriented ontology on the arts map. Carolyn Christov-Bakargiev's curatorial approach was largely shaped by these new philosophical waves, and the reverberation of her influence through the international contemporary scene has been undeniably substantial. Although closely associated with speculative realism, object-oriented ontology predates it and is characterized by a more defined ontological derailment of object relations. Graham Harman's conception of objects in object-oriented ontology essentially rejects the Kantian gap between the subject and the material world, or what commonly goes by the name of *correlationism*—it acknowledges objects as autonomous realities while recognizing in them the presence of turbulent, ambiguous, hidden depths—an object is an infinite recess.[49]

The "call of things," or the acknowledgment that objects constitute more than passive tools at the periphery of anthropocentrism, had already been placed on the map in 1988 by the collection *The Social Life of Things*, the effort of sociocultural anthropologist Arjun Appadurai.[50] Thereafter, in 2001, Bill Brown's "Thing Theory," with its appropriation of Heidegger's distinction between objects (tools that work) and things (tools that no longer function), pointed more directly at the socially encoded values and networks of relationships that shape our coexistence with them.[51] And it is this very Heideggerian "thread of the broken object," the one that troubles the continuity of our expectations, that constitutes Harman's foundation of object-oriented ontology.[52] This new awareness of what we normally take for granted brings us to rethink our experience of the world, the constructed centrality of the point of view of the subject, and, along with it, most of the foundation of western philosophy, at least since Descartes.

Harman's conception of humans as other objects achieves just that—it decenters the philosophical subject. Object-oriented ontology thus moves beyond the conception of representation as a place in which objects appear subordinate to humans, where they figure as entities revealed only by man's manipulation as intrinsically passive in their being. And it is perhaps not a coincidence that object-oriented ontology takes issue not only with representation but also with realism and materialism. At this point some analogies in animal studies, posthumanism, and object-oriented ontology can be seen to emerge. These disciplines, in different ways, conceive of nonhumans, whether animals or objects, as *actants* in knowledge production. This turn entails surpassing the western tradition of scientific materialism and its reduction of objects to physical micro-components. The ultimate aim becomes that of devising and embracing antireductive strategies that can free us from the primacy of human consciousness in epistemology.

Most importantly, the multiple new directions that have recently surfaced at the cultural horizon are all more or less connected by a rejection of textual critique, and by a fervent desire to speculate about the nature of reality itself. The fragmentations proposed by speculative realism share a political concern for the Anthropocene and more specifically with ecological crises. This, more than other aspects, characterizes a departure from self-indulgent and self-reflexive postmodernist agendas while substantially supporting experimental, open, new-media-based discussions shifting intellectual grounds at unprecedented speed.

The questions underlying these new philosophical shifts are therefore essentially ontological in nature and aim at deterritorializing the centrality of man within a network in which human and nonhuman actors equally influence the world at corporeal and incorporeal levels.[53]

The new philosophical wave of new materialism attempts to redeem the traditionally discounted value of matter as opposed to the idealities of continental philosophy. New materialism has emerged as the result of the decline in popularity of Marxist materialist approaches during the 1970s and 1980s and the simultaneous rise of poststructuralism and its general disinterest in materiality.[54] Ontology, epistemology, politics, and ethics appear decentralized by the new materialist conception of matter as recalcitrant, a subversion of the traditional conception of agency, resistance, and power. The significance of corporeality and the place of em-

bodied humans within a material world are, in new materialism, also interlinked to a defining awareness of the interconnectedness of biospheres and ecospheres, and the inherent fragility of the systems we co-constitute and simultaneously share.

Many of the questions underpinning the concerns of new materialism are ontological in nature. The rethinking of anthropocentrism and the consequent disavowing of our dominion over nature is reconfigured through a reimagining of the fundamental structures of matter.[55] As Diana Coole and Samantha Frost, authors of *New Materialism: Ontology, Agency, and Politics*, argue, "The Cartesian-Newtonian understanding of matter yields a conceptual and practical domination of nature as well as a specifically modern attitude or ethos of subjectivist potency."[56] Thus, new and vastly feminist materialist approaches renounce determinism and attempt to describe active and generative processes of materialization in which objects and humans are equally engaged through an immanent vitality. These new ontologies thus aim at identifying "materiality that materializes, evincing immanent modes of self-transformation."[57]

Different aspects of object-oriented ontology and new materialism have substantially influenced the writing of this book in the acknowledgment that taxidermy objects constitute a particularly ontologically unstable type of material presence characterized by pronounced specificities that are in turn problematized by the exhibiting space. Most importantly, in this book, taxidermy objects are contextualized as an interface, sensitive substrates upon which human/animal relationships co-shape discourses, practices, and, ultimately, ecosystems.

Chapter 1, "Reconfiguring Animal Skins: Fragmented Histories and Manipulated Surfaces" reconsiders the traditional historiography of taxidermy to recover the medium's agency. This new trajectory moves away from traditional object-based analysis to develop a conception of taxidermy as a site in which discursive networks, practices, and power relations can be mapped. The task begins with dismantling the metanarrative of progress to recover essential statements, discourses, and practices of which taxidermy is a sedimentation.[58] Shifting the focus from silent historical beginnings, the emergence of the word *taxidermie* in 1803–1804 is highlighted as a defining moment in the material history of the medium.[59]

Acknowledging the commodity status that underpins taxidermy, and considering it as a thing, but also as an interface inscribing animal afterlives, this chapter bypasses previous interpretations of taxidermy that have centered on abstracted notions of longing and loss favoring an analysis of the reification, dispersion, and sedimentation. Adopting the critical lenses provided by Arjun Appadurai, Bill Brown, and Garry Marvin, the intrinsic work of agential concatenations can be recovered from the manipulated and preserved animal skin.[60]

The end of chapter 1 recapitulates and expands these important threads through an analysis of Snæbjörnsdóttir/Wilson's *between you and me* (2009). The piece is contextualized as an example of speculative taxidermy: the typology of works of art that enables viewers to recognize the totalizing force of the linguistic nature of realistic representation and make us reconsider human/animal relationships beyond their naturalized transparency. This emergence substantially depends on the threads explored here: the impact of linguistic statements upon materiality, the synergic relationship of language and representation in the production of realism, and a conception of commodification that results from their synergy—a material trace of human/animal epistemic cruxes, a productive point of access for a discussion of human/animal relations in the gallery space.

In a discussion ranging from early religious texts, herbaria, and natural history illustration to cabinets of curiosities, chapter 2, "A Natural History Panopticon: Power, Representation, and Animal Objectification," further excavates the cultural and material conditions that enabled taxidermy to emerge as the ultimate objectifying gesture operated by humans upon animals during the Victorian period. The focus here shifts to the discourses and epistemic strategies via which "the real" of nature is constructed through history. In this context, the spatializations of knowledge and their material specificities are evidenced as defining actants in the production of natural history realism as a substantially panoptic modalities of observation. It is in this context that Mark Fairnington's post–natural history illustrations and Mark Dion's critical cabinets of curiosities enable the outlining of the Foucauldian informed concept of the "natural history panopticon."

Chapter 3, "Dioramas: Power, Realism, and Decorum," focusses on the recent ontological turn in philosophy, its impact upon the appraisal of

images, their ability to index a "real" that transcends the limitations of language, and their relationship to power frameworks. Therefore, this chapter traces a genealogy of the notion of realism in art and natural history, thus problematizing the lifelike aesthetics of taxidermy and dioramas. The simultaneous emergence of photography and taxidermy as epistemic tools of natural history and science is in this context problematized by the discursive and technical parallelisms that led taxidermy to transcend the ethical-epistemic, mechanical objectivity of scientific epistemology in the nineteenth century.[61] Thereby, notions of stillness, decorum, and ideology become central to a revisitation of Donna Haraway's positioning of taxidermy as a sedimentation of patriarchal discourses of imperialist conquest and subjugation. This chapter is bookended by Mark Dion's anti-diorama *Landfill* (1999) and Oleg Kulik's *New Paradise Series* (2000–2001). In different ways, both artists engage with forms of speculative aesthetics designed to address anthropogenic moments of crisis in relation to classical registers of realism.

Chapter 4, "*Tableau-objet*, or the End of the Daydream: Taxidermy and Photography," notes that through the eighteenth century, natural history was a practice concerned with the meticulous examining, transcribing, and cataloging of animal and plant surfaces through a process of synthetic purification.[62] During the nineteenth century, taxidermy and photography furthered this specific epistemological project through a new kind of absolute visibility of animals, and by simultaneously enabling the emergence of an unprecedented cultural construction of nature. Returning to the modern period as a pivotal moment in the molding of contemporary human/animal relations, this chapter further problematizes the realism of lifelike taxidermy through the aesthetics of camera hunting. The photographic diptych *Dead Owl*, by Roni Horn, and her *Bird* series, are identified as works of art in which the inherent objectifying and passifying paradigms typical of camera hunting are subverted by the artist's treatment of the animal body through a reconfiguration of the medium's idiom. Horn's images challenge the affirmative, anthropocentric relation between viewer and animal representation, proposing opportunities to rethink our relationship with nonhuman beings through representation itself. This approach, I argue, is symptomatic of a cultural crisis—one that is unavoidably underpinned by a sense of guilt and anxiety regarding our relationship with the planet. Our anthropocentric conception of

the world has led us to a state of alienation in which we constantly recoil upon ourselves, incapable of connecting with other beings and environments beyond utilitarian values. This chapter is structured around five key concepts from Foucault's texts on art. These are quattrocento painting, the *tableau-objet*, resemblance, similitude, and the event.[63] "Ontological mobility," a key concept I theorize in this chapter, provides an opportunity to rethink our taken-for-granted modes of human experience through art.[64] The taxidermy object is here connoted as an unstable speculative tool questioning our modes of perceiving, constructing, and consuming animals.

Chapter 5, "Following Materiality: From Medium to Surface—Medium Specificity and Animal Visibility in the Modern Age," is bookended by Meret Oppenheim's *Object* and Robert Rauschenberg's *Monogram*, some of the very first works of art to employ the taxidermy medium with an unprecedented critical awareness designed to destabilize the viewer's anthropocentric standpoint. This chapter returns to the emergence of animal skin in the gallery space for the purpose of refining the concept of speculative taxidermy as three-dimensional object. This intention leads to a recovery of Cezanne's multifocal perspective as a meaningful manifestation of the analytic of finitude.[65] As argued by Foucault, and thereafter by Akira Mizuta Lippit, the emergence of modern man as object of knowledge and subject who knows, or enslaved sovereign and observed spectator, proposes an epistemic circularity from which animals have been excluded by the very processes that enable man to emerge as a finite being.[66] Problematizing Berger's and Lippit's view that animals disappeared from everyday life and that they simultaneously reappeared in the economies of visual media underwritten by capitalism,[67] the concept of a "representational animal migration" reveals an important connection between medium, materiality, realism, and representation in relation to new economies of visuality. Upon this specific contingency characterizing the first half of the twentieth century, the surrealist object is recovered as a revolutionary site in which, for the first time, animal skin appears charged with a political potential that will become central to contemporary, speculative taxidermy. Nicole Shukin's conception of "rendering," Ron Broglio's "flattening of animals," and Johanna Malt's "commodity fetishism" in surrealism play key roles in the emergence of the political proposal of taxidermy in art.[68]

In chapter 6, "The Allure of the Veneer: Aesthetics of Speculative Taxidermy," four works of art enable a comprehensive mapping of different strategies employed by speculative taxidermy in contemporary art: Maria Papadimitriou's installation *Agrimiká: Why Look at Animals?* (2015), *Inert* (2009) by Nicholas Galanin, Nandipha Mntambo's *Mirror Image* (2013), and Berlinde De Bruyckere's *K36 (The Black Horse)* (2003). These pieces are problematized from the perspectives of object-oriented ontology, vibrant materialism, and agential realism. *Agrimiká: Why Look at Animals?* offers the opportunity to consider the productivities and challenges involved in nonathropocentric perspectives grounded in flat ontology. The juxtaposition of everyday objects and taxidermy skins in *Agrimiká* questions our bioethical stance in relation to an ever-present sovereignty of the gaze in human/animal relations. Nicholas Galanin's *Inert* further problematizes the relationship between realism and abstraction through a focus on the linguistic aspects of realistic representation. In this instance, speculative taxidermy functions as a site in which naturalized discourses and practices are deliberately disconnected and reconfigured in ways that enable ethical reconsiderations of human/animal relations. This process, in the hands of Nandipha Mntambo and Berlinde De Bruyckere, enables the recovery of embodiments of the physical vulnerability that we share with animals. Mntambo's work especially alludes to the transhistorical, metaphorical, and economic overlap between woman and animal through notions of exploitation and domestication, while De Bruyckere's reworked horsehides construct an original iconography of human/animal vulnerability in which specific material manipulations gesture toward the naturalized systems of oppression and co-becomings that have substantially shaped human/animal relations in the Anthropocene.

Chapter 7, "This Is Not a Horse: Biopower and Animal Skins in the Anthropocene," focuses on the influence of the Duchampian readymade through the second postwar period as a new contestation of bourgeois principles and values, highlighting how this paradigm informs the emergence of speculative taxidermy.[69] Neo-Dada's anticonformist spirit drove artists to incorporate new materialities in contemporary art, reproposing the readymade paradigm through a problematization of Duchamp's notion of "aesthetic disinterest"—a preponderant attitude toward the object designed to refine the task of aesthetic analysis. In this chapter I argue

that the readymade-informed artworks of the neo-avant-garde equally incorporated aesthetic strategies borne of the Dadaist and surrealist readymade for the purpose of surpassing aesthetic disinterest. In this maneuver lies a deliberate will to politically engage with the material world beyond the transcendentalism of modernist aesthetics. According to Andre Breton, the surrealist object had expressly emerged for the purpose of "challenging indifference through a poetic consciousness of objects."[70] The first half of this chapter therefore follows this line of argument, advancing the idea that to engage in an aesthetic experience that presupposes a consistent and sustained disinterest for the object's physical existence is simply impossible within a framework informed by animal studies when animal skin or animal matter is deliberately implemented within the economies of visibility of the art object.

Thereafter, the Foucauldian conception of *dispositif* leads a biopolitically oriented analysis of *It's Hard to Make a Stand* by Steve Bishop, a piece of speculative taxidermy strongly inspired by surrealist sensitivities to materialities and by the work of the neo-avant-gardes. Simultaneously a monument and a ruin, Bishop's assemblage is configured as a Foucauldian heterotopia—a spatialization characterized by an existence in a reality demarcated by an ontologically unstable heterogeneity.[71] At this point, Foucault's anatomo-politics of the human body, technologies of the self, conceptions of docile bodies and relationships of domination, and governmentality enable the recovery of intertwining transhistorical, transspecies, human/animal sets of power/knowledge relationships of the type inscribed in domestication, domination, and consumption.[72] The allure of *It's Hard to Make a Stand* poses important questions: Where does domestication begin and domination end? How much do these relationships of power overlap and where do they differ in order to remain relatively ontologically distinct from one another, so as to be differently named? And most importantly, what are the implications involved in the intrinsic impossibility of clearly distinguishing the underlying discourses that perpetrate these types of relationships?

In "Coda: Toward New Mythologies—the Ritual, the Sacrifice, the Interconnectedness," the themes explored in this book are considered in the light of the potentialities entailed in participatory installation art that involves animal materiality. In the early nineties, the first signs of discontent with the cynicism of postmodernism began to appear. Suzi Gablik's

controversial book *The Reenchantment of Art* laid the foundations of many essential artistic/political concerns that have become central to today's scene. For instance, Gablik proposed to abandon the "modern traditions of mechanism, positivism, empiricism, rationalism, materialism, secularism and scientism—the whole objectifying consciousness of the Enlightenment."[73]

Cole Swanson's *Out of the Strong, Something Sweet* (2016), the only example discussed in this chapter, operates a series of ontological derailments designed to map the intermingling of multispecies relationships connected by mythical, transhistorical, and material ties. Central to this installation are different notions of mimesis and indexicality, their implicit ability to structure different registers of realism, and the materiality through which realist narratives are implicitly validated. Different and seemingly unrelated techno-ecological economies are made to intersect in Swanson's installation through the very cunning notion of sacrifice: in Lippit's words, "a melancholic ritual, replete with sadism and ambivalence, which repeats the origin of humanity."[74] The underlying principle of *Out of the Strong, Something Sweet* is in fact *bougonia*, an ancient ritual, recounted by Virgil in the *Georgics*, involving the miraculous rebirth of bees swarming from the rotting carcass of a calf.[75] With its poetic and yet sharply symbolic sacrificial antidote to apocalyptic destruction, *Out of the Strong, Something Sweet* situates itself at the heart of the current anthropogenic crisis: in the face of ultimate life-threats, the means through which propitiation might be secured entails the rather cunning proposal of regenerating bees by sacrificing the cow—a plea for a sustainable human/animal/environmental coexistence.

The appendix of this book, "Some Notes Toward a Manifesto for Artists Working With and About Taxidermy Animals," is provided by artists Mark Dion and Robert Marbury. Although this book does not aim to promote the use of taxidermy in contemporary art, its content might arouse interest in practitioners who intend to implement it in their work. It therefore seemed appropriate to include a set of ethical guidelines written by artists for artists in order to lay down some shared concerns.

I am aware that to some animal studies scholars and students this book might, at first, appear ethically questionable: the suggestion that a critical contextualization of taxidermy might instill positive change in human/animal relations may seem in itself an odd proposal. Yet, a few

important considerations should be drawn here. The artists discussed in this book do not kill animals in order to make taxidermy. They either appropriate or repurpose vintage objects or garments, or they closely work with veterinary institutions involved in the unavoidable and monitored euthanization of pets and farm animals. Some might disagree with these approaches too, but I argue that this level of ethicality already constitutes an important stance in art making. In this book I have deliberately refused to align my own views with those generally held by many animal rights and vegan scholars, for these are most regularly structured around ethical paradigms predominantly relying on visuality. More precisely, as I have extensively argued in my 2015 stand-alone editorial for *Antennae* titled "Animal Studies and Art: Elephants in the Room," the discursive registers of animal rights and veganism tend to rely on a logic of witnessing that is intrinsically humanist and simultaneously anachronistic. In that editorial I argued that this logic has proposed a range of productive opportunities in contemporary art, but that it has also limited discourse to a serious degree, especially at a time when the relationship between biopolitics and materiality is becoming more urgent. So this is not to say that animal rights and vegan ethics are inherently flawed, but my invitation to reconsider some aspects of the visuality upon which their agendas rely should be understood as an acknowledgment that times and perspectives do change and that frameworks need to be updated accordingly in order to retain relevance in contemporary discourses.[76]

Contemporary art involving taxidermy is usually rejected outright in many animal studies circles on the grounds that an animal skin represents an undeniable gesture of animal objectification and human supremacy over animals. This argument is extremely simplistic, it is not in line with discourses of materialities in contemporary art, and it effectively hinders any academically valuable exchange on the subject. I regularly remind those who complain at the sight of taxidermy in a gallery space that animal products are always in the mix of the materials used for the making of all classical, the majority of modern, and a large number of contemporary works of art. Animals have been rendered invisible, but they are undeniably present in brushes, paints, and varnishes: mollusks, fish, eggs, rabbits, horses, boars, hogs, oxen, squirrels, goats, and badgers

have been for centuries, and still are, imbedded into works of art in one form or another. These animal deaths, like the visible ones that attract much attention in contemporary art, cannot be ignored, especially as a renewed attention to materiality is becoming more and more prominent in different scholarly disciplines. It is in this sense that this book takes on the challenge of meaningfully and openly considering the presence of taxidermy in contemporary art outside the strictures of these parameters of judgment.

FOUCAULT, ART, AND ANIMALS

Six aspects of Foucault's thinking have motivated my interest in his work in relation to taxidermy in contemporary art. These aspects are the rejection of generalizations and universal normative judgment, the focus on specific contexts and localities, the ability to recover pasts for the purpose of critically constructing the present, the intent of discovering parallelisms between seemingly unrelated practices and discourses, the interest in power relations, and the tendency to focus on the marginalized.[77] As will be seen in the next chapters, of essential importance to this book is Foucault's interest in discontinuities and contradictions in historiography. Through a substantial process of defamiliarization, this approach proposes many opportunities for rethinking order and naturalized relationships of power.[78] One of Foucault's merits lies in his ability to uproot the concept of power from its Freudian/Marxist conception as a mode of oppression, enabling instead the identification of a diffused, pervasive, formative, and networked system of power relations: biopolitics. The biopolitical register this book is concerned with and unfolds on the representational stratification of human/animal relations situated on the surface of works of art. The focus is therefore not so much on governmentality or on situating the rights of animals. Although such concerns are interesting and pertinent, the biopolitical register central to this book is not concerned with the discrepancies among our treatment of different species, but instead focuses on the implicit "biopower of becoming with" that taxidermy in contemporary art can inscribe. In this sense, the emergence of

the technology of power is a regularizing representational force inscrib-
ing the sovereignty of man and the resistance of the animal, right on
the liminal materiality of the animal skin, as defined by operations of
surveillance, regulation, classification, and consumption.

I am aware that Foucault may not initially appear to be an obvious
choice for a human/animal studies perspective for two reasons. The first
is related entirely to Foucault's treatment of animals in his philosophical
project, and it constitutes the main reason why he is not particularly
popular in this field. It is indeed true that when animals figure in his
work, they do so as the prisoner, the mad, and the patient—they consti-
tute embodied metaphors of irrationality that largely contribute to the
definition and emergence of modern man.[79] This treatment of animals
and Foucault's lack of interest in a human/animal context have recently
become the focus of criticism from some human/animal studies schol-
ars.[80] Most notably, Paola Cavalieri has been highly critical of Foucault's
lack of engagement with a nonanthropocentric conception of animality,
and in her essay "A Missed Opportunity: Humanism, Anti-Humanism
and the Animal Question," she directly challenged Foucault's "amnesia"
regarding the nonhuman and his lack of focus on early scientific animal
experimentation in the classical age.[81]

The second reason why Foucault may not seem an obvious choice for
this type of analysis lies in the fragmentary nature of his work on art. Un-
like other continental thinkers such as Derrida, Deleuze, and Merleau-
Ponty, Foucault never developed a cohesive and consistent approach to
painting or art in general.[82] He planned to gather his texts on art in a
book provisionally titled *Le Noir et la Couleur*, which was never com-
pleted and whose chapters were unfortunately lost.[83] Most notably, as is
well known, his approach to the image has generated controversy in art
history circles. Foucault's analysis of Velasquez's *Las Meninas*, featured in
the opening of *The Order of Things*, has attracted much criticism for its
avoidance of traditional art historical approaches.[84] In his reading, Fou-
cault entirely disregards the classical art historical analytical apparatus:
the biographical account, the attention to technical virtuosity, and the
importance of influences and precursors, and he is not concerned with
questions of genre, style, and iconography. Neither is Foucault interested in
the sociohistorical relations responsible for the painting's appearance in the

first place.[85] Essentially he reads *Las Meninas* as a sedimentation of the discourses and practices that characterize the classical episteme; therefore Velasquez's painting is one about representation and the impossibility of critically questioning representation as an epistemic tool of the classical age itself. The strength of his approach lies in his ability to construct new tools for the production of knowledge through art, and this strength has not gone unnoticed in art history discourses.[86] Ultimately, Foucault's approach to painting has contributed to the emergence of new thinking in French philosophy, which in turn led to the New Art History of the 1970s and 1980s.[87] But moving beyond the emphasis given to *Las Meninas* in Foucault's approaches to painting, my research has focused on his substantially undervalued work on Manet and Magritte and his lesser-known works on Gérard Fromanger.[88] Although, as mentioned, Foucault's approach to animals is generally not aligned with human/animal studies perspectives, it is important to note that *The Order of Things* famously opens with a passage from "a certain Chinese encyclopedia" centered on an animal taxonomy—one that transcends the classical organization of western science.

> The encyclopedia divides animals into the following categories: a) belonging to the Emperor, b) embalmed, c) tame, d) sucking pigs, e) sirens, f) fabulous, g) stray dogs, h) included in the present classification, i) frenzied, j) innumerable, k) drawn with a very fine camelhair brush, l) *et cetera*, m) having just broken the water pitcher, n) that from a long way off look like flies.[89]

From a human/animal studies perspective it is compelling to note that an unorthodox animal taxonomy can expose the limitations of man's thinking, to reveal the fictitiousness and arbitrariness of such ordering exercises upon which our lives are nonetheless structured.

It is thus from this very point that Foucault's archaeological reconfiguring of general grammar and philology, natural history and biology, and the analysis of wealth and political economy can begin.[90] It is from the possibility of conceiving radically different ontologies between man and animals that western thought can be thus brought into question, and in this sense the mistrust for realism nurtured by speculative taxidermy can

indeed become a powerful tool. Foucault said that this passage made him laugh; it was a laughter marked by a certain uneasiness Foucault found difficult to shake off—one that can in a sense be understood to mark the beginning of postmodernism, along with its irreverence for modernist order, rationalization, idealization, and pragmatism.[91]

1

RECONFIGURING ANIMAL SKINS

Fragmented Histories and Manipulated Surfaces

We will work with iron and wood, with wool and sawdust; starting with the head—whose stuffing is easily removed—and the trunk, then moving on to the body and the legs. A firm structure will be provided by iron—in the legs and to replace the vertebrae—and pieces of wood will be readily shaped to represent the form of the Elephant; then each part of this structure will be inspected thoroughly by myself; should it fail to reach my high standards, the work will be taken apart and we will start again.

—ANDREW DRUMMOND, *ELEPHANTINA*

Do not allow your mounted specimens to look like stuffed ones.

—OLIVER DAVIE, *METHODS IN THE ART OF TAXIDERMY*

UNDOING TAXIDERMY

The renewed interest in taxidermy is a complex phenomenon encompassing interior design, fashion, television series, contemporary art, and the publishing field. As in the nineteenth century, when texts on taxidermy became ubiquitous in France and Britain, we are today not only faced with a new desire to see and own mounted animal skins, but we are also

keen to rediscover the history of the craft, to learn how it was made and who made it first.

Recently published titles like Melissa Milgrom's *Still Life: Adventures in Taxidermy* and Dave Madden's *The Authentic Animal* have presented lively narratives capitalizing on the colorful and eccentric personalities that for years have punctuated taxidermy competitions in the United States.[1] Others, like *Taxidermy* by Alexis Turner and *Taxidermy Art* by Robert Marbury, are presented as lavishly illustrated coffee-table books packed with interesting and well-researched information.[2] Meanwhile, academic publishing has critically embraced the return of taxidermy through some challenging and highly informative titles like Pat Morris's *A History of Taxidermy*, Rachel Poliquin's *The Breathless Zoo*, and *Life on Display* by Karen A. Rader and Victoria E. M. Cain.[3] Most notable in the artistic publishing field have been the contributions of the artist duo Snæbjörnsdóttir/Wilson (Bryndís Snæbjörnsdóttir and Mark Wilson). An edited collection on taxidermy that documents their epic project *nanoq*, and Snæbjörnsdóttir's own *Spaces of Encounter: Art and Revision in Human-Animal Relations*, offer extremely important institutional critiques as related to the medium.[4] Also attesting to the growing popularity of taxidermy in art are two issues of *Antennae: The Journal of Nature in Visual Culture* published in 2008 and entirely devoted to the subject.[5] A number of edited collections on natural history and museum displays have also featured important essays on taxidermy.[6]

One recurring element shared by many of the aforementioned texts is the persistent desire to legitimize the practice through the construction of a historical metanarrativization of taxidermy's development through time. This approach mirrors that of the nineteenth-century texts in which authors aimed at popularizing taxidermy as a noble pursuit and scientific endeavor. According to most, taxidermy developed from a clumsy and haphazard stuffing of animal skins reaching the heights of pure realism in natural history dioramas. Authors regularly claim that taxidermy was shaped by slow and steady technological advancements: small refinements in the preservation and mounting methods led to the perfection of hyperrealist dioramas that enthralled audiences in the nineteenth century. But in the suspicion that this metanarrative, like all others, would conceal more interesting realities, I decided to return to the original books that charted and shaped the history of taxidermy for the

purpose of recovering what may have been erased through classical historiography.

HISTORIES WITH NO BEGINNING

As is well known, preserved animal bodies are perishable and vulnerable to attack by insects and mold. Thus the material evidence of taxidermy vanishes as we look back in time, curtailing the possibility of establishing meaningful connections between modern taxidermy and any true ancient precursor. According to Pat Morris, the oldest surviving taxidermy mount is a hippopotamus skin stuffed for the purpose of appearing in the collection of early naturalist Ulisse Aldrovandi (1522–1605).[7] Prior to that point we find only speculation. To compensate, many nineteenth-century authors felt compelled to identify a silent beginning from which to write a metanarrative of taxidermy that usually begins with a disambiguation between taxidermy and Egyptian mummification. Inevitably, the vast majority of taxidermy treatises and manuals from the nineteenth century open with an introductory chapter that identifies the material and theoretical matrix of the craft in order to justify the existence of the practice or to disclose something intrinsic to its charged but cryptic appeal.[8] Montagu Browne's *Artistic and Scientific Taxidermy and Modeling* (1896)[9] and Oliver Davie's *Methods in the Art of Taxidermy* (1894) present opposing views.[10] While Browne situates the dawn of taxidermy in Egyptian mummification, Davie discounts the effective relevance of a link between taxidermy and mummification on the grounds that "embalming is simply a means of preservation, is a separate art, and cannot, strictly speaking, come under the head of taxidermy, while taxidermy proper attempts to reproduce the forms, attitudes, and expressions of animals as they appear in life."[11]

In line with Davie's position, contemporary expert Pat Morris argues that Egyptian mummies should not be linked to taxidermy because "they do not represent an attempt to recreate lifelike form (nor were they usually 'stuffed'), so taxidermy does not begin thousands of years ago with the ancient Egyptians."[12] Similarly, Rachel Poliquin states that "mummification leaves the skin intact and in place, [so] the process cannot properly

be considered taxidermy."[13] It seems that to many authors, an essential definition of taxidermy requires the evaluation of technical and aesthetic qualities. But this distinction is generally unsatisfactory because of its sweeping nature—it totalizes all mummified and taxidermy objects into general categories that do not account for the fact that objects refuse to remain constant through history; that they split into multiple objects; and that they morph, diverge, and sometimes converge again through time, geographical spaces, and institutional practices and discourses.[14] In many ways, it is true that Egyptian mummification of human bodies might have little to do with modern taxidermy. However, a closer focus on the Egyptian mummification of animals can reveal some intriguing analogies.

Salima Ikram, a distinguished professor of Egyptology and animal representation, has shown that in many cases, the viscera of animals were mummified separately and returned to the animal body as it was "further stuffed with soil and sawdust, giving the [animal] the shape [it] had enjoyed in life."[15] Although the reproduction of "life-like form" may not have been the primary motivator behind the process of animal preservation in Egypt, examples such as the dog found in the Valley of the Kings[16] and dating to 1500 BCE prove that mummification, in its diverse range of purposes and applications, went well beyond the wrapping of bodies into lumpy bundles.[17] Considering that cultural connections between Egypt and Italy predate the ascent of the Roman empire, it is plausible to contemplate that such animal preservation techniques might have been shared, as was true for some burial practices popular in the south of Italy that originated in Egypt. So why is this connection usually overlooked, and why do authors insist on this historiographical maneuver?

The need to address the connection, or lack of thereof, between Egyptian mummification and taxidermy seems to be caused by a desire to legitimize, characterized by a deep, yet unnecessary, preoccupation with the separation of the secular from the spiritual. Distancing taxidermy from mummification only attempts to validate the former as a rational, secular, and thus scientifically valid epistemic tool—it reassures the author (and thus the reader) that they are not dabbling in the mystifying spirituality of mummification, something that might diminish the seriousness of their subject of study.

It is, perhaps, not a coincidence that Montagu Browne, curator of the Leicester Museum, instrumentally identified Sir Hans Sloane's bird col-

lection (dating from 1725) as the oldest example of known modern taxidermy, from which he began writing his own historical account.[18] Sloane was an erudite collector, knowledgeable in chemistry and botany, who eventually founded the British Museum in London.[19] Cherry-picking this beginning for his own taxidermy treatise helped Browne to firmly establish the practice within a purely scientific tradition, implicitly rendering it a noble and rationalized pursuit.

Likewise, historiographers have rarely resisted the temptation to provide an essentialist, and therefore totalizing, definition of what taxidermy *is* rather than what it *does*.[20] In *The Breathless Zoo*, for instance, Poliquin contextualizes taxidermy as a *practice of longing*. She argues that

> taxidermy is deeply marked by human longing. All organic matter follows a trajectory from life to death, decomposition and ultimate material disappearance. The fact that we are born and inevitably disappear defines us, organically speaking. Taxidermy exists because of life's inevitable trudge toward dissolution. Taxidermy wants to stop time. To keep life.[21]

In a sense, Poliquin is right, but doesn't this definition bring us back to the realm of the transcendent? Furthermore, this essentialist logic could be extended to all classical paintings and sculptures without requiring much alteration—wasn't preserving beauty and youth one of the main purposes of the visual arts before the invention of photography? To my point that generalizing definitions of taxidermy serve little purpose, it is important to acknowledge that, when it comes to art objects as well as taxidermy, it is underneath the overarching ambition to preserve beauty and youth that the object's originality, meaning, and agency are found.

TAXIDERMIE

Bypassing the reductive writing of metanarratives has been proposed in Foucault's conception of knowledge as something that does not progressively advance but that instead sediments—hence his approach to rewriting history is called *archaeology*. The first and most important archaeological

task is to remove the sedimented strata of knowledge for the purpose of revealing the hidden connections between individuals, groups, texts, discourses, and institutions. This defining phase is known as *negative work*. In the task of dismantling the metanarrativization of taxidermy, negative work constitutes the first and essential step toward a substantial reconsideration of the newly acquired visibility gained by the emergence of the practice in contemporary art. This undoing enables the recovery of statements, underlining discursive formations, and systems of dispersions.[22] At stake in these recoveries is the possibility to unveil human/animal relations that may otherwise be forever lost and that, in some ways, could help us to better understand our contemporary relationships with taxidermy and, most importantly, with living animals.

Departing from the hermeneutics of classical historiography and its structuralist linage, archaeology is concerned with the possibility of describing discontinuous surfaces of discourses for the purpose of denying any absolute truth or meaning; it rejects conceptions of continuous evolution of thought and accumulation of knowledge driven by progress.[23] However, archaeology simultaneously acknowledges the existence of and capitalizes upon the traceability of regularities, relations, continuities, and totalities.[24] The archaeological level of inquiry is therefore essentially concerned with the point of historical possibility for something to happen or emerge—the cultural and material conditions that enable practices and discourses to form and intermingle.[25] Its ultimate scope, therefore, is to describe epistemic systems of dispersions that essentially exist in opposition to the totalizing approaches of traditional historiographical methodologies.[26]

Adopting elements of archaeological analysis,[27] we can see the importance of the emergence of the French term *taxidermie* as an essentially defining moment in the histories of modern taxidermy. It is not therefore a matter of identifying a first example of taxidermy, but one of situating a moment of agential rupture. The word *taxidermie* essentially emerged as an interface between the natural world and the institutional bodies that seek to organize it, and in so doing it influenced both. *Taxidermie* can be thus considered as what Foucault called a *statement*, or a term which

> opens up to itself a residual existence in the field of memory, or in the materiality of manuscripts, books, or any other form of recording; . . . like

every event, it is unique, yet subject to repetition, transformation, and reactivation; . . . it is linked not only to the situations that provoke it, and to the consequences that it gives rise to, but at the same time, and in accordance with a quite different modality, to the statements that precede and follow it.[28]

The statement constitutes the smallest element of a discursive formation, yet it is something that can affect the material world.[29] Statements are charged with agency. They open up possibilities for new disciplines to arise or cause ruptures in established institutional discourses. They have different magnitudes and can cause deliberate change or trigger minor societal or epistemic shifts. Most often, however, they constitute *interruptions* of some kind—they are points at which epistemic trajectories can be diverted.

The French naturalist Louis Dufresne was the first to use the term *taxidermie*, in the scientific reference work *Nouveau Dictionnaire d'Histoire Naturelle* (1803–1804).[30] He was a curator at the Muséum National d'Histoire Naturelle in Paris in 1793 and undertook voyages of discovery to South America, Alaska, and China on board the ship *Astrolabe*.[31] From the start, the term appeared as an elusive and unspecific compound of the Greek words *taxis* (to arrange) and *derma* (skin).[32] Prior to the emergence of *taxidermie*, the term *empailler* was most commonly used. A text from 1811 by J. P. Mouton-Fontenille, titled *Traité Élémentaire d'Ornithologie, Suivi de l'Art d'Empailler les Oiseaux* (Elementary Treatise of Ornithology on the Art of Stuffing Birds), suggests that the first books entirely dedicated to the subject (preceding Dufresne's own treatises) were published in France toward the end of the eighteenth century. In these early accounts, the verb *empailler* is used to capture the essence of the procedure involved in the preservation of bird skins.[33] The verb *empailler* also featured prominently in the title of a popular treatise by a French monk, Monsieur l'Abbé Manesse, published in 1787: *Traité sur la Manière d'Empailler et de Conserver les Animaux, les Pelleteries et les Laines* (Treatise on the Manner of Stuffing and Preserving Animal Skins and Hides).[34]

Empailler essentially means "to stuff with straw." It was widely used in early publications because of its versatile linguistic root: in French, it simultaneously came to designate the practice of upholstery of chairs and divans and the practice of preserving animal skins in a three-dimensional

FIGURE 1.1 Peregrine Falcon on Flight, showing Method of Binding etc. Illustration in Browne, M. (1896), *Artistic and Scientific Taxidermy and Modelling* (London: A. & C. Black). Image in public domain.

form.[35] This linguistic overlap became further entangled because both practices, the stuffing of animal skins and upholstery, were performed in the same workshops.

Conceiving of Dufresne's first use of the term *taxidermie* as a statement also allows us to see how it functioned as a threshold of emergence—a point at which a new discursive formation begins to emerge.[36] As a point of interruption, in this case, the term *taxidermie* appeared at the intersection of many localized practices of animal stuffing and the international disciplinary rules, laws, and methods of natural history.

In 1820, another book by Dufresne, titled *Taxidermie, ou, l'Art de Préparer et de Conserver la Dépouille de tous les Animaux, pour les Musées, les Cabinets d'Histoire Naturelle,*[37] further inserted the statement *taxidermie* into scientific discourses.[38] The international relevance of this title was highlighted by an entry in the *Monthly Review or Literary Journal* published in London in the same year.[39] The entry (which also contributed to the repetition and dissemination of the statement) spoke of an English translation of the original French text and emphasized the newness of the word *taxidermie* in the French language, explaining its etymology but still referring to the practice of skin preservation and arrangement as *stuffing*. The short text also acknowledged the institutional need for this neologism.[40] The author noted that "since, however, a new word had become necessary, expediency might have suggested the adoption of one that was expressive of the *ordonance* of specimens of natural objects in general."[41] This passage directly refers to the shared root *taxis* (arrangement) in the words *taxidermy* and *taxonomy*. The term *taxonomy* quickly acquired popularity in scientific circles and was subsequently adopted in the classification of any groups of organisms.[42] Both terms pertain to the discourses that have demarcated the Enlightenment and share significant epistemological preoccupations with the crucial scientific practice of arranging—which, as will be seen, played a defining epistemic role in Victorian culture.[43]

Therefore, the statement *taxidermie* separated the older practices of stuffing animal skins, most of which had been related to hunting, from the epistemic focus of scientific taxidermy mounts. Linguistically, within the enunciative paradigm inhabited by the statement, this separation was facilitated by the emergence of the verb *to mount* (*monter*). In the *Nouveau*

Dictionnaire d'Histoire Naturelle, in relation to the preservation of larger animals of a specific shape such as sharks and crocodiles, Dufresne mentioned that *empailler* was the main technique in use ("bourrés avec de la paille") and further explained that this technique had been replaced by *monter* ("*que nous avons réformé pour y substituer celui de monter*"). Interestingly, in this text, Dufresne stated that "taxidermy has only made progress in the past fifty years."[44] And in the English translation of this expanded text, which was published in 1820, the above-mentioned passage is followed by a line clarifying that *mounted* "does not perfectly express the idea we would convey but it is always more correct than the former" (*stuffed*).[45]

Through the nineteenth century, a series of (at times nonattributed) English translations of Dufresne's work emerged. Some of these translations made the subject accessible to scientists in the United States. Paying attention to the agential qualities of *taxidermie*, its effect on the discourses and practices of mounting animal skins, shows how natural history effectively appropriated the practice of stuffing skins and molded it to fit its taxonomic needs. This operation evidences a rupture in the constructed fluidity of taxidermy metanarratives. Never is this essential moment in which the linguistic and the material intertwine given any relevance, possibly because it also problematizes the simplistic distinction between "good" and "bad" taxidermy that most authors regularly endorse.[46] In *Scientific Taxidermy for Museums*, drafted by R. W. Shufeldt for the Smithsonian Museum in 1892, attempted to distance scientific taxidermy from stuffed skins by stating that the work of "Thomas Brown . . . had its due influence in lifting taxidermy from the realm of an ignoble pursuit to the broad platform of one of the most important and exact of all the sciences."[47] The implication is rather clear: a progressivist vision of the history of taxidermy defines the discipline as a developing succession of improvements motivated by a transcendental notion of a yet unrealized but implicitly shared master idea: *hypernaturalism*. The assumption is that the result of this developmental chain is "natural history taxidermy" and that the "ignoble pursuit" of stuffing animals somehow disappeared entirely through the development of new techniques. Stuffed animals, with their approximated and nonnaturalistic forms, essentially constituted sedimentations of discourses very different from those of natural history. Stuffed animals were not bad taxidermy, as many authors state. Perfect realism simply was not the preponderant value endorsed by

craftsmanship at the service of hunters. In opposition, the lifelike essence of natural history taxidermy was very much driven by the new discourses in which realism itself became the essential aesthetic representational force.

Technological advancements were not simply the result of an ideal process of continuous perfecting—they reflected the imposition of natural history discourses setting clear standards for the material practices of the discipline. And much of this new technical standard was driven by the term *taxidermie* itself, for its agency of potentiality and connectivity ontologically shifted stuffed animals into taxidermy specimens even before aesthetic realism was fully accomplished toward the end of the nineteenth century.[48] Focusing on the linguistic agency of *taxidermie* also allows us to bypass the recurring connotation of stuffed animals as the clumsy, aesthetically flawed, or downright worthless predecessors of scientific taxidermy. This historiographical cliché has substantially limited our understanding of these objects and the pivotal roles they have played in shaping human/animal relationships prior to the rise of natural history. As will be seen, rethinking our assumptions regarding the aesthetic worth of stuffed animals will bear considerable importance in the analysis of taxidermy in contemporary art practices.

TAXIDERMY: ANIMAL, OBJECT, OR THING?

Another important, yet limiting line of inquiry about taxidermy focuses on its ambiguous ontological status: an object pretending to be alive. "Animal or object?" is the recurrent question that has informed much contemporary writing on taxidermy.[49] And while I agree that this tension is indeed palpable, I am not inclined to dwell on ontological essentialism in order to think about the agency of this type of object instead. Let's be clear: taxidermy produces objects—no misunderstanding there. The matter is not so much whether these objects vacillate between the ontological status of natural or man-made, but that they essentially are commodities that can enable the retrieval of discursive formations, cultural conditions, practices, and power/knowledge relationships between humans and animals.

An interesting attempt to better grasp the undeniably elusive charge that taxidermy objects inscribe has been proposed in the contemporary

art of Snæbjörnsdóttir/Wilson. It is in the context of their work that anthropologist and animal studies scholar Garry Marvin proposes a methodological approach designed to move beyond essentialist lines of questioning.[50] In an essay titled "Perpetuating Polar Bears: The Cultural Life of Dead Animals," Marvin draws a parallel between the bodies of leaders, heroes, artists, and those of taxidermy animals.[51] Marvin's approach paves the way for rethinking animal life and death through a taxidermy object. He proposes a subversion of the postcolonial conception of taxidermy as pacified, subjugated animal representation and recovers its agency, defining a model for the writing of a *biography of objects* based on webs of interrelations between animals, humans, environments, institutions, texts, discourses, and practices. To Marvin, the live animal that preceded the taxidermy object clearly died; we find no ambiguity there. However, and most importantly, the biological death of the animal does not equate to the end of animal agency. Thus Marvin speaks of the *cultural afterlife* of the mounted animal skin as a pointer in networks of relationships between humans and animals and between humans and animal-objects. Writing a cultural afterlife of a taxidermy object thus entails the adoption of a biographical approach whereby a taxidermy specimen is returned a kind of individuality through the mapping of specific events that shaped its material existence. And note that Marvin's approach to the agency of taxidermy objects does not rely on the aesthetic judgment of the quality of the animal skin or the realism of the mount, but rests on the notion that something deeper and more complex lies at the core of human/animal relations in which animals have been made objects.

Geographer Merle Patchett has also focused on the idea of the cultural afterlife of the mounted animal skins. Her work is informed by a 1986 collection of essays edited by Arjun Appadurai that introduced the concept of the *social lives of things*, in which the interaction between humans and objects is conceived as a reciprocal, reflexive relationship.[52] From this vantage point, it becomes possible to conceive of objects as having ascribed value, rather than inherent value. But how is such value ascribed and through which relationships?[53] While Appadurai's method seems to have somewhat fallen out of fashion in academic discussion, it is important to recognize that his edited collection was one of the first serious attempts to consider objects beyond the classical limitation of the metaphysics of presence upon which much post-Kantian philosophy

relied. And most importantly, Appadurai's Foucault-informed cultural life of things is responsible for shifting the focus of inquiry from the *essence* of things to their *function*. Subject/object relationships appeared to be investigated in a defined and limited context, a spatiotemporal milieu enabling the surpassing of inherent transcendentalism. At the dawn of the new millennium, Appadurai's methodological fetishism was further problematized by Bill Brown's "Thing Theory" (2001), in which Heidegger's phenomenological distinction between *object* and *thing* began to play a defining role in the formation of new conceptions of material complications. According to Heidegger, an object is an object when it fits a precoded relation between function and purpose in the subject/object relationship. An object such as a fork or a blender that functions according to the cultural and personal expectations of the subject can be understood as such. However, once the object ceases to function, or when it malfunctions, it challenges our expectations, commanding a heightened register of attention: it becomes a *thing*.[54]

A thing is that which is not yet fully or even partially codified in representation, and as such, it challenges the subject through a series of non-affirmative experiences of the world. Should one really wish to insist on the essentialist questioning line, the appropriate question in relation to taxidermy objects may therefore not be "animal or object?" but "animal or thing?" As art critic Leo Stein claimed, "things are what we encounter,"[55] while objects vanish to consciousness, absorbed by anthropocentric functionalities. In opposition, things hold within them an "audacious ambiguity"[56] that objects lack. They are distinguished from functional objects by a sensuous presence that exceeds the limitations of purpose and function.

I have previously stated that taxidermy mounts are essentially commodities and that, as such, they have an ascribed commodity value (monetary and symbolic) that is of essential importance to the understanding of the human/animal relationships inscribed in it. In Marx's conception, a commodity is an object external to ourselves that "satisfies human wants of some sort or another" and that is essentially defined by its *use value*, intrinsic to its effective usefulness, and its *exchange value*, the common factor in the exchange relation between commodities.[57] In the first half of the first volume of *Capital*, Marx unveils the complex relation between commodities and labor time in order to reveal the dynamics involved in the exploitation of the proletariat by the wealthier social

classes who own and invest capital. His discussion of the commodity is primarily articulated around the adoption of pragmatic examples relying on inanimate objects/substances, such as linen, gold, diamonds, wheat, and sugar. When animals appear in his writing, they do so as "providers of labor," like the proletariat. It is not, therefore, a coincidence that Marx's attention turns to domesticated animals: "In the earliest period of human history domesticated animals, *i.e.*, animals which have been bred for the purpose, and have undergone modifications by means of labor, play the chief part as instruments of labor along with specially prepared stones, wood, bones, and shells."[58] Considering the commodity status of taxidermy objects through Marx's theorization of "all those things which labor merely separates from immediate connection with their environment," we see that things are identified as *subjects of labor*, a means of production: the subject of labor that is "seized upon and modified as desired" can prove productive.[59] "Such are fish which we catch and take from their element, water, timber which we fell in the virgin forest, and ores which we extract from their veins," states Marx.[60] In light of this theorization, let us therefore argue that human/animal relationships can be said to be substantially informed by commodity values and that live animals can acquire commodity value at different points during their lives or just upon dying. From a Marxist perspective, wild animals that have been captured for the purpose of producing taxidermy objects initially constitute a *subject of labor*, at least before they acquire the status of exchangeable commodity.

However, the ontological ambiguity of taxidermy objects appears to be problematized by the concept of *commodity fetishism* more than by a transcendental or elusive inherent aura. Incorporating Foucault's genealogical methodology to Marvin's approach can help us better grasp the agency of taxidermy animal things. A split register of inquiry quickly surfaces. On the one hand, this approach enables the recovery of the cultural afterlife of the animal, and on the other, it proposes a possibility of piecing together the discourses, practices, and power/knowledge relations that led to the animal's death. Both registers of inquiry are substantially shaped by the materiality of animal bodies as agency-imbued entities capable of affecting, and reflexively shaping, human/animal relations.

Appropriately positioning the moment in which the animal may have been endowed with commodity value therefore becomes important to the writing of the biographical account of the object itself. Some animals ac-

quire commodity status at the moment of their birth. This is especially true of animals bred and raised by farmers or landowners. Alternatively, wild animals can acquire commodity status upon capture. Transportation from one country to another may affect their commodity status more or less favorably—think of the notions of the rare and the exotic, for instance. However, killing an animal doesn't automatically equate to the acquisition of commodity status. Live animals destined to become pets have commodity value, as do animals that traveled from the tropics as prepared skins. Identifying the moment in which the animal acquired commodity value can aid in the recovery of the cultural systems of belief that turned the animal into an object, positioning it within a specific discursive formation or at the intersection of multiple ones.

THE SECULAR AND THE SACRED

Acknowledging the commodified status of taxidermy enables a conception of this class of objects as a material interface inscribing human/animal relationships shaped by power/knowledge relationships, practices, and discourses. Here, too, Foucault's approach to the analysis of relations between institutions, subjects, and objects, his genealogical method, can prove productive. Conceived as an extension of the discursive retrieval operated by archaeological analysis, genealogy mainly distinguishes itself from archaeology through a heightened analytical focus on the processual aspects of the interlinking and overlapping of discourses as actively shaped by invisible and pervasive relationships of power.[61] Foucault saw archaeology and genealogy as complementary. However, genealogy goes further into defining the tactics by which discursivities are implicitly shaped by power relations.[62]

In Foucault's conception, power is constituted through accepted forms of knowledge; it is an all-forming entity capable of producing objects and subjects in discourses and practices. It is not centralized and operated by one individual, but is instead diffused, and most importantly, it links discourses to the materiality of bodies as political sites in which institutionalized knowledge influences local practices. The human body, the animal body, or the bodies of animals-made-things, are all subjected, in different but interlinked ways, to the forming agency of power. Thus configured,

power is an inextricable entity enmeshed with objective capacities (skills and preexisting knowledge) and communication (dissemination of knowledge, exchange of information).[63] It becomes a transformative agent affecting the processual aspects of the discursive relationships in which actions actively modify other actions in the attempt of producing a nexus between what is seen and what can be said.

To acquire a certain commodity value, inanimate "natural objects" have to be durable. It is not, therefore, a coincidence that some of the most important challenges involved in preserving taxidermy have been posed by moths, mites, and mold.[64] It has been claimed that all taxidermists had their own, more or less efficient, secret recipe to prevent decay. James Petiver was among the first to compile a written set of methods for the preservation of specimens. However, most of the techniques, such as keeping the animal bodies in salted water, rum, or brandy, substantially discolored plumage and fur.[65] French scientist René Antoine Ferchault de Réaumur proposed, among other techniques, baking the specimens in a warm, but not too hot, oven.[66] These preventive measures, however, proved only temporarily effective in the fight against decay. Most notably, in 1738, Jean-Baptiste Bécœur, an apothecary from Metz in northern France, began experimenting with different chemicals for the purpose of preserving animal skins. By 1743 he had invented the formula for arsenical soap. However, Bécœur died without disclosing his secret—he had hoped to be able to sell it and recoup some of the costs incurred in creating it—and thirty years elapsed before the formula was published.

Many engravings illustrating Renaissance *wunderkammers* reveal the presence of preserved birds, of which today no trace remains. These preserved animals essentially were commodities prone to decay. They did not look much like the original animal they derived from because of the preservation techniques that were used, and they were probably regularly replaced in the whimsical and idiosyncratic cabinets of curiosities. Instead, the fascinating search for the best preservations methods that took place during the eighteenth and nineteenth centuries was driven by the new discursive formation of natural history. The discourses shaping the practices of collecting, taxonomy, and archiving imposed the paramount necessity of new techniques to preserve animal skins in their natural appearance as closely as possible (to serve taxonomic purposes) and for as long as possible (to function as reference specimens). Thanks to the

new preservation techniques, the specimens cataloged during the nineteenth century still survive, mostly in good shape, today. Their cultural afterlives are exclusively linked to natural history discourses: they are used by researchers to learn about evolution, extinction, and other genetic data that can be gleaned from preserved biomatter.

In *A History of Taxidermy: Art, Science and Bad Taste*, Pat Morris has tracked the oldest extant stuffed objects for the purpose of outlining the ultimate, most up-to-date metanarrative account of the history of taxidermy.[67] In Morris's text, preserved animals are discussed as evidence within the classical framework of connoisseurship; they are judged according to their execution, realism, and conditions of preservation. The resulting considerations are interesting but simultaneously limit what these objects might tell us about human/animal relations. Considered from archaeological and genealogically informed perspectives, these specimens raise questions about the discursive features that led to the stuffing and mounting of animal skins. Who was involved in such processes and why? What power/knowledge relationship shaped the preserved animal body in the form we see today? At which point did the animal become a commodity, and what discourses and practices made that commodification possible? Which institutions commissioned collection and preservation processes and to what end? Why were certain animals chosen instead of others? But most importantly, these questions enable the emergence of a variety of narrativizations in which the biographies and cultural afterlives of taxidermy mounts show that taxidermy cannot be defined simply by a longing for immortality or by a desire to subjugate nature.

An interesting case is provided by two opposed categories of animal-objects identified by Morris as some of the oldest extant examples: the stuffed hippopotamus skin at the Medici Museum in Florence that was apparently destined to join the collection of early naturalist Ulisse Aldrovandi (1522–1605) and a stuffed crocodile hanging from the ceiling of the church of Nossa, Italy (1534). During the second half of the sixteenth century, Aldrovandi's museum (which opened in 1547 in Bologna) became the model for the early institutionalization of natural history. The self-appointed naturalist began to theorize a new science based on "observation, collection, description, careful reproduction, and ordered classification of natural objects."[68] His collection, which included more than

7,000 natural objects, anticipated the taxonomical approaches of the Enlightenment.[69] The hippopotamus was stuffed to become an epistemological tool for one of the earliest and most prestigious institutional collections of natural objects (fig. 1.2). It originally was the possession of Granduca Pietro Leopoldo, and it is reported to have lived for a year in the Boboli Gardens in Florence before being preserved and eventually becoming a specimen in the Museo della Specola in Florence. Before becoming a display piece at the Medici Museum, the hippopotamus may have been involved in a number of transactions through which its exchange/commodity value changed from living, wild animal to royal pet (a form of trophy), then to stuffed animal, and finally to museum specimen in different objectifying/commodifying stages. Mapping these moments in the animal's past enables the identification of the discursive formations, practices, and power/knowledge relations that brought the individual animal to become a museum piece in the first place. The cultural afterlife of this specimen thus began as the result of the emergence of the discursive formation of natural history and the need to tangibly classify living beings in accordance with the epistemic modalities of the Renaissance. This analytical approach positions the object as the sedimentation of a circular power/knowledge relation involving discourses, practices, institutions, and author-function networks. The hippopotamus inscribed kingly power—its visibility in the museum assessed the omniscience of the Granduca in the eyes of illustrious guests and citizens. It signified a much valued love for scientific knowledge as directly linked to the wealth, social status, strength, and power necessary to own such an exotic and exclusive animal. Its rarity heightened the prestige of the collection and, by implication, that of the Granduca, who could be therefore seen as actively contributing to the production of knowledge.[70] Transactions involving natural objects lay at the epistemological core of medieval and early Renaissance culture. The trade of religious relics and natural objects alike, initiated by the crusaders, provided a representational materialization of the mythologized conquests of nature that was central to the episteme of that period.[71] It is within this interlinking of discourses, practice, and power/knowledge relationships that the crocodile hanging from the ceiling of the church at Nossa can be reconsidered. In this case, the crocodile was prepared to hang from the ceiling of a church and not to be displayed in an early natural history exhibit. Its function was defined by the discourses of natural theology of the Middle Ages. The

skin was stuffed and suspended for the purpose of frightening the faithful and reminding them of the devilish things in life and death.[72] Both crocodiles and hippopotami were known in Italy at least since the fourth century. A passage in the *Storia dei Monaci* by Rufino da Concordia (345–410/411 CE) recounts that a monk called Beno chased away, with the intensity of his gaze, a crocodile and a hippopotamus that were destroying the land.[73] They became threatening animals in the imagination of the time. It is therefore not a coincidence that the jaws of the crocodile displayed in Ponte Nossa, as well as the mouth of the hippopotamus, were set wide open. This iconography charges the evidential materiality of the preserved animal body with the suggestion of evil powers. It is plausible that discursively, within the context of the church in which it is still displayed, the crocodile's skin would have served a validating, epistemological purpose, materializing a dragonlike creature enmeshed in

FIGURE 1.2 Hippopotamus at the Museo di Storia Naturale, La Specola, Firenze, Italy. 2011. Photograph courtesy of Sailko, CC BY-SA 3.0.

religious imagery echoing the legendary fight between St. George and the dragon, a story that established itself in popular culture during the eleventh century.[74]

The animal past-life of this stuffed object was recorded in documents dating from 1549 and preserved in the parish of Bergamo. The documents recount that the crocodile lived in the river Serio and that it fed on travelers.[75] Recent research carried out by Don Enrico Caffi, a priest in charge of the church at Nossa, has revealed, however, that according to a local legend, the crocodile was killed near Rimini (220 miles from Bergamo) by a merchant who, in his struggle to break free, invoked the help of the Virgin Mary. But Don Caffi has also suggested that the crocodile skin may have been simply purchased somewhere in Rimini (a thriving commercial port during the early Renaissance) and placed in the church to provide evidential tangibility of the alleged miraculous event.[76]

In this specific case, the animal-past is indissolubly embroiled in the mythical narrativization that instrumentally positions it as an epistemological tool of theological discourse. As the animal was killed, its skin entered a process of commoditization and was imbued with theological value by the church. In this sense, the preserved body was the result of institutional power, and it functioned as an *object of power* akin to that theorized by Foucault in "The Spectacle of the Scaffold."[77] Suspended from the ceiling of the church and therefore elevated for all to see, the animal-object admonished the faithful. It shaped human subjectivity and defined cultural identity through the production of institutionally constructed truths.[78]

In this case, the story of which the animal skin becomes the implicit validation is semantically intertwined with the narratives that brought it to its current display. Ontologically as well as physically suspended, the animal-object itself is not imbued with sacred value, but it nonetheless functions within religious discourses as a reminder of the temporary defeat of evil, while simultaneously gesturing toward the greatness of God. In contrast to the bare specimen function performed by the Medici hippopotamus, the crocodile of Nossa is an object imbued with transcendentalism—some of the narratives that surround it position it as a trophy of some description, but its materiality is not simply the evidential sign of the existence of the animal (fig. 1.3). Emerging as the trace of entirely different discursive formations, the Medici hippopotamus

FIGURE 1.3 Crocodile suspended from the ceiling of Chiesa Santa Maria Annunziata at Ponte Nossa, Italy, 2013. Photograph courtesy of Ago76, CC BY-SA 3.0.

functions as a precursor of the modern conception of natural history specimen in the museum, its cultural afterlife somewhat suspended between the epistemic ambitions of early science, the status of royal pet, and that of the trophy granted by its size and rarity as the centerpiece of a collection.

SPECULATIVE TAXIDERMY: MATERIALITY AND REPRESENTATIONAL REGISTERS

So far, this chapter has been concerned with the epistemic limitations of traditional taxidermy historiography, the way metanarratives conceal human/animal relationships, and the recovery of power/knowledge dynamics that define discourses and practices involved in them. This

process enables a fragmentation of the object/subject dichotomy, thus outlining the role of actants in the production of material bodies that are always, at different points, reified. Taxidermy mounts thus appear as sites in which, as Donna Haraway would have it, concatenations between actants are inscribed.[79] But whereas the productivities of this approach are more readily obvious in historical and ethnographic contexts, how can this approach be incorporated in the discussion of contemporary art? In the next chapters, it will become evident that the recovery of cultural afterlives, the consideration of taxidermy objects as commodities serving as a material interface for human/animal relationships shaped by practices and discourses and enabling the recovery of sometimes invisible connections between power and knowledge, plays essential roles in contemporary art. Works of speculative taxidermy tend to encompass multiple discourses and practices involving human/animal relationships. They instate themselves as problematization-surfaces of these very relationships by disconnecting naturalized discourses and thus highlighting the paradoxes and contradictions embedded in human/animal relationships.

Most speculative taxidermy usually operates in a transhistorical dimension in which multiple naturecultures are conflated, collapsed, or made to overlap with the intent of gesturing toward possible and different futures. As will transpire, the past of human/animal relationships is just as important as present relationships: animal objectification has taken place over millennia, and understanding the power dynamics that govern it is essential to future change. In this sense, most works of speculative taxidermy entail a moment of reconsideration in the viewer—the access to a new level of awareness, or an ability to reconsider what we thought we already knew. In this context, the deliberate inclusion of taxidermy skins within the semantic structure of a work of art is capable of producing an alluring charge that heightens the ontological instability performed by the animal skin itself. This ontological instability inscribes productive potentialities through a deliberate questioning of realism, the ways in which we construct realism, and the effects on life and ecosystems that our conceptions of realism bare. As a material typically produced by the discourses and practice of anthropology and natural history, the animal skin in the gallery space thus acquires a polysemic valence that in its ambiguity nonetheless maintains ties with the disciplines that originally produced it. In other words, speculative taxidermy

works as a crux of past and present discourses and practices that can never be reduced to the internal economies of the work of art, or simply to artistic discourses. It always, and insistently, gestures to the outside, to the past, to the present, and it regularly provides a platform upon which the possibility of different futures can emerge.

Many examples of speculative taxidermy present an ethnographic lineage in which indexicality plays an indispensable evidential role. But this ethnographic lineage is usually inscribed in the work for the purpose of subverting the sweeping generalizations typical of the processes of *othering* that characterized past ethnographic approaches. It is an element that points toward particularities of experience. It capitalizes on a broadening of sensory and affective registers beyond those culturally pre-encoded in the aesthetic experience. The new forms of representation that incorporate this ethnographic lineage do so to very different degrees and in many and varied ways. The most overt manifestation of this inclination in works of art is at times clearly visible in the deliberate positioning of the artist as pseudoethnographer, or in the methods used, the display solutions adopted, or the range of materialities displayed. At other times the ethnographic vein runs deeper, embedded in multiple layers of materiality and processes, where it gestures intermittently, flickers, or alludes.

In a number of ways, Snæbjörnsdóttir/Wilson's multimedia project *between you and me* (2009) entails many of the leading threads untangled in this chapter. But most importantly, it also shifts the methodological approach thus defined to the specifics of the artistic context: it problematizes and expands important concepts related to biography and the cultural lives of animals, and it fragments perceptual modes through the use of different materialities and the mediation of ontologically distinct but interrelated representational registers.

Snæbjörnsdóttir/Wilson's *between you and me* focuses on the relationship of humans and seals because of the animals' substantial historical importance as subsistence for human beings living in the coastal towns of Iceland. This shared past generates traces of human/animal relationships in the form of food, clothing, or other anthropocentric forms of representation.[80] The artists are thus concerned with instances in which the animal becomes a commodity, for this is the undeniable condition underpinning the unfolding of human/animal relations. They are interested in the different points in which that relationship shifts commodity

values in relation to specific cultural milieus. On these bases, the project explores human/animal relationships in an attempt to disentangle the "representational" animal from the living one: at stake is the possibility to temporarily occupy the space of the other beyond the metaphorical or the symbolic.[81] This operation is performed in consideration of the three registers of representation outlined by Joseph Kosuth in a seminal piece from 1965 titled *One and Three Chairs*. Kosuth's installation comprised a three-dimensional chair, its photographed image, and a vocabulary definition of it. Next to each other, the object, image, and text pose ontological questions designed to heighten the viewer's critical ability to recognize the totalizing force of the linguistic nature at play in realistic representation.

According to Kosuth's installation instructions, the size of the photograph of the chair must match the size of the three-dimensional chair displayed next to it. Capitalizing on the one-to-one scale relationship, Kosuth leverages the indexical value of photography in ways akin to the role of taxidermy. He produces an ontologically distinct copy of the referent while retaining its original size. The relationships between object, image, and text thus appear semantically problematized—their ability to linguistically substitute for each other is exposed with seemingly naturalized fluidity. This fluidity is what conceptually enables the formation of metanarratives—it is the condition under which the material histories of objects regularly dematerialize and congeal into symbolic form. But in this instance, the proximity with which the three iterations of the chair are displayed enhances their substantially different materialities and their abilities/inabilities to connect with other objects. In this way, the internal economies of this work of art deliberately orchestrate a tension between the intrinsic role language plays in the construction of representation, our reliance on language, and the materiality of objects that regularly is disavowed by language itself. Ultimately, the ontological game staged by Kosuth is a contradictory minefield that simultaneously works as a semiotic model that attempts to defy formal analysis. But most importantly, this semantic short-circuiting is designed to question subliminal notions of equivalency that affect our valuing of animal life.

This preoccupation with representation, realism, and materiality has played a substantial role in Snæbjörnsdóttir/Wilson's career, most visibly in their epic project *nanoq: flat out and bluesome*, which brought together thirty-four taxidermy polar bears in one museum display accompanied

by texts and photographic images. This project revealed the entanglements in which the dynamics of natural history display are regularly caught. It deconstructed its most pronounced rhetorical structures, revealing the systems of power relations that are historically inscribed in such displays. It categorically refused dramatization and suppressed any opportunity for the "sublime animal" to surface. This ultimately is one of the most important objectives of Snæbjörnsdóttir/Wilson's works: to encourage a cognitive awareness in the viewer, an awareness capable of generating a temporary disruption and a shift in the modalities of thinking about human/animal relationships. Their views are substantially aligned with Lippit's perspective that living animals are made to disappear through representation for the purpose of being assimilated in human discourses.[82] This condition metaphorically prevents them from truly dying—through language and other representational modalities, animals generally vanish. This conception is articulated by Lippit through an interpretation of Leibniz according to which only the "souls of rational creatures are prone to creation and destruction."[83] The animal as automata, the animal as expendable resource, is central to Cartesian philosophy and to the conception of animals in modernity. It is that which enables the ethical suspension in animal consumption, or that which enables multiple registers of rendering to relentlessly transform and synthesize animals in endless material figurations. The commodification of animals simultaneously is the cause and effect of this impossibility of dying—commodification enables the systematic killing, it organizes the material substitution of an animal with equivalent one, and in the case of domesticated animals, it endlessly multiplies them. It is for these reasons that Snæbjörnsdóttir/Wilson are interested in recovering the sociocultural and economic milieus in which animal commoditization unfolds, problematizing the philosophical paradigms that enable this condition to emerge. To the artists, the bodies of living animals, like those of animals photographed, painted, or appearing in texts, are always sites constructed by symbolic representations that inscribe this impossibility of animal death. This is the tragic essence of human/animal relations that their work attempts to highlight and circumnavigate.

Snæbjörnsdóttir/Wilson's ethnographically informed methodologies rely on long-term relational and socially engaged practices.[84] They collect narrative evidence for the purpose of recovering human/animal

FIGURE 1.4 Snæbjörnsdóttir/Wilson, *the naming of things*. Video still from the installation *between you and me*, 2009. © Snæbjörnsdóttir/Wilson.

past relationships that have unraveled in situated geographical realities and specific sociohistorical milieus. Thus, in their projects, mappings of power/knowledge relationships are inextricably linked to societal shifts, animal behavior, local laws, practices, and landscapes (shared spaces).

Their work *between you and me* comprises six short films, each presenting different ontological registers in which human/seal relationships are recovered in their sedimentations. Thus, in some of the films, seals are visually present, and in others they appear through spoken Icelandic words and in the superimposed English subtitles—the linguistic utterance is here the equivalent of the taxidermy animal skin: a liminal point of contact between animal and human, but always one in which the animal nonetheless remains absent (plate 1). In one of the videos, titled *the naming of things*, the artists filmed a taxidermist molding the skin of a seal into a representation of itself. Here, Snæbjörnsdóttir/Wilson derail the convention of the documentary genre in order to prevent realism from constructing a symbolically burdened animal, one shaped by metanarratives. Thus the frame is vertical rather than horizontal. This disrupts the perceptual (approximate) analogy between the human scopic field and the cinematic lexis. This simple rotation of the frame already constitutes a powerful derailment of the "suspension of disbelief" status, which essentially constitutes a critical inhibitor in the viewer. This initial challenge is further problematized by the close-ups of the taxidermist's hands, the polystyrene body, and the animal skin. Close-ups are effectively used to fragment the surface of the animal body, indissolubly merging it with the manipulating human hands. Importantly, the animal body-shape never fully appears in the frame, and neither does the body of the taxidermist. Not even at the end, nor at the beginning, is the full animal body shown as a whole or complete. Rather, the viewer's desire to see a naturalistic mounted body, the result of a linear process, is frustrated by a final partial view of the head of the seal mount, which appears uncunningly animated yet far from the livingness of naturalistic realism.

Further deliberate derailment of the realistic syntax in the filmic components is operated by the slowing of the footage. In classical cinematography, slow motion is typically employed to emphasize a specific moment or to dramatize, to elevate a transcendental moment from the realistic spatiotemporal dimension inhabited by the surrounding footage. However, by also slowing the soundtrack, Snæbjörnsdóttir/Wilson achieve an antiheroic effect in which slow motion becomes another active device in the obstruction of the realistic lexicon. The overall result is one in which the struggle involved in pulling the skin, and the resistance that its materiality poses to the hands of the taxidermist, are sensually accentuated.

At this point, *the naming of things*, as a title, encapsulates the complicities and inescapably reductive processes involved in the frictions between linguistic registers, materiality, and representation. The act of taxidermy is here metaphorical as much as it is effective. The molding of the animal skin over a man-made mannequin gestures toward our innate ability to mold animals into linguistic forms we conceive as realistic. It points to the assimilation of animals into human discourses, or the ways in which we model them in realistic form to serve the purpose of our discourses and practices. As a work of speculative taxidermy, *the naming of things* employs taxidermy for the purpose of questioning taxidermy itself, its realistic ambition, and the linguistic dimension of representation that so much defines human/animal relations. Its speculative dimension, however, is that which moves beyond a simple rejection of realism to reveal the structure upon which human/animal relations have thus far unfolded. Here, realism no longer is an aesthetic standard to aspire to. It is a collection of modalities through which embodied and mediated access strategies are constructed in relation to specific geographies, materialities, and epistemologies.

The seal is reduced to a surface underneath which its animality has been replaced by a modeled piece of foam. Its ultimate objectification is inscribed in the malleability of its skin—a relative resistance that is ultimately forced into shape: here the workings of language are exposed in a visual metaphor. The project thus surfaces and problematizes the interconnected dynamics of *naming* and *taming* through different ontological registers—the processual contingency intrinsic to humanist epistemology that was originally performed by Adam and that equates to an affirmative act of dominance over creation.[85] In this context the medium of taxidermy is made to emerge as a highly complex metaphorical crux—it becomes the effective representation of the philosophical impossibility of animal death. No longer simply the effigy of man's subjugation of nature, taxidermy is now the place where the recovery of the discourses, practices, and power/knowledge relationships that have shaped human/animal shared histories are mapped as the mechanism that governs them is made visible. The viewer is thus compelled to piece these fragments together, to consider the paradoxes that shape human/animal relationships, and to envision ways in which to reconfigure them.

2

A NATURAL HISTORY PANOPTICON

Power, Representation, and Animal Objectification

One finds in the programme of the Panopticon a similar concern with observation, with characterization and classification, with the analytical arrangement of space. The Panopticon is a royal menagerie; the animal is replaced by man, individual distribution by specific grouping and the king by the machinery of a furtive power. With this exception, the Panopticon also does the work of a naturalist.

—MICHEL FOUCAULT, *DISCIPLINE AND PUNISH*

So it is that we have cornered the animals by limiting their sense of depth. We have corralled them under the concept animal. What depth they do have is dismissed as lesser than that of humans, or so foreign as to be untranslatable and not worth pursuing in our human endeavors. This flattening of animals' worlds into a thin layer of animal world as a life on the surface of things has legitimated any number of cruel acts against animals.

—RON BROGLIO, *SURFACE ENCOUNTERS: THINKING WITH ANIMALS AND ART*

THE EYE OF POWER

This chapter further traces the search for a genealogy of speculative taxidermy by focusing on natural history and the importance of its

epistemic strategies as the quintessential discipline through which "the real-register of nature" was constructed. Better grasping the artistic, scientific, philosophical, and technical processes and discourses that led to the golden age of taxidermy will contribute to a clearer understanding of the emergence of speculative taxidermy in contemporary art.

For this purpose, this chapter is bookended by Mark Fairnington's paintings (plate 2) and Mark Dion's cabinets of curiosities (plate 3). Their work incorporates, or indexically inscribes, taxidermy, raising a range of aesthetic preoccupations relevant to the current interest in speculative aesthetics. In a number of ways, the work of these artists is concerned with nonhuman actants, the registers of interconnectedness that the taxonomical systems of natural history deny, and the desire to challenge the relation to philosophical affirmation that asserts that cognition ultimately grasps a real that is not constructed. Thus the speculative aesthetics employed by Fairnington and Dion provide opportunities to appraise the ways in which the experience of nature has been constructed in the past and how experience might be deconstructed and reconfigured in the present through a careful and critical manipulation of medium-specific idioms and their defining materialities. These speculative aesthetics bear a political force and can be seen to influence the processes of subjectivation, which the agency of the image is capable of. As will become more apparent in chapter 4, speculative taxidermy gains traction upon the formulation of ever-new speculative aesthetics that constantly defy past notions of anthropocentric realism. For this reason, this chapter takes a few steps back to recover the past aesthetic approaches that defined a transhistorical process of animal objectification. Victorian taxidermy emerged from these discourses and practices.

Mark Fairnington's practice has been characterized by a critical stance designed to challenge and problematize ontology and representation of the nonhuman. Many of his best known works are concerned with taxidermy and the space between *seeing* and *saying* from which naturalistic representation emerges. As the artist states:

> One focus of my research is the line that can be traced between observed fact and speculated fiction. Within the natural sciences these fictions, in

which narratives have been woven around things that exist or are observed, are important representations of our changing relationships with the natural world. While they may be described as footnotes in the history of science their power as narratives persists.[1]

Fairnington's engagement with natural history directly addresses the tradition of illustration for the purpose of questioning its epistemological roots and representational strategies, its discourses, its iconographies, and its ontological functioning. His approach to the classical iconography of natural history is, therefore, critically driven by a desire to subvert the representational modalities that have characterized the discipline through an emphasis on the concept of *specimen*. The Latin root of the word is linked to the verb *specere*: to see. In zoological terms, the specimen is the established standard of morphological integrity representing a whole species. In natural history, the specimen must be anatomically perfect. It is the epistemological object par excellence: suspended between the linguistic and the material, it is the animal-object laid bare, the building block of institutional taxonomic discourses. It lays transfixed in an atemporal milieu in which any individual history is removed by preparation and decontextualization. Fixed in death, its ideal, singular form relentlessly implies the multitude of its living referents. Its cultural afterlife is constrained by the taxonomic grid. Perfectly situated with the system of scientific knowledge, the specimen has neither past nor future. As the emblematic animal-made-object, it encapsulates many of the contradictions and paradoxes typical of human/animal relations.

Since the Renaissance, natural history illustration has attempted to immortalize the recurrent morphological traits of animals, usually merging drawings of multiple individual animals or plants into one. This affirmative method was perfected toward the end of the Enlightenment when, in the production of his beautiful ornithological illustrations, John James Audubon would kill up to a hundred birds just to produce the image of a single specimen. Fairnington's paintings of praying mantises and other insects first challenged the construction of the specimen as operated by natural history illustration: the artist's intention was that of restituting some kind of individuality to the specimen, to return the

abstracted icon, the Platonic idea, to a material level that is closer to the animal and further away from language, to a register of realism that impeaches scientific discourse.

Fairnington thus turned to the very tools through which realism operates. He photographed museum specimens with the aid of a microscope, capturing the damages, imperfection, and discolorations that over time have affected the surface of selected animal bodies. But unlike Audubon, Fairnington had no interest in representationally resurrecting his animals. His insects remained well dead. Stark against the neutral background of natural history illustration, these damaged specimens uncomfortably posed as themselves: a Caravaggesque memento mori in which decay metaphorically returns the specimen to an imperfect dimension of bio-interconnectedness.

This ontological quivering proposed by Fairnington is further problematized by the conceptual overlay of artistic media inscribed in the final work. His paintings of animal specimens always derive from photographs—sometimes from multiple, collaged photographs. Through this process, the artist engages in a complex dialogue with the idiomatic nature of these media, and their relationships with nature, realism, and ultimately epistemology.

The level of realism defining his early paintings is brutal—broken legs, torn wings, and entomological pins transfixing bodies were all accurately documented. Likewise, his taxidermy study-skins of birds of paradise produce a difficult-to-negotiate tension between the beauty of the plumage and the flattened body of the birds. Refusing to resurrect, embellish, and perfect, the artist deliberately blurs the boundaries between the most regularly attributed subjectivity of painting and the presumed realistic objectivity of photography by problematically intertwining their idioms. As a result, his images uncomfortably sit in the gap between seeing and saying: the rupture between the world, the presumed realism with which we represent it, our perception of it, and the possibility of articulating such perception.

Fairnington's paintings insert themselves in the history of opticality of natural history, leveraging the moment of implementation of photography's mechanical eye in scientific inquiry. By reversing the historical order in which these media constructed the real of natural history, in his use of photography before painting Fairnington positions himself as an

FIGURE 2.1 Mark Fairnington, *The Parrot Plant*, 2009. Oil on panel. 70 × 40 cm.

antihistorical document-maker: one engaged in the negotiation between the conceptual and the sensory, operating in a web of aesthetic contradictions in which animal objectification is key.

Importantly, the artist's critical revisionism of natural history illustration is substantially problematized in a series called *Flora*, in which

the objectifying tendency of natural history illustration is subverted by a different speculative aesthetic. Between 1999 and 2011, Fairnington produced twenty-two canvases capitalizing on a captivating realism combined with an iconic compositional balance generating an overall sense of supreme harmony. The attention to detail, once again, is impeccable, and the overall impression of naturalism undeniable. Here, too, the artist's approach is critical—the paintings don't just celebrate natural beauty, but question the work of realism as the epistemic tool of representation; they offer opportunities to develop awareness of interrelated ethical and epistemic intricacies in the institutional representations of animals and plants.

From this vantage point, it becomes possible to appreciate that his paintings involve a series of nonaffirmative operations, the first of which is clearly embedded in the title of the series. The name *Flora* suggests a scientific focus on plants, but in opposition to the tradition of natural history illustration that separates animals from plants, the artist juxtaposes them according to the rules of resemblance that governed the Renaissance episteme.[2] Like the assembly of objects in a cabinet of curiosities, the composition of plants in *Turaco Green Lady* brings together flowers and foliage sharing substantial morphological assonances despite being wholly different species originating in distant geographical locations. In *The Parrot Plant*, the vivid green of the bird's plumage associates the animal with the plants on which it perches, while its red collar shares aesthetic affinity with the cherries the bird gazes at. Similar aesthetic resemblances are at play in *The Golden Leaves*, where the patterns on the underside of the wings of two butterflies echo the flatness of adjacent leaves and the colors on the fleshy surface of the flower of a nearby pitcher plant. These nontaxonomic associations are problematized by the *now* of photography and the implied *past* of painting that are made to interlace in each image—the resulting time-space dimension that Farnington outlines further confuses livingness and death. The demise of precise referents is in some paintings exacerbated by a deliberate disrespect for natural scale—another measure of the real is challenged. In these paintings, realism is essentially pushed to its linguistic dimension in natural history: the very surface of things.

TRANSCRIBING ANIMALS: LIMITING
AND FILTERING

In *The Order of Things*, Foucault noted that natural history essentially emerged as a system of viewing beings through a grid of knowledge.[3] The discipline became one of the most prominent in the classical age,[4] a historical period whose episteme involved a substantially deep reorganization of knowledge (1650 to 1800).[5] At that time, the most important practices substantiating the register of truth in natural history involved the careful observation of objects and the transcription into "smooth, neutralized, and faithful words": realism.[6]

The emergence of new spatializations of visuality proposed by *spaces of juxtaposition* such as herbaria, collections, and gardens was of defining importance to this new epistemological approach. These new spaces inscribed an abstract atemporality residing in the neutrality of the rectangular page upon which plants were displayed according to the new rules of clarity. There they could be juxtaposed, one next to another, for the purpose of evaluating similarities and differences of morphological traits.[7]

From the essentially theatrical epistemic spaces of the Renaissance, such as fairs, tournaments, cabinets of curiosities, and combats, to the new cataloging spaces of zoology collections and botanical gardens and herbaria, it appears clear that the epistemic shift from the Renaissance to the classical age was demarcated by a reconfiguration of *opticality*.[8] The relationship between the gaze and the object of scrutiny was substantially reconfigured through the materiality of the new epistemic spatializations of natural history. And the construction of new epistemological spaces of visibility enabled natural history to form into a discipline dedicated to the ordering of the nomination of the visible.[9]

At this point we encounter the beginning of the exclusive epistemic predominance that vision acquired through the classical age as a means to filter new epistemic-empiricist approaches into the clarity of institutionalized objectivity. In this way, a self-substantiating regime of visibility came to define natural history's epistemic language, one that essentially produced knowledge through the rendering of lines, surfaces, forms, and volumes on paper.[10] But most interestingly, this reductive representational process was also characterized by the epistemic necessity of visually, as

well as metaphorically, immobilizing the object of knowledge, whether it be animals or plants. This constant factor encompassed the emergence of taxonomical arrangements typical of the classical age and the collecting practices of the nineteenth century alike. The crystallization of form enabled the visibility of beings whose normally elusive nature would resist observation and classification.[11]

The line that drew the animal body onto the page was essentially the same line that wrote it into sentences. This epistemic contingency has been well exemplified in Lévi-Strauss's idea of the miniature as a site underlined by power politics intrinsic to objectification. In *The Savage Mind*, Lévi-Strauss stated that miniatures seem to have intrinsic aesthetic qualities derived from the dimensions of the objects in question.[12] Similarly to Foucault, Lévi-Strauss points to essential and inescapable concepts of size and scale understood as part of reductionist operations, whereby "the paintings of the Sistine Chapel are a small-scale model, in spite of their imposing dimension, since the theme which they depict is the End of Time."[13] According to Lévi-Strauss, "even 'natural size' implies a reduction of scale since graphic or plastic transposition [what Foucault calls transcribing] always involves giving up certain dimensions of the object: volume in painting, colour, smell, tactile impressions in sculpture and the temporal dimension in both cases since the whole work represented is apprehended at a single moment in time."[14]

Whereas Foucault attempted to configure the discursive and technical intermingling that led to the prominence of scientific illustration as a tool of natural history, Lévi-Strauss identified the virtue of reduction for the purpose of positioning art "half-way between scientific knowledge and mythical or magical thought."[15] "To understand a real object in its totality," Lévi-Strauss argued, "we always tend to work from its parts. The resistance it offers us is overcome by dividing it."[16] The miniature, or the natural-size replica, thus enables the exercise of "power over a homologue of the thing, and by means of it, the latter can be grasped, addressed, and apprehended at a glance."[17] Metaphorically, the sealskin manipulated in Snæbjörnsdóttir/Wilson's *the naming of things* undergoes a process of miniaturization through limiting and filtering.

As seen in the previous chapter, the practice of naming is an intrinsically humanist one—an affirmative act of dominance originally performed by Adam through the naming of animals in the Garden of

Eden.[18] Both Foucault's and Lévi-Strauss's theorizations ultimately relate to the visibility of the outside of objects: their surfaces. Internal organs and functions fell outside the range of visibility of the episteme of the classical age—they were invisible to the discourse and practices of the time.[19] An inherent exclusivity is at play in the modes of visualizing and rendering visible of any episteme. As a result, some objects of knowledge become visible through one episteme as they fall into invisibility in another, for it is impossible for man to access the totality of knowledge.[20]

The fact that epistemic modalities of the classical age were substantially defined by a focus on surfaces is of defining importance to natural history and to the emergence of taxidermy alike. It is upon the surfaces of natural objects that the relationship between seeing and saying essential to taxonomy unfolded.[21] And it is from this perspective that Fairnington's critique of natural history illustration appears to gain currency. His juxtapositions of animal and plant bodies suggest an ontological collapse gesturing toward the reductionism of natural history and the primacy of the surface as a very privileged epistemic stratum. In this sense, the study of botany essentially laid the epistemic foundations of zoology. In the classical age, plants were understood to wear their organs on the outside; once flattened on the page of the herbarium, they clearly displayed all that there was to know about them during that specific epistemic milieu.[22] This condition encapsulated the epistemological modality of the seventeenth and eighteenth centuries, in which it was possible to know and to say only what could be ordered within a taxonomic area of surface visibility.[23] It is for this reason that an early system of natural history taxonomy can be found in the herbarium.

THE *BESTIARIUM* AS NEW EPISTEMOLOGICAL SITE

Although Fairnington's paintings directly subvert the iconography that characterized natural history in the classical age, it is also important to consider how this objectifying approach to animal representation operated over time for the purpose of identifying the aesthetic regularities that established this iconography and its objectifying paradigms.

The epistemic uniqueness of the Middle Ages lies in the pervasiveness of the logos of God.[24] Then, the authoritative optic on nature shifted in the hands of monks who found to be discursively congenial an anonymous text on the subject of animals and nature titled the *Physiologus* (probably originating in Egypt and written in Greek), which became "one of the most popular and widely read books of the Middle Ages."[25] In the *Physiologus*, pagan tales of animals were infused with Christian morals by subsequent anonymous revisers. The book thus became a widely adopted reference for iconographical sourcing at the time.[26] Its authorial anonymity and its many translations in different languages, including Greek, Syriac, Ethiopic, Coptic, Armenian, and Latin, situated its authorship in a nebulous dispersion through different times and geographical sites.[27] But most importantly, as a didactic text, the *Physiologus* constituted a new epistemic spatialization in which animals and fantastic creatures were essentially represented through the enmeshing of animal semantics. Animal semantics are the words interwoven in the very fabric of "represented animal": they are intrinsic to their materialization in discourses and essentially constitute the archive of symbolic representations, practices, and discourses produced by human/animal relations.[28]

The impact of the *Physiologus* on human knowledge of animals was defining and long-lasting. It provided the visual and literary arts with many allegorical images of phoenixes and unicorns. Of great relevance to this argument is that the *Physiologus* became instrumental to the emergence of another important book on animals, the *Bestiarium*, a zoological-epistemological site that profoundly marked medieval and Renaissance culture in Europe. The Latin text of the surviving early bestiaries effectively is a translation of the *Physiologus*.[29] It is this connection that makes them both similar to archives: collections of propositions repeated and dispersed, functioning as thresholds to the emergence of discursive formations in early natural theology. But most importantly, moving beyond the *Physiologus*'s unorganized assemblages, the *Bestiarium* provided visual representations of animals, first unclassified (before the twelfth century) and thereafter classified in loose orders.[30]

In the *Bestiarium*, animal semantics encompassed the legendary, the mythical, the anecdotal, and the phenomenological (fig. 2.2). They constructed a realism of nature that was substantially different from that which followed in Renaissance representation. The text constituted a

FIGURE 2.2 "The Whale," and "The Lion: a) eating ape; b) sparing prostrate; c) afraid of a cock," in *The Ashmole Bestiary*, unknown miniaturist, originally early thirteenth century. Bodleian Library manuscript, Ashmole 1511, folio 86v. and folio 010r.

peculiar epistemological spatialization in which animal semantics not only substantially define the symbolic essence (signature) of animals in flesh and bones, but in which they operate at a high intensity, acquiring the ability to materialize mythical animals, such as the griffin or the unicorn. Through the Middle Ages, in the macrocosms or the microcosms, animals appeared to be indissolubly enmeshed in the animal semantics that materialized them as signifying, morally charged, symbolic objects of religious value: the "medieval naturalist" was a theologian.[31] Medieval bestiaries, dispersed across a number of different geographical and cultural areas, established enunciative modalities that were subsequently appropriated by the discipline of natural history.

In bestiaries, the newly established relationship among animals, text, and illustration was initially an extremely fluid one. As argued by

archaeologist and historian John R. Allen, "a tiger is described as a kind of serpent, and is actually drawn as a dragon with wings."[32] Naturalism had lost prominence in artistic production throughout central and eastern Europe since the fall of the Roman Empire.[33] As an epistemic modality, naturalistic realism in representation became inadequate to the provision of the rendition of a world constructed through the "already coded eye" of Christianity.

As will be seen in the next two chapters, the reemergence of naturalistic realism as an epistemic tool in natural history coincided with the positivistic approaches of the Enlightenment and played a fundamental ideological role in the processes of animal objectification. From an art historical perspective, the departure from naturalistic realism that characterized the postclassical phase has been generally acknowledged as the result of the influence of so-called barbaric art, or Celtic, Germanic, Hiberno-Saxon, and Viking art.[34] Simultaneously, throughout central Europe, medieval painting was produced by discourses and practices that prioritized representation as an ordering agent in a highly dystopian world. Painting became the site of God's materialization; a limited, filtered, flattened, and miniaturized world better lent itself to be controlled and assimilated into discourses by becoming more and more graspable. Medieval painting and manuscript illuminations thus engaged in circularities between discourses and representation in which one reciprocally validated the other—God's word was truth and the representation of God became the word.

However, within the flatness of medieval painting two major epistemic achievements took place. First of all, flatness operated as the marker of the spiritual. Flatness suggested a lifting from the metaphysical—figures were deliberately extrapolated from the spatial as well as temporal flux of the world.[35] Once flattened, they existed exclusively in symbolic registers. Second, by extrapolating figures from the three-dimensionality of the world, medieval art enhanced the possibilities of organizing the world according to the omnipotence of God. Bypassing realism enabled artists to construct hierarchical structures in which figures were arranged in size according to their theological importance, not in relation to the positioning of the viewer's gaze. Thus, images and words ontologically coincided in the material condition they shared: the flatness of manuscript pages or the wooden boards of paintings. Repeated and disseminated through

the manual reproduction of bestiaries around Europe, the newly ac-
quired visibility of animals defined a new epistemological spatializa-
tion. There, animals acquired visibility in a double bind of words and
pictorial form.

THE FLATTENING OF NATURE

By the second half of the thirteenth century, bestiaries had consolidated the
epistemic spatialization of the book page as a flat surface upon which ani-
mals were most regularly made to materialize. And it is this very spatial
structuring that early natural history books appropriated. One of the most
widely circulated early natural history books that included illustrations was
Historiae animalium by Conrad Gesner, published between 1551 and 1558
(fig. 2.2).[36] Aristotle's and Pliny's texts did not originally feature images.
Therefore, Gesner's book represented an important moment of rupture in
the tradition of scientific inquiry. Another notable innovation lay in the re-
moval of some animal semantics originally included in the bestiaries. This
collection was organized alphabetically, but Gesner's optics still engaged in
the construction of an emblematic natural history in which animals
were relatively caught up in an intricate network of symbols, emblems,
and metaphors.[37] As Ashworth notes in his discussion of *Historiae
animalium*:

> To know the peacock, as Gesner wanted to know it, one must know not
> only what the peacock looks like but what its name means, in every lan-
> guage; what kind of proverbial associations it has; what it symbolizes to
> both pagans and Christians; what other animals it has sympathies or af-
> finities with; and any other possible connection it might have with stars,
> plants, minerals, numbers, coins, or whatever.[38]

Although in Gesner's book the theological teachings that defined the
representations of the *Physiologus* and the *Bestiarium* were no longer so
prominent, *Historiae animalium* still featured unicorns and griffins,
along with some "monsters." But despite still being grounded in an
emblematic approach to natural history that owed much to medieval

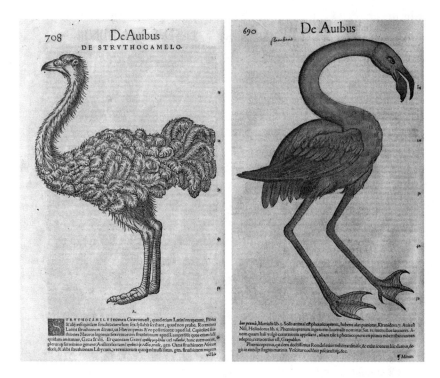

FIGURE 2.3 "Ostrich" and "Flamingo," illustrations in Gesner, C. (1551–1587), *Historiae Animalium* (Tigvri: Apvd Christ. Froschovervm), vol. 3, p. 708 and p.690. Open-access images courtesy of the National Library of Medicine, Bethesda, Maryland.

epistemic parameters, Gesner's work also demonstrated new awareness of the importance images could play in the study of animals. In the preface of the first volume, he states that "princes of the Roman Empire used to exhibit exotic animals in order to overwhelm and conquer the minds of the populace, but those animals could be seen or inspected only for a short time while the shows lasted; in contrast, the pictures in the *Historiae animalium* could be seen whenever and forever, without effort or danger."[39] This new conception of images shifted the relevance of animal representation from the symbolism of the theological field to a more empirical realm of concern where animals could be "seen or inspected."

Another substantial innovation in Gesner's book was the inclusion of exotic animals arriving in Europe from the far north, the New World,

and the East Indies.[40] These new animal bodies appeared somewhat suspended between the empirical and the fantastical as the novelty of their colors and shapes made them implicitly otherworldly. But their undeniable physical presence challenged authors with a blank space in the place of narratives. The new animals were wholly or mostly unknown and did not carry with them any animal semantics: they were as symbolically bare as they could be. The impossibility of interpreting these animal bodies through a defined anthropocentric, sociosymbolic schema brought Gesner to focus on their morphology in order to register with accuracy their essential features instead. As a result, Gesner's illustrations capitalized on a representational naturalism that had already resurfaced in the sculptural and pictorial arts through the revival of classical art and Greek philosophy during the Renaissance.

This important epistemic crisis is problematized in Fairnington's paintings in the *Flora* series, where exotic and European varieties of plants and species of animals visually merge with a fluidity that obliterates animal semantics and enables the emergence of new orders of juxtaposition. Many of the titles of Fairnington's paintings emphasize this fluidity by disregarding scientific nomenclature. Interestingly, the word *flirt* recurs more than once in different titles, such as *Flirt (tortoiseshell)* and *Flirt (six butterflies)*. A nonscientific term, the word *flirt* suggests a playful game of attraction—one standing in direct opposition to the rigidity and separateness of the taxonomical grids of natural history. Fairnington's paintings thus gesture toward a "what if . . . ?" What if natural history had adopted a different epistemic modality through which to produce knowledge of animals and plants? What if instead of isolating animals and plants within the perimeter of the page, the natural history illustration had opted for a fluid and open intertwining of life? What would our relationship to animals and plants be like today?

But instead, the absence of animal semantics bore other implications in two iconographical registers. Stylistically, a more realistic approach to animal form became favored. Compositionally, the plain backgrounds against which animal bodies were positioned became more common. The absence of backgrounds was indicative of the absence of animal semantics. In the absence of specific cultural knowledge of exotic animals, the new iconographical modality at play in the production of illustrations positioned animal bodies in a contextual vacuum, capitalizing upon only

those formal traits that could be empirically recorded, such as body shape and color. The representation stopped at the evidence, and the evidence was provided without context.

This aesthetic shift was also characterized by a different positioning of animal bodies within the epistemic spatialization of the page as they began to more regularly appear longitudinally situated across the page. Unlike the animals illustrated in the bestiaries, which were usually represented as participants in some narrative act surrounded by a contextualizing backdrop that functioned as a theatrical stage (at times shared with men and other animals), Gesner's animals were singled out.

The semantic networks that connected animals to the world they inhabited were thereafter altogether removed in the representational work of John Jonston published in 1657 and titled *Natural History of Quadrupeds*. As Foucault notes:

> The words that had been interwoven in the very being of the beast have been unraveled and removed: and the living being, in its anatomy, its form, its habits, its birth and death, appears as though stripped naked. Natural history finds its locus in the gap that is now opened up between things and words—a silent gap, pure of all verbal sedimentation, and yet articulated according to the elements of representation, those same elements that can now without let or hindrance be named.[41]

Most importantly, Gesner's and Jonston's optics established the iconographical modality of scientific representation in classical natural history. Filtered and limited for the purpose of being transcribed into discourses, starkly rendered and longitudinally positioned in the pictorial plane so as to display their formal attributes with heightened clarity, animal bodies appeared aligned as closely as possible with the words that described them.

By the mid-sixteenth century, the classical iconography adopted by natural historians was characterized by a recurring type of draftsmanship that predominantly transcribed the objects of inquiry through a sense of linearity, in opposition to the "seeing in masses" of a more painterly approach. A formal analogy can be drawn between linear draftsmanship and the words that accompanied the illustrations in

natural history treaties. The shared reliance on the traced line rendered animal bodies more "wordlike," implicitly facilitating their assimilation into discourse.

Linearity, in art historian Heinrich Wölfflin's conception, implies that the "sense and beauty of things is first sought in the outline" emphasizing the distinctness of the object itself.[42] Recession, which connotes the depth of the image, is absent in many illustrations from this time, for the classical optic of natural history had been dramatically shortened to single out the animal.[43] As a result, images predominantly relied on the construction of closed forms, whereby a demarcated distinction between background and object formed "a self-contained entity, pointing everywhere back to itself." This construction contributed to a sense of unity, revealing "the beauty of form through *clarity*."[44] Thus silenced, immobilized, posed, isolated, and flattened, animal bodies became fully exposed to the objectifying gaze of the natural historian (fig. 2.4).

This flattening operation can be problematized through a concept introduced by human/animal studies scholar Ron Broglio, who stipulated that according to a long continental philosophical tradition revived by Cartesianism, animals are understood as intrinsically lacking "depth of being"—the very quality that allows man to be self-reflexive and therefore cogitant.[45] Relegated to living "on the surface of things," animals have therefore become wholly accessible to man, but only on a surface level.[46] On these grounds Broglio proposes to rethink our relationship with animals, instrumentally adopting this very metaphorical and literal flatness. Taking animal and artistic surfaces as the main epistemological interface upon which the reconfiguration of human/animal relations can be operated provides a productive point of departure.[47] The strength of Broglio's proposal lies in its acknowledgment of the anthropocentric limitations intrinsic to phenomenology, and the possibility of crafting alternatively productive philosophical/artistic synergic approaches that emerges from the awareness of such limitations. In this configuration, art is positioned as a privileged human/animal interface capable of "unhinging philosophical concepts and moving them in new directions."[48]

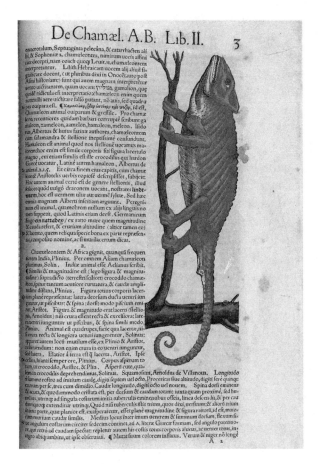

FIGURE 2.4 "Chameleon," illustration in Gesner, C. (1551–1558), *Historiae Animalium* (Tigvri: Apvd Christ. Froschovervm), vol. 2, p. 3. Open-access image courtesy of the National Library of Medicine, Bethesda, Maryland.

BOTANY: SETTING THE ICONOGRAPHY
OF NATURAL HISTORY

Fairnington's *Flora* series challenges the viewer with an inherent onto-logical provocation: despite its title, both animals and plants appear in the paintings. As we have seen, the importance of this provocation lies in the acknowledgment that the epistemic modality of early natural history found relevant discursive data only on the surfaces of objects: taxonomy organized by juxtaposing morphological forms for the purpose of identi-

fying assonances and discrepancies. For this reason, the gaze of the natural historian ontologically equalized animals and plants. *Flora* unashamedly visualizes this aesthetic continuity that metaphorically and aesthetically flattened both animals and plants. As will be seen in this chapter, this emphasis on surfaces and the epistemic practice of flattening proved to be of paramount importance to the emergence of taxidermy in the Victorian period.

Visual traces of the study of plants date back to the second century BCE and the work of medic and botanist Crateva di Mitridate, who is today considered the father of botanical illustration. Although his body of work has been entirely lost, it is claimed that his drawings were incorporated into medieval texts.[49] Thereafter, the field was furthered by Pliny (23–79 CE) and Pedanius Dioscorides (54–68 CE), although next to nothing remains of their work.[50] One of the most interesting examples of the iconographical approach originally employed in botanical illustration can be identified in the illustrations of the *Vienna Dioscurides*, an early sixth-century illuminated medical manuscript from Greece.[51] In this collection of illustrations and medical texts, plants already appear flattened and clearly manipulated to best fit the flatness and borders of the page on which they were drawn (fig. 2.3). The background appears neutral, like in Gesner's and Jonston's later images, while most of the leaves and flowers are parallel to the page. These examples show how the iconographical choices that would become central to the emergence of zoology were already in place in the study of botany. The contemporary *Herbarium Apuleii Platonici* incorporated similar representational strategies and became one of the most popular herbaria of the Middle Ages. Here the realism characterizing the illustrations of plants was reduced in favor of a more synthetic approach that would become typical of medieval European representations.[52] Likewise, *The Old English Herbarium* (late tenth century) proposed flattened and largely synthetic representations of plants.[53]

The epistemic shifts that enabled the emergence of the new iconography of natural history, as seen in Gesner's and Jonston's zoological work, influenced the production of more realist images in Brunfels's *Herbarum Vivae Eicones* (1532–1536) and Fuchs's *De Historia Stirpium* (1547).[54] But around this time, alongside the epistemic importance gained by illustration in the representation of plants, we also encounter the emergence of herbaria in which plants are not drawn but are actually preserved as pressed specimens. The collection of live plant specimens was initiated by

FIGURE 2.5 "Plant cottony Blackberry (Wolliger Brombeer, Rubus Tomentosus)," in Vienna Dioscurides manuscript, early sixth century. Cod. med. Graec. 1, folio 83r. Open-access image courtesy of the Austrian National Library.

Luca Ghini, founder of the academic study of nature in Bologna and Pisa.[55] Ghini introduced the field trip and specimen collection as essential parts of his courses and is credited as being the first researcher to establish an herbarium involving preserved dried specimens.

Flattened and dried, plants were affixed to sheets of paper in ways that aesthetically echoed the preceding tradition of botanical illustration. Leaves and flowers were laid parallel to the page surface, while stems were organized in order to impose a sense of clarity and definition; the overlap of leaves and stems was avoided whenever possible. Despite the loss in coloration and three-dimensionality, dried specimens provided the much-needed evidential truth necessary to begin a secular, taxonomical, and empirical cataloging project. The emergence of taxidermy during the

nineteenth century is the result of the emergence of this very *metaphysics of presence* that largely drove natural history to catalog the indexical instead of the referential. Secularization depended on the empirical, and the empirical required the death of the object of study.

The discourses and practices of botanical research strongly influenced zoology and the illustration of animals, setting the semantic perimeters of epistemic spatializations and, most importantly, outlining its iconographical standards. This influence is confirmed by Ulisse Aldrovandi's citation of Cibo's influence on his own work in *Catalogus Virorum qui mea studia adjuvarunt*.[56] Aldrovandi incorporated Cibo's approach by developing a strong interest in the epistemic value of illustration and consistently advocating the importance of color in the painting of specimens *ad vivum* (from life). Aldrovandi claimed that "there is nothing on earth that seems to me to give more pleasure and utility to man than painting, and above all painting of natural things: because it is through these things, painted by an excellent painter, that we acquire knowledge of foreign species, although they are born in distant lands."[57] Furthermore, he specified that painting played a key epistemic role because "it could imitate products of nature *al vivo*."[58] Aldrovandi's impression of the ability of painting to replace the animal object was also expressed by Gesner in his own collection. It is reported that Gesner sometimes settled for drawings and paintings because of the prohibitive costs of exotics.[59] This overlap of material specimen and specimen illustration will become central to the closing section of this chapter. But for the time being, it is important to note that the aesthetic intermingling that characterized the structuring of epistemic constructions in botanical and zoological studies also proposed an ontological alignment between animals and plants. This, I argue, constitutes a vastly underscrutinized aspect of the processes of animal objectification.

TOWARD A NATURAL HISTORY PANOPTICON: THE BIRTH OF THE SOVEREIGN AND THE DEATH OF THE ANIMAL

The relationship between seeing and saying, and the consequent dynamics involved in the power/knowledge relationships that shaped the discursive formation of natural history, have been linked already in this chapter to the

material contingencies of the spatializations through which nature was culturally constructed—the role played by architectural configurations in the shaping of power/knowledge relationships should never be underestimated.

Foucault's interest in the spatializations of knowledge is well known. His attention to institutionalized spatializations, such as the hospital, the prison, and the asylum, focused on the concept of surveillance and control.[60] Surveillance and discipline did not simply figure as tools for the control of individuals but were outlined as more complex concepts simultaneously entailing *containment* and *making visible*.[61] In *Discipline and Punish*, Foucault focuses on the functional, as well as hierarchical, roles played by the organization of cells, places, and ranks in late Renaissance and classical institutions.[62] He draws a direct link between the materiality of the architectural spaces of schools, hospitals, and prisons and his earlier analysis of natural history illustration featured in *The Order of Things*.[63] Surveilling and disciplining spatializations are simultaneously real but also ideal—they are real in the sense that they physically structure and organize spaces and bodies, and ideal in that they enable "arrangements of characterizations, assessments, and hierarchies." Here the connection between the materiality of human bodies, architectural spaces, and the representational ordering operated by the arrangement of botanical and zoological gardens, becomes overt. This is what Foucault calls a "disciplining space of natural beings."[64]

The materiality of the epistemological spatialization, and the material contingencies of the page in the natural history treatise, played a substantial role in the ontological and representational flattening process of representing animals. Confined within the margins of the page, circumscribed by written text, immobilized against a plain background, rendered clearly visible, and silenced, animal bodies could be subjected to a metaphorical/representational surveillance and disciplining. What emerges at this stage is a triad of parameters through which animals are culturally constructed in natural history during the Renaissance and the classical age: space, power, and knowledge. Along with natural history illustration and the herbarium, this triad played a key role in a third important spatialization in fashion at the same time: the cabinets of curiosities that emerged during the late fifteenth century as the new epistemic spatializations for the observation of eclectic gatherings of objects. Cabinets of curiosities were the most opulent and visibly ostentatious sedimentation of power/knowledge relationships involving natural objects, and

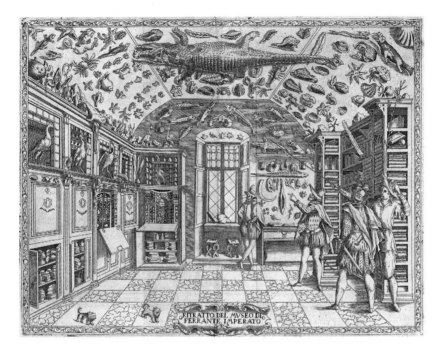

FIGURE 2.6 "Ritratto del Museo di Ferrante Imperato," in Ferrante, I. (1599), *Dell'historia naturale* . . . (Naples: C. Vitale), 12 p. l., 791 p. illus., double plate. Open-access image courtesy of the Smithsonian Institution Libraries.

relied on an ontological flattening that aligned natural objects and art objects, contributing to the process of animal objectification essential to the emergence of taxidermy.

Through the Renaissance and the classical age, the power of the gaze of the natural historian defined the epistemology of natural history—it gave birth to the *sovereignty* of the viewer. The positioning of the gaze as key ordering principle in epistemology was exemplified by Jeremy Bentham's late eighteenth-century design of the panopticon. Its roots lay at the foundation of the practices of segregation and monitoring enforced by the syndics during the plague in medieval society.[65] The panopticon was thus conceived as a system in which economies of power could be dispensed through architectural configurations that imposed visibility for the purpose of surveillance.[66] In Bentham's design, a tower stood in the center of an annular building divided into cells in which opposed windows enabled

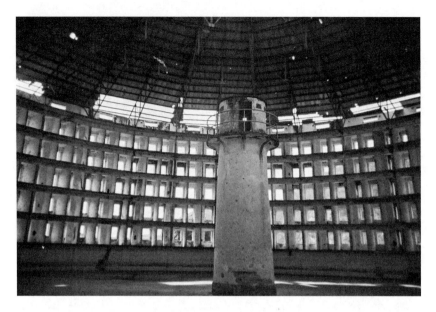

FIGURE 2.7 "Panoptic architecture," inside one of the prison buildings at Presidio Modelo, Isla de la Juventud, Cuba. Photograph courtesy of Friman, CC BY-SA 3.0.

absolute clarity. By the effect of backlighting, an observer placed in the central tower could survey the captive individuals around it.

Structurally, shelves and cabinets organized on the perimeter of the room facing toward the center of the cabinet of curiosities propose a structural precursor of Bentham's spatialization of surveillance (fig. 2.7). Like the panopticon, the cabinet of curiosities positioned the observer at the center of the field of visibility, in a privileged, all-seeing position of sovereignty. Situated against the neutral background of the cabinets' walls and shelves, each object was imparted with an axial visibility. As each object appeared dislocated from its interlinks with the world, the "universe" could thus be arranged by the centrality of the sovereign—from this vantage point, power over creation could be exerted, and dystopias were aligned into utopias.[67]

Similarly, natural history illustration also configured an early form of spatial panopticism in which the architectural site of the page functioned as dividing cells. The partitioning of animals inside delimited spaces

enabled the organization of an effective analytical system.[68] At the core of the removal of the background in the iconography of early natural history thus lay a power/knowledge relationship in which the gaze of the naturalist exercised a sovereign, ordering power over nature, capable of stripping animals of their semantics, and heralding the role of the collector as the epistemic origin capable of activating the otherwise passive hidden wonders of nature.[69] Fundamentally humanist, the cabinet of curiosities and natural history illustration constituted a literally anthropocentric epistemic blueprint for future studies of nature.

THE CARTESIAN SYNERGY

Because conceptions of panopticism and sovereignty have emerged as values embedded in the epistemic spatializations of natural history, it is legitimate to wonder how the Cartesian conception of *animals as automata* that emerged in the seventeenth century might be related.[70] Traces of their cultural synergy might be found in the ontological fluidity that characterized the heterogeneous gathering of objects in cabinets of curiosities. As seen, this had already operated an ontological flattening between animals and artifacts. Along with paintings, sculptures, jewelry, and curious artificialia, naturalia such as fossils, bones, shells, corals, preserved birds, mammals, and dried botanical specimens were arranged on shelves.[71] The ontological fluidity characterizing the Renaissance has its roots in relations of resemblance that played a defining epistemological role in outlining the nexus between disparate objects.[72] The formation of knowledge during this period revolved around the linking of things by relations of physical similarity and analogy. The primary task of knowledge was therefore that of teasing out similitudes between objects.[73] Knowledge identified similitudes on the grounds that objects were intrinsically defined by their *signatures:* their embedded, symbolic signification. Thus, in this epistemic milieu, words and things appeared intertwined in seamless ways. In the Renaissance, all that there was to know about an object, or an animal, resided on its surface. It was not necessary to look underneath the skin of animals or the bark of trees to know their nature.[74] The principal ordering agent of signatures was *convenientia.*

Convenient things shared an aesthetic continuity when juxtaposed—they seemed, in a sense, naturally hinged to each other.[75] Other objects were more pronouncedly linked by *aemulatio*, a natural kinship existing in things distant from each other. *Analogy*, which incorporated traits of *convenientia* and *aemulatio*, enabled knowledge to weave connections between extremely different objects.[76] And ultimately, the mobility principle of *sympathy*, with its free associative powers, was mostly responsible for the ontological equalization of naturalia and artificialia in the cabinet of curiosities.[77] The blurring of boundaries between the wonders of art and the wonders of nature caused astonishment and admiration, augmenting the power of the owner of the cabinet.[78] However, at the same time, it consolidated the growing objectification of nature within the discourses and practices of European culture—an objectification that would indelibly define human/animal relations for centuries to come.

In human/animal studies, Cartesian philosophy has been frequently positioned as the originator of animal objectification. In "The Animal That Therefore I Am," Derrida argues that "the mechanicism of the animal machine nevertheless belongs to the filiation of the Cartesian *cogito*."[79] Derrida highlights the persistency of the foundation of Cartesian metaphysics as reliant on the unquestionable sovereign centrality of man in continental philosophy, especially when animal otherness began to newly emerge in philosophical discourses.[80] Positioning itself at the core of the positivistic discourses of the Enlightenment, the engendering of man *as cogitant being* resulted in a relentless and convenient mechanization and reduction of nature as a resource to be exploited and dominated.

Descartes's metaphysics of rationalism advocated animal inferiority on the grounds that animals cannot produce reasoned speech—a sign demonstrating the lack of rational souls.[81] Theologically structured Cartesian arguments on *animal loquens* proposed a fundamental parallelism with the discourses of positivism that shaped the zoological field in the early eighteenth century, something that strongly contributed to its success.[82] Denying the existence of animal souls simultaneously negated the depth of cognition and self-reflexivity, resulting in a metaphorical flattening of animals.[83] Written across the epistemes of the Renaissance and the classical age, Descartes's philosophical statements were substantially defined by the epistemic parameters of these milieus. Thus, discursive and

practical parallelisms with the epistemic rules of formation that informed natural history illustration and the cabinet of curiosities can be identified in the work of resemblance, the ordering principle that shaped knowledge in the Renaissance. And importantly, the ontological fluidity that likened naturalia and artificialia in the cabinet of curiosities also played a substantial role in the parallelisms between animals and machines in Descartes's thought. In *Treatise of Man* (1629) Descartes described his encounter with a fountain in the royal gardens of Saint-Germain-en-Laye, which featured, among other machines, an automaton of the goddess Diana, bathing.[84] When a person entered the garden, a mechanical trigger would cause the statue to move, seemingly of its own will. Descartes's description of his experience suggests excitement and awe for machines' ability to perform movement while nevertheless lacking rational souls.[85] The ability to perform movement and the incapacity to speak, which, in his eyes, both automata and animals shared, thus provided an empirical foundation for the discursive formation of Cartesian thought. As evidenced in a passage from *Discourse on the Method*: "If any such machines bore a resemblance to our bodies and imitated our actions as closely as possible for all practical purposes, we should still have two very certain means of recognizing that they were not real men."[86]

As animals and mechanical objects were made to conflate through an internal and external flattening that took place over the Renaissance and the classical age, an irreconcilable distance between animals and man also began to widen. Descartes's statements will thereafter proceed to normalize the use of animals and animal matter upon which a number of discursive and nondiscursive practices of the modern age, such as medicine, fashion, and intensive agriculture, will develop.

DECONSTRUCTING NATURE IN DION'S CABINETS OF CURIOSITIES

This chapter has positioned the practices of natural history illustration and collecting in cabinets of curiosities as intrinsically panoptic in scope.

Both epistemic modalities constructed spatializations whose material specificities defined the optics of natural history. The metaphorical and technical flattening of animals and plants operated by these two epistemic spatializations enabled the transposition of the living organism into the discourses of the new discipline. But at the same time, it set the epistemic blueprint of the scientific modality for centuries to come—a modality based on reduction, objectification, and commoditization of the nonhuman. As is seen in the case of Fairnington's paintings, some contemporary artists are concerned with critically addressing this anthropocentric construction of knowledge for the purpose of dismantling metanarratives and unhinging disciplinary discourses to move them forward in new and challenging directions. Among the contemporary artists who have engaged in a critical appraisal of these epistemic modalities, Mark Dion's work provides an interesting problematization of this chapter's content.

Recent years have seen a symptomatic surge of interest in the notion of curiosity.[87] Artists and curators indulge in the possibility of bypassing the scientific rationalizations of the world, and they long for a momentary return, at least in art, to a different ontological fluidity.[88] As the *Guardian* reported in winter 2014:

> You can barely walk into a museum these days without being confronted by an eerie-eyed raven or a monkey's shrunken head. From Margate to Nottingham, from Hackney to Bradford, exhibition spaces are filling up with a macabre menagerie of dead things—from bones and beasts to stuffed birds. Indeed, next week the Milton Keynes Gallery will join the trend, opening a modern "cabinet of curiosities" that will set paintings by Gainsborough, Millais, Warhol and David Bowie next to taxidermied pelicans, medieval maps, and even an Aston Martin DB4, much like the one driven by James Bond in the 1960s.[89]

Mark Dion has been one of the earliest and most critically grounded artists to seriously engage with cabinet of curiosities for the purpose of operating a critique of the epistemological practices that have shaped our relationship with nature. Dion is well aware that "nature is one of the most sophisticated arenas for the production of ideology,"[90] and therefore his practice most regularly targets the museum in its anthropocentric

epistemological essence. Far from indulging in the ostentatious theatricality of some recent apparitions of cabinets of curiosities in art, Dion's work seriously reimagines epistemological processes, questions authorial practices, blurs ontological categorizations, and promotes multidisciplinarity. That the critique is allowed to take place within the institutions toward which it is directed simply enhances the sharpness of such operations. But perhaps most interestingly, Dion's work also strikes a peculiar balance between the idea of pure pleasure, or wonder, and scientific curiosity.

The tension between these two poles emerged at the end of the Middle Ages, when natural philosophers began to interpret wonder as unsuited to true philosophical inquiry. They conceived wonders as *praeter naturae*, outside the regularities of nature and therefore bearing no substantial importance in analysis.[91] St. Augustine had complained that some men were far too enthralled by "all manner of sights and sounds and smells that afford novel pleasures"—a diversion from faith and the principle of sin.[92] In 1240 Franciscan friar Roger Bacon identified wonder with ignorance, perhaps not surprisingly if one considers that the beginning of the revival of Platonic and Aristotelian philosophy had already set the foundations for causal knowledge and a model of natural orderliness.[93] Thereafter, Francis Bacon noted that classical mythology also gave wonder a negative connotation, and by the seventeenth century, John Locke firmly assessed scientific curiosity as the best antidote to the ignorance of wonder and as the principle of education during the Enlightenment.[94]

Most of Dion's cabinets of curiosities have attempted to strike a balance between the ontological restrictions of scientific epistemology and the wonder that characterized the Renaissance cabinets of curiosities, aiming in a way to create discursive and practical overlaps that transcend the separation of art and science that took place during the Enlightenment. Aiming to generate critical awareness of the ideological structures that underpin institutional power, Dion's artistic proposal is highly political, as his cabinets directly question the means by which epistemic affirmation is produced, validated, and disseminated as truth. The artist's work clearly acknowledges that nature is a construct constantly reinvented by humans and that representational acts are imbued with repercussions of an ethical kind. It is for this reason that representation and the processes that construct it are usually rendered visible by Dion through the

FIGURE 2.8 Mark Dion and Robert Williams, *Theatrum mundi: Armanium*, 2001. Wooden cabinet, mixed media. 110 2/3 × 110 3/7 × 24 4/5 in. (281 × 280.5 × 63 cm). Installation view, The Macabre Treasury, Museum Het Domein, Netherlands, January 20 to April 29, 2013. Courtesy of the artist and Tanya Bonakdar Gallery, New York.

practices of participation and delegation. Focusing on the aim of generating ecological awareness, the artist diffracts his authorial authority, enlisting groups of volunteers entrusted with managing collection processes as well as curating the display stages of the projects. This operation is particularly important because, on the performative level, it derails the single authorial role played by the kingly owner of the cabinets of curiosities, a role that was eventually replaced by the individual authorial role of the early natural scientist of the Enlightenment. Dion's approach thus merges both roles into a plurality of disciplinary and nondisciplinary voices of amateurs and experts in an attempt to undermine the limitations of ideologically charged institutional approaches.

Theatrum Mundi: Armarium is one of Dion's most interesting cabinets of curiosities and has largely contributed to the renewed interest in the subject within contemporary art (fig. 2.8). The piece comprises three cabinets housing objects entrusted with the representational duty of materializing the ladders of beings (*scala naturae*) devised by the post-

Aristotelian cosmologies of two alchemists, the Majorcan philosopher Ramon Lull (1232–1215) and the English Paracelsian physician Robert Fludd (1574–1637). The organization of objects in the cabinets thus juxtaposes two different *scala naturae*, materializing the inherent connections involved in man's elevation to godlike status through the acquisition of knowledge. In this instance Dion wants to highlight the arbitrariness with which the contents of the cabinets are organized. As different forms of realism, Fludd's *scala naturae* ascended from the baseness of *sensus* to *imagination*, *ratio, intellectus, intelligensus, verbum*, and finally *Deus*, whereas Lull's ascended from *lapis* to *flama, planta, brutu, homo, lelum, angel*, and *Deus*.[95]

Although they employ the materiality of objects as validating building blocks, in this configuration the juxtaposition of these two classificatory systems reveals their constructedness and fictitiousness. In this context, taxidermy is incorporated as a critical counterpoint to the anthropocentric act of ordering. The mounted birds housed in the top half of the Lull cabinet, juxtaposed to the animal toys on the shelf directly above them, reassess the permeability of ontology and the fallibility of taxonomy. More specifically, side by side, the cabinets problematize the nature/culture dichotomy, the anthropological divide that characterized the Enlightenment's debates on education and that still animates discussions of the Anthropocene today.[96] In this instance, like in many others in his work, Dion's critique is grounded in the past of institutions and disciplines to reveal the persistence of outdated anthropocentric approaches.

In this instance, Dion also shared his authorial ownership by directly curating only the Lull cabinet, and delegating the other to Robert Williams, a professor of fine art at the University of Cumbria, where the project evolved. The central cabinet that separates the two others contains a human skeleton, emblematically situated in the position of the author who can turn left or right toward one cabinet or the other, but who ultimately cannot directly access the very essence of his own existence amid the objects that define it. The skeleton simultaneously gestures to the traditional use of the memento mori in classical painting—the reminder of death as the inevitable equalizer of all life. These elements draw the viewer to participate in a process of interpretation guided by the presence of the skeleton's presence as silent, prophetic mirror. Specifically, left to our own devices in making sense of the world, have we lived a fair life in preparation

for God's judgment? Quite cunningly, encapsulating the need to make sense of human existence through the materiality of the nonhuman, the absence/presence and utter unrepresentability of God is inscribed in the top section of each *scala naturae*, where an empty shelf emblematically represents the limitation of man's epistemic modalities.

Sitting above the central cabinet in line with the skeleton's skull is a taxidermy magpie. Dion has frequently placed a single object on top of his cabinets to somewhat anchor the multiplicity of subtexts that can be produced by the viewer. Among birds, the magpie has carved a special place in popular culture because of its alleged collector tendencies. Its intrinsic, inquisitive nature seems to suggest an interrogation of the conceptual underpinning of representation from the perspective of an animal capable of an aesthetic discernment that surpasses utilitarianism. Thus positioned, the taxidermy magpie becomes an ambiguously flickering symbol suspended between the scientific specimen and the popular culture's conception of it. Its commodified taxidermy status simultaneously conveys our desire to construct nature, the epistemic limitations involved in such a process, and the strictures a "magpie approach" to constructing nature imposes upon it. Therefore, centrally positioned, apart from and superseding the objects inside the cabinets, the taxidermy magpie simultaneously anchors the contents of all three cabinets within the discourses of collecting, a presumed naturalization of such practice in humans (a tendency we share with other animals) and the inherent and irrepressible idiosyncrasies that characterize one's own interpretation of the world: after all, magpie collecting takes place outside the epistemic structures of human knowledge. Literally as well as metaphorically above all, the displayed theft—the implied crime signified by the presence of the bird—comments on the modalities of acquisition that characterized much of scientific taxonomy. Despite the noble pursuit of truth and knowledge that on the surface drove the organization of objects in cabinets, the magpie ventriloquizes the essence of a cultural entitlement linked to a naturalized conception of superiority that objectified the nonhuman and often justified collecting practices by unethical means.[97]

3

DIORAMAS

Power, Realism, and Decorum

Form, attitude, naturalness of coloured parts, adjustment of wings, angle of legs, centre of gravity, smoothness, neatness of finish, quality and arrangement of natural or artificial surroundings. If your conceptions of all these have the touch of the true artist and student of nature, your work will be admired and studied by the most indifferent observer.

—OLIVER DAVIE, *METHODS IN THE ART OF TAXIDERMY*

The fine arts never respected taxidermy and never will, [Joe] Kish told me. "If you take five of the best sculptors who ever lived and ask them to sculpt something, you'll get five different results. If you ask the five best taxidermists in the world to mount a white-tailed deer, aside from some stylistic differences, they'll all pretty much look like white-tailed deer. We're trying to duplicate something that nature already created. It's kind of like medical illustration."

—JOE KISH, QUOTED IN MELISSA MILGROM, *STILL LIFE: ADVENTURES IN TAXIDERMY*

MARK DION: THE ANTI-DIORAMA

Whereas cabinets of curiosities set the blueprint for the establishment of institutionalized collections in museums around the world, dioramas provided dramatized displays to maximize engagement. While cabinets

of curiosities individualized and decontextualized objects against plain backgrounds, natural history dioramas presented complex and rich juxtapositions of objects. However, both aesthetic approaches capitalized on narrativization: in opposition to the idiosyncratic tone of the cabinets of curiosities, dioramas spoke of universal ethicosocial values. This aspect made dioramas the most successful epistemological tool of natural history during the modern age: Through the implementation of taxidermy, dioramas could credibly vocalize ideological truths.

In 1999, Mark Dion began work on a full-scale diorama titled *Landfill* (fig. 3.1). As in his critical approach to cabinets of curiosities, Dion demystified objects. He evidenced the diorama as an epistemological tool whose aesthetics can be critically problematized by deterritorialization. This operation shows that natural objects do not simply embody meaning, but that meaning is unstable and can be produced by a number of variables, including their institutional matrix and affiliation. Thus,

FIGURE 3.1 Mark Dion, *Landfill*, 1999–2000. Mixed media. 71 1/2 × 147 1/2 × 64 in. (181.6 × 374.7 × 162.6 cm). Courtesy of the artist and Tanya Bonakdar Gallery, New York.

situated in a contemporary art gallery, the diorama no longer ventrilo-
quizes the rhetoric of natural history but becomes a tool through which
this very rhetoric can be dismantled and appraised.

More specifically, in Dion's diorama it is the work of realism that is
deliberately problematized. The artist is acutely aware that, despite the
range of materialities and technical approaches they entail, the ontologi-
cal difference between a cabinet of curiosity, a diorama, and a classical
painting is indeed minimal. All three are assemblages in which art and
nature intermingle for the purpose of producing images that always and
inevitably appear to be sedimentations of discourses. The selectivity with
which objects are included or excluded, the care with which they are as-
sembled within the epistemological architecture that confines them, the
intrinsic positioning of the viewer they designate, and the construction
of the scopic field—all these carefully orchestrated operations implicitly
embody multiple layers of ideological values. Dion also knows that for
these values to be delivered successfully, the illusion of realism must be
firmly in place. It is for this reason that *Landfill* incorporates all the aes-
thetic elements of classical natural history dioramas: the perspectival
painted background, the taxidermy seagulls, and the trash scattered ev-
erywhere in the diorama all present the viewer with a consistent level of
realism.

As in Dion's reconfiguration of cabinets of curiosities, the idea is to
short-circuit objects, their interrelated discourses, and associated prac-
tices by collapsing or unmasking the rhetorical machinery that operates
underneath the realist veneer that characterizes them. *Landfill* thus in-
vites a negotiation between the sensory and the conceptual, a negotiation
defined by the material complicities that in this instance allude to the
nonhuman networks and ecosystems that we are substantially enmeshed
in but that we culturally disavow.

The first clash produced by Dion is between two registers of realism:
the formal realism of the painted background, the taxidermy animals,
and the objects included in the diorama, and the contextual realism of
the scene itself: a landfill. The setting of the landfill stands diametrically
opposed to the Garden of Eden aesthetic that has been traditionally con-
structed in dioramas. As previously seen, the prerogative of Victorian
dioramas excluded man from the unspoiled, deep nature depicted in
these scenes, but Dion subverts the rhetoric of the genre, inscribing

man's indelible impact on the environment by littering the scene with signs of the indiscriminate capitalist registers of production and consumption. Here, humans' absence suggests a lack of environmental commitment and care, rather than indebtedness to and admiration for nature. The dominion over unspoiled nature of classical dioramas is compromised—the panoptic frame is maintained, but the power relation is altered. Here there is nothing to tame, control, or aspire to. This type of scene troubles the viewer in the implication that our relationship with nature is problematic and that humans' actions toward the environment are often reckless and inconsiderate. In "Visualizing the Anthropocene," Nicholas Mirzoeff points out that "we now find ourselves confronting an autoimmune capitalism that seems determined to extract the last moment of circulation for itself, even at the expense of its host lifeworld."[1] No location effectively stands outside the anthropogenic dimension, and the landfill thus emerges as a politically charged site in contemporary representation. Utterly ignored by official culture and thus ostracized from philosophical discourses, the landfill was recently and controversially brought to cultural attention by Slavoj Žižek, who argued that "the properly aesthetic attitude of the radical ecologist is not that of admiring or longing for a pristine nature of virgin forests and clear sky, but rather of accepting waste as such, of discovering the aesthetic potential of waste, of decay, of the inertia of rotten material that serves no purpose."[2] The landfill thus becomes a site of anthropogenic truths, one that we should attempt to understand not solely on the grounds of shame and corruption but as a legitimate ecosystem produced by human/nonhuman economies. In opposition to the assertion of ecological ideologies that invite us to reconnect with a pristine nature in which humans essentially have no place, Žižek suggests that we should instead embrace our alienation from nature as a pathway to different ethical responsibilities toward waste.

In this sense, Dion's diorama vacillates between the paternalistic accusatory dimension of classical ecological strategies and the possibility of considering the landfill as an ecological biosystem of equal importance to those celebrated by natural history rhetoric. On the grounds of this ambiguity, *Landfill* simultaneously exposes the productive interconnectedness between human-generated pollution and animal life: the ability of some animals to adapt to the dire conditions humans create and to thrive

despite, or simply because of, humans' alteration of the environment. This is an example of the dark ecological loop characterizing the Anthropocene—a loop that constantly brings the human back into the image as a circular actant among others; a loop in which a human action is always confronted by another, usually unpredictable, nonhuman countermove. The image Dion creates makes us painfully aware that natural history has methodically constructed its conception of nature and the realism of ecosystems by selecting the ones that ventriloquize patriarchal ideologies of strength and purity. In this sense, *Landfill* also points a finger at the institution of the natural history museum and ecological marketing for not acknowledging the importance and realness of these ecosystems, thus contributing to the separation between nature and culture that so greatly affects the anthropocentric attitudes of today.

The undoing of the rhetorical structures that define actual material power in *Landfill*, as in an authentic natural history diorama, ultimately rests upon the inclusion of taxidermy animals. In classical dioramas, the undisputable material realism of hides and feathers predominantly served to anchor the veridicality of an impossibly harmonious scene. The premise of the natural history diorama lay in its ability to materialize scenes of uncontaminated nature that city dwellers might never encounter in their lives. Dion's *Landfill* appropriates this premise, paradoxically subverting the concept of purity with that of decay and thus proposing another scene that city dwellers usually do not (like to) see: the by-product fields at the periphery of their own cities. From childhood, we are culturally trained to care about our waste only until it reaches the trash can—the rest becomes invisible to us, enabling a dangerous game of delegation: Our responsibility toward waste might extend to sorting different materials for recycling, but we are thereafter visually and ethically disconnected from the impact of our personal waste on the planet.

Through these operations *Landfill* subverts the important notion of *decorum* on a number of levels. First, the setting does not comply with the prescriptions of classical art, nor with those of natural history dioramas, which are derived from classical art. In classical art, stagings were chosen very carefully—landscapes and cityscapes were traditionally constructed as elegant backdrops anchoring the stories of all-important humans who fought, won, and conquered. But there is no purification at play in Dion's diorama—if anything, the artist deliberately takes the opposite way, and

drags us down from the pedestal of classical rhetoric to the dystopian realism of the final stages of consumerist disavowal.

Second, *Landfill* bears at its core the lives of scavengers. Unheroic animals often considered pests, scavengers have been substantially undervalued in natural history as well as in art. The tradition of classical art has substantially capitalized on heraldic animals, those that lent themselves well to the ventriloquization of the values and attributes that humans aspire to possess. Rapacious birds of prey, regal African felines, dangerous wolves—these are the animals in which we have historically inscribed our narratives of power over others. In classical painting and sculpture, animals have predominantly functioned as symbols of human virtues or vices, but in either paradigm, the animals were represented with decorum—they were lifted from the raw realism of their everyday lives and were elevated to a rhetorical register of universal truth. Thus a taxidermy seagull would evoke poetic feelings of freedom echoing the novel *Jonathan Livingston Seagull* if situated in a diorama constructing a wild marine scene, whereas it immediately loses all its poetic charm if situated on top of a garbage pile.[3] Scavengers feed on remains. In our minds, at least, they are contented with what they find in their path. They don't have to develop refined hunting skills to survive, and ultimately tend to display opportunistic behavior. It is easy to see that within the rhetoric of natural history, these animals do not work well as vehicles through which human ambitions, values, and morals can be ventriloquized.[4]

THE EMERGENCE OF NEW REALISMS

The recent ontological turn in philosophy has placed particular emphasis on the reappraisal of images and their ability to index a "real" that exceeds the limitations of language. The relationship between images and language, central to the semiotics discourses of the last century, is in constant evolution, continually problematized by new modalities of image production and cycles of dissemination and consumption. Yet, there exists a fairly stable and durable link between realism and language in figurative representation that taxidermy, among other media, pushes to the fore of artistic discourses. The presence of taxidermy in contemporary

art points directly to this tie between language and realistic representation, thereby questioning the indexical nature of what is being seen as veritable truth. Truth essentially is correspondence in a triangulation between representation, thought, and the material world—in this relationship, representation functions as a constructed interface. Robin MacKay, Luke Pendrell, and James Trafford, authors of *Speculative Aesthetics*, have identified the emergence of this awareness as a condition in which "contemporary art vigilantly exposes its own compromises with the aesthetic, in an ongoing admission of failure and culpability."[5] As seen in the previous chapters, the works of Snæbjörnsdóttir/Wilson, Mark Fairnington, and Mark Dion leverage exactly this paradigm. In parallel with certain tendencies of speculative realism, their work directly aims to derail the power structure of language inscribed in the visual register by reconfiguring, overriding, reconnecting, and collating fragments of realistic constructions. In their work, at the bottom line, the naturalization of realism is revealed as our construction, not an immutable given. The aim is neither to produce an unmediated image nor to accomplish the elusive representational departure of Deleuze and Guattari's becoming animal, which ultimately abstracts animals. These artists are directly concerned with the materiality of living/dead animals. Their manipulation of materiality equates to the manipulation of language and knowledge. It enables the identification and therefore the alteration of power relations and dynamics. In their work, a precise dimension of ethicality emerges. These artists keep animals at the forefront of their research—they cannot afford to lose themselves in an aesthetic poetics in which the material presence of the animal dissolves into pure symbol. Their aim is to ontologically reposition our perceptions of our relationships with animals through new registers of realism. They critically assess the ways in which images work and have worked as mediators of the real and simultaneously contribute to the production of a new realism in our perceptions of animals and what we call nature. This new realism emerges from the deconstruction of traditional, anthropocentric iconographies, and it is one in which power is diffracted and networked. At this stage it is important to acknowledge that the aesthetic rhetoric of natural history firmly stands in the way of new and different conceptions of animality and nature, and that identifying, understanding, and subverting the power/knowledge relationships that crystallized this rhetoric is what contemporary art can most aptly accomplish.

Realism is a complex and elusive term, constantly shifting in different disciplines, time periods, and media. The conception of realism in Renaissance painting, for instance, is very different from that of photographic realism in the nineteenth century. And both conceptions are substantially different from the realism of film and digital photography of today. In all cases, the nature of realism is substantiated by the materiality of the medium that enables its emergence, and by the ideological structures that organize its signifiers. Realism thus becomes a circular interface through which the epistemic modality of a certain period can become manifest. It is a shared modality of interpreting and forming the world that underlines discourses and practices. Realism has the tendency to naturalize itself through repetition, empiricism, and synthesis, and thus it simultaneously constitutes a way to construct the world. In this way it produces a limited and ideologically encoded perceptual experience of it.[6] During the Renaissance, for instance, when optical realism remerged following the flattened and synesthetic visions of the Middle Ages, realism was the tool of God—a tool at the artist's disposal for the reproduction of God's perfect creations as they appear to us.

NEW VISUAL ENCOUNTERS

During the second half of the eighteenth century, especially in central Europe, the emergence of state-controlled institutions staffed by paid, full-time expert researchers added to the epistemic contributions of the amateur gentlemen and gentlewomen enthusiasts.[7] This phenomenon guided major reconfigurations in the economies of visibility of natural history and consequently in the power/knowledge relationships involved in taxidermy, realism, and museum displays. This reconfiguration is what Tony Bennett called the *exhibitionary complex*, a response to the problem of order that developed simultaneously with the reorganization of visibility and invisibility in the carceral system—another Foucauldian-informed connection between exhibiting spaces, surveillance, and discipline.[8] During the nineteenth century, the notions of spectacle and surveillance explored in the previous chapter were also further problematized by the fragmentation of optics that characterized the episteme of the

modern age. The new regimes of visibility that emerged at this time were in fact no longer the private domain of the aristocratic class or kingly prerogatives: the displays of the modern age played a key role in the education and civilization of the masses.[9] This shift in the production and consumption of knowledge was characterized by a widening divide between the amatorial and professional approaches to *seeing* and *saying* in natural history—a change that had substantial consequences in the history of natural history itself.

The 1793 opening of the Muséum National d'Histoire Naturelle in Paris played a pivotal role in the institutionalization and growing popularity of modern, western natural history.[10] As previously mentioned, right at the beginning of the modern age, in 1803–1804, the practice of stuffing animals was officially appropriated by natural history through the emergence of the statement *taxidermie*. Taxidermy then became a new and spectacular epistemic tool of visuality at a time when museums of natural history aimed to engage nonspecialist audiences. In that context, despite frequent assumptions to the contrary, it is worth remembering that the most prominent role of museums was to entertain audiences, and taxidermy surely provided the means to fascinate. However, this form of entertainment capitalized on the specific ontologization of the museum display: in opposition to other entertainment-oriented spatializations of the time, such as the circus or the fair, the natural history museum had to provide *truth*.[11]

As sites of visibility, the display structures and modalities of natural history museums incorporated the sedimentations of the panoptic relationships that defined natural history illustrations and cabinets of curiosities. On one level, the museum "disciplined" the bodies of objects through practices of spatial ordering, organizing displays and defining pathways and routes to best deliver moral and normative narrativizations. On another, it facilitated educational processes by metaphorically and physically placing visitors' bodies at the center of the exhibiting (panoptic) complex.[12]

Historically, if considered amid the events that characterized their emergence, the museum's ordered, self-contained, and rationalized visualizations counterweighted the ever relentless widening of an uncontainable world increasingly shaped by imperialist and industrializing forces. The new and exciting materialities of the natural objects on display

symbolically bridged distances between Europe and far continents that most visitors would never experience in person. The intense cultural impact of these new visual encounters on nineteenth-century city dwellers of Paris, London, and other cities across Europe and in the United States generated an unprecedented amatorial frenzy for practices like collecting, cataloging, beachcombing, studying geology, gazing at exotic animals, pinning butterflies, and growing ferns.[13] This new regime of visibility, vastly purported by the display of taxidermy and other natural objects, simultaneously played a preponderant role in the configuration of the new optics of the modern age in transdiscursive ways. Barbara T. Gates argues that this new opticality transcended natural history, influencing art practices:

> A reliance on observation rather than on theory was in fact one of the things that set natural history apart from much of the science practiced in universities. The aesthetic of particularity that we have become accustomed to examining in the work of John Ruskin, the Pre-Raphaelites, and Gerard Manley Hopkins was trained through the Victorian fascination with scrutinizing nature. It was a legacy from romanticism funneled through the lens of Victorian natural historians, who looked with the naked eye, the hand lens, the microscope, and the telescope until they had their fill.[14]

As will be seen later in this chapter, this transdiscursive intermingling between natural history and art will play a pivotal role in the recovery of the discourses, practices, and power/knowledge relations at play in the rise of taxidermy during the modern age.

DIORAMAS AND THE CONSTRUCTION OF NATURE

The new epistemic modality that prescribed the faithful simulation of the natural realm provided the context in which dioramas became the quintessential tool for constructing concepts of nature. In the United States and northern Europe, dioramas emerged during a period of intense social and technological change. In 1875, Gustaf Kolthoff, a Swedish hunter-

naturalist, pioneered taxidermy dioramas. His setups did not include painted backgrounds, but they situated the mounted animal skins among recreations of the local vegetation.[15] Subsequently, Carl Akeley included painted backgrounds in his white-tailed deer tableaux in Chicago's Field Museum. Olof Gylling, a scientist trained in taxidermy and a landscape painter, in 1902 added the painted backdrop to his scenes and also introduced the term *diorama* in this context. The same year, across the ocean, Frank Chapman's diorama including a painted background was unveiled at the American Museum of Natural History in New York (fig. 3.2). Chapman was the curator of ornithology at the museum, and he nurtured a fervent conservationist ideology that brought him to closely consider the emotive effect of painted scenes in sensitizing public opinion. This was the professed motivation behind the desire to construct dioramic scenes: environmental conservation campaigns required awe-inspiring visuals to promote legislative changes and mobilize public opinion: How could city dwellers care for and support the conservation of nature they could never see? In some cases, this strategy worked. The institution of the first federal bird reserve was largely motivated by Chapman's diorama of Pelican Island, which persuaded president Theodore Roosevelt to declare it protected land. Chapman understood dioramas' engaging potential as

FIGURE 3.2 Frank Chapman, *The Wading Birds Diorama*, 1903. Image courtesy of the American Museum of Natural History, New York.

deriving from different traditions of representation and display. These windows into nature included elements appropriated from the performing arts, such as their three-dimensionality, the enclosed proscenium, the use of lighting, and their theatrical staging. The sublime drama staged by dioramas engaged viewers through the operation of an astute aesthetic maneuver that concealed the deaths of the specimens for the purpose of preserving the lives of their referents in the wild. But besides the accuracy of representation and the consistency of naturalism in color, it was the *stasis* characterizing the displays that enthralled viewers. This stasis bears substantial aesthetic assonances with classical painting, classical sculpture, and perhaps surprisingly with a form of three-dimensional religious modeling originally from Italy: the *presepe* (Nativity crèche).

Presepi are complex and very detailed scale models involving miniature architectural scenes, artificial plants, painted backdrops, and statuettes reconstructing the Nativity scene (fig. 3.3). They became popular in Neapolitan churches during the thirteenth and fourteenth centuries, and by the eighteenth century they had become increasingly dramatic and theatrical.[16] The subsequent tradition of the tableau vivant, with its stati-

FIGURE 3.3 Detail from a Neapolitan *presepe*, on display in Rome, 2006. Photograph courtesy of Howard Hudson, CC BY 2.5.

cally posed actors, brought the three-dimensional illusionism of the *pre-sepe* to life scale, reaching unprecedented popularity during the Victorian era.[17] This interest in artifice and modeling was further supported by new technologies of visual production and consumption, including magic lantern shows, optical toys, and the emergence of kinetic images.

In 1822, outside the context of natural history, Louis Daguerre introduced the diorama as a form of entertainment to the Parisian public.[18] Daguerre was a painter and physicist whose flair for innovation eventually led him to invent the daguerreotype, the astonishingly detailed photographic process that captivated audiences between 1839 and 1855. And it is precisely in this desire to capture reality without an artist's mediation that the previous histories of three-dimensional mimesis converged in Daguerre's *Diorama*, which in a theater setting exposed viewers to a stage displaying large translucent canvases measuring twenty-two by fourteen meters (fig. 3.4). Colored lights visually alluded to atmospheric effects, suggesting movement and the passing of time.[19] Yet one of the most important innovations in Daguerre's dioramas was the inclusion of occasional trees, stones, and in one instance a live goat.[20] This tension

FIGURE 3.4 Illustration of Louis Daguerre's and Charles Marie Bouton's *Diorama*, 1822. Image in public domain.

between the mediation imposed by the traditional means of representation, such as sculpture and painting, and the desire to recreate nature in the most faithful possible way deeply characterized the Victorian interest in visual consumption. The inclusion of what today would be referred to as "found objects" caused controversy. Critics accused Daguerre of using aids that were illegitimate for a painter; the artist responded that his "only aim was to produce the most complete illusion."[21] Daguerre's justification for combining art and nature, the tension between which had substantially defined the cabinets of curiosities, eventually became the accepted norm in natural history dioramas. But nonetheless, it precluded this genre from ever being accepted as a legitimate art form in its own right, despite the undisputed level of artistic skill necessary to bring to life elusive visions of wildlife.

PHOTOGRAPHY: ETHICAL-EPISTEMIC MECHANICAL OBJECTIVITY

Nicéphore Niépce successfully developed the first photograph, titled *View from the Window at Le Gras*, in 1826. The small, grainy image was a far cry from the sharper daguerreotypes that began to circulate ten years later. With the rise of its reproductive accuracy, the new medium was rapidly assimilated by scientific disciplines of the early modern age as the epistemological tool of preference.[22] Simultaneously, photography captivated a growing section of the public, for whom the value of mechanized achievements embodied the essence of progress and truth.[23] Momentum enabled photography to cause a deep rupture within the histories of visual representation that had previously entrusted painting and illustration with the task of preserving nature. Although many critics of the time, like Baudelaire, loathed photography, Foucault's retrospective consideration understood the popularity gained by the medium in the nineteenth century as a liberation of the image, distinguished by "a new freedom of transposition, displacement and transformation."[24] In other words, photography rescued the image from the exclusivist economies of social power and wealth that characterized painting, thus constructing

new modes of visual consumption based on the widespread circulation of relatively affordable reproductions.

This certainly is one of the ways in which photography constructed a new realism that transcended the realism of classical sculpture and painting. Photography's ability to freeze time and immobilize the transience of beauty while bypassing the mediation of the artist was bewildering—the photographic lens seemingly appropriated sections of the world, complete with the irrelevant minutiae that the strict aesthetic rules of classical painting loathed.[25]

As photographic images began to rival illustrations, the disciplinary demand for ethical-epistemic mechanical objectivity in scientific enquiry also grew.[26] Mechanical objectivity expressly connoted photography's ability to minimize the intervention and interpretation of the artist-author, promising to faithfully process nature—to extrapolate natural objects from the materiality of the world and to immortalize them on a sheet of paper in every minute detail. The belief that photography could transparently capture the natural world from an extensively objective standpoint became solidly rooted in the epistemic discourses of the early modern age.[27] Thus, the photographic image quickly imposed itself as a naturalized, truthful, and mechanized model of human perception; it established iconographical standardizations through which new animal visibilities could be constructed. The mechanical eye, it was believed, saw more and far better than the human one, thus seeming to fulfill the desire for empiric objectivity that so prominently shaped scientific discourses and practices of illustration through the classical age. In this way, photography provided science with an epistemological tool that produced flattened and manageable copies of animal bodies. And in so doing, it surpassed natural history illustration in material clarity, accuracy, and alleged evidential veridicality. Like natural history illustration before it, photography furthered the practice of transcribing animals into discourses through a new and sophisticated limiting and filtering process capitalizing on a seemingly accurate retinal reproduction of surfaces.

The relationship between seeing and saying was therefore once again reconfigured, not solely by disciplinary discourses but by the complicity of discourses and the material specificities of the new epistemic spatializations and practices through which knowledge had come to be produced

and dispersed. The presumed veridicality of the photographic image, which in semiotic terms is called *indexicality*, constituted only one of the many incarnations of the desire to possess natural objects—dioramas were the other. Photography's effect on the emergence of natural history dioramas was indeed defining. A literalist approach to recreating a fragment of wilderness led to a pre-Raphaelite obsessiveness devoted to the painstaking production of the exact spot and surroundings in which the animals were found and killed.[28] However, this approach was short-lived, and as Haraway's analysis of Carl Akeley's taxidermy aptly demonstrates, the ethical objectivity of photography was quickly replaced by the construction of a "morality play on the stage of nature."[29]

SHOOTING ANIMALS: TAXIDERMY, DIORAMAS, AND PHOTOGRAPHY

By the 1860s, through the dissemination of prints and publications, the newly institutionalized optic of natural history entered a normative phase—it set a new register of realism. By the end of the nineteenth century, mechanical objectivity became the standard of scientific representation—the evidential, rigorist, epistemic value of photography constructed *truth in science*. This notion was so widespread that wildlife photographer Osa Johnson claimed in his 1923 prospectus to the American Museum that "the camera cannot be deceived . . . [and therefore it has] enormous scientific value."[30] However, despite photography's ability to produce mimetic material exactitude, its adoption as an aid in the making of taxidermy was very controversial.[31]

In reference to mounting animal skins, Montagu Browne, curator of the Leicester Corporation Museum and Art Gallery, claimed that an amateurish approach to photography could constitute "a great mistake, especially if the ubiquitous 'Kodaker' is not an artist."[32] Browne warned of the startled and frightened look animals may reveal if the photographer is "anxious to take a 'snap shot.'"[33] The use of the term *snapshot* is of particular interest here because it reveals a key contradiction within Browne's own argument. His fear that photography may produce the image of an awkward animal betrays the essential selectivity implied by the so-called

lifelike value that scientific taxidermy was expected to embody. And here lies the main reason why taxidermy, despite having conquered realism of the most sophisticated kind, could not become a legitimate art form: it was denied legitimacy because of its indexicality, a malaise in the eyes of classical art, which it shared with photography—a form of representation that was also excluded from the canon at the time.

Within the limitations imposed by the photographic lexis and its intrinsic indexical quality, the snapshot constitutes a specific photographic genre, one that compositionally relies on the spontaneity of "apparent chance" and that contextually puts forward candid claims of veridicality. Christian Metz described the snapshot as a peculiar photographical occurrence in which "the instantaneous abduction of the object out of the world into another world, into another kind of time" takes place.[34] By essence, the snapshot catches its subject by surprise—in the context of taxidermy, and in the encounter with wild animals, the snapshot may indeed capture animals in "unflattering poses" as they are startled or attempt to flee. In so doing, the snapshot image would reveal the implicit presence of the human within the scene, even perhaps revealing the horror that preceded the killing. But taxidermy, in its resurrective approach to animal bodies, has always been concerned with undoing death, suturing wounds, and wiping blood. The intricacies proposed by the overlapping of the technologies of the camera and those of the gun were originally explored by Susan Sontag in *On Photography*.[35] Here, in the context of taxidermy, they bear a new and striking level of complexity—one that Donna Haraway has fully explored in "Teddy Bear Patriarchy: Taxidermy in the Garden of Eden, New York City, 1908–1936." Her analysis, as will be later seen, aptly mapped the ideological undercurrents of patriarchal, national identity, gender, and racial values that taxidermy began to embody.[36]

What is the elusive lifelike quality of taxidermy—that quintessential value so essential to the most convincing and awe-inspiring dioramas? The lifelike virtue that taxidermy came to embody at the turn of the century entailed much more than capturing a truth of animal livingness, and it meant more than simply capturing a photographic image of an animal. Browne may not have been aware that his objection to the use of photography ideologically stood on more complex grounds than the aesthetic ones he vocalized. As Haraway argued, taxidermy animals in dioramas were presented as inhabitants of an unspoiled Garden of Eden from which

western man had been expelled.[37] Man's "having been there" must be concealed and cannot be mirrored in the startled animal's awareness of him. Carl Akeley, the most notorious taxidermist in the history of the medium, used photography in order to assemble his magnificent scenes (fig. 3.5). He

FIGURE 3.5 Carl Akeley's great apes in the Mikeno-Karisimbi forest in the diorama of the African Hall of Mammals, under construction, c. 1936. Image in public domain courtesy of the *New York Times*.

cunningly said that dioramas should offer a "peep-hole in the jungle," aptly reassessing the spatial conceptions of division, exclusion, and surveillance at play in natural history tableaux.[38] The outstanding realist quality of Akeley's mounts was primarily attributed to his skills as an academically trained sculptor and painter. He became, in 1890, the first to complete a habitat diorama in the United States, and claims that Akeley had successfully elevated taxidermy to high art status were published in 1927 by *Scientific Monthly*, among others.[39]

In opposition to Browne, ethnographer Robert Wilson Shufeldt was in favor of the use of photography for the crafting of taxidermy and dioramas. In "Scientific Taxidermy for Museums," he praised the optical tool as an extension of the unaided eye, "for the camera can secure subjects that . . . the pencil can never give," he wrote.[40] However, as seen, to Browne the problem clearly was an ontological one: he believed that taxidermy should be considered high art and that the adoption of photographic tools constituted falseness in the theory and practice of taxidermy itself.[41] The contradiction underlying Browne's argument thus becomes overt: although arguing in favor of a more lifelike taxidermy, he effectively advocated an emphasis on deliberate representational construction, as opposed to the ethical-epistemic mechanical objectivity expected of photography. Browne's claims bring representational issues related to the notion of realism to the fore.

Haraway's main argument in "Teddy Bear Patriarchy" substantially revolved around realism and its intricate role in the representation of nature. Although her positioning of taxidermy as suspended between photography and sculpture is reasonably evident, Haraway did not consider the productive potential of an analysis of the artistic discourses underlying the emergence of taxidermy itself.[42] Thus she claimed that "realistic art at its most deeply magical issues in revelation."[43] But Haraway's conception of realism appears to be predominantly informed by anthropological and scientific paradigms and is only loosely linked to artistic discourses: in her conceit realism figures as intertwined with biological sciences, organicism, and eugenics,[44] whereas in its more explicit representational value, realism connotes "an aesthetics proper to an anxiety about decadence."[45] Although Haraway is indeed right, her conception of realism overlooks one of the most important and culturally defining forms of realistic representation: that of classical art.

It is worth remembering that throughout its early stages, photography shaped its representational lexicon and syntax through a series of more

or less accomplished appropriations from the canon of classical paint-ing.[46] Photography's ability to allow nature to be copied with effortless accuracy became indissolubly bound, in its aesthetic representational strategies, to the art historical conception of realism. At the ideological core of taxidermy, as an essential part of the dioramic experience, thus lay an aesthetic modality shared by the media of sculpture, painting, and, lastly, photography: *stasis.* Along with the mimetic verisimilitude upon which realism relies, stasis constitutes the essential gateway to transcendental-ism; it is the quality that indissolubly interlinks taxidermy to classical representation. In classical art, sculptural stillness constitutes the repre-sentational element signifying a moral dimension imbued with a medita-tive sense, suggesting the solemnity of an event and the ethical elevation of a subject matter.[47]

In an essay titled "Acts of Stillness: Statues, Performativity, and Passive Resistance," art historian David Getsy upheld a statue's refusal to move, its resilient immobility, as a performative act that affects the viewer.[48] Through stasis, "the physical copresence of the statue initiates a cascade of effects on the viewer in which she or he attempts to manage the incur-sion into their space by a material object that is equivalent to the image that it depicts three-dimensionally."[49] This "still" confrontation, accord-ing to Getsy, takes the form of a desire to control, manifesting itself "in fantasies of rape, in violence, in paternalism, in destruction, in mocking indifference, and in violation."[50] Similarly, stillness metaphorically objec-tifies the animal body beyond the convenience of scientific observation. It engages the viewer in a complex negotiation between a moving body, one that now functions as a vehicle through which power relationships can be performed and inscribed.

As seen, realism lacks a straightforward and unanimously agreed-upon signification in the study of the visual arts.[51] Essentially intrinsic to the illusive essence of mimesis within visual representation, realism can be understood in classical terms as relentlessly engaging in the produc-tion of a beauty immortal in its perfection, one proposing a transcenden-tal experience.[52] This configuration suggests that the lifelike virtue of scientific taxidermy, in its constrictive, corrective, and perfecting ap-proaches, should be conceptualized more carefully than has previously been done.

LIFELIKE OR DECORUM?

We have thus far assessed that realism played a key role in the epistemological work of taxidermy, especially in dioramas. But more than realism was at play in the most successful taxidermy of the modern age. The emergence of realism in the practice of taxidermy was a phenomenon largely driven by the discourses of natural history and its need for realistic copies of animal bodies to be available for research and display in museums. As seen earlier in this chapter, Browne asserted that for the new school of taxidermy to emerge, the education of the taxidermist had to include excellent knowledge of comparative anatomy, drawing, and modeling. He thus drew a substantial parallel between artistic training and taxidermy mounting, asking: "Would any person expect to arrive at eminence as a sculptor if he were unacquainted with the established preliminaries of his art, namely, drawing and anatomy? The thing is so self-evident that I am only surprised it has not long ago been acted upon."[53]

Studying anatomy for the purpose of realistically portraying human and animal bodies is associated with the realism of classical art. During the Greek classical period (fifth to fourth century BCE), in which dissection was not commonly practiced, anatomical knowledge was obtained from the observation of body surfaces. During the Renaissance and the classical age, artists developed their knowledge of anatomy by dissecting human and animal bodies alike. However, as noted by art historian L. J. Freeman, artists do not "gain by this exact method [a] greater appearance of reality, and the eye is tired by the details thrust upon it, details which it would never see for itself, but which the sculptor represents because he knows from his anatomy that they are there."[54]

It is well known, through Condivi, that Michelangelo Buonarroti persevered with the dissection of human bodies until a late age, despite the fact that it made him ill.[55] However, this dedication to the practice of dissection did not necessarily translate into careful reproduction of human anatomy. In fact, Michelangelo's sculptural work and his frescoes in the Sistine Chapel present substantial distortion of human form, posing questions about the direct links between anatomical studies and realism in art. Likewise, Leonardo da Vinci carried out numerous dissections of human bodies, especially around 1508; however, most of the figures he painted were heavily clothed, with only hands and faces showing.[56]

Although Leonardo dissected and recorded what he learned in his private notebooks, when it came to painting, the lifelike quality his figures embodied was also the result of a careful study of surfaces.[57] Browne claimed that knowledge of animal skeletons may not be relevant, but that knowledge of the muscular structure is.

> Twenty years have now rolled away since I first began to examine the specimens of zoology in our museums. As the system of preparation is founded in error, nothing but deformity, distortion, and disproportion, will be the result of the best intentions and utmost exertions of the workman. Canova's education, taste, and genius enabled him to present to the world statues so correct and beautiful that they are worthy of universal admiration.[58]

Browne was correct in using Canova as an example to support his argument as the artist keenly studied anatomy and also dissected human bodies.[59] However, Browne made the mistake of conceiving realism as a transparent, mimetic representational device based on optical registers alone. Browne failed to acknowledge that Canova was in his time the most prominent exponent of the neoclassical style, which in Europe characterized the period between the mid-eighteenth century and the end of the nineteenth century. As Johann Joachim Winckelmann tellingly wrote in 1755, "the only way for us to become great or, if this is possible, inimitable, is to imitate the ancients."[60] This return to classical art was not a simple revival of aesthetic norms, but it more specifically entailed the reemergence of discourses and practices of classical culture. The rhetorical realism of classical art embodied an ethical-epistemological condition that stood in stark opposition to the ethical-epistemic mechanical objectivity of science, for the artist here had to comply with a deliberately restricted optic filtered by moral and ethical precepts.[61]

Winckelmann argued that "the general and most distinctive characteristics of the Greek masterpieces are, finally, a noble simplicity and quiet grandeur, both in posture and expression."[62] However, to understand these aesthetic qualities as natural would require a gross miscalculation of the power of realistic representation to effortlessly convey meaning, values, and ideals through a ventriloquization of human and animal bodies alike. Unknowingly, Browne's realistic conception of lifelike taxidermy implicitly advocated the implementation of the strict selectivity and highly

manipulative operations proposed by neoclassical art, such as modera-
tion, restraint, harmony, and balance between parts.[63] Unlike Browne,
Winckelmann was aware of the power that realism carried in classical
art, about which he stated that "the expression of such nobility of soul
goes far beyond the depiction of beautiful nature."[64]

Here thus lies the main problem with the emergence of lifelike taxi-
dermy during the Victorian period. Taxidermists may have indeed be-
lieved that aspiring to the aesthetic standards of classical art would result
in accomplishing genuinely naturalistic renditions of live animals. How-
ever, in pursuing these aesthetics, they also blindly embraced the ideologi-
cal values inscribed in classicism. It is thus important to acknowledge that,
informed by ideological discourses of virtue and moral value, neoclassical
art deliberately aimed at ennobling nature in accordance with historical
and iconographic truth, or as it is otherwise known, decorum.[65]

It is important to clarify that, as Winckelmann acknowledged, the
Greeks, in their favoring of nobility, operated a consistently reductivist
approach to anatomy, deliberately simplifying, generalizing, and omitting
for the very reasons argued by Freeman. Archaeologist and art historian
Guy Metraux drew attention to these processes through a categorization
of the three main typologies of manipulation operated by classical art:
"distortion of proportion," "reconfiguration or invention of skeletal and
muscular structures," and "contortion of the body" (fig. 3.6).[66] Metraux
argued that in classical art "sculptors were not engaged in descriptive
anatomy. They were involved in manipulating the body for effectiveness
and clarity."[67] The clarity he referred to constitutes the intrinsic beauty
that Aristotle understood to be embedded in the world as a sign of its ra-
tionally balanced modality.[68] Imperfections and idiosyncratic subjec-
tivities were expelled from Aristotelian conceptions, equating truth to
beauty in the acknowledgment that true knowledge-forming can only be
traced in idealized realism.[69]

Browne's position on lifelike taxidermy thus poses important questions
about the real meaning of the term *lifelike realism* itself. His persistence
in comparing taxidermy to classical sculpture suggests that the notion
of classical decorum, an integral essence of classical realism, may have
also played an important role. To the Greeks, the aesthetic notion of *de-
corum* signified that which "is proper, fitting, and just."[70] It incorporated,
as it still does today, an ideal of beauty that substantially differed from
symmetria, the beauty intrinsic to nature, and that exclusively found its

FIGURE 3.6 Antonio Canova, *Theseus and the Centaur*, 1804–1819. Marble. Kunsthistorisches Museum, Vienna. CC BY-SA 3.0.

application in the human form, or in artifacts. Decorum was the ennobling factor in realistic, classical representation—it was the most insidious facet of realism, the element that could subliminally shape our conceptions of race, class, gender, and sexuality without us realizing it. In classical art as well as in culture, decorum was a normative agent, governing the appropriateness of the occasion, and capable of distancing societal groups by assigning gender-specific roles to those from certain social classes and races. It was capable of crystallizing acceptable behaviors by inscribing ethical and moral standards based on a discerning of otherness in which the other was always inferior and undesirable. Thus decorum would support social segregation by reverberating the moral and ethical standards set by aristocratic, white males—it produced models to follow and aspire to, which substantially shaped ideals of white supremacy linked to social Darwinist notions of civilization. For instance, the respectability of black individuals in the Victorian period was regularly evaluated through the analysis of their acquired gentility, their ability to emulate the decorum

displayed by white, civilized individuals.[71] Likewise, decorum defined the essential traits involved in being a lady: the appropriateness of looking and being seen, in knowing what to wear and how to wear it, in understanding what to say and when not to speak. But most importantly, decorum operated on the level of the surface. It defined textures and materialities governing the inscriptions of status in objects and bodies alike—it directed the gaze toward or away from objects, and it regularly hindered or annihilated emotional responses. Taxidermy, with its reliance on surfaces and intrinsic passification, perfectly lent itself to ventriloquization of decorum.

As a concept pivotal to poetics and oratory, decorum exclusively ruled the actions of humans, not those of animals.[72] Yet, the taxidermy animals exhibited in natural history dioramas embodied decorum by suggesting the appropriate positioning in the depiction of social interactions; by always looking healthy, groomed, and powerful; and by displaying a sense of composure and elegance even in the charged moments of the

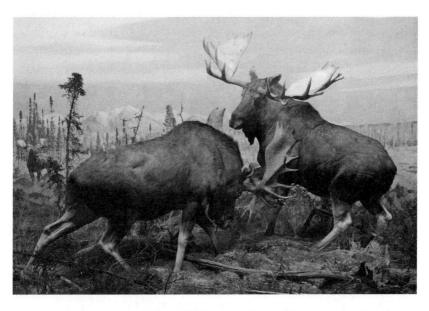

FIGURE 3.7 Alaskan moose diorama in the Bernard Family Hall of North American Mammals at the Natural History Museum, New York. Photograph courtesy of Mike Peel, CC BY-SA 4.0.

hunt (fig. 3.7). Decorum constituted a pervasive and yet extremely subtle anthropomorphization that reassessed for the viewer the naturalized and thus unquestionable nature of human demeanor.

To impose decorum on the representation of animal bodies clearly indexes (on a discursive level) what Haraway argued: that dioramas, in the early modern age, functioned as a "morality play on the stage of nature."[73] The aesthetic fixity of dioramas, along with their incarnations of deep, unspoiled nature, constructed a permanence upon which ideals of racial purity (eugenics) could be inscribed. Simultaneously, the conservationist ideals, which on the surface motivated the construction of dioramas, emerged as the ultimate attempt to preserve a threatened manhood through the salvaging of the materials required for that very moral formation to be constructed.

It is in this sense that natural history dioramas came to constitute a substantial assertion of ideological values of a patriarchal kind. They appropriated animal bodies for the purpose of narrating human stories. But that this would happen, considering the discourses and practices at the crux of which taxidermy dioramas emerged, was perhaps inevitable. As Hegel stated, "art digs an abyss between the appearance and illusion of this bad and perishable world, on the one hand, and the true content of events on the other, to re-clothe these events and phenomena with a higher mind born of the mind. . . . Far from being simple appearances and illustrations of ordinary reality, the manifestations of art possess a higher reality and a truer existence."[74]

In this sense Haraway is also right that "realism is an aesthetics proper to anxiety about decadence"—an aesthetics that natural history discursively appropriated from art historical discourses and practices. It is also in this context that Haraway assigned to the modern museum of natural history the role of medical technology and hygienic intervention against the decadence of modern man.[75] The space of confinement proposed by the museum was therefore a moralizing one—one through which the consumption of patriarchal narratives portrayed in diorama displays provided "purification" from the corruption of industrialization and civilization. Simultaneously, in the museum of natural history, the taxidermy animal was purified of its violent animality, that *unreasoning* that in Foucault parallels the animal and the mad.[76] The neutralized form of objectivity produced by the sovereign gaze of the naturalist had the main purpose of

clarifying the animal on grounds of a prescribed and formulated discursive truth, thus fulfilling a precise and essential sociocultural role.

CLASSICAL ART: INSTITUTION AND IMPERIALISM

The predominance of vision in the epistemologies of the eighteenth and nineteenth centuries simultaneously produced two different but related exhibiting institutions: the natural history museum and the art salon. Both institutions engaged in simulacral practices, but they differed substantially in the essence of the truths they claimed. Ultimately, they overlapped in the intensity of a desire to own the real that was regularly fulfilled in the fabrication of the fake. In Umberto Eco's view, the diorama had a superior layer of effectiveness in comparison to painting—the diorama was more vivid and somewhat more apt at replacing reality altogether.[77] The preponderant quality that placed the diorama in an advantaged position in the politics of hyperreality, according to Eco, is three-dimensionality—the statuary, in general, has the edge.

Since 1735, the institution of the Salon at the Louvre in Paris became pivotal in the operation of a new system of power relations between audiences, art critics, art historians, the ruling classes, and artists.[78] Practices such as collecting, previously associated only with the courtly elite, began at this time to surface in the newly configured power relations at play in the functioning of the academy. Looking at the dioramas in natural history museums and looking at art became central to the education and moralization of audiences through the regular repetition of the iconographical statements of classical art, the didactic language of choice of the late classical and early modern age. The composure, clarity, stasis, and rationalized attributes typical of Enlightenment utopianism embodied in neoclassical art therefore functioned as a tool for the education and control of the masses.[79]

By the mid-nineteenth century, technological advancements enabled the inexpensive reproduction of classical sculptures, enhancing the visibility and popularity of the artistic style as well as perpetuating a florid commerce in England.[80] Most producers and merchants of these objects were initially based in Italy and France, where the sculptural production focused

on classical art exclusively. It is therefore this contingency, among others, that granted classical art a lease of extended supremacy in the sculptural field of production of western Europe during the nineteenth century. Most importantly, this commerce was largely substantiated by the demand of academies, through which the classical standard was repeated, imbued with neoclassical ideological values, and thereafter reproduced and dispersed, enacting a cycle of self-perpetuation of the style in sculpture.

Classical art was considered by traditionalists as one of the last bastions of "good taste"—that taste linked to antiquity through a dependence on the study of the past. Meanwhile, the artistic discourses of the modern age were fragmenting underneath the glossy surface of institutions. The idealized marble figures of Canova that Browne so much admired had already been challenged by the new romantic and the political mimesis of realist aesthetic alternatives.[81] These cultural responses were the result of the sociocultural turmoil that stirred the political events of the late eighteenth century, culminating in the French Revolution and the destruction fostered by the Napoleonic campaigns.[82] New cultural tendencies opposed the systematization of training in the academies of beaux arts. But at the same time the emergence of the art dealer, a pivotal figure in the construction of the modern artist, and an ever-expanding network of exhibiting spaces established the supremacy of neoclassical art in the institutional commercial field. As sculptural practices continued to stylistically fragment during the latter part of the nineteenth century, throughout Europe three-dimensional representation also began to emerge in the scientific discourse as a didactic tool, especially for the representation of the imperialistic construction of the other in the popular setting of the Great Exhibitions.[83]

Themes of visuality and the inherent power/knowledge relations that configured the visualities of subjugation typical of imperialism began to surface more clearly in the spatializations outlined by the world expositions. The Crystal Palace erected in London's Hyde Park for the Great Exhibition of 1851 was a monument to consumption, a place that synthesized and summarized new and old dynamics of consumerist and ideological politics.[84] Christopher Frost, one of the most prominent modern historians of taxidermy, argued that the exhibition at Crystal Palace "marked an era in English taxidermy."[85] According to Pat Morris, the pieces exhibited in 1851 were "much admired—a spectacularly dramatic tableau of a red deer being brought down by hounds, especially captured

audiences' imagination."[86] Subsequent exhibitions that took place in 1871, 1886, and 1887 also contributed to the strong interest in taxidermy among Victorian audiences.[87] The 1886 exhibition was particularly responsible for the coming into fashion of large, exotic taxidermy trophies from the Cooch Behar district in East India, while the mounted heads of buffalo, antelope, elk, and caribou from Canada also enthralled audiences.[88] Notably, the American Trophy Exhibition, which took place in 1887 in London, displayed more than two hundred trophies of large mammals and provided the format for a number of similar exhibitions that followed in Europe between the end of the nineteenth century and the first thirty years of the twentieth century. At this point in history, taxidermy came more and more to be defined by imperialist discourses and hunting practices that substantially led to the irreparable unbalancing of ecosystems on a global scale.

OLEG KULIK: THE MUSEUM OF NATURE, OR THE NEW PARADISE

Much of the recent critical revisionism on the subject of taxidermy and dioramas has been played out in photographic terms. In the next chapter I will explore more in depth why this is the case, but for the time being it should suffice to say that the photographic idiom has played an essential critical role in relation to issues of realism, truth, and constructedness. Dioramas simultaneously are three-dimensional structures and two-dimensional images. They unstably situate themselves at the crux of the sculptural, the painterly, and, because of their intrinsic indexicality, the photographic. Thus dioramas provide ample opportunities to engage with a criticality that not only addresses the representational tropes presented by the image but also reaches deeper into important issues of an idiomatic and epistemological nature.

Among the many contemporary artists who have engaged in photographing natural history dioramas for the purpose of addressing or deconstructing specific aspects of the rhetoric underlying them, Iroshi Sugimoto has been "reanimating the animals" through an ambiguous play of idiomatic specificities. In the series *Dioramas* (1974–1994), the tension

between the "real" and the "fake" is exacerbated by the photographer's disentangling of the image from any museological context. The black and white of his images augments a sense of naturalness in the scene that is nonetheless far from any realistic representation of nature, while the balanced composition of the diorama still reveals the work of decorum. Karen Knorr has photographically deterritorialized taxidermy animals, taking them from their diorama stages to the interiors of different buildings around the world. She engages animal forms in aesthetically intriguing dialectic relationships with architecture, an operation that short-circuits the nature/culture dichotomy through the problematizing approach of digital photography, in which conceptions of reality are relentlessly revisioned. Meanwhile, Diane Fox has focused her attention on the glass that separates the scenery from the viewer in order to derail the metanarratives of purification and redemption that dioramas embody (fig. 3.8). The reflections that Fox captures produce paradoxical "double exposure effects"—awkward representational moments that fragment both the realistic unity of the picture's plane and its allusive powers.[89]

FIGURE 3.8 Diane Fox, *Deer*, 2008. The Slovak National Museum, Bratislava, Slovakia. © Diane Fox.

At roughly the same time that Diane Fox began to focus on reflections upon the glass of dioramas, Oleg Kulik, perhaps the most controversial Russian artist of all time, embarked on a project in which the reflection on glass is not accidental or serendipitous, as it is in Fox's work, but carefully staged. In the many images from the series *The Museum of Nature, or the New Paradise* (2000–2001), the overall effect is that of an uncanny double exposure. Instead of making the glass overt, Kulik deliberately uses it as a supplementary screen. The overall effect is similar to that of nineteenth-century magic lantern shows, in which transparencies and overlaps constituted visual narrative strategies.

All images in the series propose the view of a classic natural history diorama, upon which a translucent image of a naked man and woman appears superimposed. Kulik, who is featured in every image, crafted the photographs using a polarizing lens, which controls the intensity and clarity of reflections upon the glass surface. The glass separating humans from the Garden of Eden constructed by natural history dioramas thus disappears, producing the effect of a "pre–original sin" apparition—supposedly a distant memory or a retinal trace of it. Biblical narratives are hard to ignore when a naked man and naked woman appear immersed in a lush natural setting. Yet, Kulik's scenes are far from complying with the iconographical decorum of the classical representations of Adam and Eve. In some images, the couple simply hold hands, staring at the overwhelming beauty of creation of which they implicitly are the only beneficiaries (fig. 3.9). But in the vast majority of the shots the couple is engaged in sexually explicit contact. And more often than not, human and animal bodies are deliberately made to overlap in allusive or ambiguous continuities, challenging the viewer's expectations while slowly unraveling through the instigation of an undeniably voyeuristic appeal. Leveraging upon the aesthetics of kitsch that have characterized much of postmodernist sensibilities, but pushing the envelope further than most artists would ever dare, Kulik collapses religious and pornographic imagery in the production of an aesthetic that critically questions the value of realism in representation (plate 5).

Nature is evidenced as an impossible construct, a rhetorical place in which the animality of the human can be recovered only through a sexual engagement that alludes to prelinguistic primordiality: the broken link between humans and animals, from which the glass separates us and

FIGURE 3.9 Oleg Kulik, *Giraffe*, from the Museum of Nature or New Paradise series, 2000–2001. © Oleg Kulik.

in which we see ourselves reflected. As in Mark Dion's *Landfill*, decorum is here the key element upholding the illusion tied to the rhetorical structure that supports it. Decorum defines the appropriate modalities of inclusion and exclusion of the human with the constructed separateness of the natural. It is in this sense that Kulik's abrasive realism subverts the discourses of social conduct and self-censorship: the dichotomy of humanity and animality plays a key role here. The images problematize the iconography of classical art, with its tendency to regularly exhibit human flesh for the purpose of arousing the viewer but simultaneously drawing a line at the graphic representation of the sexual act.

It is no coincidence that in natural history dioramas, animals are never shown having sex, urinating, or defecating. These activities, all of which could be described as "naturally" occurring in all beings, have been purged from the representational archive of natural history because they do not comply with decorum. It is in this sense that I favor a reading of Kulik's dioramas as inscribing a wholly anthropogenic crisis—the struggle to embrace the challenge of overcoming the separation between human and nonhuman that was culturally orchestrated by the expulsion

from the Garden of Eden. Kulik might not directly propose practical answers to how a different "becoming worldly" might emerge from this realization, but his images gesture insistently enough to a number of pressing questions.

What is realism in Kulik's dioramas? Within the mythical, atemporal dimension constructed by the constructed deep nature visible in the dioramas and the nudity of the human figures, Kulik's paradise appears timeless. Does Kulik's work gesture toward a critique of the dimension in which humans find themselves today? Because we are simultaneously animals and excluded from nature, our presence in this picture can only be a superimposition. Have we become a pale reflection relegated to a superficial relationship with nature? As animals appear utterly indifferent to us, our impossibility of communicating with them, in turn, alienates us from the environments we share. Are there any productive points of contact that could be recovered? And is this dimension one in which sex constitutes the only instance in which we can momentarily glimpse a point of contact between us and other animals? In opposition to the use of the term *natural* in popular culture, and the association with animality usually drawn in relation to sexual acts, sexuality, like nature, can no longer occupy a prelinguistic dimension in which the power of representation hasn't already codified even the most seemingly primordial human drives and instincts. It is in this sense that Kulik's series extends the metaphorical value of the diorama to its anthropogenic conclusion: the dark loop in which we are simultaneously in and out, human and animal, interconnected with everything but ultimately irreparably alienated.

4

THE END OF THE DAYDREAM

Taxidermy and Photography

Guns have metamorphosed into cameras in this earnest comedy, the ecology safari, because nature has ceased to be what it had always been— what people needed protection from. Now nature—tamed, endangered, mortal—needs to be protected from people. When we are afraid we shoot. But when we are nostalgic, we take pictures.

—SUSAN SONTAG, *ON PHOTOGRAPHY*

Photographs of stuffed animals . . . represent a kind of double mimesis and reinforce the shared ways in which photography and taxidermy are manifestations of a desire to possess and control nature.

—JAMES R. RYAN, "HUNTING WITH THE CAMERA: PHOTOGRAPHY, WILDLIFE AND COLONIALISM IN AFRICA"

WHAT IS SPECULATIVE TAXIDERMY?

Through the first three chapters, taxidermy emerged as the sedimentation of intertwining histories of affirmative and ideologically charged representations in which artistic media, materialities, and their affiliation to power played pivotal roles. Taxidermy's materialization was shaped by positivistic, epistemic spatializations in which the absolute sovereignty of

the viewer's panoptic gaze structured essentially objectifying human/ animal relations. This considered, it is now possible to ask how much of this epistemic platform still matters in the emergence of taxidermy as a new medium in contemporary art. And what does its presence mean in relation to its scientific past?

As mentioned in the introduction of this book, an important turning point in the agenda of critical artistic production related to these themes has certainly been the thirteenth edition of dOCUMENTA, the quinquennial international art event with a demarcated academic taste. This edition, in 2012, was accompanied by the publication of one hundred short essays. Those by Karen Barad, Donna Haraway, Graham Harman, and Claire Pentecost delivered firmly anti-anthropocentric notions designed to affirm art as a productive epistemic system in which essential reconfigurations of knowledge can now take place. Thus Barad's "What Is the Measure of Nothingness? Infinity, Virtuality, Justice" introduced the anti-objectivity concept of "intra-action" as the key to reassess the importance of looking between the object and agencies of observation.[1] Harman's "Third Table" invited readers to move beyond scientific and humanist epistemic approaches for the purpose of engaging with objects in ways that are more attuned to today's sensitivities.[2] And pushing the boundaries of representation and the representable, Pentecost's essay proposed a revisitation of the importance of soil and the interlinks between bacteria and microorganisms.[3]

Before the emergence of speculative realism in 2007, posthumanism had already shaken the foundation of the humanities to its core by enabling multidisciplinary interconnections that academic ordonnance previously prevented. The ambition to craft new epistemological modes is also not entirely new. Serious attempts to ontologically reposition objects, as seen in chapter 1, were initiated by Arjun Appadurai in the 1980s. Since then, the interest in objects and our relationships with them has become more central to discussion in the humanities. In the 1990s, ecological philosophy books like David Abram's *The Spell of the Sensuous* introduced the possibility of recovering participatory practices of perception from what western thought had come to conceive as a far and archaic past: the magic-imbued sensualities of indigenous sorcerers to whom animals and plants never were specimens of natural history.[4] Of course continental philosophy already had its fair share, albeit limited, of decentralizing the

human—just think of Deleuze and Guattari's becoming animal as an opportunity for reconfiguring anthropocentric systems into rhizomatic networks and lines of flight.[5]

We currently are at a moment of cultural crisis—one that is unavoidably underpinned by a sense of guilt and deep anxiety toward our relationship with the planet. Our anthropocentric conceptions have led us to a state of alienation in which we constantly recoil upon ourselves, incapable of connecting with other beings and environments beyond the base of utilitarianism. We have largely lost our abilities to be sensually attuned to the world. The suspicion that our approach may also underlie many of the seemingly irresolvable sociopolitical problems we have caused, and coexist with, is also gaining currency. It is across this scenario that ecophilosophies as well as object-oriented ontology, speculative realism, and new materialism have emerged. However, it would be wrong to assume that any of these approaches could work as a passe-partout to a better world. Yet, in their contradictory ways, they all offer new opportunities to rethink perception and epistemology, and thereby to reconsider our relationship with animals, environments, and art.

The decentering of the Cartesian subject has become the preponderant aim of the ontological turn. The new philosophies identify the limitations involved in structuralism, poststructuralism, and deconstruction while searching for new conceptions of realism that may better suit the ecological, technological, and economic paradigms that mold human experience today. These philosophies share a renewed interest in and enthusiasm for speculation on the nature of reality as independent of thought—they all more or less thrive on a derailment of Kantian correlationism. Surpassing the perspectives of previous linguistic and critical turns, object-oriented ontology, speculative realism, and new materialism refuse the idea that humans only have access to the correlation between thinking and being.[6] Language and thought still remain part of the equation that enables our relation to the outside world, yet they no longer constitute the exclusive point of access and the defining, structuring system. Kantian critical philosophy constructed a system of metaphysics, substantially understood as antirealist, in which experience appeared preempted by the existence of a priori categories. Thus, speculative realism does not argue that we have unmediated access to reality—the outside world cannot possibly be exhaustively contained by our perceptive tools—

but it acknowledges the distinct existence of something out there. This something exists beyond our sensorial capabilities, and it triggers our sensorial responses in the first place. In speculative realism, and even more so in object-oriented ontology, the rejection of the default metaphysics of the continental tradition invites us to bravely rethink everything we thought we knew.

This antirealist metaphysics, according to Levi Bryant, Nick Srnicek, and Graham Harman, authors of *The Speculative Turn*, "has manifested itself in continental philosophy in a number of ways, but especially through preoccupation with such issues as death and finitude, an aversion to science, a focus on language, culture, and subjectivity to the detriment of material factors, an anthropocentric stance towards nature, a relinquishing of the search for absolutes, and an acquiescence to the specific conditions of our historical thrownness."[7] What I call speculative taxidermy in this book constitutes a category of *contentious objects* that from many perspectives seems to be better comprehended as defined and problematized by this new set of philosophical concerns. Speculative taxidermy, unlike its natural history counterpart, deliberately derails ontological structures well beyond animal/object categories. Speculative taxidermy functions as an object-actant whose impact is grounded equally on its aesthetic openness, its irrepressible materiality, and its problematic indexical relationship to "the real." It moreover problematizes the classical notions of realism in art and philosophy through a focus on surfaces in art objects and is deeply embedded in the contradictions that characterize the latest, critical stage of the Anthropocene: the rise of virtual reality, growing global social/financial instability, and the proliferation of eco-catastrophic narratives.

Surfaces are the outermost layers of objects, and as such, they constitute the interfaces upon which our perception of their materiality is defined. Surfaces are intrinsically sensuous and simultaneously dialectic. They are sites upon which complex negotiations are played out. Most regularly they implicitly inscribe deeper promises of material qualities that we cannot ascertain without damaging or destroying the surfaces. Thin objects, like leaves or photographs, appear to be essentially constituted by surfaces, whereas the surfaces of other objects conceal a depth upon which they have been grafted; they are veneers. Veneers belong to economic or historical realities that are extrinsic to the mass of the object they

envelop. The deceit of the senses that they operate plays out exclusively upon their surfaces. Some surfaces thus become ambiguously political—simultaneous everything and nothing. They usually are the sites upon which forms of representation like painting and drawing unfold, and as such, they are especially important in our relationship with animals and art alike.

More recently, an interest in the materiality of objects has arisen equally in philosophical and art historical discourses, where the need to reconstitute the presence of an embodied human within a material world has become more and more pressing. Like speculative realism, new materialism aims to be connected with current ethical and political concerns related to science and technology—climate change, global capital, population flows, biotechnological engineering, and the digital, wireless, and virtual prosthetics that make our lives what they are today.[8] Rethinking materialities thus entails surpassing Cartesian conceptions of matter and the dualisms that conceived nature as a quantifiable and measurable entity that can be subjugated.

A CRITICAL DISTANCING

Speculative taxidermy is a dual phenomenon—one simultaneously involving the representational tropes of two-dimensional media, such as photography, and three-dimensional sculpturalism. The importance of the former lies in the proposal of a critical distancing from the taxidermy object itself. It is in this double distancing from the live animal, first through the rendering into taxidermy and thereafter through its transposition into another indexical medium, that a critical approach, an undoing of human/animal past histories and future potentialities for engagement, can arise. This *mediated taxidermy representation* thus proposes the possibility of what I have called ontological mobility: the opportunity to reconfigure our taken-for-granted modes of being.[9] Ontological mobility is a specific moment in the phenomenology of art involved with, but not exclusive to, works of speculative taxidermy. It is the result of the agency of the work of art, its ability to leverage preinscribed values and structures in order to take the viewer through a critical appraisal of realism and to

highlight the importance that any conception of realism plays in defining human/animal relations.

Roni Horn's photographic diptych *Dead Owl* (1997) and her series *Bird* (1998–2007) can be taken as example of a two-dimensional encounter with animal representations employing new, speculative aesthetics. Regardless of the original artistic intentionality, the interest in photographing taxidermy that has recently surfaced in contemporary practice provides an opportunity to ask questions such as what roles taxidermy plays in our relationship with live animals today, how speculative taxidermy operates as a signifier in contemporary representational tropes, and how taxidermy could be used as a vehicle for devising new animal epistemologies informed by human/animal studies discourses in art.

Every work of contemporary art demands its own perspective, its own theoretical approach, and its own mode of encounter, whereas sweeping theories that force many different works of art into one typology implicitly limit what can be thought and said. Likewise, it is worth noting that speculative taxidermy objects are materializations in which animal agency and human agency are equally engaged and shaped by the discourses, practices, and materialities through which they encounter one another— the encounter staged by speculative taxidermy is never just between artist and animal. It always inscribes a transhistorical sense of agential becomings defined by the formation of institutional practices and discourses. It is this engagement in the reconfiguration of historical fragments of knowledge, discourse, and practices that is essential for inducing *ontological mobility*, the opportunity to rethink human/animal relations through a work of art.

The epistemic reconfiguration that characterized the modern age (1800–1950) entailed a regrouping of knowledge around pivotal questions and statements.[10] Starting with Manet's *Déjeuner sur l'Herbe* and *Olympia* (both from 1863), the crumbling of representation reached beyond the polished surfaces of classical realism to delve into the *modern invention of man*.[11] "The visible order" of the classical age, "with its permanent grid of distinctions, is," according to Foucault, "now only a superficial glitter above an abyss."[12] At this point, as discussed in the final chapters of *The Order of Things*, the interrogation of human finitude became the essential epistemological project of the modern age, one that painting primarily addressed from the beginning of the nineteenth century.[13] What Foucault

termed *the birth of man,* as the essential moment in the history of humanity, is the result of "the reappearance of language in the enigma of its unity and its being as by a threat."[14] It is therefore a detachment of language from representation that enabled language itself to become a philosophical problem—nothing is any longer naturally inscribed as a transparent given, everything is open to question, and everything demands speculation. This new epistemic modality had a major impact on the crumbling of classical, positivistic certitudes. Most importantly, it altered the relationship with visuality, which was linguistically defined by the relationships between seeing and saying.

In "What Is Enlightenment?" Foucault discusses Baudelaire's essay "The Painter of Modern Life" as an example of the new conception of the modern image.[15] Baudelaire's essay exemplifies a break with tradition operated through the *heroization* of the fleeting and the seemingly irrelevant through art.[16] The heroization of the passing moment was entangled in a process of *desacralization,* one in which a "difficult interplay between the truth of what is real and the exercise of freedom" appear to unfold.[17] This ontological liberation, or *practice of liberty,* as Foucault called it, became the intrinsic feature of a modernity in which human finitude could be produced. Baudelaire's attack on the persistence of classical art throughout the nineteenth century resolved in the refusal of rhetorical classical forms: an epistemological break that positioned the artistic sphere as the predominant, new site upon which the construction of man in modernity could take place.[18] Within this context, Foucault's conception of the aesthetic experience in the modern age can be understood as simultaneously shaping the present while enabling a transformation of the future. This new approach to art proposed new transformative processes: a "transfigurative play of freedom with reality" that is traceable in Horn's work on birds.[19]

TAXIDERMY AND PHOTOGRAPHY: THE END OF THE DAYDREAM?

Through the classical age, natural history was configured as a practice concerned with the meticulous examining, transcribing, and cataloging

of animal and plant surfaces through a process of synthetic purification.[20] Through the modern age taxidermy and photography furthered that specific epistemological project by producing a new absolute visibility of animals, and by simultaneously enabling the emergence of an unprecedented cultural construction of nature. Absolute visibility relied on similar technical advantages in the visualization, immobilization, and preservation of animal bodies. During the second half of the nineteenth century, the relationship between photographic discourses and practices and those of natural history became further entangled. Taxidermy practically froze animal life in photographically constructed tableaux situated inside the natural history museum. But outside the walls of the museum taxidermy was also used to technically compensate for the extremely long exposure times typically required by early cameras and films. This condition endured until the 1890s and forbade the possibility of visually capturing live animals.[21] Taxidermy objects therefore stood for live animals in the construction of tableaux that offered faked images of deep nature in which man's manipulation was present and yet concealed. Simultaneously, this practice marked the beginning of a new photographic practice: camera hunting.[22] Camera hunting gained recognition at the beginning of the twentieth century as an activity requiring great skill, incorporating and simultaneously exceeding the skills possessed by the hunter (fig. 4.1).[23] As argued by James R. Ryan, author of *Picturing Empire: Photography and the Visualization of the British Empire*, because of the complex narrativizations a photograph could effortlessly convey, the commemoration of the hunt became almost more important than the trophy itself.[24]

According to John Berger's influential essay "Why Look at Animals?" the physical marginalization of animals that characterized the rise to modernity produced more resilient cultural animal presences that rely on the photographic image for their materialization.[25] Berger argued that wildlife photography provided the opportunity for a construction of nature as a value-concept, another form of realism—one opposed to the artificial social structures denying man its "naturalness."[26] Simultaneously, camera hunting and wildlife photography functioned as romantic shorthand for audiences who were increasingly repressed by capitalism and industrialization. Thus, classically staged, "the image of a wild animal became the starting point of a day-dream: a point from which the day-dreamer departs with his back turned."[27]

FIGURE 4.1 "Hunt with a Kodak" and "There Are No Game Laws for Those Who Hunt with a Kodak." Kodak camera advertisements, 1905. Image in public domain.

Berger's "day-dream" provides a model that ultimately capitalizes on the viewer's affirmation, typical of classical painting. Here, in opposition to the practice of liberty that began to pervade other representational genres, the sovereignty of the viewer remains unchallenged and undisturbed in its knowledge-forming agency: language is transparently embedded in representational realism. Accordingly, animals appear quelled, remote, and immersed in a deep nature from which humans have been long excluded.[28]

SEEING DOUBLE: THIS IS NOT AN OWL

Over a career spanning thirty years, Roni Horn has produced drawings, sculptures, and installations, but it is her photographic work that has

more recently gained international notoriety. Her professional success is due to the fact that Horn, unlike many other artists, has managed to forge a substantially original approach to the idiom of her medium of choice, making her work aesthetically distinctive, but also conceptually relevant.

Horn's critique of the rhetoric of photographic representation is in itself important because it questions the foundations of art, the materiality of photography, natural history, and human perception while encompassing histories of representation and the epistemic processes that are interlinked to these histories. This complex operation is performed by Horn through the presentation of photographic diptychs—the juxtaposition of two identical or slightly different images (fig. 4.2). Of this uncanny doubling, Horn said: "the idea was that to create a space in which the viewer would inhabit the work or at least be a part of it."[29] This inhabiting, based on experience and the viewer's presence, is not a comfortable one. The

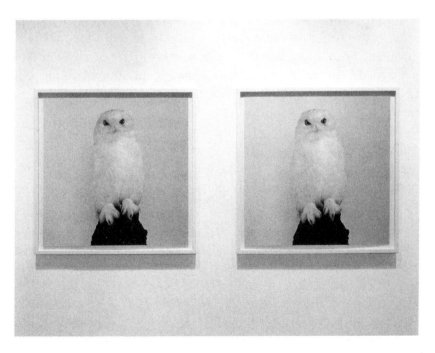

FIGURE 4.2 Roni Horn, *Dead Owl*, 1997. Two iris-printed photographs on Somerset satin paper. Each 22 1/2 × 22 1/2 in. (57.2 × 57.2 cm). Courtesy the artist and Hauser & Wirth. © Roni Horn.

diptychs directly question anthropocentric systems of knowledge: they subvert the naturalized processes through which we construct a comfortable world through representation.

The presence of animals in Horn's images problematizes conceptions of identity and difference, and the possibility or impossibility of conceiving animals within such a paradigm—Horn's images invite us to look, think, and look again. This embodiment of looking through a performative shift of the gaze, and a demand for multiple glances, entails a cognitive shift triggered by the indeterminacy caused by the doubling in her work. But before we more carefully consider these aspects of Horn's diptychs, it is worth assessing that in itself, the presentation of two identical images in art can constitute a negation of affirmation—a substantial derailment of the epistemic condition that constructs the realistic artwork as the copy of the original referent in the world. In painting especially, a portrait is a representation that captures a unique individual in a unique moment in time. The value and validity of the portrait traditionally rests on this exclusive and univocal relationship. According to the value system that grants painting a special place in the history of representation, the uniqueness of the image validates its genuine relationship to the model. The idiom of painting may not technically exclude the possibility of multiplicity in image production, but it certainly has been culturally expected to do so.

Paradoxically, photography's technical essence, as well as its pivotal difference from painting, lies in the intrinsic reproducibility of the image, an idiomatic condition that has been traditionally repressed by cultural frameworks of image consumption. Thus the reproducibility of photography has been always excluded from the exhibiting space, forcing the photographic idiom to adhere to that of painting through a renunciation of its specific ability to make nonaffirmative statements about realism.

The title of the work, *Dead Owl*, reinforces the self-reflexive semantic economy of the image. It plays a pivotal role in problematizing the system of ambiguities by which a lifelike owl is pronounced dead by the artist. Furthermore, the white plane behind the owl betrays human intervention: it inscribes the tension between nature and culture. If the owl is presumed alive, the implication may be that it is kept captive, for the uniformity of the white backdrop denotes an artificial enclosure. However,

as will be seen, it is the doubling of Horn's image that constitutes the truly nonaffirmative element in *Dead Owl*.

According to the history of western philosophy, the three essential representational modalities are the copy, the sign, and the simulacrum. I would like to propose that the elusive charge of taxidermy mounts is substantially defined by the collapsing of these modalities into one representational register. Each modality influences the viewer's perception with multiple intertwined and overlapping signs at once—this is *representational overload* at its best. It is therefore not a surprise that photographs of taxidermy should actively exacerbate this representational intensity. In this case Foucault's formulation of the concepts of *affirmation* and *nonaffirmation*, and those of *similitude* and *resemblance*, can prove useful in better illuminating the complexity proposed by Horn's photographic diptychs.[30]

In *This Is Not a Pipe*, a book about Magritte's work (fig. 4.3), Foucault speaks of resemblance and similitude as prominent epistemic ordering relationships between representation and the world, and there lies the importance of these concepts.[31] Resemblance essentially is mimesis, the

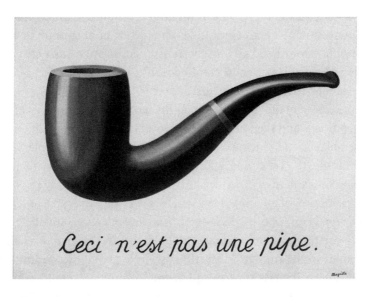

FIGURE 4.3 René Magritte, *The Treachery of Images* (*This is not a pipe*), 1929. Oil on canvas, Overall: 25 3/8 × 37 in. (64.45 × 93.98 cm). Los Angeles County Museum of Art, Los Angeles, California. © ARS, New York.

realism of classical art. It proposes an original model that hinges the representational plane to the outside world. Here lies the essence of affirmation: the viewer standing in front of the canvas can state: "this is. . . ." Like the prince in the cabinet of curiosities, or the king in front of *Las Meninas*, resemblance positions the viewer as the ordering agent of the world. Thus, resemblance lies at the foundation of what Foucault calls *quattrocento* painting—the quintessential anthropocentric representational paradigm in which clarity, perspectival structuring, and lighting encapsulates a sense of dominion over the world. Resemblance, the essence of correlationism, made knowledge of things possible.[32]

In opposition, *similitude* constitutes an arbitrary process of equation in which phenomena are not hinged by hierarchical relationships.[33] Similitude essentially is a circular repetitional system of closed allusions and references. Through a derailment of the linear connection between the representational plane and the real world typical of resemblance, the work of similitude, in the late nineteenth century, began to reconfigure the canvas as a new epistemological spatialization in which the clear comparative vision of taxonomy began to blur.[34] It is within this context that Foucault identifies in some of Magritte's early twentieth-century paintings an important aesthetic shift, one in which resemblance becomes problematically intertwined with similitude. The intrusion of similitude within the straightforward and seemingly transparent relationship between resemblance and affirmation in painting results in the production of copies of copies that no longer can be distinguished from an original.

In the case of photographs of taxidermy mounts, the precarious hinging between image and the portion of the world it represents is held together by resemblance and is defined by an ever so slightly derailing intervention of similitude: the repetition within the repetition caused by the photographing of taxidermy. A taxidermy mount effectively already constitutes a representation of an animal, even before it is photographed as a three-dimensional copy of other living animals. As Foucault claimed, "Similitude circulates the simulacrum as an indefinite and reversible relation of the similar to the similar."[35] It is this very role played by similitude and its ambiguous intertwining to resemblance that produces a crumbling of affirmation in photographs of taxidermy mounts. And Horn's *Dead Owl* pries open this very crevice in the configuration of the ontological standpoints of her images.

FOUCAULT'S *TABLEAU-OBJET* AND THE EVENT

Two more concepts from Foucault's analysis of art will become useful in this chapter: the *tableau-objet* and the *event*.[36] The concept of the *tableau-object* was theorized by Foucault in a series of lectures on Manet's paintings that he gave in Tunis and of which fragments have been gathered in the posthumous book titled *Manet and the Object of Painting*. It is a much undervalued concept in Foucault's body of work and has more recently come into alignment (although it remains ignored) with the current philosophical preoccupation with objects and their agency.

Foucault further expanded the notion of quattrocento painting as introduced in *The Order of Things* and *This Is Not a Pipe*. He argued that classical painting deliberately relied on forgetting the materiality of painting itself, inviting the viewer into a daydream.[37] In opposition, the *tableau-objet* is a type of painting that reclaims the materiality of painting for the purpose of making the viewer "conscious of his presence and of his position within a much larger system."[38] To the trompe l'oeil aesthetic intrinsic to quattrocento painting, the *tableau-objet* substitutes a deliberately awkward flatness, as is visible in Manet's *Olympia*, *Déjeuner sur l'Herbe*, and *A Bar at the Folies-Bergère*. The solid structuring of interior lighting in quattrocento painting, the element enabling the ordering of the world, is replaced in the *tableau-objet* by the ever-changing, arbitrary illumination of the room in which the painting is displayed.[39] These structural reconfigurations prove defining in the physical positioning of the viewer in front of the "object of painting" itself. The positivist, internal light source of quattrocento painting simultaneously structures the image and ask the viewer to stand right in front of the painted surface (fig. 4.4). This vantage point produces a position of sovereignty situated at the center of the representational world, like in a cabinet of curiosities; everything seen is subordinate, pacified, and dependent upon the viewer. Thus, the physical interlocking established between viewer and painting in classical art, vastly secured by the solidly prenegotiated bridging of realism, is collapsed by the *tableau-objet*'s nonaffirmative aesthetics. One of the most challenging statements proposed by the *tableau-objet*, however, lies in the acknowledgment and self-confessed revelation of its representational value, or what painting substantially has always been: a material circulation of images—a flat board or stretched canvas upon which a picture has been

FIGURE 4.4 Structural diagram of Leonardo Da Vinci's *Last Supper*. Image in public domain.

outlined. The most important aspect of Foucault's *tableau-objet* is therefore that it turns the inherent transcendentalism of classical painting on its head—clearly restituting painting to the material realm as an object capable of actively moving the viewer's body in order to change the viewer's conceptual perspectives. The *tableau-objet*, by definition, is representation with a pronounced type of agency.

Foucault never actually connected the concepts of *tableau-objet* and event. It seems plausible, however, that the two could be interrelated to provide a more extensive mapping of new aesthetics in art. Foucault discussed the importance of the event in his essay on Gerard Fromanger's work, where he claimed that the idiomatic in photography was rediscovered through the intercession of painting. Foucault argued that Fromanger's appropriation and transfiguration of images proposes an *event* that endlessly takes "place in the image, by virtue of the image."[40] Circulating beyond the remit of the original photograph, an event is able to draw the viewer into a nonaffirmative experience.[41] This process of magnification, making manifest, or becoming aware acquires considerable relevance when animals are present in the picture plane. From this vantage point, Horn's *Dead Owl* appears to propose a complex form of event unleashed by the infringement of the classical semantic structure of the photographic idiom.

Thus far I have introduced five key concepts from Foucault's writings on art. These are quattrocento painting, the *tableau-objet*, resemblance, similitude, and the event. These concepts will be further explored in the discus-

sions of all the works of art that will become central to the next chapters. Considered together, they provide a new set of tools devised to put art at work for the purpose of rethinking human/animal relations within broader biopower systems. In "Photogenic Painting," Foucault specifically contextualizes the event as that which "transmits and magnifies the other, which combines with it and gives rise, for all those who come to look at it, to an infinite series of new passages."[42] I argue that is possible to conceive of the event as an experience unleashed through the tensions presented by artworks that comply with the specifications of the *tableau-objet*.

DEAD OWL: A TROUBLING TAUTOLOGY

Horn's images are strikingly realist.[43] The title of the work *Dead Owl* reinforces the self-reflexive semantic economy within the image. It actively plays a pivotal role in problematizing the system of ambiguity by which a lifelike owl is pronounced dead by the artist—something that we cannot ascertain but need to consider. The text is as open as it can be: Has the bird been killed and then resurrected by taxidermy? Or is the artist alluding to the symbolic killing/resurrection operated by the camera? What may be a taxidermy mount now appears equally likely to be alive; or what was once alive may have been metaphorically killed by the act of being photographed, and then representationally resuscitated.

As Roland Barthes observed, "the photograph possesses an evidential force, and . . . its testimony bears not on the object but on time."[44] It is because of the inclusion of time in the indexical equation that both photography, as Sontag noted, and by extension taxidermy become involved in a *freezing of time* that intrinsically alludes to the absent presence of death.[45] Thus, the "return of the dead," as articulated by Roland Barthes in *Camera Lucida*, the *spectrum*, or the object photographed, is "returned" essentially on the grounds of the indexical: the undeniable materiality of its past presence in the traces. *Dead Owl* is deliberately constructed to deliver a nonaffirmative riddle that grows more and more intricate as the viewer attempts to disentangle it.

Establishing a nonaffirmative relationship between title and work, Horn's *Dead Owl* problematizes the aesthetic strategies deployed in Magritte's

famous painting *The Treachery of Images*, from 1926.[46] More specifically, it relates to the tautological problematization of the paradigm proposed by Magritte's 1966 reprise of that painting into the one titled *The Two Mysteries*, in which a copy of the 1926 original is repainted on an easel above which the enlarged image of the same pipe hovers. The repetition of the pipe is here simultaneously undermined by the calligram. Thus a transgression of the representational prescriptions of classical affirmation is enacted by the interruption of the naturalized links between objects and words. Magritte and Horn appear equally invested in a defamiliarization of the everyday proposed through a specific dislocation of the links between visual representation and words—their work denounces the structuralist reliance on representational systems and the intrinsic power/knowledge relations that language enacts in epistemology. At stake here is a revelation of the power images have to construct reality by pointing at the seemingly transparent ways in which we consume representation.

The formal element of Magritte's calligram, as Foucault pointed out, connotes the primary school teacher's voice: the voice of authority that imparts institutionalized, normative knowledge to children.[47] Horn's *Dead Owl* operates a similar "choking" of the voice of affirmation. The images deliberately rely on classical realism. However, because the image is presented as a diptych, this statement of affirmation is derailed through a *tableau-objet* proposal. What kind of affirmation is Horn attempting to unsettle, and how does the presence of taxidermy, effective or presumed, function within the semantic economy of this diptych? Here, too, Horn's image appears already freed by the artist from any textual anchoring— the viewer's experience is deliberately staged on uncertain ontological grounds. But a more problematic, nonaffirmative operation is enacted by Horn's presentation of two practically identical images.

Magritte's *The Two Mysteries* (fig. 4.5) essentially proposes a problematized version of the original perceptual conundrum triggered by *The Treachery of Images*. This problematization was caused by Magritte's deliberate denouncing of the latter as a painting. Here, too, as in Horn's diptych, the viewer is confronted by what Foucault classes as "similitude restored to itself—unfolding from itself and folding back upon itself."[48] This tautology affirms and represents nothing. Therefore, the event proposed by Horn is triggered, not by an obfuscation of realism, but by the essence of simili-

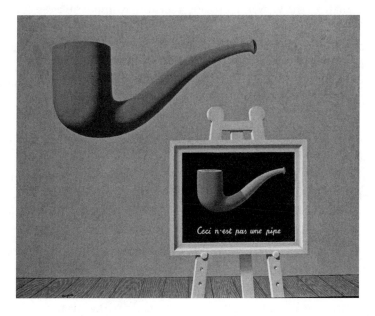

FIGURE 4.5 René Magritte, *Les Deux Mysteres* (*The Two Mysteries*), 1966. Oil on canvas. 65 × 80 cm. Private collection. © ARS, New York.

tude: a juxtaposition typical of repetition—but if Magritte proposed a double troubling of realism, Horn proposes a multiplication that further challenges the viewer to provide resolution: a trebling of realism.[49]

At this stage, it is worth examining more closely the dynamics at play in the realist entanglements proposed by Horn. As seen earlier in this chapter, resemblance essentially is the representational paradigm governing classical art. It is the hierarchical ordering agent that capitalizes on realistic representation. It connects what is painted on the canvas to the real world. Similitude, a modern phenomenon grounded in the multiplication of images proposed by photography, is the domain of the simulacrum: "the copy of the copy without original" that attracted the attention of Lyotard. In Magritte's work, and by extension in Horn's, it is the interplay of similitude and resemblance that problematizes the image, causing a short-circuiting of the anthropocentrism inherent to affirmative images.

The ontological mobility initiated by Horn is therefore triggered by the intrusion of similitude in the realism of resemblance: the multiplication

that challenges the viewer to provide a seemingly impossible resolution.[50] Owls are nocturnal predators symbolically linked in classical representation to "the feminine, night, the moon, death, magic and dreams."[51] Grounded in the symbolic orders of classical representation, these associations would easily relegate the presentation of a single image of the owl to a network of pre-encoded cultural symbolisms. But, in front of *Dead Owl*, the viewer's urgency to symbolically read the images is halted by the demand of solving the challenging doubling first, before the voice of symbolism is enabled to speak.

In *Dead Owl*, both birds stare back, beyond the representational plane, returning the gaze in a manner that only owls are capable of. The owls' eyes aesthetically and morphologically suggest the binocular vision of mammals and consequently humans' own. In "Why Look at Animals?" Berger identified the "looking sideways" of most animals as a defining reason for marginalizing them in the history of human/animal relations.[52] The elusive "looking/not looking" of most animals is therefore conceived as *lack*— it reaffirms a relational inability on the animal's part. This morphological trait was explored at length in Bill Viola's film *I Do Not Know What It Is I Am Like*,[53] a filmic critique of wildlife cinematography, in which all the expectations for action and narrative are frustrated and reconfigured through a syntax of extremely slow sequences in which animals seem to do nothing. In one specific sequence, the director's camera relentlessly closes up on the eyes of an owl, which stares back, unperturbed. The impenetrability of the animal becomes tangibly unnerving in this video work through a substantial manipulation of conventional filmic construction of time and space. Likewise Horn's *Dead Owl* confronts the preconceived expectations of narrative structures in photography by frustrating the experience and only alluding to a narration that is never delivered. In the tradition of western art, the diptych format either promises a "before and after" narrative sequence or proposes a dichotomic complementary relation, such as that between good and evil, day and night, or man and woman.[54]

THE STEREOSCOPIC ILLUSION

In their ambiguous doubling, which, as seen, is intrinsically bound to similitude, Horn's diptychs perform the frustration of a pivotal technical

step that substantially influenced the production of affirmation in photographic representation during the nineteenth century. With their roots firmly grounded in the Victorian technical visuality enacted by the stereoscope and troubling of optical realism, Horn's diptychs perform a speculative maneuver that inscribes the looping trappedness of anthropogenic representational politics.

The stereoscope utilized two superimposable images taken at slightly different angles that, when placed side by side, as in Horn's work, and gazed at through a set of lenses, merged to create the illusion of one three-dimensional object (fig. 4.6). This reversal of the photographic process fascinated audiences because it provided a miniaturized mimetic model of

FIGURE 4.6 A Holmes stereoscope from the nineteenth century. Photograph in public domain.

a classifiable world, which transcended class and language barriers.[55] In 1926, the famous taxidermist Carl Akeley adopted the use of stereoscopic photography in order to more accurately render the three-dimensional lifelike quality distinctive of his taxidermy mounts.[56] Similarly to the taxidermy dioramas produced from the 1890s onward, the stereoscope proposed a rationalized model of the world that in its construction was both finite and completely legible from a safe anthropocentric positioning. The flattening of the animal skin, like the flattening of the photographed object, required remodeling into three dimensions for the object to occupy a spatial field of visibility enabling voyeurism, surveillance, and classification. The heightened photographic affirmation constructed by the stereoscope staged a panoptic relation between viewer and object, and proposed an ineffable illusion, one in which the flat was passed for three-dimensional, the dead for alive, and the ideological for natural.

By metaphorically removing the stereoscopic lenses—the epistemic symbol of the Enlightenment's thirst for ordering the world through the enhanced primacy of sight—Horn deliberately withholds affirmative resolution from the viewer. Preventing the two images from merging into a stereoscopic illusion leaves the viewer to grapple instead with a *troubling tautology*. Instead of being translated into words almost immediately, the owl/s are allowed to exist outside of meaning for a short while. The trompe l'oeil, the view of a single three-dimensional owl that would have emerged from the intercession of the stereoscopic lens, could have produced the weightiest burden of affirmation.[57] The result would have equated to the most solid ruse of a convincing resemblance: the opposite of the practice of liberty and indeed the epitome of quattrocento conventions. It is in this very failure—the deliberate frustration of the desire to see and say and therefore to possess—that the event is unleashed.[58]

Horn's allusion to the possibility that the owl in the two images may be taxidermy further problematizes the tension between resemblance and similitude. Kitty Hauser noticed that the indexicality proposed by photography is different from that of taxidermy in that, in the latter, "the sign has swallowed up its referent."[59] If photography ambiguously plays with the notion that that which is photographed might be understood as ontologically dead within the economies of the image, taxidermy proposes the certainty of death. Thus, the taxidermy mount already always is a

copy. Photographing and displaying the same mount multiple times produces copies of copies with no original required for the copy to exist.

The white background against which the owl has been placed functions similarly to the presence of the blackboard in Magritte's *The Two Mysteries*. The blackboard, in this instance, inscribes the affirmative representational power of the teacher, which produces knowledge through the institutional support of the school.[60] The surface upon which the pipe is drawn is extremely important in asserting its affirmative value. The double negation of its ontological status as a pipe is simultaneously challenged by the scrawl underneath it and the presence of a giant floating pipe right above the blackboard, which Foucault claims fluctuates in a space "without reference point, expanding to infinity," diametrically opposed to the solidity of the pedagogical space.[61]

Replacing a natural environment, the white background suggests the scientific institutionalization of the natural history museum: an epistemological spatialization. Similitude therefore infiltrates itself in the work of resemblance not only within the encounter with the image to which it is juxtaposed but with the referent in the external world through the already represented taxidermy body. In opposition to the deep nature of wildlife photography, which states "this is a wild lion" or " this is a wild tiger," this owl appears forced to the foreground, in an image that simultaneously affirms and undermines its own status. If this is not the image of a wild animal, then what is its real value? If the original referent is not a living wild animal, then what is this image saying? Is the white background alluding to the epistemological spaces of science? What does the image tell us about what we call nature?

NONAFFIRMATIVE BIRDS

The nonaffirmative dynamics Horn experimented with in *Dead Owl* were further problematized in the series called *Bird* (1998–2007) (plate 6). In contrast to *Dead Owl*, in which the taxidermy animal stares back, each diptych in this series proposes a view of birds' heads seen from behind. The series proposes a subversion of the portrait genre by borrowing its distinctive framing and cropping of the upper part of the body but rotating

the animal head 180 degrees away from the viewer. This operation is designed to subvert anthropocentrism and to simultaneously inscribe anthropomorphism—here Horn presents us with another set of apparent contradictions. Posed against the similar off-white backdrop used in *Dead Owl*, these bird heads formally transcend the presence of the animal-trace to elusively lean toward a form suspended between realism and abstraction. Horn's diptych strategy is also employed. But in this case we no longer stand in front of the photographed object—we stand behind it. Or do we? The inversion of the subject operated by Horn makes us instantly aware of the inherent anthropocentrism that governs our outlook on animals— the necessity to paradoxically prioritize the vis-à-vis, even when we acknowledge that the animals can't really stare back.

The turning away of Horn's bird portraiture is designed to hinder the affirmative taxonomical ordering of natural history through the concealment of eyes and beaks. What is the scientific value of these images? Do they hint at the impossibility of accessing animals beyond their body surfaces? The composition recalls the painterly genre of the portrait, but what type of animal portrait are they? Is Horn inviting us to partake in a taxonomical comparison of animal morphology? If so, to what end?

Prolonged observation of some of the bird heads unavoidably results in the surfacing of placeholders for eyes and beaks upon the feathery lumps. This uncanny phenomenology, called *pareidolia*, reveals how hardwired our perceptual visual tropes are, such that the mere summoning of the stylistic coordinates of the portrait genre enables anthropomorphic responses to emerge on the back of the bird's head. During the nineteenth century, photographic portraits actively partook in the process of identity formation through an appropriation of the aesthetic paradigms of portrait painting. But identity, in these photographs, is not fixed by the eyes and the mouths— it becomes dispersed in the repetitive minutiae of the plumage patterning that distinguishes each couple of birds from the next, and the viewer is required to work harder to develop a heightened register of observative immersion with the images. Levinas's paradigm of the impossibility of an "animal face" inevitably comes to mind. To Levinas, the face becomes the threshold through which ethical obligation is established among beings, and the unknowability of the other is the one element that continuously calls for a furthering of the relational. But do birds have faces in a Levinian sense? Even if we were to see the faces of

these birds, would they look distinctive from each other or not? And is it perhaps this aesthetic replaceability characterizing human/animal politics at this very time that Horn's operation hints at?

Observation of the diptychs in *Bird* reveals that in some pairs, it is the same bird that is photographed, sometimes captured from a slightly different angle (fig. 4.7). In others, it clearly is two different birds of the same species that have been juxtaposed. Paradoxically, by infringing the conventional route to species identification and concealing the animal attributes that have been selected to embody such coordinates in the history of taxonomy, we cease to see the specimen standing in for the species and begin to see an individual bird through the idiosyncratic nuances of its plumage. Through photography, Horn has staged an experience that metaphorically alludes to animal unknowability while also inviting the viewer to look more carefully, beyond the pre-encoded knowledge acquired elsewhere.

FIGURE 4.7 Roni Horn, *Bird* (detail), 1998/2007. Iris and pigment printed photographs on Somerset Satin paper. Ten pairs (twenty pieces), 22 × 22 in. (55.9 × 55.9 cm) each. Courtesy of the artist and Hauser & Wirth. © Roni Horn.

In "The Death of the Animal: Ontological Vulnerability,"[62] Kenneth Shapiro identifies two different but related ways in which animals are denied individuality, a positioning that, the author claims, makes animals vulnerable to mistreatment by man. The first vulnerability involves a loss of individuality; the second, a "loss of species identification" wherein an animal becomes a "generic animal," thus replaceable.[63] In relation to the first ontological vulnerability, Shapiro identified the concept of species as a reified entity rather than as an aggregate of individuals. Our experiences of animals are therefore shaped consistently by a clash of conceptions between the animal as a singular individual and an idea of the species, which conjures generalized morphological and ethological traits. Animals are thus understood as "impersonalized, deindividualized but reified abstractions."[64] According to Shapiro, this conceptualization to which almost all wild animals are subjected "dissolves the individual [animal] and invests the aggregate of, now, non-individuals with a kind of unified being that allows members of the species to be killed as if they were so much grass being mowed."[65]

Taxidermy as a scientific epistemological tool indeed emerged because of taxonomy's urge to classify animals into organized species, not for the purpose of recognizing individuals: scientific taxidermy loathes idiosyncrasies. As a result, animals became "the exemplar non-individual" in order to preserve individuality exclusively for the human.[66] It is this complex set of issues that Horn's birds propose in their enigmatic juxtaposition. What can we say about a bird beyond recognizing the species it belongs to, and what does that say about the bird in front of us, or the one that we stand behind? How can we reimagine our relationship with animals through an undoing of the representational paradigms that have constructed our expectations of what nature and animals ought to be? As our gaze constantly oscillates left and right to ascertain what we think we know already, Horn's undermining of photography as a medium of truth challenges us to move forward, not by outlining possible avenues of enquiry, but by making us painfully aware of our epistemic limitations. These questions triggered by the tautology proposed by Horn bring us to rethink our relations with animals through a critical adoption of the media of taxidermy and photography.

5

FOLLOWING MATERIALITY

From Medium to Surface—Medium Specificity
and Animal Visibility in the Modern Age

*New Materialist ways of thinking accordingly challenge traditional dis-
tinctions between human and non-human, as well as classical hierarchies
that describe a descending scale from God, through human, animal, and
vegetal, to minerals and the inorganic. Instead a singular yet variegated
upsurge of materialization is countenanced.*

—DIANA COOLE, "FROM WITHIN THE MIDST OF THINGS: NEW SENSIBILITY,
NEW ALCHEMY, AND THE RENEWAL OF CRITICAL THEORY"

*Aesthetic experience is nothing that can be "had" by the subject. The term
"experience" refers to a process between subject and object that trans-
forms both—the object insofar as it is only in and through the dynamic of
its experience that it is brought to life as a work of art, and the subject in-
sofar as it takes on a self-reflective form, its own performativity.*

—JULIANE REBENTISCH, "ANSWERS TO QUESTIONNAIRE ON THE CONTEMPORARY"

CRISIS OF THE OBJECT

The idea came during a conversation at a Parisian café in 1936. Dora Maar
and Pablo Picasso were having tea with Meret Oppenheim when the fur-
covered bracelet she wore attracted her friends' attention. Reportedly,

Picasso exclaimed that "anything could be covered in fur!" which prompted Oppenheim's response: "Even this cup and saucer!"[1] *Object,* as the cup and saucer covered in Chinese gazelle fur was titled (fig. 5.1), has since become, for obvious reasons, the quintessential surrealist object—it has paved the way for many other everyday objects-made-strange; it is a textbook incarnation of the Freudian uncanny; it flirts with a subtle notion of abjection; it overlaps multiple consumptive desires; it inscribes and challenges gender prescriptions; it spells out *fetish*; and it alludes to, but never solves, a multitude of contradictions.

The hermeticism of its title, along with its iconic yet diminutive stature, has turned the work into a magnet for symbolic readings. Yet, for all the interest this art object has generated, it remains nearly impossible to find a text that does it justice beyond the clichés of surrealist interpretation. All surrealist objects are regularly reduced by the popular culture appeal that sexual allusion fulfills—this constitutes a highly anthropocentric and gendered perspective on the works. Without disavowing the

FIGURE 5.1 Meret Oppenheim, *Object,* 1936, Paris. Fur-covered cup, saucer, and spoon. The Museum of Modern Art, New York. © ARS, New York.

influence that Freudian theories undeniably had on these artworks, it is also important to remember that the introduction of everyday objects in the surrealist context involves more than sexuality and desire. According to André Breton, the main aim of the surrealist object lay in its ability to derail the perceptive processes, the cultural conventions that conceal objects to our perception, thus dialectically rewiring perception and representation.[2] However, art historical discourses inevitably default to an anthropocentric, epistemological finitude, which regularly stops its critical prodding at the point of the inaccessibility of Kantian transcendental idealism.

Careful consultation of surrealists' texts reveals, for instance, that Breton[3] and other artists were concerned with an early form of flat ontology in which objects, similarly to those in Graham Harman's object-oriented ontology, existed in two dimensions: the "material realm," the essence of the object or the impenetrable essence that characterizes it, and the sensual realm, the numerous qualities that an object displays in relation to other objects.[4] This condition will be further explored in chapter 6, but for the time being, it is important to note that the Freudian notion of the uncanny entails a rather similar structure. The uncanny object is simultaneously materially present and epistemologically withdrawn, yet it is also in constant relation to other objects. By establishing this fluidity, Harman hopes to instill an ontological instability by which all objects are made uncanny, not in the sense that they quiver in symbolic allusions, but that they remain inaccessible beyond the sensuality that other objects cast upon them—"the mist of accidental features and profile" that material presence cannot escape. Our apprehension of the object is therefore always relegated to the surface level: even when we cut into an apple or an animal body, our action is only capable of multiplying surfaces: the essence of the object relentlessly withdraws. Our impossibility to ascertain the essence of objects situates all experienceable surfaces as veneers, thin layers of materiality inscribed with information but simultaneously unable to make deeper claims about the essence of the objects they conceal.

As a surrealist piece and in consideration of its emphasis on surface aesthetics, Oppenheim's *Object* can be simply understood as leveraging this very notion of phenomenological essentialism—one that is sufficient to grant the piece an agential force it would not possess without its fur coating. Trained by the long-lasting legacy of classical art, the western art

historical gaze, far too quickly, defaults on the anthropocentric games played upon the symbolic register. In this game, the hermeneutical key is always at hand.

The material register of surrealist objects, the grounds upon which the semantic instability of the object unravels, has been substantially under-scrutinized. Leveraging the materiality, or remaining closer to it, prevents interpretation from "leaving the object behind" in the production of pure symbols. The erotic allusions inscribed in *Object* have always been given precedence over anything else the art piece might be capable of doing. Its uncanny *thingness* is thus castrated and domesticated with every seemingly successful symbolic reading that the art historical gaze stitches onto it. But what could be gained in refraining from the symbolic leap? And how can the surrealist object be understood as a glimpse of a broader crisis of materiality that will become exacerbated in the current stage of the Anthropocene?

There exists an ethical and political dimension to the readymade work of art that can only be teased out from its materiality and by following its materiality through sociocultural transactions and inscriptions that are specific and interlinked. This is the proposal underlying the anthropogenic condition in art, a proposal that would entail following the materiality of the object, daring to adhere to a literalist dimension that simultaneously acknowledges the material histories inscribed in surfaces while enabling the object to gesture toward narratives that remain anchored within it. This approach is justified by the artistic choice of implementing an everyday object in the artistic discourse rather than its painted or sculpted platonic referent. Here, therefore, lies the political charge of the everyday object, one akin to the emergence of collage and photomontage as a strategy designed to negotiate *shifting and conflicting perceptions* of the world. From this vantage point, it becomes possible to peel off meaning from the outer surface of these artworks in order to reach for a semantic dimension that lies between their materiality and the purely symbolic register of art historical hermeneutics. In this sense, Oppenheim's *Object* can be considered a precursor of speculative taxidermy on the grounds that it destabilizes the sovereignty of the viewer to invite negotiation of political and ethical considerations. More specifically, this piece provides the first and most clear model of ontological derailment incorporating a form of taxidermy.

Pushing aside the transcendentalism of the symbolic register can thus reveal that Oppenheim's teacup alludes to the increased availability of the mass production of objects at the beginning of the twentieth century; the affirmation of exploitative regimes of industrial production aligning the human and the animal; the convergence of multiple environmental impacts of unprecedented magnitude involving slavery, slaughter, deforestation, and the emergence of mass-agricultural production; the local (the mouth) and remote (the tea and sugar trades) forms of interrelated and self-perpetuating colonialist economies of production and consumption; the decorum inscribed in a social ritualistic object defining class and cultural status; the expectation of feminine fragility as defined by patriarchal values; the full assimilation of animals as ontologically aligned to mass-produced objects; and the pacification of animal skin, which, although removed from the animal, still looks lively, thus metaphorically never allowing the absent animal to die. This is the matrix of the material condition that will become central to object-based contemporary art in the Anthropocene: a set of inextricable entanglements in which multiple histories collide, unveiling inherited epistemological contradictions and recovering the all-important, and yet utterly overlooked, interconnectedness of biopower.

CÉZANNE'S DOUBT

Toward the end of the nineteenth century, Cézanne began to experiment with space, lines, and color. His ultimate aim was to incorporate and reconfigure the affirmation of classical representation. *Cézanne's* landscapes, but more so his still-life paintings, subtly revealed the materiality of the medium of painting as an intrinsic part of the aesthetic experience, without renouncing representation. His breakthrough, later called *multifocal perspective*, was a representational system generating an embodied scopic field that assembled multiple and personal viewpoints into one flat plane.[5] This aesthetic modality essentially constituted a nonaffirmative maneuver. It derailed the affirmation typical of the power/knowledge relationships established by quattrocento painting through the introduction of what Merleau-Ponty termed the "lived perspective."[6] After Manet's

work, *Cézanne's* constitutes a new rupture in the production of painting as agency-imbued object in the modern age.

Cézanne's groundbreaking idea was that of producing "a *trompe-l'oeil* married to the laws of the medium": a vision in which paint could be revealed in its material qualities (and not made to wholly disappear into the resemblance of other materials) and where the canvas ceased to be an objective mirror of the world.[7] In fact, *Cézanne's* more definite innovation lay in the problematization of the *physical and implied mobilization of the (painter's and) viewer's body*: in front of a still-life painting by *Cézanne*, and similarly to the condition prescribed by Roni Horn's diptychs, the viewer is not locked into the anthropocentric viewpoint of classical perspective, but is engaged in an active act of embodied negotiation.

Producing nonaffirmative paintings was for *Cézanne* a matter of drastically reconfiguring classical tradition. It was therefore plates, draperies, vases, coffeepots, bottles, statues (of human bodies), and tables that in their mundane, absolute stillness enabled *Cézanne's* gaze to construct the new spatializations of multifocal perspective. The frequent inclusion of apples, oranges, and onions as natural elements subsisted only as far as it provided the artist with the archetypal spherical forms of geometry he required to problematize his formalist vocabulary (fig. 5.2). It is this process of geometrization of the everyday object that Braque and Picasso problematized in their own still-life paintings, laying the foundation for cubism.[8]

Merleau-Ponty conceives *Cézanne's* multifocal perspective as that which phenomenologically gestures toward a prescientific possibility of relating to nature.[9] In this context, the artist's vision emerges as a nonclassical, nonpositivistic mediation between body and objects. But from this perspective, the persistent absence of animals in *Cézanne's* vision remains symptomatic of an overarching, anthropocentric approach. The artist's project, that of simultaneously attempting to transcend the unifying, illusional affirmation of quattrocento painting, does not equate to abandoning anthropocentrism itself. Consequently, when *Cézanne* reportedly claims to be "attempting a piece of nature," he would be more appropriately understood to be "attempting a piece of [*human*] nature." As T. J. Clark notices, in *Cézanne's work*, "the world has to be pictured as possessed by the eye, indeed totalized by it; but always on the basis of exploding or garbled or utterly intractable data—data that speak to the impossibility of synthesis even as they seem to provide the sensuous ma-

FIGURE 5.2 Paul Cézanne, *Still Life with Apples and Peaches*, 1905. Oil on canvas. 31 7/8 × 39 9/16 in. (81 × 100.5 cm). Open-access image courtesy of the National Gallery of Art, Washington, DC.

terial for it."[10] Nonetheless, *Cézanne provided* the possibility for a departure: the opportunity for degrees of nonaffirmation to infiltrate the history of anthropocentrism in painting and art history. The paradox intrinsic to the episteme of the modern age, one that defines *Cézanne's still-life work,* lies in the acknowledgment that being human means to be caught between the immanent and the transcendent—simultaneously object to be studied and subject who studies, surrounded by the unthought and simultaneously functioning as source of intelligibility, the source and the result of history, the epistemic modality of the modern age.[11]

In *The Order of Things*, Foucault emphasizes the self-reflective nature of measurable finitude through the emergence of modern disciplines. Anthropology therefore became the discipline preoccupied with calling into question man's very essence, his finitude, his relation with time, and

the immanence of death,[12] whereas psychoanalysis focused on the relations between representation and finitude.[13] It is through the emergence of this specific project that human/animal relationships become further problematized in the ambit of modernity. Therefore, animals make conspicuous appearances in both psychoanalysis and anthropology, as markers of the extreme limits of discourses. But their very purpose is that of demarcating the limits of human finitude—the essence of being human as defined by the inability and presumed lacking of the animal. Thus, animals appear as transcendental symbolic entities (in psychoanalysis) or as immanent measurers of otherness (in anthropology).

Cézanne's paintings inaugurated a new epistemic space in which the analytics of finitude could be mapped and constructed and in which animals therefore vanished from the canvas. And it is also not a coincidence that this disappearance, one that involved the work of many other European artists of this period, took place along the emergence of photography and film. These new media simultaneously incorporated and challenged the aesthetics of classical painting, causing a deep rupture in the discourses and practices that characterized it until that point. Acknowledging the role played by the new technologies of visuality in the modern age elucidates why animals representationally migrated from the medium of painting to that of photography and film at this very point in history. Tracking the movements of this animal migration enables the identification of an early anthropogenic loop that will become essential to contemporary speculative taxidermy.

MECHANIZED VISION AND PERCEPTION: A REPRESENTATIONAL ANIMAL MIGRATION

The animal migration I have just introduced problematizes Akira Mizuta Lippit's notion of modernity's exclusion of animals as a rhetorical sacrifice.[14] In *The Electric Animal*, Lippit states that "modernity can be defined by the disappearance of wildlife from humanity's habitat and by the reappearance of the same in humanity's reflections on itself: in philosophy, psychoanalysis, and technological media such as the telephone, film, and

radio. During this period, the status of the animal itself began to change at the very point that animals began to vanish from the empirical world."[15] Reading animals' presence in film as a spectral phenomenon and thus extending John Berger's original argument on mourning and loss, Lippit is primarily concerned with the conception of cinema as "a vast mausoleum for animal beings," a concept resonating in Poliquin's connotation of taxidermy as a practice of longing.[16] But this romanticized conception of animals' disappearance from the natural world and their simultaneous, spectral appearance in film and photography is essentially limited, for it excludes painting from the economies of animal visibilities and invisibilities that governed image consumption during the first half of the twentieth century. Lippit and Berger somehow failed to acknowledge that the relationship between photography and painting, and therefore between mechanized vision and human vision, was indeed an interrelated one throughout the nineteenth century.

For instance, photography constructed new registers of representational realism. The belief that the mechanical nature of photography would restrict intellectual creativity in painting was widespread among artists and theorists alike. *Cézanne,* unlike some other impressionist painters, positioned his painterly practice within a constrictive, skeptic attitude toward photography. As Steven Platzman, scholar of *Cézanne's* body of work, argued, "For *Cézanne,* only the painted or drawn image, based on observation, rather than photographically generated, could serve to define and build his ever evolving identity."[17] Likewise, cubist artists' incorporation and problematization of *Cézanne's* multifocal perspective have been largely understood to constitute a project diametrically opposed to the mechanization of vision proposed by the photographic and the filmic lenses. As seen, *Cézanne's* early modern paintings, and subsequently those of cubism, proposed radically nonaffirmative representational strategies in which the viewer's body was physically mobilized and engaged in an active process of mediation and resolution, a process designed to explore individual perception—an interiorized world. In opposition, the cinematic apparatus and the photograph looked outward, and in so doing, these media reproposed panoptic spatial relationships between viewer and image. The cinematic apparatus, especially, positioned the spectator as a transcendent subject upon which specific ontological

structures could be imposed.[18] Both media provided parameters through which the human could self-construct, self-observe, and simultaneously be observed, allowing to study and be studied, seemingly, in the most specularly and objectifying of ways.[19]

Rather than a transition from material world to the representational register of film and photography, it was a *migration* from painting to photography and film that characterized the new modalities of animal representation in the modern age. This representational animal migration was forced upon animal visibility by the persistence of classical sovereignty; the new sovereignty was enabled by the flickering beam of light shining through the mechanical objectivity of the projector. Filmic images of animals appeared new and fresh in comparison to those produced by classical painting, yet they structurally reenacted and reinforced old panoptic relations. What is amiss in Berger's and Lippit's view that animals disappeared from everyday life and simultaneously appeared in film and photography is the all-important emergence of a preanthropogenic loop involving materiality and aesthetics.

THE ANIMAL AUTOMATON: ASSEMBLY, DISASSEMBLY, AND FILM

During the nineteenth century, predominant modalities governing human/animal relations were structured by technocapitalist economies of visibility. Nicole Shukin's cultural materialist engagement with representation in *Animal Capital* enables a further problematization of sovereignty and filmic image consumption to emerge in this context. Shukin identifies intrinsic, structural parallelisms and overlays between the mechanized development of the slaughterhouse, the birth of the automobile industry, and the rise in popularity of the cinematic apparatus at the end of the Victorian period.[20] The author configures Henry Ford's assembly lines as a reversal of the dynamics at play in the abattoirs' disassembly lines—both, she argues, structurally resembled the sequential running of celluloid frames (gelatin produced from the synthesis of animal tissue) in front of the projector's lamp. The latter appears "mimetically premised"

on the reversal of the logistics of animal disassembly through the work-ing of endless cycles of visuality of technological replication.[21] These two seemingly unrelated moving lines, one disassembling animal bodies and the other assembling car parts, appear aligned in a complex mimetic relation specific to the technological/visual interfacing of the turn of the nineteenth century.

The structural parallelism between the slaughterhouse disassembly lines and automobile part assembly is also aligned to the technological cinematic image by time-motion economies—as the photographic frame, spliced and repeated in the filmic reel, first disassembles the animal body into a multitude of minutely different replicas of itself and then reassembles them in the production of the moving, realistic illusion. As Shukin notes, animals hoisted onto overhead tracks were put into motion like the pho-tographic frames of cinematic technology.[22] And just like in Muybridge's zoopraxiscope, which was developed at around the same time, the abat-toirs capitalized on intermingling and increasingly popular new modes

FIGURE 5.3 Eadweard Muybridge, 1887, *Animal Locomotion: An Electro-photographic Investigation of Consecutive Phases of Animal Movements* (Philadelphia: J. B. Lippincott), plate 704.

of image production and consumption, running very popular abattoir tours.

Interestingly, both processes, the photographic and the industrial, engage in unprecedented animal renderings intrinsic to the politics of the mechanized visualities of animal capital in the early modern age. Rendering is here used in two ways: the first entails an act of mimesis intended as the copying of an object through manual or mechanical reproduction; the second refers to a process of industrial recycling of animal materials[23]—a technologically operated form of transubstantiation. This double entendre of rendering well serves Shukin's ontologization of animal matter and representation, one in which the materiality of animal bodies ceases to disappear in the depths of discourses and instead functions as an irreducible agent in the problematization of representation itself.[24]

In reference to the object of film stock more specifically, Shukin convincingly argues that "in its celluloid base and its see-through gelatin coating—it is possible to discern the 'two-layered mimesis' through which modern film simultaneously encrypted a sympathetic and a pathological relationship to animal life."[25] Thus, in the workings of rendering, we can identify the essentialist, capitalist complicity that objectifies animals, not simply through representational tropes but through an undeniable incorporation of animal materiality intrinsic to the mechanized technologies of the early modern age. Modern rendering thus emerges as a precursor of later anthropogenic conditions in which causality and the aesthetic dimension cooperate in indissoluble entanglements. This results in a weird loop in which the politics of coexistence inevitably appear contingent and contradictory.[26]

This aesthetic and material contingency lies at the core of the charged instability that underlines speculative taxidermy objects, in which the recalcitrant material indexicality of animal skin challenges the viewer on the grounds that that which is being presented is no longer an animal in the classical/objective sense of the term, and neither is it simply the encounter between artist and animal, but the *result* of human/animal relations defined by technocapitalist economies of the Anthropocene. This will become central to the elaboration of a biopolitical theory of mimesis in which symbolic and physical technologies of reproduction are indissolubly intertwined in taxidermy.[27] Thus, speculative taxidermy is charged on the representational and material level—or carnal level—

through the display of animal skin as the preponderant signifying surface element.[28] Rather importantly, in Shukin's view, "rendering expands the sense of mimesis beyond its canonical associations with realist rendition."[29] As will be seen, the representational animal migration from painting to photography and celluloid therefore poses a set of pressing ethical questions related to representation, sovereignty, and image production/consumption in the modern age that is directly linked to today's practices in contemporary art.

ANIMALS AND ART: TAKING THE MATERIALITY OF SURFACES SERIOUSLY

The indissoluble synergy of the representational and the material proposes an ethical problematization of indexicality. Speculative taxidermy flaunts its materiality as an irreducible trace of discourses, practices, and, most importantly, past human/animal interactions. The agency of the artwork equally rests on its materiality and on its ability to mobilize discourses and practices through cultural allusions. The representational project of classical art has historically been distinguished by a basic, one-directional dynamic of transubstantiation in which the diverse materiality of the three-dimensional world was rendered through a process of reduction into one material. The Platonic conception of art as mimesis intrinsically implied a process of mediatic transference. Thereafter, the power/knowledge relationships that shaped artistic practices in the western world (until Duchamp) assessed materials such as bronze, marble, tempera, watercolor, and oil paint as preponderant vehicles for this task. By necessity, the Platonic and Aristotelian "condition of art" was implicitly supported by this very univocal process.[30] Therefore, an object that "imitates" another *is* an artwork, and furthermore the imitation in question must be rendered through a medium extraneous to that of the object it resembles. Of course, this conception of art has been vastly bypassed by modern and postmodern approaches, but new questions about the importance of materiality in works of art have recently been emerging in the study of contemporary practices. Especially in this sense, in its critical relation to animal materiality, speculative taxidermy surpasses postmodern aesthetics to inscribe ethical questions

about realism and the conditions that different notions of realism impose on human/animal relations.

As argued by James Elkins, art history has traditionally taken interest in the materiality of works of art on a general and abstract level.[31] This contingency has predominantly been the result of a reliance on phenomenology, especially capitalizing on Merleau-Ponty, Sartre, and Husserl.[32] But the changing scenery of contemporary artistic production is one in which the materiality of a work of art can no longer be ignored.[33] For instance, Elkins's extreme close-up analysis of the painterly surface central to his book *What Painting Is* replaced historicity with materiality, acknowledging what usually remains unuttered in art historical discourses.[34] This traditional epistemic modality was inherited from the practices and theories of neoclassical art that informed artistic production during the modern age. Ingres's point of view on painting and materiality, for instance, reflected popular positions on the relationship between the two. He believed that the painter's manipulation of materials should be concealed from the viewer's gaze, allowing the image to surface beyond the materiality that enables its visibility. "Touch should not be apparent. . . . Instead of the object represented, it makes you see the painter's technique; in the place of thought, it proclaims the hand."[35] Materiality was thus muted and paradoxically conceived as a domain irrelevant to art historical interpretation, as that which belongs to the realm of production, and therefore inferior. According to Elkins, "there is no account of the materiality of physicality of an artwork that contains an argument about the limits of historical or critical attention to materiality, and therefore there is no reason not to press on, taking physicality as seriously as possible, spending as much time with it as possible, finding as many words for it as possible."[36] A greater focus on materiality, he argues, can lead to a sense of anxiety about what can be said in a professional remit: a nonaffirmative maneuver that might cost the status quo. As Elkins points out: "[But] it is a *fact*, an unpleasant one, that the overwhelming majority of art historians and critics do not want to explore beyond the point where *writing becomes difficult*."[37] Following this line of thought, it becomes visible that venturing where writing becomes difficult in the pursuit of materiality also requires the will to abandon anthropocentric frameworks. Ultimately, the parameters of what we are allowed to see and to say in an art historical analysis have for centuries been limited by anthropocentric and

patriarchal epistemic structures. Taking the materiality of works of art seriously can therefore challenge the intrinsic anthropocentrism embedded in our relationship to objects, leading to the recovery of networks and agential relationships inscribing a political agenda, as seen through the work of Jane Bennett or Karen Barad. In the Anthropocene, materials no longer are inert conduits for meaning, and as anthropologist Tim Ingold argues, they are *substances-in-becoming*: their qualities are histories that invite us to follow and retrieve agential engagements between human and nonhuman networks.[38]

In this context, rendering becomes the starting point for the configuring of a human/animal studies–influenced and Foucauldian-informed theory of resilient materiality as central to this book. This materiality is burdened by an undeniable indexicality; it is charged with a specific type of allure, relentlessly gesturing toward human/animal power/knowledge relationships culminating in animal deaths. But to follow this line of thought, it will be necessary to return to the early modern period as shaped by the analytics of finitude, Cézanne's experimentation with still-life paintings, the increased popularization of photography, and the emergence of film.

Reconsidering the materiality of surfaces in early modern art inevitably leads to Braque's and Picasso's experimentation with the last stage of cubism, known as *synthetic*.[39] In those works, the artists furthered Cézanne's analytical work and implemented so-called primitivist aesthetics, thus radically challenging the boundaries of painting's classical conception of technical materiality. They therefore juxtaposed nonartistic surface textures as deliberate, nonaffirmative, formal elements upon the canvas.[40] Braque's and Picasso's derailment of classical affirmation was exclusively operated through the insertion of man-made, mechanically produced materials in the painterly plane (fig. 5.4). In this aesthetic challenge, the basic relations among art materials, surfaces, sign, and discourses, were willingly misplaced, proposing an ontological collapse between the representational plane of painting and the outside world that it used to straightforwardly represent.[41] In this sense, we can understand cubist collage as opening a path, not to modernism at its most arid, but to the recontextualizing strategies of postmodernism.[42]

The ontological reconfiguration played out by the juxtaposition of material surfaces in cubism was further problematized at the beginning of the twentieth century by Marcel Duchamp's readymades and the

FIGURE 5.4 Pablo Picasso, *Compotier avec fruits, violon et verre* (*Bowl with Fruit, Violin, and Wineglass*), 1913. Charcoal, chalk, watercolor, oil paint, and coarse charcoal or pigment in binding medium on applied papers, mounted on cardboard. 64.8 × 49.5 cm. Open-access image courtesy of the Philadelphia Museum of Art.

proposal of an even more radical ontological collapse of resemblance upon itself. In a compelling argument, Thierry de Duve posits the Duchampian readymade as an object more closely related to the history of painting than to that of sculpture.[43] What he means is that the readymade was the sign of a crisis: the signifier of an impossibility to continue to paint.[44] Painting had been pushed to relentlessly reinvent itself by the pressure that photography and film placed upon realistic representation. The introduction of the readymade object in the category of the art ob-

ject further problematized the economy of materiality and surfaces initiated by cubism. Duchamp's interest in the aesthetics of industrialized functionalism proposed by the readymade was suggested to the artist by a visit to the Salon de la Locomotion in 1912, where he is reported to have said, "Painting's washed up. Who'll do anything better than that propeller?"[45] Similarly to Henry Ford's experience of the mechanization of Chicago's meat-packing district, the direct experience of the new aesthetics of mechanical objects informed Duchamp's radical line of questioning introduced by the readymade objects.

At this point, implementing Ron Broglio's proposal for a heightened attention to surfaces in art to Shukin's sensitivity for animal-materiality in dealings of animal capital will provide a sound base to outline a modern genealogy of speculative taxidermy. As seen in chapter 2, the main premise of Broglio's book *Surface Encounters: Thinking with Animals and Art* lies in taking animal, human, and artistic surfaces seriously.[46] The totalization of the anthropocentrism of humanism through the positivistic violence of the Enlightenment reduced animals to beings "living on the surface."[47] In opposition to the cogitant/spiritual depth of man, according to Cartesian conceptions, animals cannot engage in critical reflection and therefore lack the depth required by self-reflexivity.[48] This reductive view condoned animal objectification, enabling cruelty against them.[49] In the light of this, Broglio proposes to reconsider our relationship with radical otherness, instrumentally adopting the metaphorical and literal flatness of animal and artistic surfaces as productive epistemological interfaces through which the reconfiguration of human/animal relations can be operated. Art "has a particular investment with surfaces that is useful in unhinging philosophical concepts and moving them in new directions," according to Broglio.[50] This proposition is worth further exploration.

MATERIALITY, TECHNOCAPITALIST ECONOMIES OF VISIBILITY, AND THE SURREALIST OBJECT

Despite the art historical conventions that emphasize the demise of figuration (largely caused by the omnipresence of photography) and the rise of abstraction, one of the most important and yet neglected turning

points in art lies in the criticality that artists develop in their relationships with surfaces. Although readymades were first exhibited during the second decade of the twentieth century (fig. 5.5), the influence of the readymade art object became more apparent after the Second World War in the hands of artists like Jasper Johns and Robert Rauschenberg, who recovered the Duchampian notion of the beholder, well before Michael Fried wrote about theatricality and minimal art.[51]

The important influence of readymade objects on the emergence of animals and taxidermy in contemporary art has been largely ignored in animal studies discourses. Baker's theorization of the postmodern animal, for instance, has overlooked the assonances between the aesthetics of some botched taxidermy and the uncanny charge of surrealist objects. In the 1930s, the surrealists held two exhibitions dedicated to objects. The first took place at the Pierre Colle Gallery in Paris, in 1933.

FIGURE 5.5 Marcel Duchamp, readymades on display at the Philadelphia Museum of Art, 2009. From left, *Bicycle Wheel*, 1913, *Bottle Rack*, 1914, and *Fountain*, 1917. Photograph courtesy of Sarah Stierch, CC BY 2.0.

The second took place in 1936, at the Charles Ratton Gallery. The gallery specialized in primitive art—something that might have facilitated the incorporation of the new pseudoethnographic aesthetics of the surrealists. Among the works were pieces by Duchamp, Picasso, Ballmer, Magritte, and Dali.

But of the many challenges posed by surrealist objects, a prominent one surely lay in the recurring positioning of the object as a crux where discourses on the body are harnessed in commoditized, mass-produced economies.[52] The body politics at play in the surrealist object thus propose a defining distinction between the productive opportunities of two conceptions of fetishism: the psychoanalytical and the socioeconomic.[53] The Marxist notion of *commodity fetishism* that underlies these objects enables a heightened fluidity of new discourses to emerge in a reconsideration of the charge of surrealist objects.[54] In the surrealist object, commodity fetishism is the preponderant theoretical tool that enables us to outline a genealogy grounded in forms and materials through the acknowledgment of capitalist commodity society as the immanent base of art production.[55] It is through the consideration of commodity fetishism in relation to the surrealist object that the social and economic registers involved in the conception of a truly revolutionary art-value in surrealism can be grasped.[56]

Among others, Walter Benjamin was particularly receptive to the agency of material objects and their vibrancy in surrealist contexts. In the "Convolute K" section of *The Arcades Project*, Benjamin describes capitalism as "a natural phenomenon with which a new dream-sleep came over Europe."[57] And according to him, the surrealist interest in commodities and their materialities represents an awakening from this very sleep. This theory is exemplified by the concept of *traumkollektiv*, or dream-collective, a type of collective unconscious that unlike Jung's version bears specific connotations to distinct historical milieus. The collective unconscious is therefore defined by the utopian desires of the nineteenth century—its promises of excessive material wealth along with the utopianist ambition to de-class society. This collective unconscious, Benjamin argues, produces "wish images" that inscribe the vestiges of collective desires in capitalist registers. It is fair to propose that surrealist objects indeed constitute "wish images" capable of inscribing social and economic relations that have fallen into an unconscious

state. The awakening Benjamin finds in surrealist works thus involves an essential notion of agency grounded in the possibility of recuperating commodities as critical tools. In this sense, Benjamin configures a model of commodity fetishism in which the object is animated by human agency as well as imbued with its own agency, establishing an important object/subject fluidity. It is in this sense that animal skin plays a key role in speculative taxidermy—it emerges as the materiality generated by human/animal relations of the body (both animal and human), relations capable of undoing the deliberate forgetting produced by commodity fetishism and enabling new connections to arise between the past and the collective.

Similarly to Shukin's double entendre of rendering in the context of animal capital, the surrealist object appears as challenging crux of seemingly unrelated discourses, all intrinsically intermingled with and by technocapitalist economies. The ambiguous duality of "the body as object" and "the object as body" is endowed with a political charge grounded in the reconfiguration of the role played by materiality in art and as articulated by the surrealist object-assemblage itself.

In *Obscure Objects of Desire: Surrealism, Fetishism, and Politics*, Joanna Malt focuses on the montage aspect of the surrealist object. Materials (machine made and animal derived) and, most importantly, surfaces effectively substitute the dream as "authentic voice of the human unconscious" and as the predominant underlying psychoanalytical base to understand surrealist art.[58] Quite rightly, Malt claims that the persistent psychoanalytical fetishistic approach to surrealist objects has traditionally diminishes their signification as works of art within a broader frame of reference: "the dream model too quickly becomes a normative stricture and reduces surrealism's power to surprise and reveal."[59] The predominantly psychoanalytical configuration of animals within the surrealist paradigm inevitably positions animals within the objectifying, anthropocentric parameters of the analytics of finitude, according to which psychoanalysis is a prominent, disciplinary manifestation.[60] As Kelly Oliver argues in *Animal Lessons: How They Teach Us to Be Human*, "Freud is especially fond of trotting out animals to perform the Oedipal drama. Freud stages the Oedipal complex, along with castration, anxiety, neurosis, and the primary processes, using animals, which appear on cue whenever his theory is in doubt."[61]

PLATE 1. Snæbjörnsdóttir/Wilson, *between you and me.* Installation view featuring *the naming of things*, 2009. © Snæbjörnsdóttir/Wilson.

PLATE 2. Mark Fairnington, *Turaco Green Lady*, 2011. Oil and gold leaf on panel. 80 × 56 cm. © Fairnington.

PLATE 3. Mark Dion and Robert Williams, *Theatrum mundi: Armanium*, 2001. Wooden cabinet, mixed media. 110 2/3 × 110 3/7 × 24 4/5 inches; 281 × 280.5 × 63 cm. Installation view, *The Macabre Treasury*, Museum Het Domein, Netherlands, January 20–April 29, 2013. Courtesy of the artist and Tanya Bonakdar Gallery, New York. © Dion.

PLATE 4. Mark Dion, *Landfill*, 1999–2000. Mixed media. 71 1/2 × 147 1/2 × 64 inches; 181.6 × 374.7 × 162.6 cm. Courtesy of the artist and Tanya Bonakdar Gallery, New York. © Dion.

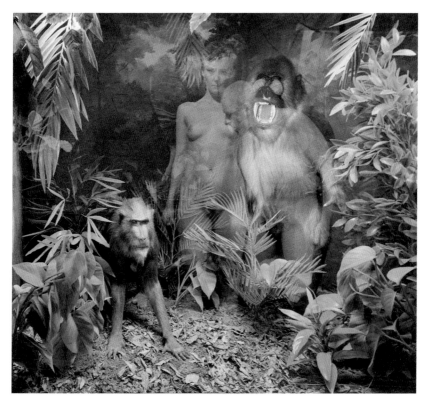

PLATE 5. Oleg Kulik, "Monkeys," from the *Museum of Nature or New Paradise* series, 2000–2001. © Kulik.

PLATE 6. Roni Horn, *Bird* (detail), 1998/2007. Iris and pigment printed photographs on Somerset Satin paper. 22 × 22 inches; 55.9 × 55.9 cm each, 10 pairs/20 pieces. Courtesy of the artist and Hauser & Wirth. © Horn.

PLATE 7. Robert Rauschenberg, *Monogram*, 1955–59. Combine: oil, paper, fabric, printed paper, printed reproductions, metal, wood, rubber shoe heel, and tennis ball on canvas with oil and rubber tire on Angora goat on wood platform mounted on four casters. 42 × 63 1/4 × 64 1/2 inches; 106.7 × 160.7 × 163.8 cm. Moderna Museet, Stockholm Purchase 1965 with contribution from Moderna Museets Vänner/The Friends of Moderna Museet. © Rauschenberg.

PLATE 8. Maria Papadimitriou, *AGRIMIKA*, 2015. Courtesy T.A.M.A Temporary Autonomous Museum for All and the artist. © Papadimitriou.

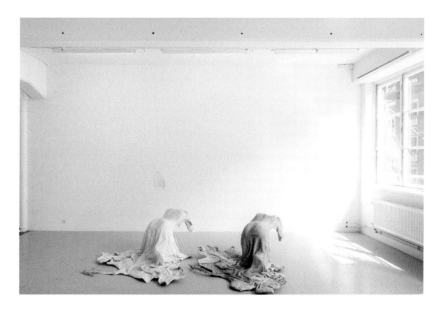

PLATE 9. Nandipha Mntambo, *Umfanekiso wesibuko* (Mirror image), 2013. Cow hide, resin. Left: 25 63/63 × 66 59/64 × 63 25/32 in; 66 × 170 × 162 cm. Right: 23 15/64 × 70 55/64 × 61 1/32 in; 59 × 180 × 155 cm. Installation view, Andréhn-Schiptjenko, Stockholm, 2013. Photo: Jean-Baptiste Beranger. Collection 21c Museum, Louisville, Kentucky. Courtesy Andréhn-Schiptjenko, Stockholm. © Mntambo.

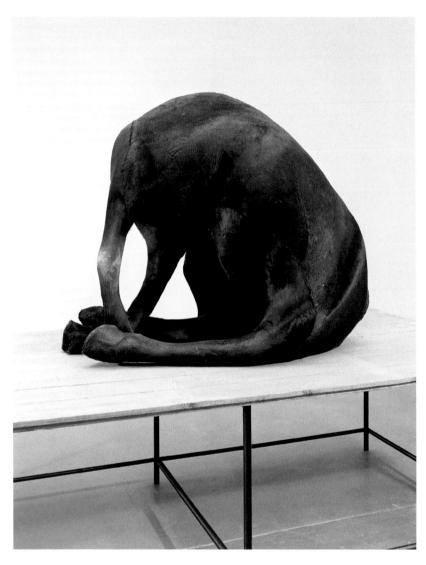

PLATE 10. *Berlinde De Bruyckere: K36 (The Black Horse)*, 2003. Horseskin, wood, iron, PU-foam. 295 × 286 × 158 cm. Collection Pei-Cheng Peng. Courtesy Hauser & Wirth and Galleria Continua. Photo: Attilio Maranzano. © Berlinde De Bruyckere.

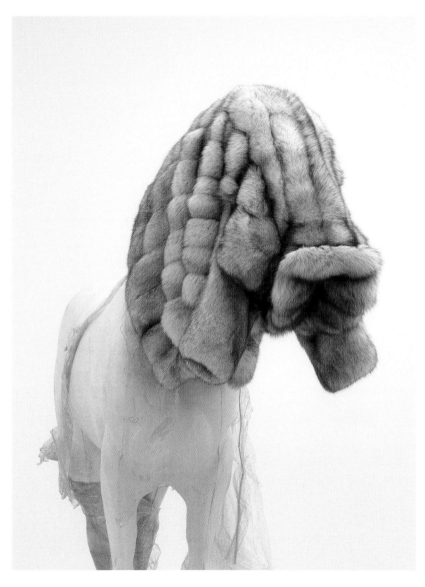

PLATE 11. Steve Bishop, *It's Hard to Make a Stand*, 2009. Fur coat, polyurethane, polythene, mirrored acrylic, wood. 215 × 196 × 102 cm. Courtesy of the artist and Carlos/Ishikawa. Photography by Michael Heilgemeir. © Bishop.

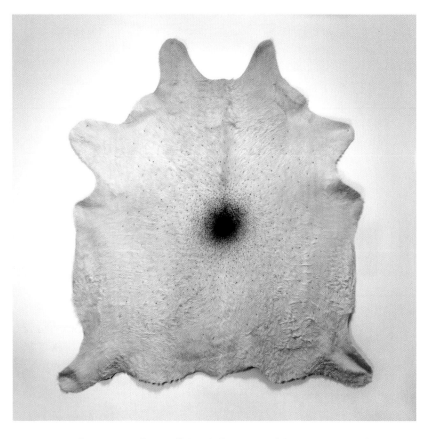

PLATE 12. Cole Swanson: "Swarm" (2015), from *Out of the Strong, Something Sweet.* Dean Palmer Photography. Exhibition curator Dawn Owen, 2016, Art Gallery of Guelph, Canada. © Swanson.

BODY POLITICS AND THE
SURREALIST ASSEMBLAGE

"What is particular to the surrealists," Malt claims, "is the desire to alter the categories of the object world, and our perception of it."[62] This desire is largely operated through the recognition that the material condition of the body is, starting with the early modern period, inscribed in techno-capitalist economies of consumption more than ever before in history.[63] But Malt's anthropocentric approach is not concerned with animals. The body she refers to is the *human body*, of course. However, the author provides two specific observations that can be used to apply this observation to taxidermy objects in art. Malt explores the treatment of the body in surrealism as "confusion between the animate and inanimate."[64] Here, the mannequin emerges as the archetypal figure in which this type of blurring can be performed on the grounds of its status as the uncanny replica, the "epitome of the commodity wearing the human form."[65] Her second observation, which will be considered in the remainder of this chapter, revolves around the ontological displacement of human and animal categories of matter performed by the surrealist object-assemblage.

In their ambiguous and enigmatic presence, fragments of fur, hair, and feathers in surrealist objects appear, as in lifelike taxidermy, ontologically suspended between livingness and death. As Malt notes, "they are of the body, but not of the flesh"—this ambiguous ontological status renders them highly unstable, indexically and materially charged objects. They oscillate between the status of everyday object and that of the relic.[66] Fur and feathers are thus identified as materials ontologically transcending the seemingly artificial inertness of machine-made surfaces.

Taking surfaces seriously prevents the ontological reduction of animal surfaces such as fur and feathers, providing a productive discursive rupture of extreme value to an analytical framework based on human/animal studies. Once brought into close proximity with the machine-made surfaces of commodities by juxtaposition, these rendered animal materials achieve a maximum potential of ontological derailment providing nonaffirmative disturbance within a work of art—in other words, these materialities cannot be silenced or made to comply within an affirmative framework any longer. In its nonaffirmative agency, this juxtaposition proposes the material-based derailing dynamics of Foucault's *tableau-objet*, that which through the deliberate derailing of ontological stability enables the unleashing of the event.

MONOGRAM AS SPECULATIVE TOOL

It was during the late 1950s that the crisis of materiality and surfaces re-
covered in this chapter opened the field of possibility from which
Rauschenberg's *Monogram* emerged. *Monogram*, one of the most enig-
matic works of art of the modern period, in more than one way, can be
considered a precursor of speculative taxidermy (fig. 5.6). In *The Postmod-
ern Animal*, Steve Baker states that *Monogram* might be "the first con-
vincing presentation of the postmodern animal."[67] He returns to *Mono-
gram* multiple times in the book to contextualize it as a confrontation that

FIGURE 5.6 Robert Rauschenberg, *Monogram*, 1955–1959. Combine: oil, paper, fabric,
printed paper, printed reproductions, metal, wood, rubber shoe heel, and tennis ball
on canvas with oil and rubber tire on Angora goat on wood platform mounted on four
casters. 42 × 63 1/4 × 64 1/2 in. (106.7 × 160.7 × 163.8 cm). Moderna Museet, Stockholm
Purchase 1965, with contribution from Moderna Museets Vänner/The Friends of
Moderna Museet. © Robert Rauschenberg Foundation.

resolves in the acknowledgment that animals remain inaccessible to us. This is the most frustrating aspect of botched taxidermy: its inherent postmodernist essence. When not indulging in pastiche and parody, postmodernism showed its darkest heart. It obsessively relished "the matter of fact." Its sarcasm would often turn to cynicism. It privileged the aesthetics of wrongness in anything, and it bore a passive pessimism at its core—one that eventually tired audiences. Baker's conception of botched taxidermy as "something gone wrong with the animal" is a product of its own time. Like many other postmodernist incarnations with a tendency to show all that was "rotten," its desire was to perform trauma, but it offered nothing, or very little, to recover from it. Botched taxidermy aligned the work of art with the impenetrability we attribute to animality—it had a revelatory power. But what can follow such acknowledgment? What can we do with the knowledge that animals are inaccessible and ever withdrawing, beyond admiring the ruin of classical representations?[68]

An important opportunity to overcome the limitations of the postmodernist aesthetic of wrongness lies in the proposal to follow materialities and surfaces in new and dedicated ways. Baker said that *Monogram* "goaded" the viewer, "putting the viewer in the position of the animal."[69] I believe that *Monogram* does a lot more than simply staging a "compellingly direct confrontation" or posing as an obstacle, and that much of what this work commands rests on its Dada/surrealist-inscribed genealogy, its unconventional deployment of materialities, and the ability to question the ontologies of natural and man-made within the context of representational realism.[70]

Monogram is a work that directly inserts the animal body among mass-produced everyday objects. It is Rauschenberg's most recognizable combine, and it has solidly secured a place in history of art because it seems to relentlessly withhold so much of itself—art historians simply don't seem to agree about what to say in relation to this sad-looking taxidermied angora goat girdled by a car tire, standing on a makeshift raft. This inability to semantically pin down this combine stems from the highly unusual and abrasive material presence of the piece itself. The angora wool looks matted; the somewhat melancholic look on the face of the goat is counterpointed by splashes of thick, glossy paint; the opacity of the rubber tire is offset by white paint applied to its tread; the surface of the

raft is covered in paint, fragments of wood, paper, cardboard, newspaper articles, prints, and traces that have been painted over with a general disregard for contours; and some of these fragments bare the visible imprint of commercial lettering—broken-up words; the failure of language. Paradoxically, the solemn simplicity *Monogram* embodies is the result of a complex interconnection and layering of many materials, textures, and surfaces: a "sculpture-painting" that challenges any canon of classical art.

Beyond the unorthodox materiality that characterizes it, *Monogram* has puzzled critics because of the enigmatic animal presence it comprises. In 1959, when it was first exhibited at Leo Castelli's gallery in New York, the use of animal skin in artistic contexts was unusual. As we know, surrealism had repeatedly flirted with the awkward and alluring materiality of fur, but presenting a whole angora goat, rather than a manipulated, fragmented, or reinvented animal body, constituted a rupture with previous discourses and practices. Initially, this work was condemned by some critics as little more than a satirical and derivative object appropriating Willem de Kooning's brushstroke, Duchamp's readymade, and the collage technique of Picasso, Braque, and Kurt Schwitters.[71] These critiques can be used to better understand *Monogram*'s allure—its gesturing charge, the elusive quality characterizing the art object itself as ingrained in materialities that enable it to surpass the role of symbol. In this combine, not only do the juxtapositions of materiality transcend the prescription of the classical artistic canon, but it is clear that Rauschenberg deliberately presented a clash among notions of classical materiality in the use of paint, its contemporary rushed and time-based application, and the liminality between what was institutionally acknowledged as artistic language and what was not.

But despite *Monogram*'s irreducible material charge, most art historians have insisted on symbolic readings. Some have interpreted the goat as the oldest metaphor of priapic energy. The symbolic charge of the goat led to a recurrent reading of *Monogram*. Roger Cranshaw, Robert Lewis, and Robert Hugs all agree that in its semantic loading of the tire as a signifier, *Monogram* proposes a metaphoric representation of the homosexual penetrative act.[72] Guided by a surrealist analytical structure, this reading, invites a Freudian game of free associations. This interpretation emerges from the consideration of Rauschenberg's own homosexuality. Hughes called *Monogram* "one of the few great icons of male homosexual love in

modern culture."[73] In general, these readings have been informed by Rauschenberg's own tendency to incorporate autobiographical elements in his work. According to Jerry Saltz, the goat is an early Christian symbol of the damned: a direct reference to Rauschenberg's status as gay/bisexual man and artist living in New York in the 1960s—therefore, allegorically, the artist was representing himself as "a satyr squeezing through the eye of an aesthetic/erotic needle."[74]

Other psychoanalytical interpretations could link the goat and the tire through the literal and metaphorical conceptions of *drive*—the goat is a symbol of sex drive, while tires are essential car parts. Cars and sexual drive have been long associated in psychoanalytical terms, while in this case, because of the position in which the tire is situated around the waist of the goat, *Monogram* could be inherently gesturing toward the friction between desire and castration—the frustration of drive itself. Also recurrent in the art historical accounts of *Monogram* is the story that, as a child growing up in a Texan oil-drilling town, the artist was traumatized upon discovering that his father had killed his pet goat for food.[75] As seen from this perspective, *Monogram* appears as the spectral return of the unresolved trauma caused by the father figure—textbook matter for Freudian analysis.

Arthur Danto has proposed another symbolic reading, in which the goat figures as a sacrificial animal. But in relation to the materiality of the piece, Danto notes that "goat and tire have identities so strong as to counteract any tendency to think of them as other than what they were. . . . The power and absurdity of the combination suggests that his gifts of adjunction surpassed entirely his—our—capacity to interpret."[76] Of relevance to the interpretative short-circuiting caused by *Monogram* is the title of the piece itself—one that fails to anchor its meaning within a specific semantic register, thereby elusively freeing the combine in what Rosalind Krauss would have called an "uncontainable network of associations."[77] Cunningly, in 1981, Roger Cranshaw and Adrian Lewis advanced that in front of *Monogram* we are "faced with an abundance of competing semantic possibilities." The work thus solicits "decodification but frustrates its operation."[78]

But many of the hermeneutical challenges involved in *Monogram*, are not simply posed by its semantic openness or suggestive allusiveness. They are posed by what Elkins identifies as a persistent art historical problem: a difficulty of saying something related to an inability of following the materiality of the work of art itself—in brief: taking materiality

seriously. Classical art has trained us to think allegorically—symbolism became the quintessential manifestation of the true artistic object. In achieving its aims, classical art has substantially relied on a methodical reductionism of materiality. The sculpture of a lion could be made of bronze or marble but not with the flesh, bones, and skin of the lion itself (the reason why taxidermy was never accepted by the canon of classical art). The transubstantiation process of classical art discussed earlier in this chapter was, however, not simply a manifestation of artistic dexterity. It also constituted a contextual operation of transcendentalism—one that prompted the viewer to bypass the actual materiality of the object in order to admire its perfected and rationalized Platonic original: the object became an image, an idea.[79]

In the case of *Monogram*, Rauschenberg could have adopted the classical strategy of transubstantiation. He could have sculpted all the components of *Monogram* in marble, stone, or metal. Yet, he intentionally built the work with actual objects—the combine is built like a three-dimensional collage of readymades and found objects. This contingency should guide the interpretative method. It is implicit that the materiality these objects flaunt should prevent the viewer from leaving the actual objects behind in the search for a symbolic register—*Monogram*'s materiality is inseparable from its semiotic components, and its semiotic components are largely determined by the materiality that defines them.

First and foremost, following the materiality of works of art entails a collapse of the object/subject dichotomy through which the viewer becomes a material-semiotic actor. In Donna Haraway's view, this entails the ontological collapse between the definitions of human and nonhuman, the social and the physical, the material and the nonmaterial.[80] The materiality of a work of art thus becomes intrinsically bound to the practices that manipulate its material component and to the discourses that define this component on aesthetic grounds: the classical relationship between matter and form is entirely brought into question. Recovering muted materialities from the textualities of symbolic readings becomes one of the important methodological steps informed by new materialism and contemporary art. Following materiality seriously takes us to the very edges of the boundaries of discourses, and well beyond the conception of authorship—it challenges what can be said and thought about the objects we shape and that shape us.

All the symbolic readings of *Monogram* that have been presented in this chapter implicitly subjugate the objects in the combine, determining a fixed anthropocentric reading and anchoring a semantic register that disavows materiality. Sensation and affect are essential to the aesthetic experience through which *Monogram* relentlessly gestures toward multiple inferences. From this perspective, its unorthodox materiality can be understood as that which derails and ruptures the rhetorical determinism of symbolism: a normative set of strictures that implicitly organizes materiality within a semantic grid capable of structuring gender roles, societal behaviors, and racial/cultural stereotypes. Most importantly, this reprioritization of materiality provides a platform upon which the viewer might bypass the overemphasis on linguistic signification and social constructivist theories in the hope of opening up a space of critique situated between the traditional descriptive and interpretative roles of art history. The irreducible materiality of the goat's wool, the rubber of the tire, and the wood of the signs upon which fragmented texts appear all bear irreducible connections to the outside world. As Rauschenberg said: "All material has history. All material has its own history built into it. There's no such thing as a 'better' material."[81]

Another hermeneutical challenge presented by *Monogram* lies in Rauschenberg's flat ontologization of the objects included—in his combines, all objects are of equal importance, and *Monogram* is no exception. In this sense, the animal surface, as in surrealist assemblages, is inserted among the inanimate and the commodity. The angora goat appears to be as important as the raft upon which it stands or the tire that encircles it. This conception of objects as "equal to each other" within a compositional scheme had already been explored in cubist paintings by Picasso and Braque, and most notably in the constellation works by Miró from the early forties, in which the artist deliberately conflated the networked flatness of macroscopic outer space with the flatness of microscopic biomorphic organisms. Miró believed in a universal equivalence of objects and that objects provided a magical encounter with chance. This simple proposition constitutes one of the most powerful nonanthropocentric maneuvers in modern art, for it disrespects the hierarchy of material values and artistic skills that have for centuries defined the very notion of power and knowledge. These perspectives anticipated by far, among others, Levi Bryant's theories of object-oriented ontology that today attract the attention of

many artists and scholars, and that will be explored in the next few chapters.[82] However, the ontological alignment of the goat, the tire, the board, and the images in this combine leads to an ethical totalization of animal life. Or can we bring ourselves to think beyond the register of visibility of animal death in order to consider that many of the objects included in the combine involve rendered animal matter, as Shukin pointed out, and that therefore animal death cannot be localized exclusively in the visibility of the animal form? Following materiality in a work of art surely entails moving beyond the literalism of visibility.

And could the realist taxidermy goat be considered art at all if it were not girdled by a tire? It is claimed that it was Jasper Johns who suggested that the tire should hoop the animal's body.[83] This intervention removed the goat from the natural history connotation it still bore as taxidermy and shifted it into the realm of artistic discourses initiated by Duchamp's readymades at the beginning of the century—think of *Bicycle Wheel*, for instance. Combines such as *Monogram* defamiliarize the familiar (another surrealist-derived strategy) and thus create a place of uncertainty in which objecthood and spectatorship involve the negotiation of a complex encounter—one bearing no easy resolution that could be retraced in a history book, a religious text, or a mythological narrative.

Caught up in a difficult-to-negotiate clash between form and materiality, this animal no longer *is* the isolated specimen of science but appears to be a part of a microcosmology of objects. What is striking about all the different interpretations of *Monogram* is that no art historian has effectively attempted to seriously think about the animal presence in the work in terms of its materiality. Even the obvious, still symbolic and rather literal interpretation of the piece as a representation of nature's and technology's antagonism, one that is consumed upon the cultural background symbolized by the painting/raft object, could bring some attention to the goat and its role in the work in a sense that is at least closer to some environmental or human/animal concern. But this is not an interpretation that the artworld has found interesting, at least thus far—for a long while, art involving ecological statements has smacked of propaganda, and in the eyes of many, its artistic value is diluted, if not corrupted.

While *Monogram* can be easily read as a clash between nature and technology, I also argue that *Monogram* can be productively understood as an early critique of realism in art. The work brings together, in an on-

tologically flattened manner, different and compromised forms of representation, from a long-awaited recognition (although tongue in cheek) of taxidermy as sculptural practice worthy of artistic attention, to the Duchampian readymade (the tire and the tennis ball), to painting, collage, photography, and traces of inked human feet. Placed next to each other and haphazardly networked in this system, they all reveal their inabilities to match reality—their limitations and intrinsic contradictions are thus made to emerge. *Monogram* situates itself at a crisis broader than that between human and animal. It inscribes the human/nonhuman crisis in the registers of ontology, realism, representation, and their indissoluble intermingling in contemporary visual production and consumption modes. It does so by questioning the essential differences between man-made objects and animal-life, technology and nature, two-dimensional images and three-dimensional ones, painted pictures and photography, and life and death. Through the juxtaposing of indexical and representational tropes, *Monogram* questions different conceptions of realism, challenging all and favoring none. Its ultimate, essential challenge might be the proposal of a "compulsory reality check." In this sense *Monogram* is a true precursor of speculative taxidermy. Its aesthetic does not suggest that something has gone wrong with our relationship with animals, but that our ontological rationalization of the world is superficial, contradictory, and ultimately unattainable—and thus is responsible for our complex and conflicted relationship with animals.

Most importantly, Rauschenberg's combines were instrumental in reintroducing figurative representational imagery in the discourses and practices of the modern period, its break from realistic illusionism and its Greenbergian predilection for medium specificity. Clearly, Rauschenberg's artworks cannot be understood as autonomous or independent entities in a sense that Fried would have agreed with. And it is here that the strength of what speculative taxidermy can achieve in art can be better appreciated. The work of contemplation that Fried elaborated is one that outright dismisses aesthetic theatricality and conceptualism as strategies worthy of attention. Fried despised the fact that minimalist art conflated the artistic idea within the object itself. The blurring of the boundary between art and objecthood was thus perceived as a threat to transcendental purity. According to Fried, the mere existence of an object, as such, lacked a substantial signifying power.[84] However, one important contingency

identified by Fried in relation to the theatricality of minimalist art was that the embodiedness of the perceiving self also played a key role. As Hal Foster thereafter acknowledged in 1986: "In short, with minimalism 'sculpture' no longer stands apart, on a pedestal or as pure art, but is repositioned amongst objects and redefined in terms of place. In this transformation the viewer, refused the safe, sovereign space of formal art, is cast back on the here and now."[85]

This "effect of presence" of the minimalist object is, however, also a condition shared by the everyday object recontextualized as art object. But the substantial difference between the theatricality at play in minimalist art and that involved in *Monogram* lies in the impossibility of muting the presence/materiality of the objects conjured in the space. As seen, their intersection and juxtaposition constantly gesture toward disparate discourses of practices that reach beyond the experience presented in the exhibiting space. But in this sense *Monogram*'s link to speculative taxidermy is feeble—works of speculative taxidermy tend to inscribe past and present discourses and practices intrinsic to human/animal relationships, they sometimes feature ethnographic aesthetics and approaches, and, most regularly, they derail the discourses and practices involved in human/animal relations for the purpose of revealing inherent contradictions and ethically problematic biases.

However, in more than one way, *Monogram* certainly is a three-dimensional materialization of the *tableau-objet*—the work of art that challenges the viewer's preconceived notions of realism through the deliberate subversion of classical representation and the flaunting of abrasive materialities. The body of the viewer is once again displaced in this unorthodox sculpture in the round, which refuses to be seen from one specific angle. Walking around *Monogram* is an experience in itself, one that is heavily defined by the materialities incorporated in the piece. Yet I have never experienced this as a confrontation of any sort. The dislocation of the viewer's body from the sovereignty of central prospective in classical art is a complex performative operation involving a nonanthropocentric negotiation, not a confrontation.

6

THE ALLURE OF THE VENEER

Aesthetics of Speculative Taxidermy

"Things" are no longer passively waiting for a concept, theory, or sovereign subject to arrange them in ordered ranks of objecthood. "The Thing" rears its head—a rough beast or sci-fi monster, a repressed returnee, an obdurate materiality, a stumbling block, and an object lesson.

—W. J. T. MITCHELL, *WHAT DO PICTURES WANT?*

Whatever we might think of Merleau-Ponty's relation to realism, he does insist on a distinction between the visible and invisible realms. For as he puts it, with typically seductive prose, the visible thing is "a quality pregnant with a texture, the surface of a depth, a cross section upon a massive being, a grain or corpuscle borne by a massive wave of being."

—GRAHAM HARMAN, *GUERRILLA METAPHYSICS*

AGRIMIKÁ: ANIMAL SKINS AND OTHER OBJECTS

The lighting is dim, and the air is filled with a distinctive musty odor of glue and leather. This is the first and lasting impression of the rooms in Maria Papadimitriou's installation titled *Agrimiká: Why Look at Animals?* at the fifty-sixth edition of the Venice Biennale. These spaces are not the fictional fabrications of the artist, like in Mike Nelson's labyrinthic

installations, but a painstakingly accurate transposition of a shop originally situated in the Greek city of Volos. To be more accurate, the artist has dismantled the entire business, piece by piece, and has relocated it in the pavilion. Its original owner, Dimitris Ziogos, has worked there since 1947 and has owned it since 1975.[1] He is electronically represented in the installation via short films in which he recounts the ups and downs of the business through the social, historical, political, and commercial relationships that defined the processing and trading of animal hides.

It soon appears clear that as a vestige of the past sociohistorical realities that once made Volos a vibrant town, the environment's material presence evokes a peculiar overlay of epistemic spatializations—the shop, the mausoleum, the archive, the exhibiting space, the cabinet of curiosities, and the surrealist exhibit: this is a space in which the materiality of the uncategorized, everyday objects on display holds the ability to connect narratives and retrieve cultural milieus in which *natureculture narratives* have intertwined for nearly a century. Here, the structure is archaeological and the backbone, ethnographic. The objects the shop contains are sedimentations—strata of cultural imprints embedded in the materiality of magazines, postcards, newspaper cuttings, obsolete tools, furniture, and animal skin. Papadimitriou's artistic gesture, that of relocating the shop/workshop in the realm of contemporary art, is a Duchampian one in essence. The whole shop is a large readymade or, more accurately, an assemblage of readymades inscribing an anthropogenic chain of agency in which humans, animals, geographies, materialities, and biodefining economies become visible.

Back in Volos, the *Agrimiká* (*agrimiká* means wild animals) shop had become a ruin (fig. 6.1). The owner predominantly kept it open as a place of conversation for the locals to meet, discuss the present, and reminisce about a better past. Now fully disentangled from its original utilitarian network, the space, along with its contents, can be understood as a Heideggerian object of the kind that no longer is ready-to-hand. According to Heidegger's tool analysis, as long as objects remain ready-to-hand and therefore serve a practical function, they disappear to our conscious. These objects are thus caught up in a paradox: they relentlessly withdraw in the thin depths of their surfaces—the veneers. When functional purpose fails, or when it is deliberately frustrated, a new awareness of objects can emerge.[2] This is clearly the agential factor inscribed in *Agrimiká*, and most

FIGURE 6.1 Maria Papadimitriou, *Agrimiká*, 2015. Courtesy T.A.M.A. (Temporary Autonomous Museum for All) and the artist.

importantly, it is the assemblage the objects form to engage the viewer in a series of considerations involving human/animal relations as sociocultural markers of historical scenarios.

Graham Harman has proposed to focus on the productivity at stake in considering objects as interconnected entities that gain significance from their references to one another.[3] To Harman, mutual interrelation does not exhaust the reality of each object. But one factor impossible to ignore in *Agrimiká* is the heterogeneity of the objects configured as a point of crisis. In *Agrimiká*, taxidermy skins propose a speculative challenge. They speak of an impossibility Harman would not agree with—the impossibility to reduce objects beyond their materialities, to get to their individual or shared truth, but also to successfully silence their historical/ cultural significance—one that is intrinsic to their material surfaces, constitutes an elusive aura, and defines these assemblages as art objects rather than simply everyday ones.

Objects have a tendency to withdraw to consciousness, Harman claims, yet they also have a tendency to withdraw from one another. The inanimate

collisions between objects (cotton being burned by fire, for instance) "must be treated in exactly the same way as human perceptions, even if the latter are obviously more complicated forms of relation."[4] But for as much as this position might appeal to current critiques of anthropocentrism, it is worth noting that its productivities might be limited. Attempting to conceive of things in themselves, might not propose posthumanist productivities after all, especially when human/animal relationships are involved. One of the most striking aspects of *Agrimiká* is in fact the juxtaposition of objects that vehemently seem to resist Harman's attempt to devise a flat ontology—tools lie on tables next to books, magazines, postcards, tins, and so forth (fig. 6.2). Objects are gathered in seemingly spontaneous tableaux or assemblages that enhance the variety of material specificity. But most importantly, in a world of objects, for Harman, animals simply are another kind of object, one that responds and functions according to the same metaphysical rules of all others.

Next to man-made objects of all kinds, in *Agrimiká* are animal skins. Some of them are flattened and hang on the walls, side by side. Others

FIGURE 6.2 Maria Papadimitriou, *Agrimiká*, 2015. Courtesy T.A.M.A. (Temporary Autonomous Museum for All) and the artist.

are piled on the floor, and some others appear in three-dimensional form, as taxidermy mounts. The flat skins more readily propose a problematic, aesthetic affinity with other two-dimensional objects situated on walls: newspaper clippings, maps, photographs; the mounted skins place the animal-made object in a different relation to the three-dimensional objects that surround them. What ethical dimension applies to this alluded ontological fluidity?

There is a peculiar parallelism between the notion that objects are inaccessible and infinitely withdrawn and the first wave of human/animal studies critiques of animal inaccessibility: the claim that animals constantly withdraw. They withdraw in the sense that we can never access their thinking, their being. Animals also withdraw from other animals, plants, stones, and environments in the sense that they inescapably collide with them but simultaneously never fully disclose their deeper intentions, and neither do they usually seem to unveil their nature to one another. Animals withdraw as formal entities, and as bodies in space they maintain an elusive attitude toward humans. Zoos, aquariums, photography, and film are visibility devices that condemn the animal body to the full visibility of present-at-hand and therefore aim to counterbalance their tendency to withdraw. Historically, the visibility imposed on physicality is erroneously mistaken for a deeper level of connection with the animal. So, how does the speculative dimension of *Agrimiká* assist us in considering the productivities at stake in Harman's object-oriented ontology when animals or animal-made objects are involved in the equation?

Bruno Latour's interest in *things* has substantially informed Harman's revisionism of metaphysics. His conception of an "object-oriented sociology for object-oriented humans" that he elaborates in *Reassembling the Social* (2005) provides an important notion of how we might build on object-oriented ontology's flat approach.[5] Latour argued that "to be accounted for, objects have to enter into accounts. If no trace is produced, they offer no information to the observer and will have no visible effect on other agents."[6]

I have found myself wondering why the animal skins and the taxidermy mounts in *Agrimiká* constitute the most charged and vibrant objects on display—but finding a definitive answer has not been easy. To state that the animal skins testify to the undeniable deaths of animals simply does not seem to suffice, for this positioning would dismiss the

plant deaths that occurred in the making of the postcards, books, and newspaper clippings—if animals die, then plants die too.

INVISIBLE ANIMAL DEATHS

One of the obvious contributions of Harman's philosophy lies in its non-anthropocentric stance, or in its attempt to craft a conception of objects that is less anthropocentric than previous ones. Yet to what extent can objects be really known, and should this be our central preoccupation at all? And how can we quantify or evaluate the impact of their agency? It is at this point that object-oriented ontology's negative answers to these questions become intriguing, especially if we consider the positive alternative proposed by new materialism.

Jane Bennett's new materialism defies reliance upon traditional definitions of matter as passive by emphasizing the "active powers issuing from non-subjects."[7] Her model of materialism draws from the tradition of Democritus, Epicurus, Spinoza, Diderot, and Deleuze, but it most importantly finds inspiration in Derrida's conception of intimacy between *being* and *following*—the being in response to a call from something Derrida developed in his thinking about animals.[8] Like Harman, Bennett conceives objects as beings in themselves, but larger networks of agency are what she is really concerned with—assemblages that are capable of acting and interacting. The ultimate aim, once again, is that of decentering the human, yet, as Bennett acknowledges, the vital qualities she attributes to material bodies might be intrinsic to an inescapable anthropocentrism.[9] The vibrant vitality of matter might therefore not be solely an independent and intrinsic quality of things, but a field of intensities of some description that defines the affections that the undeniable presence of objects causes. To Bennett, not only can objects impede or block the will and designs of humans, but they can "also act as quasi agents or forces with trajectories, propensities, or tendencies of their own."[10]

At the beginning of the first chapter of *Vibrant Matter*, Bennett tells of the encounter with a random assemblage of objects, including a dead, or perhaps sleeping, rat found on a grate over a storm drain.[11] Her attention is not simply drawn to the objects because of their materialities. As she

explains, it is the network they create, the contingent tableau, but also the sunlight that hits them and the setting in which they appear. The fact that the objects are deterritorialized from their ready-to-hand condition also plays a key role. This situation generates an oscillation between the withdrawn state of debris and the agency of things.

"Thing-power," as Bennett calls it, the ability some objects have to stop us in our tracks because of their inherent vitalism, their ability to vibrate, applies equally to organic and inorganic objects.[12] Here lies an interesting albeit complex aspect of both object-oriented ontology and vital materialism: a substantial reconfiguration of the concept of *the living*. Similarly to object-oriented ontology, Bennett's thing-power operates an ontological flattening that appears problematic when non-man-made objects, living beings, or once-living surfaces are involved. However, unlike Harman, Bennett conceives thing-power as a political tool—something the author says might lead us to treat "animals, plants, earth and even artifacts and commodities more carefully, more strategically, more ecologically."[13] At the core of Bennett's hope lies the conviction that our conception of passive matter, something defined by capitalist materialism, has for too long fed "human hubris and our earth-destroying fantasies of conquest and consumption."[14] In some sense, I believe she is right—a heightened awareness of everything around us can constitute a positive platform for a different future. However, how can this awareness emerge through the strictures of capitalist materialism and its construction of a realism that dictates ethical norms? As Bennett claims, capitalist materialism essentially is an antimaterialism that consistently hinders the vitality of matter in order to enable capitalist consumption.

It is on these grounds that my curiosity for the animal skins included in *Agrimiká* brought me to consider more carefully the challenges involved in thinking about taxidermy and animal skins through the suspension of the ethical considerations regularly involved in animal death—not because animal death does not matter, but because a relentless emphasis on animal death has negatively characterized taxidermy through the lens of postcolonial critique and limits serious scholarly consideration of its agency in art. *Agrimiká* implicitly questions this paradigm. In this sense, more than any other, the return of Berger's original question "Why look at animals?" as part of the installation title should gesture toward new challenges of visuality and ethics.

Importantly, both object-oriented ontology and vital materialism ultimately focus on the challenges involved in speaking without erasing the independence of things or without obscuring the intensity of impersonal affect[15]—this is the essence of a project that structurally, in part, resembles human/animal studies' interest in the possibility of writing histories in which animals are not erased.[16] In Bennett's encounter with objects at the beginning of *Vibrant Matter*, a rat simply appears dead, or so the author suspects. In the same paragraph, Bennett wonders if the animal might be asleep instead. Whichever the case, the alive/dead status of the rat does not matter much to her.[17] From this perspective, the animal skins and taxidermy mounts in *Agrimiká* should ontologically share the same vibrancy. In *Vibrant Matter*, Bennett emphasizes the continuity between the traditionally living and the nonliving categories by focusing on the vital materials that compose both: the dead rat's body still is a living site for bacteria, microorganisms, fleas, mites—the livingness of the rat's organism has thus shattered into the livingness of multiple networks of microscopic agents. And, in a sense, it already, all along, was a conglomerate of bacteria and other microorganisms, which actively partook in the life of the rat when the animal was, biologically speaking, alive. In vital materialism there is no point of pure stillness, and a quivering can be traced down to the atomic level; hence everything is in a state of constant becoming. In this sense, Bennett's vital materialism has substantial similarities to Karen Barad's agential realism and its desire to collapse traditional notions of animate and inanimate, organic and inorganic. Avoiding an intrinsically hierarchical ordering of things is, according to Bennett, the essential prerequisite for the possibility of opening up space for forms of ethical practice. But what type of ethical practices can emerge when animal life is, at least discursively, ontologically aligned with that of a discarded glove or a bottle cap?

In Harman's conception, flowers, stars, wild animals, pirate ships, and copper mines have all been equally undermined in the pre-Socratic period, by the implicit ontological dependency they bore to the fundamental elements of the cosmos. Harman is critical of this approach because it defines the perspectives of new materialism—a philosophy he does not agree with.[18] The preoccupation that objects can be either relentlessly undermined or unnecessarily overmined establishes the degree of metaphysical essentialism characterizing Harman's object-oriented ontology.[19] He thus

argues that "rain striking a tin roof does not make intimate contact with the reality of the tin any more than the monkeys on the roof or the impoverished resident of the tin-roofed shack are able to do." What matters to object-oriented ontology is to identify what all things have in common, and at the same time to do justice to the distinctive force of these specific objects, "to the eruption of personalities from the empire of being."[20]

One of the most important aspects of Harman's theorization of objects lies in their inherent inaccessibility, their tendency to inexorably withdraw, which pushes the contact/relational zone to the surface, making it the decisive area in which object relations take place. It is therefore in the *Agrimiká* shop that an essential difference between the relationships of the different object-surfaces on display causes the taxidermy skin to "vibrate" in a more resounding way than others. However, despite the efforts of vibrant materialism and object-oriented ontology to escape anthropocentrism, I am left under the impression that what triggers the "vibration" of the taxidermy skin is a specific ethical register defined by technocapitalist economies of consumption in which visibility still remains sovereign. The attempt to devise a flat ontology of objects in art, whether it be in the fashion of Harman or Bennett, should recognize that we overmine the visual inscription of death in animal surfaces as we simultaneously undermine the animal deaths that have been materially rendered invisible. Materially as well as historically, *Agrimiká* is a human/animal mausoleum. But it would be erroneous to ethically overmine the animal skins in this assemblage without perceiving the animal deaths included in glue pots, wooden furniture, fabrics, books, and so forth—all the *invisible animal deaths*: the animal renderings that generate object materiality. This mode of thinking bears major repercussions for our actions toward animals and environments, and for ethical choices in human/animal relations. In this sense, the deliberate exposure of preserved animal skin operated in speculative taxidermy bears a political proposal.

Despite the impression that flat ontology equates to flat ethics, object-oriented ontology and new materialism achieve something important: they invite us to slow down, to reconsider what we thought we already knew. This modality was explored in the first chapter of this book through Snæbjörnsdóttir/Wilson's *the naming of things* and the derailment of linguistic affirmation that commands a heightened attention in the viewer's negotiation with the sealskin. The linguistic derailment proposed by

speculative taxidermy sets a critical stage upon which the viewer can begin a process of renegotiation. And it might be plausible that, ultimately, both philosophical movements have something to say with regard to animal thingness. After all, both object-oriented ontology and new materialism find in surfaces a point of access or a decisive contact interface where relations begin, form, and become. Bennett's encounter with debris at the beginning of *Vibrant Matter* is articulated in the relations between the different surfaces of disparate and randomly gathered objects. She claims to have, for a moment, achieved Thoreau's life goal, that of being surprised by what we see. The American philosopher trained his gaze for this very purpose and said, "The perception of surfaces will always have the effect of a miracle to a sane sense."[21]

WÖLFFLIN AND THE PHOTOGRAPHY OF SCULPTURES

In the *Quadruple Object*, Harman argues that we do not better grasp an object by viewing it from every side. He claims this to be "physically, mentally, and perhaps logically impossible."[22]

At the end of the nineteenth century, just at the time when neoclassical art still represented the most powerful and persuasive educational tool of institutional power and when lifelike taxidermy entered its golden age, art historian Heinrich Wölfflin posed the pivotal question: "How should one photograph sculpture?"[23] Wölfflin essentially argued that photography was corrupting the perfect beauty of classical sculpture. The art historian claimed that an arbitrary positioning of the photographer's camera could prevent the materialization of *full clarity*.[24] As Wölfflin stated: "[A work made in] the good [old] tradition provides one main view, and the educated eye feels it is a virtue that here the figure explains itself all at once and becomes completely understandable, so that one is not driven around it in order to grasp its content, but rather that it informs the beholder about its viewpoint right from the start."[25]

Wölfflin identified the most appropriate positioning of the viewer as the frontal view.[26] The photographic image of the three-dimensional object should subscribe to this affirmative prescription imposed by the perspec-

tival construction of space typical of quattrocento painting. The relationship Wölfflin wanted to see established between viewer and object was one of affirmation, one in which absolute clarity, a positivist clarity inherited from the scientific optic of the classical age, could enable the ideal epistemological conditions for seeing and saying. In defending the essential importance of this viewpoint, Wölfflin even dismissed the usefulness of obtaining multiple photographic images of the same sculpture for the study of art.[27] "Few know that, by doing so, in most cases the best quality [of the sculpture] is lost. One destroys the silhouette on which the artist has set himself and this does not only mean that the lines are brought out of harmony, no, this means much more: great artistic effort was expended precisely in laying out the entire sculptural content in one plane."[28] Wölfflin allowed that a sculpture could also demonstrate aesthetic value from a side view, but he negatively judged these instances as most regularly producing distortions and unclear seeing. He conceded that there might be a pleasure in displacing oneself only momentarily in front of the original sculpture, but only to allow the viewer's gaze to produce affirmation. Only this perspective would enable "that purified image to emerge, which stands calm and clear and in the true sense is felt to be a liberation."[29]

In some ways Wölfflin's unease with photographs of classical sculpture resonates with Harman's argument that "we do not grasp a tree or mailbox by seeing it from every possible side. The object is attained not by adding up its possible appearances to us, but by *subtracting* these adumbrations."[30] Yet this conception seems at odds with the very important avant-garde work of Cezanne, for instance, and subsequently with the cubist experimentations of Picasso and Braque, all of which seriously considered the implementation of different viewpoints of objects in the painting of new epistemic spatializations. What is really at stake in the challenges involved in seeing more?

QUASI-ANIMALS

The economies of visibility and object/materialist theories just discussed can help to better grasp the agency of *Inert*, by Alaskan-born artist Nicholas Galanin. The piece engages in an interplay of three-dimensionality

and flatness of animal skin, thus producing a substantially nonaffirmative object. Essentially, *Inert* is a *tableau-objet*, in the sense that it frustrates the possibility of easy conclusions by displacing the viewer's body in a way that Wölfflin would have not approved. This structural precondition is essential to *Inert*'s ability to operate its agency. In chapters 2 and 3, realistic, lifelike taxidermy, the kind championed by Browne, Shufeldt, and Akeley as the artistic apogee of the practice, was inscribed within a context of animal objectification driven by patriarchal systems of power. This context, it was argued, began to emerge through the essentially panoptic spatializations of the cabinet of curiosities and natural history illustration during the Renaissance. Thereafter, the decidedly Apollonian epistemic essence of the classical age brought about an exacerbation of animal objectification through an effective synergy provided by Cartesianism, the conception of the animal as automaton, and the emergence of natural history as a discipline substantially based on the epistemic truths provided by taxonomy. At this point, lifelike taxidermy became the complex sedimentation of multiple and seemingly unrelated imperialist and artistic discourses, which in different ways aimed at "preserving a threatened manhood," as Haraway would have it. Its perfectly idealized realism became the materialization of the Apollonian essence that perpetuated the epistemic value of the practice itself, well beyond the remit of the classical episteme that initially produced it.

In the nineteenth century, the implementation of the practices of dissection and anatomical study became pivotal to the shift from natural history to biology. Dissection, the violating of the surface, operated a departure from the "field of concomitance of the natural history of the period of Linnaeus and Buffon [which was] defined by a number of relations with cosmology, the history of the earth, philosophy, theology, scripture and biblical exegesis, mathematics (in the very general form of a science of order)."[31] Georges Cuvier "toppled" the jars of the French museum, "smash[ed] them open and dissect[ed] all the forms of animal visibility that the Classical age had preserved in them."[32] This shift involved the reconfiguring of the dynamics at play between the observed object, the eye of the beholder, the spaces of optical inquiry, and the power/knowledge relationships between the institutions and the observers.

From this perspective, Derrida's summoning of the 1681 dissection of an elephant for the gaze of Louis XIV, the greatest of kings, constitutes

the apogee of the panoptic power that the positivistic affirmation of the Enlightenment could produce. The famous anatomy lesson, described in *The Beast and the Sovereign*, made "the beast as dead object, an enormous, heavy body under the gaze and at the disposal of the absolute knowledge of an absolute monarch."[33] The slaying open of the animal body, along with the power/knowledge relationships that enabled and justified it, conferred on the animal the maximum visibility of affirmation—the totalizing force resulting in the death of the animal.

Keeping this historical background in mind, we find that Galanin's *Inert* becomes an intrinsically contradictory object suspended in the friction between realism and abstraction (fig. 6.3). As an example of speculative taxidermy, *Inert* can be understood as alluding to Latourian quasi-objects, the type of objects characterized by a sense of hybridity that supplants the order of modernity in the acknowledgment that certain objects play defining roles in actor-network systems shaping social relations between materiality and concepts, between object and subject. Quasi-objects, according to Latour, are "collective because they attach us to one another, because

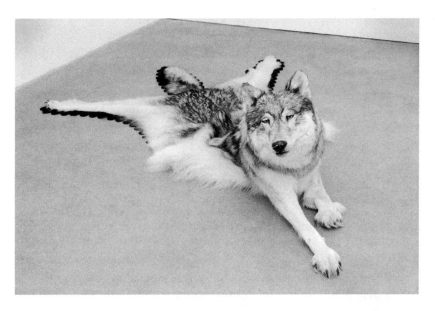

FIGURE 6.3 Nicholas Galanin, *Inert*, 2009. Wolf skins and felt. Photograph by Wayne Leidenfrost/PNG. Courtesy of the artist. © Nicholas Galanin.

they circulate in our hands and define our social bond by their very circulation. They are discursive, however; they are narrated, historical, passionate, and peopled with actants of autonomous form."[34]

Galanin's animal-made-object is materially thin, shallow, hollow, and flat. As seen in chapter 2, denying animals' souls negated the depth through which cognition and self-reflexivity could operate: *the flattening of animals*.[35] Through an object-oriented ontology perspective, we can see how in many ways the opening up of the animal body, its evisceration, simply multiplies its surfaces, producing a series of adumbrations that further conceal one register of the real into another. Harman argues that in these instances productivities might be made available not by "philosophies that regard the surface as formal or sterile and grant causal power only to shadowy depths" and that instead "we must defend the opposite view: discrete, autonomous form lies only in the depths, while dramatic power and interaction float along the surface."[36]

THE ALLURE OF THE OBJECT

According to Harman, *allure* is what takes place "when an object is split from its qualities and seems to hover outside them, beyond our grasp."[37] We experience the allure of the object when the ready-to-hand status of the object is momentarily ruptured to reveal a glimpse of its elusive depth. The allure creeps upon us as a surprise, it derails expectations, and it dominates all the "surface qualities of the object without being identical to them."[38] A unified object split from its properties ultimately is one we can sense but never fully define and exhaust even on the sensual level.

Harman aligns the allure to the bewitching emotional effect of aesthetic experience and argues that allure causes the object to exert a certain gravitational pull that attracts vaguely defined qualities of other objects, drawing them haltingly into its orbit. Metaphor, another object in Harman's ontology, breaks qualities free from other objects as it relies on allure and allusion.[39] In *Agrimiká*, the displaced assemblages of objects on display derive their allure from the interruption of the ready-to-hand condition that Papadimitriou inferred upon them. This operation triggers a vibrancy between objects; it opens spaces in which metaphors could oper-

ate in the generation of new objects. Thus the flattened skin of *Inert* relies on allure for the purpose of alluding to other objects (where objects are also understood as human/animal relations).

The flattened inside of the hide is in contact with the ground. It is therefore the flatness of the hide's exterior surface that declares this wolf dead despite the lifelike realism of the head and front part of the body. Any scientific/natural history anchoring of the piece is problematized by the ornate edging that circumscribes the animal skin—a device that is instrumental in the generation of specific metaphors. This border is an object of liminality. It functions as a Derridean *parergon*, as that which is against, besides, and in addition to the *ergon*.[40] Neither wholly outside nor inside, it physically marks that which limits the border of the animal in relation to the man-made materiality of the gallery space that surrounds it. This thin layer of fabric extends the materiality of the animal skin while simultaneously containing it. Its man-made attribution, rendered undeniable by the rhythmic, scalloped edge motif, frames the implicitly recalcitrant nature of the animal hide through an Oedipal maneuver of totalization. The machine-made pre-encoded cuteness of the scalloped edge, a bourgeois statement of conformism, regularity, predictability and domesticated femininity, contains the animality inscribed in the form and surface of the wolf's hide. The wolf is thus passified and infantilized, in a sense castrated, and indeed flattened in the sense Broglio intends. The castration narrative is substantiated by Deleuze and Guattari's argument:

> Lines of flight or of deterritorialization, becoming-wolf, becoming-inhuman, deterritorialized intensities: that is what multiplicity is. To become wolf or to become hole is to deterritorialize oneself following distinct but entangled lines. To become a hole is no more negative than a wolf. Castration, lack, substitution: a tale told by an overconscious idiot who has no understanding of multiplicities as the formation of unconscious. A wolf is a hole, they are both particles of the unconscious, nothing but particles, productions of particles, particulate paths, as elements of molecular multiplicities.[41]

Deleuze and Guattari's objection to the castration complex was based on Freud's "wolfman," a neurotic patient who had a childhood nightmare involving wolves.[42] In the dream, a small pack of white wolves threatened

the patient, leading Freud to conclude that the wolves represented his father and thus the menace of castration he posed. Freud's interpretations of the unconscious and sexuality, and the tendency of the Viennese psychologist to reduce the human experience to the Oedipal cycle with its centrality of the phallus as symbol, proposed transcendental politics of the One. In opposition, Deleuze and Guattari focus on the multiplicities that congregate, like packs and swarms: bodies of intensities bearing the potential for becoming. From this vantage point, the taxidermy wolf of *Inert* emerges as an iconic representation of the incongruity of Freud's operation, which imposes a metaphorical domestication of the wolf in order to grant its figural functioning as a psychoanalytic figure. Deleuze and Guattari argued that "Freud only knows the Oedipalized wolf or dog, the castrated-castrating daddy wolf, the dog in the kennel, the analyst bow-wow."[43] This reduction of the animal is doubly performed in *Inert* by the representational trope combined with the medium of taxidermy that castrates the castrating daddy-wolf figure with its lower part of the body flattened in the shape of a rug (covering the floor, underneath which might be a hole)—thus it appears clear that this wolf has been biologically and metaphorically rendered inert on multiple registers. To a certain degree, this interpretation of *Inert* has moved further afield from the surface of the work than I would normally contemplate in this context. However, it is one nonetheless linked to the unconscious dimension of hunting practices that reaffirmed patriarchal values in society and upon nature. *Inert*'s allure, its proneness to lean toward the symbolic register, is rich with narratives rooted in far too real conflictual human/animal relations. Thus far, I have argued that the use of materiality in art should be anchoring something of the human/animal relationship and its transhistorical becoming, which led to the materialization of the art object. Yet, in opposition to the general mistrust for symbolism that has pervaded art historical analysis in human/animal studies, this piece requires a more careful consideration of the problematics at stake.

Galanin was born in Sitka, in southeastern Alaska, and his work is openly concerned with the traditional crafts that have shaped the history of Native Americans. The artist's statements about the piece point toward different interpretations. "Mainstream society often looks at indigenous or Native American art through a romantic lens, not allowing a culture like my Tlingit community room for creative sovereign growth. The

back half of this piece is contained, a captured trophy or rug to bring into the home, while the front continues to move. It is sad and the struggle is evident."[44] Some claim that the artists had in mind the uncontainable sprawl of human expansion, thus pointing toward the generalized and relentlessly present dichotomies between nature and culture, domesticated and wild, animal and object, that persistently still shape the world we live in. Contemporary artworks are quintessential, polysemous objects, and thus it is in the interlacing of multiple readings that these objects might be able to, sometimes contradictorily, gesture toward productivities involving human/animal relationships. The challenge posed by the anthropogenic lens involves the task of mediating symbolism and materiality so that the former does not obliterate the latter, thus erasing the histories, discourses, and practices that are inscribed in the animal skin.

The wolf is one of the oldest and most complex Native American totemic symbols. Its relevance is inscribed into numerous stories that provide a demarcation of the differences between the generally negative, shape-shifting, symbol of twilight and othering European wolf, and a more benevolent American counterpart that is essential in tribal and ceremonial life. In this sense, a psychoanalytical reading of *Inert* would conceive of the taxidermy wolf in the work as a European wolf, while the artist's intention seems to situate the animal directly within his own Native American cultural past. But it is in this very tension between geography, history, and animal symbolism that *Inert*'s allure is magnified in a speculative taxidermy sense. If we do not refuse the work of symbolism as relevant to animal representation, it becomes possible to consider human/animal relationships in which the symbolic and the material are indissolubly bound—they are a part of the same object. So it is true, as Baker argues, that "symbolism is inevitably anthropomorphic," but it is also not always true that it makes "sense of the animal by characterizing it in human terms, and doing so from a safe distance."[45] In many instances symbolism actively shapes human actions toward animals; it influences their geographical situations, commodification values, probability of extinction, and likelihood of survival. Wolves are central to the myth-making that exceeds white colonial legends and its contribution to the shaping of specific American identities in which Europeans and Native Americans collided. For instance, in the seventeenth century, English colonialists

symbolically conflated Native Americans and wolves, producing an intertwining of metaphors and symbols that effectively purported, in equal measure, the extermination of wolves and the killing of Native Americans. Heads of wolves and heads of Indians were publicly displayed to proclaim dominance over "beasts and beast-like men."[46] For centuries, wolf bounties promoted the killing of wolves, supporting an economic system of racial discrimination kept in place by the indissoluble intertwining of material and symbolic registers.

SPECULATIVE TAXIDERMY AS ARCHAEOLOGY

It becomes at this stage possible to outline a recurrent trait of characters most regularly displayed by speculative taxidermy. As seen, the *tableau-objet* reclaims the materiality of the medium as an intrinsic part of the aesthetic experience for the purpose of derailing the predetermination of affirmative power/knowledge relationships charging the work of art with a potential for agency.[47] Through similar nonaffirmative aesthetics, *Inert* derails the naturalized connections between discourses and practices inscribed in the material manipulation of the taxidermy skins. In this sense—and this is perhaps its most important quality—speculative taxidermy cannot be said to be a direct sedimentation of power discourses, as can be instead claimed for the lifelike taxidermy of natural history museums. The opposite is indeed true. To draw a parallel, paintings and sculptures of classical art constitute sedimentations of power discourses, such as the historical, mythical, and religious. They relentlessly inscribed and naturalized ethical and moral discourses while providing the ruling classes with invaluable opportunities for operating power through the use of well-tested representational strategies. For instance, the prepared skin in *Inert* is capable of summoning seemingly unrelated discourses and practices ranging from the mythological, therianthropic, and taxonomical to popular culture and hunting-trophy souvenirs. Galanin's quasi-wolf equally emerges from all these practices and related discourse: the specimen, the pest, the pet, the trophy, and the myth are all made to collapse into one reworked animal skin. This reconfiguration of the interlinks between discourses and practices makes paradoxes visible—the

manipulation of the skin here stands as the materialization of the different conceptions of animality we produce in order to dominate animals. Galanin's animal skin is no longer a wolf but a third object. This is where the most noticeable productive strength of speculative taxidermy lies: as characterized by its precarious balancing between realism and abstraction, it nonetheless retains a signifying openness, a level of freedom, that ultimately enables the juxtaposition and critically addresses a range of human/animal power/knowledge relationships.

Further problematization of *Inert* emerges if the tensions between abstraction, figuration, and the symbolic are carefully considered. This constitutes one of the most important differences between botched taxidermy and speculative taxidermy. While the "wrongness" and abrasiveness of botched taxidermy gestured, in a resigned manner, toward things that appear to "have *gone wrong* with the animal," speculative taxidermy proposes nonaffirmative aesthetics in which taxidermy skins become the very interface upon which intra-active human/animal becomings take place: zones of resistance and inscription of transhistorical practices that have shaped the coevolution of humans and animals.[48] In opposition to botched taxidermy, which sees symbolism as that which makes the animal disappear,[49] speculative taxidermy recovers symbolism as an essential feature of human/animal relations focusing on the meaningful instances in which animal symbolism directly affects the living animals represented by the taxidermy skin. In this sense, speculative taxidermy functions as a Foucauldian archaeological site. Archaeology concentrates on rewriting—it does not propose a return to an innermost ever-elusive origin, but it instead engages in a description of discourses, practices, and the objects of both.[50] In the process, it attempts to defamiliarize the familiar for the purpose of rethinking the past in order to reimagine the present.

THE SEXUAL POLITICS OF SKINS

Nandipha Mntambo's remodeled cowhides further problematize the speculative taxidermy aesthetics mapped through Galanin's *Inert*. The artist's interest in forensics and science brought her to experiment with the preservation of animal skins.[51] As Mntambo explains, materials are

of paramount importance, and more specifically, they are central to a process of destabilization between the spoken and the unspoken, the visible and the invisible, the personal and the public.[52] In the gallery space, her taxidermy hides are displayed as freestanding sculptures or appear secured to the walls. In either instance, unlike in *Inert*, the hides have been treated and manipulated in order to suggest the absent presence of a female human body.

The allure that her animal-made-objects possess manifests from a deliberate blurring of the outline of animal morphology: the intriguing work of folds appears dramatized by a human/animal hauntology. Unlike *Inert*, in which the skin appeared to be predominantly stretched flat across the gallery floor, and clearly outlined, Mntambo's are modeled against her own body (and at times that of her mother) and thus indelibly bear the three-dimensional trace of her having been there. This operation problematizes the animal skins by inscribing a double indexicality: we simultaneously see traces of the animals that originally bore them and traces of the human body that wore them.

This play of presences and absences captures something of the inherent impossibility, previously discussed, of exhausting the depths of objects—a universal condition that not only applies to our relationship with objects but also defines the relationships between objects and other objects.[53] As Harman argues, the encounter between objects (in this case, the cow's body and the human body) can only be vicarious in the sense that no object can access the depths of another object in full. A sensual object is, therefore, detachable from its adumbrations, the angle at which we perceive it, and the lighting and shadows that sensually define its presence. But can the object also be detached from its innermost qualities? The essential qualities of speculative taxidermy objects surely lie in the inconfutable presence of animal skin. The element that characterizes the surface of the object and removes the skin from an animal, to a certain degree, equates to a gesture of appropriation of the sensual truth of the animal itself, or the outermost register of reality we can grasp of an animal—surfaces.

Mntambo's cowhides, through the processes of removal, tanning, molding, and setting, have become sensual objects in their own right, independent objects that materially allude to their past adherence to the animal body (fig. 6.4). Here and there, anatomical parts more or less clearly surface from the alluded, hollow depth underneath the hide. Here, peeling off

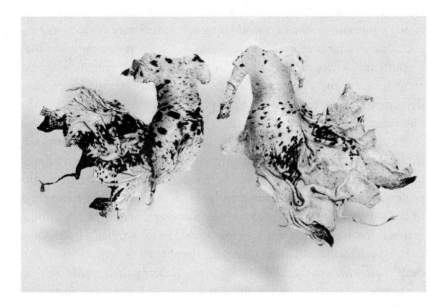

FIGURE 6.4 Nandipha Mntambo, *Titfunti emkhatsini wetfu* (*The Shadows between Us*), 2013. Cow hide, resin. Left: 49 7/32 × 52 3/4 × 11 27/64 in. (125 × 134 × 29 cm). Right: 57 7/8 × 59 27/32 × 10 5/8 in. (147 × 152 × 27 cm). Installation view, Andréhn-Schiptjenko, Stockholm, 2013. Photo by Jean-Baptiste Beranger. Courtesy Andréhn-Schiptjenko, Stockholm.

the animal body and grafting upon the human have collapsed into one gesture. This repositioning triggers an allure, along with the "bewitching emotional effect" that characterizes it.[54] The resistance that each form, the animal and the human, poses against the other opens up the possibility for the emergence of allusions—allusions that relentlessly gesture toward ghostly objects situated beneath and beyond the familiarity of sensual ones.

In opposition to Galanin, Mntambo has surprised critics by defying postcolonial readings and arguing that her work is not a direct exploration of the "African female body" nor that it has a "feminist agenda at its core."[55] Her cowhides, she says, do not "directly reference historical indigenous cultural practices" from South Africa, where she is from.[56] Likewise, the interpretative restrictions she places on her work attempt to evade the seemingly inescapable labels of "black artist" and "black art" within the international context of contemporary art.[57] Mntambo is keen

to free her work from the racial and gender stereotypes that a predominantly white and western art world imposes on minority groups—the expectation of a form of unacknowledged contemporary primitivism that romanticizes Africa through the construction of an authenticity nurtured by white consumers' market variables. In opposition, the artist argues that attention should be given to the physical and tactile qualities of the hides and the aspects of control that allow or prevent her manipulation of the animal skin. And this emphasis is indeed essential to her work. Mntambo's pieces ultimately encourage important, alternative modes of looking at both the animal and the female body.[58] But despite a self-professed interest in materiality and the desire to prevent certain readings of her work, the artist seems to simultaneously undermine the animal material she uses. In Mntambo's view, the skins are symbols of "sacrifices in rituals of birth, initiation, marriage, thanksgiving, appeasement and death," but I believe that their strength really lies in their irreducible essence as a surface layer peeled off from an animal.[59] This ambiguity with which the animal skins are incorporated in her work is accentuated by the fact that Mntambo never includes cow heads in her sculptures. The removal of the head causes specific alterations of the ways in which the materiality of the skin is allowed to intermingle with cultural references and texts. Unlike *Inert*, in which the stark realism of the animal head defined the allure of the art object, Mntambo's hides appear more readily suspended between the status of garment and that of a once living being.

In *Umfanekiso wesibuko (Mirror Image)*, two cowhides of slightly different shades of brown have been molded to suggest two female bodies with hands and knees to the floor. Here, the absent artist's body and that of the cows from which the skins have been removed appear to be mimetically aligned as closely as they could possibly be. The animal skins adhere to the upper part of the bodies and elegantly unfold to the ground, visually alluding to female dresses. Likewise, the way in which the objects are positioned in the gallery space, and their abstract/figurative aesthetic essence, are designed to engage the viewer in a *tableau-objet* dynamic. The open form that characterizes their presence deliberately invites the viewer to move around them in an attempt to better grasp their essential qualities. In this instance, more than any other in Mntambo's work, the skins metaphorically allude to the transhistorical, metaphorical, and economic overlap between women and cows. We are thus pushed back to the

surface of the cowhide by an irreducible carnal quality that places these objects in an uncomfortable representational dimension, suspended by allure in a precarious balancing of metaphorical poetics and undeniably carnal suffering.

The animalization of women that *Mirror Image* gestures toward is further underlined by the notion of domestication—a domestication that simultaneously references the sexualization and feminization of certain animals, the metaphorical fluidity that ensues, and the cultural constructs that emerges from it. Could this be the "mirror image" that Mntambo alludes to in her title? How much of Carol J. Adams' "sexual politics of meat" reverberates through these hollow skins? It is hard not to detect the intricate representational modalities constructed by patriarchal values and meat eating—a naturalized system of oppression that has substantially shaped much of the world we still live in today. Both skins in *Mirror Image* (fig. 6.5) propose a fragmentation and dismemberment,

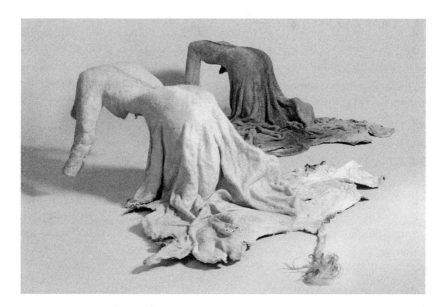

FIGURE 6.5 Nandipha Mntambo, *Umfanekiso wesibuko* (*Mirror Image*), 2013. Cow hide, resin. Left: 25 63/63 × 66 59/64 × 63 25/32 in. (66 × 170 × 162 cm). Right: 23 15/64 × 70 55/64 × 61 1/32 in. (59 × 180 × 155 cm). Installation view, Andréhn-Schiptjenko, Stockholm, 2013. Photo by Jean-Baptiste Beranger. Collection 21c Museum, Louisville, Kentucky. Courtesy Andréhn-Schiptjenko, Stockholm.

along with the loss of individuality (the lack of heads) of both animals and women that plays a pivotal role in the objectification/replaceability in the politics of meat consumption. Simultaneously, the interweaving of oppression between women and animals, Adams argues, relies on the play of absent referents: a psychosocial detachment that separates the one who consumes from what is being consumed, thus enabling consumption.[60] In this specific place, these skins simultaneously embody multiple registers of domestication, subjugation, exploitation, marginalization, slavery, and consumption through the production of more than metaphorical incarnations. The tragic realism with which these manipulated animal skins gesture toward vulnerability is as palpable here as it could possibly be.

TAXIDERMY AND VULNERABILITY

Berlinde De Bruyckere's modeled horsehides offer the opportunity to further untangle speculative taxidermy's ability to surface embodiments of our shared physical vulnerability with animals. Unlike Galanin's *Inert* and Mntambo's hollow skins, De Bruyckere's animal bodies propose a demarcated three-dimensionality that further problematizes the notion of affirmation in speculative taxidermy.

De Bruyckere began to work with horse skins in 2000, when she was commissioned by the In Flanders Fields Museum in Ypres to produce artwork with war as its core theme. The artist's research in World War I archives unearthed many photographs of dead horses lying on the streets. It is from these images inscribing loyalty, subjugation, love, exploitation, companionship, and betrayal that her body of work developed. Like the other taxidermy pieces discussed in this chapter, *K36 (The Black Horse)* (2003) entices the viewer to solve an incomplete and inconclusive representational scenario in which multiple intertwined narratives, histories, and human/animal relationships are inscribed in skins (figs. 6.6 and 6.7). The manipulated animal form, like Mntambo's cow skins, exceeds the parameters of realistic figuration, capitalizing on the allure that emanates from the clash between the realism of animal skin and the abstraction of form. And like Mntambo's hides, *K36*, in a more indirect way, evokes

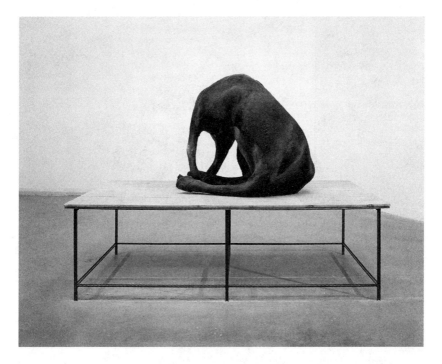

FIGURE 6.6 Berlinde De Bruyckere, *K36 (The Black Horse)*, 2003. Horseskin, wood, iron, polyurethane foam. 295 × 286 × 158 cm. Collection Pei-Cheng Peng. © Berlinde De Bruyckere. Courtesy Hauser & Wirth and Galleria Continua. Photo by Attilio Maranzano.

a female body materialized by a classical, submissive iconographical construction.

As discussed in chapters 4 and 5, the dynamics involved in the *tableau-objet* and the force of the event lie at the foundation of the phenomenological, nonaffirmative proposal of ontological mobility: that which contributes to the rethinking of human/animal relations through art. Galanin's work proposes a complex balance between flatness and three-dimensionality, between realism and manipulated form. Mntambo's cowhides draw the viewer into a complex negotiation defined by the allusive conflation of human and animal form. In both approaches, the allure that characterizes these objects is rooted in the simulated livingness of the preserved animal skin. However, the real challenge posed by

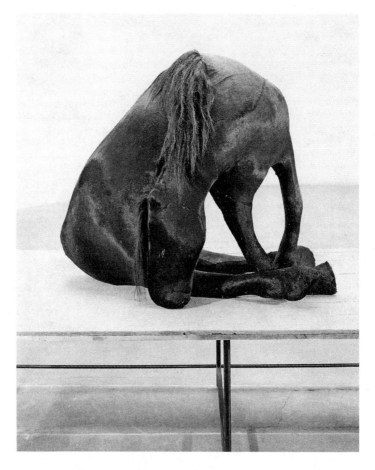

FIGURE 6.7 Berlinde De Bruyckere, *K36 (The Black Horse)*, 2003. Horseskin, wood, iron, polyurethane foam. 295 × 286 × 158 cm. Collection Pei-Cheng Peng. © Berlinde De Bruyckere. Courtesy Hauser & Wirth and Galleria Continua. Photo by Attilio Maranzano.

speculative taxidermy is that of mediating the balance between the linguistic domain and the abrasive essence of materiality. At this point, can the abandonment of realism equate to a departure from the condition that traps materiality within the linguistic domains?

K36 confronts the viewer with a deliberately nonaffirmative reconfiguration of a very familiar animal body, that of a horse. Through her reworking, De Bruyckere deliberately blunts the realism of details, which

in natural history taxidermy is essential to the illusion of livingness. As a result, her animal bodies appear neither dead nor alive—they are somewhat suspended in a twilight of representation, frozen in an ambiguously sensual stillness. Their abstracted body masses deliberately ask the viewer to walk around them, yet no definitive answer is provided as to which might be the correct viewing point. Wölfflin would have found *K36* extremely frustrating. Likewise, contrary to the classical taxidermy methods developed by Akeley and others at the turn of the nineteenth century, which prescribe the casting of a life-size mannequin for the purpose of accurately stretching the animal skin to lifelike effect, De Bruyckere's mounts propose substantial indeterminacy. In the lack of an anatomically realistic mannequin supporting the skin, the animal body appears vacated of its rhetorical grandeur and the elegant stability that generally characterizes equine bodies. *K36*'s muttering of the affirmative statement "this is a horse" is confused, unclear, insecure, and as muffled as it could possibly be (plate 10). *K36* is not a horse; it's a *quasi-horse*, a horse/human coevolutional inscription stripped of its symbolic cultural constructs. The rhetorical strategies of realism have been derailed for the purpose of enabling surfaces to speak. Through the blunting of the animal's anatomical accuracy and through the erasure of detail, De Bruyckere thus severs the discourse/practice links that transhistorically bind man and horse through the erasure of that which most tangibly links them: the concept of pure breed.

In *The Sport of Kings: Kinship, Class and Thoroughbred Breeding in Newmarket*, Rebecca Cassidy carefully describes the sociocultural importance of the practice of selectively breeding horses in nineteenth-century England. The concept of pure breed as that which embodies the uniqueness of the animal and simultaneously that of the owner is, according to Cassidy, equally based on the values of form and surface and their reflexive impact on a presumed interiorization of ability and value fixed in blood by cross-breeding.[61] Cassidy highlights the direct discursive links of wealth, power, and social status to the practices that fixed the pedigree as the intrinsic guarantor of value inscribed in aesthetic characteristics embodied in the living animal.[62] De Bruyckere's manipulation and the resistance posed by the animal skin sever these links in the proposal of a catastrophic reversal of the thoroughbred process that inscribed power, speed, and stamina into animal form.[63] As a result, these animal bodies

appear to be ultimately annihilated—they are inert, useless to the discourses that for centuries have crafted their bodies to construct the superior specimen: the stallion.[64]

It is in this sense that *K36* is not a horse—it's a horse/human coevolutional inscription. In speculative taxidermy, the manipulated form of a horse's body no longer is a horse in the sense that all classical animal representations could never equate to live animals, and in the sense that all animal representations always involve human manipulation of animal form. But, more specifically, these bodies are the result of the transhistorical power/knowledge relations that have played a key role in the emergence of certain discourses and practices in human/animal relations.

As will be seen in the next chapter, the domestication of horses by no means constitutes a straightforward narrative of reciprocal, loving companionship, as some would like to believe. Fragmentations, incongruences, and contradistinctions lie at the core of an unbalanced power/knowledge relationship of domestication (and many other human/animal ones, of course). In *When Species Meet*, Donna Haraway highlights the seamless isopraxic continuity that animal body and human body can achieve in horse riding. Quoting Vinciane Despret, Haraway argues that "human bodies have been transformed by and into a horse's body. Who influences and who is influenced, in this story, are questions that can no longer receive a clear answer."[65]

The undeniable materiality of the manipulated animal surface summons the long-lasting relationship between human and horses in the all too real practices of agriculture, farming, transportation, sport, war, art, and companionship. These practices, all underlined by the processes of domestication, appear intertwined with a multitude of discourses, such as those related to the division of labor, strategies of war, selective breeding, evolution theories, wealth, power, recreation, psychoanalysis and cognition, theology, zoology, and pageantry.

The indeterminacy of the nonrealistic form is never simply a negative space. It instead lends itself to function as a screen upon which an overlaying of images from the cinematic archives of western and war film genres, memories of encounters with live horses, can gather. Placed in the context of the contemporary gallery space, *K36* also summons previous representation of horses in art, including the numerous equestrian portraits of Roman emperors; the awkwardly flat horses of Paolo Uccello's

early renaissance *Battle of San Romano* (1438–1440); the blue and orange ones painted by Franz Marc (1911); Chana Orloff's art deco, horse-riding *Amazone* (1915); George Stubbs's *Whistlejacket* (1762); Leonardo's studies for Ludovico il Moro's never realized monument (1490); Xu Beihong's un-bridled stallions (1940s–1950s); the trebly ambiguous equine presences in Leonora Carrington's *Self-Portrait* (1937–1938); the distinctly elegant horses in Jan Brueghel the Elder's paradise paintings (early seventeenth century); the ones victoriously carrying Napoleon through history in the paintings of Jacques-Louis David (1801); Picasso's tragic horse at the cen-ter of *Guernica* (1937); those photographed in motion by Muybridge (1887); and the twelve live horses that Jannis Kounellis tethered to the walls of a gallery in Rome in the late 1960s.

All these images, functioning as sedimentations of past discourses, practices, and representations, construct a vivid archive of forming sur-faces in human/horse relations—all vivid, but all equally failing to match the fragmentary, nonaffirmative embodiment that De Bruyckere pres-ents. It is this discrepancy between the past representations summoned by the barely realist elements of *K36* that bridges the "then and now" of hu-man/animal experience. This offers the opportunity not just to free the animal presence in a flight from classical thought but also to critically address the past for the purpose of questioning today's human/animal relations.

All the works discussed in this chapter propose, in different ways, an important shift from the different theatricality of classical and minimal art to a nonaffirmative performativity characterized by a difficult balanc-ing between words and the impossibility of containing the entangle-ments of human/animal relations within the linguistic domain. Ontology is here regularly undermined by the agency of materiality itself and the loosened interconnectedness between materiality and language. Accord-ing to Karen Barad, performativity is linked to the formation of the subject and simultaneously to the production of the matter of bodies. In formu-lating *agential realism*, Barad draws from Judith Butler's account of ma-terialization, Haraway's notion of materialized figuration, and Foucault's analytic of power.[66] A theory of materialization of the body, Barad argues, would take into account how the anatomy and physiology of the body itself are shaped by other material forces. Barad expands Foucault's un-derstanding of the productivity of power to the social to incorporate

"important material and discursive, social and scientific, human and nonhuman, and natural and cultural factors."[67] Boundaries between the human and the nonhuman are thus prodded through the consideration of a host of material-discursive forces constituting the processes of materialization. The focus is placed on the relationship between discursive practices and material phenomena. Therefore, agential realism rejects representationalism as that which ontologically structures domains of words and things as separate, proposing instead the forming of the subject as part of a web of representations that generates a conception of a different metaphysics than that of relata.[68] The causal relationship between the dispositifs that produce bodies and the phenomena produced, Barad argues, relies on a dynamic of agential intra-action.[69] In this sense, "phenomena become the ontological inseparability of agentially intra-acting 'components'"[70] where bodies do not precede their interactions but instead emerge as the mutual constitution of entangled agencies. It is in this sense that the manipulation of animal form that characterizes all the works discussed in this chapter can be better understood as alluding to agential forces whose origins might be impossible to precisely situate geographically, historically, physically, and temporally. The semantic and ontological indeterminacy that ensues thus results in Barad's conception of meaning as that which no longer is "a property of individual words or groups of words but an ongoing performance of the world in its differential intelligibility."[71]

7

THIS IS NOT A HORSE

Biopower and Animal Skins in the Anthropocene

Another image comes to mind: Nietzsche leaving his hotel in Turin. See-
ing a horse and a coachman beating it with a whip, Nietzsche went up to
the horse and, before the coachman's very eyes, put his arms around the
horse's neck and burst into tears. That took place in 1889, when Nietzsche,
too, had removed himself from the world of people. In other words, it
was at the time when his mental illness had just erupted. But for that
very reason I feel his gesture has broad implications: Nietzsche was try-
ing to apologize to the horse of Descartes. His lunacy (that is, his final
break with mankind) began at the very moment he burst into tears over
the horse.

—MILAN KUNDERA, *THE UNBEARABLE LIGHTNESS OF BEING*

It was really hard to make a base for it—that's where the title comes
from. The stand has a double beveled edge as a nod to public sculpture.
It's like a defaced memorial, like when you see a statue of a soldier on
a horse and someone's put a traffic cone on its head—what does that
gesture stand for?

—STEVE BISHOP, ON *IT'S HARD TO MAKE A STAND*

AESTHETIC INDIFFERENCE AND ANIMAL SKIN

In *The Return of the Real*, Hal Foster contextualizes the influence of the Duchampian readymade through the second postwar period as a new contestation of bourgeois principles and values.[1] This anticonformist spirit drove artists to conceive new materialities as political agents. It is in this context that Jasper Johns's two bronze Ballantine Ale cans titled *Painted Bronze* (1960) and Rauschenberg's *Monogram* (1959), in different ways, paved the way for the emergence of animal bodies in the art of the time. In fact, these examples can be adopted as representatives of the two main strands of "commodity-based-sculpture" produced in the postwar period in the west.[2] *Painted Bronze* and *Monogram* problematize Duchamp's paradigm of the readymade through an incorporation of a surrealist-object-assemblage aesthetic. Johns's *Painted Bronze* ostensibly relies on the polished and painted metal surface for the purpose of ontologically derailing the high art/commodity dichotomy already questioned by the Duchampian readymade. The other, *Monogram*, incorporates rough ma-terialities that deliberately blur the boundaries between natural, man-made, and machine-made, thus embedding a critique of realism through the economies of the assemblage. Both categories, in different ways, refused the minimalist level of intervention typically performed by Duchamp. And in both cases they transcended the paradigm of aesthetic indifference that Duchamp championed. Practicing the "beauty of indifference" was Duch-amp's essential form of restraint in the production of readymades.[3] Taste constituted the root of the bourgeois aesthetic that Duchamp discredited—hence his predilection for the mechanical, cold, enigmatic, irreverent, and minimalist presence of the seemingly culturally irrelevant, mass-produced object of the modern age.

Duchamp's disinterestedness essentially derived from the Kantian no-tion of aesthetic disinterest as a preponderant attitude toward the object for the purpose of refining the task of aesthetic analysis. Kantian disin-terestedness was grounded in indifference toward the physical, material existence of the object. Thus, popular aesthetics represented a form of barbarism because of the centrality played in judgment by ethical stan-dards or by the senses.[4] Duchamp's aim was, therefore, to challenge the beholder to exercise the disinterested contemplation of pure aesthetics.

However, his approach did not remain unchallenged for long. On the first page of the *Surrealist Manifesto*, Breton stated that the implementation of everyday objects in surrealist art is expressly operated for the purpose of "challenging indifference through a poetic consciousness of objects."[5] As emphasized by Ulrich Lehmann, materiality plays a key role in this ontological subverting agency.

> Although the Surrealist's own categorizations and typologies of the objects over the course of a decade do not necessarily reveal a linear development, it becomes apparent how the various Surrealist interpretations trace the course of a broad historical movement that not only defined a changing perception of materiality, but over and above this, also demonstrated the instrumental transformation of the understanding of materialism. This means a transformation from an empirical, mechanistic comprehension of the world to a revelation of the objectifying, alienating structures within it.[6]

It is critical at this stage to acknowledge that, in the surrealist object-assemblage, materiality can perform a political critique of the technocapitalist economies of visibility defining human/animal relations in the Anthropocene. The substantial difference between Dada objects and surrealist objects is, from this vantage point, an ethical one.

Historian Erica Fudge argues in favor of the irreducible agency of animal skin in objects through the analysis of case studies from the English Renaissance.[7] Stressing that a human/animal studies framework should consider animals as "truly active presences in the world,"[8] Fudge challenges the strategies of technocapitalist ontologies of production, which conveniently disentangle living animals and animal-derived-matter for the purpose of facilitating consumption: "Like subject and object," Fudge argues, "they are utterly intertwined."[9] Therefore, Fudge's animal-made-object paradigm is in many ways akin to Shukin's *rendering*, and presents another fitting double entendre that emphasizes the surface of materialities: on one hand we have the animal body/matter, reified as object/commodity, and on the other, we have the culturally objectified animal. The alluring recalcitrance of the animal-made-object is thus configured by Fudge as an active, irreducible agent in human/animal relations, one

ultimately "possessing a transformative power over humans."[10] But how do these conceptions of animal studies relate to the new sensitivities to materiality proposed by vibrant materialism, object-oriented ontology, and the emergence of animal skin in contemporary art?

Fudge's recognition of the irreducible materiality of animal skin within technocapitalist systems relies on Heidegger's tool-being and relates to Graham Harman's conception of sensual objects. Although both theorizations emerge outside artistic contexts, Bill Brown also argues:

> We begin to confront the thingness of objects when they stop working for us; when the drill breaks, when the car stalls, when the windows get filthy, when their flow within the circuits of production and distribution, consumption and exhibition, has been arrested, however momentarily. The story of objects asserting themselves as things, then, is the story of a changed relation to the human subject and thus the story of how the thing really names less an object than a particular subject-object relation.[11]

The loss of function has been identified as one of the prerogatives of objects-cum-art.[12] De Duve clearly summarizes this process in relation to the Duchampian readymade as follows: "Duchamp chooses an industrial product, displaces it, puts it to another purpose, whereby it loses all its utilitarian dimension as well as all ergonomic adjustment of its form, but by the same act, gains a function of pure symbol."[13]

Fudge's argument therefore not only presents assonance with Shukin's own conception of rendering but also echoes Broglio's invitation to take animal surfaces into serious consideration. Seen through these lenses, the animal skin, the animal-made-object, the rendered surface that cannot be silenced, becomes a destabilizer of affirmation on the account that the animal-livingness that characterized it, along with its otherness, ontologically sets it apart from any other inert artistic/mechanically produced material. However, as mentioned in the discussion of *Agrimiká*, this primacy assigned to animal skin is far from being ethically unproblematic. The contemporary emphasis on flat ontology and its aim to decenter anthropocentrism brings us to consider the vibrancy/livingness of all materials and thus invites a reconsideration of the very concept of life itself. The invisible animal deaths inscribed in everyday objects should count just as much as visible ones.

TOWARD A GENEALOGY OF HUMAN/
ANIMAL RELATIONS IN ART

Although not conceived specifically as an art historical tool of analysis, the Foucauldian concept of *dispositif* can be used to retrieve the intermingling sets of power/knowledge relationships inscribed in works of art where animal and man-made surfaces are juxtaposed.[14] The concept of became pivotal to Foucault's shift from archaeological to genealogical inquiry.[15] As a concept, its main role became that of providing a structure upon which to map power/knowledge relationships at play in diverse societal functionings. The *dispositif* thus enables the retrieval of "discourses, institutions, architectural forms, regulatory decisions, laws, administrative measures, scientific statements, philosophical moral and philanthropic propositions. . . . The apparatus [*dispositif*] itself is the system of relations that can be established between these elements."[16] A focus on the *dispositif* may enable the emergence of a posthumanist critique— one that refuses the unproblematic metanarrativization of "inherently good" domestication and companionship narratives.

As a piece of speculative taxidermy, in its challenging, fragmented, *tableau-objet* materiality, *It's Hard to Make a Stand* by artist Steve Bishop constitutes a nonaffirmative body structured around the juxtaposition of different man-made objects and preserved animal skin (fig. 7.1). The piece can be seen to problematize *Agrimiká*'s original proposal through the incorporation of a life-size taxidermy mannequin of a horse—the kind that can be purchased from one of many taxidermy suppliers—mounted on a precarious and cheap-looking plinth. A shroud of cellophane covers the back of the mannequin, while a fur coat is haphazardly draped over its head.

In this instance, the nonaffirmative determination to destabilize the sovereignty of the viewer, the overall fragmentation proposed by the representational trope, gestures toward systems of relations involving discourses, practices, knowledge, and power. As discussed at length in chapters 3 and 4, optical realism constituted the main representational prerogative of quattrocento painting. In the epistemic configuration of the classical age, the clarity of optical realism bore a linguistic nature and was conceived as the result of the totalizing forces of positivism: animals were rendered visible in perfected forms, adjusted, purified, idealized, and ultimately objectified. As seen in the previous chapter, speculative taxidermy can be understood

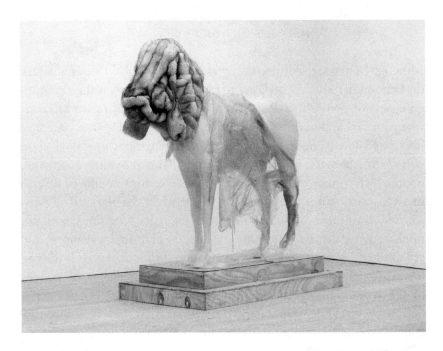

FIGURE 7.1 Steve Bishop, *It's Hard to Make a Stand*, 2009. Fur coat, polyurethane, polythene, mirrored acrylic, wood. 215 × 196 × 102 cm. Courtesy of the artist and Carlos/Ishikawa. Photography by Michael Heilgemeir. © Steve Bishop.

to operate on two levels. On aesthetic grounds, the object appears as the sedimentation of artistic discourses and practices, while on a semantic one, it dislocates the naturalized interlinking of discourses and practices through a process of nonaffirmation.

In the case of *It's Hard to Make a Stand*, the juxtaposition of different surfaces and materials can be further problematized by the Foucauldian concept of *heterotopia*.[17] Standing in opposition to the idealistic homogeneity and unreality of utopias in classical painting are the counter-sites of heterotopia as characterized by an existence in a reality demarcated by an ontologically unstable heterogeneity.[18] Although Foucault constituently configured heterotopias as the power/knowledge structures of physical spaces such as the cemetery, the museum, the library, and the garden,[19] in the introduction of *The Order of Things* the concept emerges in relation to the famous passage from Borges—the one from the "certain Chinese encyclopedia."[20] This constitutes one of the most powerful forms

of heterotopia, for the most disturbing, Foucault claims, make undermining language their prerogative.[21]

Heterotopias are therefore intrinsically nonaffirmative—they shatter, overlay, and tangle. While utopias enable discourses to form and disperse over the surface of a rationalized world, heterotopias "stop words in their tracks, . . . dissolve our myths and sterilize the lyricism of our sentences."[22] In so doing, heterotopias defamiliarize the everyday, the commonplace. That which is always already taken for granted as understood, dissipates. Linking together what is incongruous, the surrealist object-assemblage essentially was an early heterotopic site, a microsite upon which irreconcilable contradictions were deliberately staged and performed. It is through this unorthodox juxtaposition, a visual non sequitur, that the surrealist object-assemblage offered the opportunity for an ontological reconfiguration of the world. In this context, the Foucauldian *dispositif* constitutes the system of power relations made visible in the space opened up by the nonaffirmation of the heterotopic site. Similarly to a surrealist object-assemblage, *It's Hard to Make a Stand* can enable the retrieval of the *dispositif*—discourses and practices shaping human/animal power relations through institutional agency. Through this process, domestication and training, as practices intrinsic to human/animal relations in companion species, can be revealed as practices involving an undeniable form of positivistic violence, one that aesthetic-moral defenses aim to conceal or naturalize as acceptable.

GHOSTLY BUT PLASTIC

As in the case of Mntambo's cowhides, *It's Hard to Make a Stand* capitalizes upon the play of presences and absences it performs. The allusive, nonaffirmative nature of the object-assemblage, through the ambiguous proposal of its heterotopic fragmentation, enacts a signifying fluidity central to the recovery of discourses and practices. Although initially it may be assumed that *It's Hard to Make a Stand* focuses on the animal figure of the horse, the assemblage conflates a complex game of heterotopic visibilities and invisibilities involving three animals: a horse, a dog, and a number of nonindividualized animals (probably mink) whose skins have

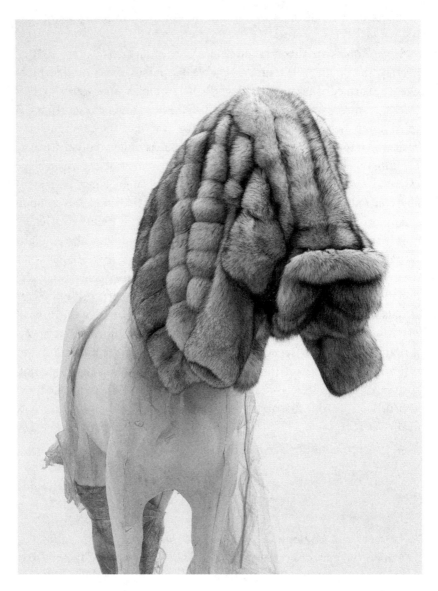

FIGURE 7.2 Steve Bishop, *It's Hard to Make A Stand*, 2009. Fur coat, polyurethane, polythene, mirrored acrylic, wood. 215 × 196 × 102 cm. Courtesy of the artist and Carlos/Ishikawa. Photography by Michael Heilgemeir. © Bishop.

been rendered into a fur coat.[23] In this context, taxidermy functions as the quintessential seal of what is simultaneously present and absent.

The horse mannequin is of the kind used in contemporary taxidermy practice—a polyurethane, machine-produced, ready-made item available in multiples and cast in a variety of sizes.[24] It symbolizes commodified animality—the polyurethane it is made of is the incarnation of the relentless industrial optimization of plastic materials that in the 1950s was driven by a desire to reduce production costs and heighten flexibility and versatility. Against this backdrop, the visible absence of animal skin performs a series of nonaffirmative operations, enacting a signifying fluidity that irreparably unhinges the relationship between image and language, between seeing and saying. Thus presented, the mannequin at once transgresses the aesthetic prescriptions of the classical natural history specimen and trophy taxidermy. It simultaneously summons a ghostly horsiness, evoking the imposing equestrian monument one second and a miniature toy cavalry steed the next. This ontological flickering appears further accentuated by the absence of a rider—that which in the classical iconography of equestrian portraiture constituted the narrativizing element: the human whose presence links the animal body to a historical event or ideological value.

The nakedness of the taxidermy mannequin is only partial; a furry mass covers its head. This mass is a fur coat haphazardly hanging from the mannequin's head—a configuration that suggests a careless and rushed human intervention. However, at play in the positioning of this luxury object within the assemblage is, once again, problematic tension between the affirmative and the nonaffirmative operated on the elusive boundaries of figuration and abstraction. From a certain viewing angle only, the fur coat casts the unexpected image of a dog's head. This vision, akin to anamorphic imagery in classical art, materializes a prosthetic head and thus suspends the whole assemblage in an ontological blurring between the aesthetic clarity of the natural history specimen and the mythological chimerical apparition. In *Rethinking Art History*, Donald Preziosi discusses the phenomenon of anamorphism in classical paintings, such as Holbein's *The Ambassadors* (1533)[25] as an absence/presence apparatus; one that manages the mutually exclusive coexistence of two perspectival constructions (time/space dimensions) assigning two very distinct viewing positions to the beholder, in the place of the single one typical of quattrocento painting.[26]

As seen in the work of Roni Horn, the actual movement of the viewer's body is phenomenologically connected to a moment in which ontological mobility can take place. Therefore, *It's Hard to Make a Stand* mobilizes this classical, representational strategy for the purpose of evidencing the hidden interconnectedness between the domestication/subjugation processes in which economies of care and exploitation appear synergically aligned. In this context, the blue cellophane that wraps the mannequin anchors a context of industrialization, alluding to technocapitalist economies, which are equally implicated in the production of man-made objects, machine-made objects, and animal bodies. As Bishop stated, this is the original wrapping material in which the mannequin arrived at his studio.[27] The material strips the mannequin of any romantic poetics and denounces it as a mass-produced object charged with a surrealist eeriness and haunting obsolescence. Simultaneously past and present, ghostly but plastic, the cellophane foldings emphasize the human/animal power/knowledge relations that have intermingled over millennia, substantially shaping those of today.

BIOPOWER AND DOCILE BODIES: CAPITALIZING ON THE LIVING

Further delving into the analysis of the *dispositifs* inscribed in *It's Hard to Make a Stand* requires a disambiguation of Foucault's notion of power and the introduction of the concept of *docile bodies*. Foucault conceives of power as a productive force present in all relationships. Power is identifiable in different ever-changing guises, it depends on a number of variables, and it is not to be solely understood as that which is imposed directly by individuals and institutions upon others. In this sense, Foucault's analysis of power is concerned with unearthing specific clusters of power/knowledge relations operating on the social and individual registers. It is conceived as circulating and flowing combinations of forces acting on the body. In Foucault's work, the body (human, that is) is configured as an epistemological site inscribing a field of forces, shaped and defined by power relations that can be illuminated by genealogical inquiry. Importantly, conceptions of the Foucauldian body are substantially underlined by a

usually unacknowledged idea of construction and materialism—the body is metaphorically and biologically constructed by discourses and practices just as much as it is shaped by the power that defines all the relationships intertwined in such discourses and practices.[28] On the social register, Foucault is interested in *disciplinary power*, technologies of power institutionally regulated and regulating through the means of spatialization: panopticism, invigilation, self-invigilation, confinement, and punishment—these entail a demarcated unbalance in the power relationships at play. Foucault refers to this register as being centered on the body as a machine ("the anatomo-politics of the human body")[29] rationalized in its functionality, as well as spatially constricted in its physicality.

On the individual register, Foucault focuses on the *technologies of the self*: relational instances in which individuals are conceded a perimeter of freedom granting a level of self-operated choices based upon restricted biological interventions on their own bodies and souls—a form of keen supervision in which the individual retains some levels of self-forming powers.[30] The operations of disciplining and regulating enacted on the registers of the anatomic and the biological constitute two polarities through which power is generally organized and exercised over life. This configuration, which according to Foucault emerged in the classical age, replaced the sovereign's absolute power of inflicting death, the ancient right to "take life or let live" (in some cases implemented as the "fostering of life and let die" paradigm).[31] Through this shift, Foucault's conception of biopower emerges as an anthropogenic configuration of power relations characterized by a problematization of the discursive and the institutional through social organization and supervision strategies shaped by the ultimate aim of enhancing productivity.[32] Capitalist growth, therefore, with its necessity to insert bodies into the machineries of production, relies entirely on this power/knowledge paradigm to substantiate itself despite its destructive ecological impact. This modern conception of power as biopower—that which capitalizes on the living as intrinsically intertwined to the sphere of economic processes—can be more productively reconfigured to include human/animal relations in Foucault's conceptualization (something he did not consider in his body of work).

It follows that human/animal relationships tend to be equally shaped by "anatomo-politics of the human body" as operated by disciplinary power and the technologies of the self. The specificities of the multiple *dispositifs*

at play in different human/animal relations are substantially shaped not only by the variables proposed by the intertwining of these two power modalities, but also by the species of animals with which such relationships are established. In the light of this proposition, it is important to note that the animal presences and absences staged by *It's Hard to Make a Stand* all gesture toward intertwining transhistorical, transspecies, human/animal sets of power/knowledge relationships of the type inscribed in domestication, domination, and consumption. Claire Palmer's and Stephen Thierman's original contributions to the subject attempt to substantially reconfigure Foucault's concept of *docile bodies* on human/animal studies grounds.[33] Developed by Foucault in *Discipline and Punish* as a productive, constructive, disciplining, and ultimately optimizing technology of power, the notion of *docile bodies* aimed at integrating the human body into the machineries of production for the purpose of enhancing capitalist productivity.[34] Foucault configures "the body as a machine: its disciplining, the optimization of its capabilities, the extortion of its forces, the parallel increase of its usefulness and its docility, its integration into systems of efficient and economic controls, all this was ensured by the procedures of power that characterized *the disciplines: an anatomo-politics of the human body*."[35] In light of this configuration, the discursive interminglings between inanimate commodity, mannequin, and preserved animal skin acquire further signification in the technical-industrial milieu.

In Foucault's work, power and resistance are interdependent values. In a broader context of power relations, Foucault identifies relationships of domination and governmentality.[36] Relationships of domination are characterized by a more stable and structured set of dynamics that suppresses the possibility of a reversal of roles, as could happen in governmentality.[37] The biopower relationships that have led to the production of the fur coat in *It's Hard to Make a Stand* can be more aptly inscribed in the relations that Foucault calls *capacities*: the type of unilateral power that humans can exert on inanimate things.[38] His subcategorization of some types of capacities as relationships of violence enables a more careful positioning of the human/animal *dispositifs* that *It's Hard to Make a Stand* enables one to retrieve. As Foucault states: "A relationship of violence acts upon a body or upon things; it forces, it bends, it breaks on the wheel, it destroys, or it closes the door on all possibilities."[39] Relationships of violence are totalizing and most readily identifiable within the context

of human/animal relations operating at the extremes of biopower, such as in factory farming and slaughterhouses. In such objectifying spatializations, the anatomo-political power operated upon the animal body is of the greatest intensity: the technologies of the self available to animals are drastically reduced and are allowed only as far as they might result in a monetizable contribution to the growth of capital.[40]

However, as an analysis of *It's Hard to Make a Stand* through anthropogenic lenses reveals, relationships of domination and violence can be inscribed in relationships of domestication, even when on the surface they appear to be based entirely on compassionate companionship. The docility of the body can be achieved equally on the anatomo-political level and on the level of the technologies of the self. Thus, domestication can be understood as a progressive molding of body and behavior, or as a process defined by a highly regimented program of training simultaneously inscribed in the practice of selective breeding or biotechnology.

Much of the productive opportunity provided by the concept of *dispositif* within a human/animal studies analysis lies in its ability to enable the recovery of incongruous and contradictory intermingling between practices, discourses, institutions, and the biopower relationships that shape them. Most importantly, the allure of *It's Hard to Make a Stand* deliberately gestures toward a dangerous continuity between the anatomo-political elements of power technologies and those of the docile bodies. Where does domestication discursively begin and domination end? Which biopower relationships between human and animal are at play in both constructs? How much do these power relations overlap and where do they differ in order to remain relatively ontologically distinct from one another (so to be differently named)? And most importantly, what are the implications involved in the intrinsic impossibility of clearly distinguishing between the underlying discourses that perpetrate these types of relationships?

HUMAN/ANIMAL PROSTHETIC RELATIONSHIPS

Steve Bishop's use of fur carries a political proposal: the fur coat in *It's Hard to Make a Stand* simultaneously inscribes the totalizing extreme of

anatomo-political power (through the inconfutable materiality of animal hide) and the working of the technologies of docile bodies (in the summoning of the dog signifier). Realism and indexicality are once again central to this proposal. The assemblage stages a theatricality that mobilizes the viewer's body for the purpose of generating a nonaffirmative value, one that surprises by inserting an alternative/complementary narrativizing element.[41] This becomes evident as the elusive image of a dog's head appears in the folds of the fur coat only when seen from a lateral viewpoint.

The seeming naturalness with which the fur coat hangs on the head of the mannequin, and the effortlessness with which this arrangement in turn visually gestures toward the canine, further emphasize the problematic naturalization that biotechnologies of control transhistorically acquire in technocapitalist economies.

As seen, the retrieval of *dispositifs* entails consideration of the intermingling networks of power relations established between "discourses, institutions, architectural forms, regulatory decisions, laws, administrative measures, scientific statements, philosophical, moral and philanthropic propositions."[42] At this stage, it is important to consider that all human/ animal relationships inscribed in *It's Hard to Make a Stand* can be categorized as *prosthetic*. Each object included in the assemblage, like in the Duchampian readymade, alludes to the missing human body part implied in the object-related action. The notion of prosthetics has played a defining role in human/animal studies conceptions of posthumanism. As Cary Wolfe argues, man "is fundamentally a prosthetic creature that has co-evolved with various forms of technicity and materiality, forms that are radically 'not-human' and yet have nevertheless made the human what it is."[43] The appearance of the dog within the signifying set of the assemblage thus places an emphasis on the self-reflexivity and intra-action essence of the technologies of biopower. Ultimately, dogs are the most successful incarnation of the application of technologies of docile bodies ever performed in the history of domestication—dogs, much more than cats, are the quintessential pet for a reason.[44] We are all familiar with the intense devotion dogs have for their human companions, but guide dogs are capable of establishing an even deeper bond. Clinton R. Sanders's view of guide dogs is that "the dog and person are defined by self and others as a unitary social actor. In this sense the dog is transformed into a literal extension of the owner's self."[45] Dogs, like horses, can therefore also inhabit

prosthetic paradigms, ambiguously vacillating between the role of pet and that of machine. Examples of these ontological ambiguities can be traced in their function of enhancing human sensory perception, as by dogs at war, or as partners in hunting or policing.[46] Similarly, the "war horse," that which inspired the taxidermy work of Berlinde De Bruyckere, also quivers between the figure of the pet and the machine, playing a key role in the private and public lives of royals, military, and aristocrats alike.

It is worth reassessing that the semantic strength of *It's Hard to Make a Stand* lies in its ability to derail human/animal transhistorical narratives of domestication and companionship as justified by aesthetic-moral defenses claiming that animals benefit from domestication. Juxtaposed to the fur coat, the horse mannequin could be simplistically understood to predominantly gesture toward biopower relations of the docile bodies. However, deeper knowledge of the processes of domestication and training of horses may reveal otherwise. Although not resulting in the killing of animals, the project of docility transhistorically operated upon horses is one that, as Paul Patton argues, entails the regular performing of "cruel practices designed to wear down the animal capacity to resist. Tying up the horse and hitting it all over the body with a sack was known as 'bagging' or 'sacking out'. The purpose of this activity, which was terrifying to young, unhandled horses, was to dull their sensitivity to touch and sudden movement."[47] The incorporation of these techniques of "training" docile bodies in the domestication practices of horses are inscribed in the fur coat of *It's Hard to Make a Stand*: as it covers the head of the horse mannequin, it alludes to the dulling of the animal's sensitivity through a process of *passivation*. The covering of the horse's eyes can also be seen to allude to the widespread use of blinders when horses are involved in transportation. According to Steven Bowers and Marlen Steward, authors of *Farming with Horses*, the blinders constitute much more than simply a practical tool of coercion. The blinders tell the horse "he is not being trusted with the full use of his faculties. This is a powerful yet subtle way of telling the horse that you want to use his body without using his mind."[48] The coat thus metaphorically bridges horse and dog as animals shaped by human/animal power/knowledge relations driven by the anthropocentric human desire to curb the horse's temper into the docility of a dog—the quintessential signifier of animal obedience.

In animal studies, critiques of the process of domestication have focused on the roles horses and dogs have played as emblems of wealth. In *It's Hard to Make a Stand* the fur coat not only incarnates generic canine morphology but more specifically alludes to the physiognomy of a hound. As noted by Gary Lim in "'A Stede Gode and Lel': Valuing Arondel in Bevis of Hampton," hounds and horses (along with awakes) constitute a particular class of gifts "associated with noble pursuit of war and the hunt."[49] Following this argument would lead to the recovery of transhistorical discourses in which social status appears indissolubly defined and simultaneously perpetuated by the ostentation of materiality in the crystallized form of the trophy. All three animal presences and absences summoned by *It's Hard to Make a Stand* ultimately appear ontologically aligned as status symbols—literally and metaphorically objectified animals, commodities intrinsically and indissolubly intertwined to the discourses of biopower that produce them.

Reiterating the problematics inscribed in these human/animal relations, Susan McHugh convincingly argued that the transhistorical practice of selective breeding (a defining base of practices of training and domestication and a manifestation of the biopower relation at play in paradigms of docile bodies), which tends to fix the human-favored recursivity of genetic configurations produces "congenital physical disorders or defects partially caused by heredity—including cleft palate, haemophilia and progressive retinal atrophy leading to blindness."[50] According to McHugh, the construct of the pure breed possesses a "power of illusion," a naturalizing ability to make invisible, which overshadows our everyday experiences with dogs through the prioritizing of social class and gender connotations.[51] *It's Hard to Make a Stand*, in its nonaffirmative fragmentation, maps the intrinsic contradictions and incongruities involved in what Patton identifies as aesthetic-moral defenses culturally connoting domestication and training as "ennoblement in the development of the animal's character and in the development of both the animal *and the handler's* sense of responsibility and honesty."[52] This is an essential modality of anthropogenic darkness, akin to that theorized by Timothy Morton in ecological terms—domestication and violence are revealed by *It's Hard To Make a Stand* as relentlessly looping upon each other in networks of discourses and practices. Acknowledging this darkness enables

us to analyze, criticize, and overcome certain repetitional patterns in human/animal relations.

THE BIOPOLITICS OF FUR

Furthering the retrieval of the *dispositifs* at play in *It's Hard to Make a Stand* through anthropogenic analytical lenses therefore entails extending the analysis of power to the institutions that shape biopower in human/ animal relationships. Along with these considerations, predominantly re-volving around the controlling spatializations of kennels, equine breeders, fur-trade caging, and practices of rendering, also reemerges the central conception of the docile body. Anatomo-political forces in the Anthro-pocene substantially affect the bodies of animals bred, reared, and killed for fur. These forces are exercised in two ways: through the limitations im-posed by architectural spaces intentionally designed by institutions, and, on the biological level, through practices of selective breeding. These prac-tices fix biological, morphological, and behavioral traits in animal bodies for the purpose of increasing capital gain. As a discursive practice operated institutionally through the deployment and enforcing of scientific state-ments, selective breeding not only plays a key role in the shaping of docile bodies but simultaneously defines the subjective formations of the humans involved in the relationships. The bodies of purebred horses, pedigreed dogs, and fur-standard mammals are all equally and relentlessly optimized for the purpose of crystallizing a status symbol of exclusive social value.

The fur trade substantially demarcated the colonial relations among Britain, France, and North America.[53] Julia Emberly's retrieval of past cultural histories of fur brings to the surface a number of *dispositifs* in which the rendered animal/material simultaneously is the product and the currency of power relations shaped by complex legislation that in Britain went as far as preventing poor social classes from wearing it.[54] As a status symbol of exclusivity, the fur coat was at the center of heated controversy in Europe during the 1980s.[55] But the poor sales of fur in the 1990s have been recently followed by a strong rebound. Most re-cently, as reported by the *International Business Times*, fur sales have

been soaring because of demand from newly powerful economies, such as China's.[56] At a time in which fur is gaining new popularity through emerging capitalist forces in the East, Bishop's *It's Hard to Make a Stand* proposes imagery that invites very careful consideration of the power relationships that produce such commodities and that shape human/animal relations. It is because of this consideration that all three absent animals summoned in the assemblage appear equalized upon an ontological level of animal/capital values defined by prosthetic and consumptive paradigms. This equalization reveals pets, fur animals, and domesticated animals as being substantially defined by far too similar ontological vulnerability. As the product of power/knowledge relations, they are paradoxically produced, shaped, used, and consumed within a shared, underlying set of animal/capital laws, administrative measures, and scientific statements.

As a piece of speculative taxidermy, the fur coat awkwardly hanging from the head of the horse mannequin constitutes the most charged signifier in *It's Hard to Make a Stand*. Here, the fur coat is not displayed in compliance with the iconography of fashion advertising; the non-affirmative proposal it produces through its materiality appears ambiguous and open-ended within the assemblage (this is part of the *tableau-objet* dynamics that this piece capitalizes upon). The retrieval of the *dispositif* that interlinks the horse mannequin and the fur coat alludes to the shared, and usually occulted, foundational technological origin of taxidermy and tailoring, situated in the ancient practices of skinning and tanning of animal hides. After this essential rendering stage, animal hides, both those fashioned as coats and those mounted as taxidermy skins, enter very different but nonetheless intermingling discourses of power/knowledge relationships. Whereas an individual animal skin in taxidermy is made to morphologically reconstitute the anatomy of the animal body from which it was detached, the fur coat is constructed using different, fragmented animal hides reconfigured upon the anatomical model of the human torso. In both cases, a naturalization of the extensively rendered, no longer living animal surface is performed by concealing joins and seams. Both the taxidermy skin and the fur coat attempt, and equally successfully perform, a disavowal of animal death: taxidermy by resuscitating the killed animal through the realistic illusion of livingness, and the fur coat by silencing animal skin into the ontology of textiles.

In the case of *It's Hard to Make a Stand*, it is upon the presence of animal surfaces juxtaposed to those of mass-produced objects that, as Foucault claims, the event passes from work of art to viewer, affecting the viewer with a force that can enable transformation.[57] The event proposed by *It's Hard to Make a Stand* therefore "transmits and magnifies the [animal] other, which combines with it and gives rise, for all those who come to look at it, to an infinite series of new passages."[58]

MAKING A STAND

Through the recovery process involving *It's Hard to Make a Stand,* I have deliberately ignored Steve Bishop's titling of the piece. In an interview, the artist humorously explained *It's Hard to Make a Stand* as follows: "It was really hard to make a base for it—that's where the title comes from. The stand has a double beveled edge as a nod to public sculpture. It's like a defaced memorial, like when you see a statue of a soldier on a horse and someone's put a traffic cone on its head—what does that gesture stand for?"[59]

Bishop's statement brings attention to the understated wooden stand that elevates the horse mannequin and simultaneously raises questions about the literal affirmative value of the fragment "making a stand" contained in the title. As noted by Malt through her analysis of the surrealist object, one of the most common features and recurring traits of surrealist objects lies in the "presence of the accouterments of artistic display. Everywhere are pedestals, frames, glass domes, and display cabinets, as if the works were declaring their status in relation to the traditional forms of art."[60] To Malt, this gesture ultimately belongs to the repertoire of the *parody*, insistently inscribing the work of art within the ontology of the artistic despite its unassuming appearances.[61] The plinth of *It's Hard to Make a Stand* is one that, as the artist explains, nods to the solid grandeur of the classical equestrian monument. However, the stand also underlines the assemblage in a deep, nonaffirmative sense, parodying the cultural symbolization of biopower inscribed in the iconography of the equestrian monument through the haphazard and amatorial juxtaposition of incongruous material surfaces. Therefore, the stand appears simultaneously alluring and disheveled, calculated but precarious. The glistening golden

mirror lining its upper part is only a thin surface of reflective veneer, and is revealed as such by an underlying plywood structure. Once again, signification can be derived from a focus on the juxtaposition of the materialities in this piece. The reflectiveness of the mirror surface shows the underbelly of the horse mannequin. In so doing, it reveals the absence of sexual organs, a reference to castration, and another reassessment of the passivating operations involved in the prosthetic relationships between horses and humans. Simultaneously, it alludes to the figure of speech in which to "show the underbelly" means to display vulnerability. The mirror points at the underlining conception of *It's Hard to Make a Stand* as the object-assemblage able to reveal the hidden contradictions, fragmentations, and parallelisms involved in human/animal relations.

Beyond the artist's claim that it literally "was hard to build the stand," the recovery of human/animal *dispositifs* inscribed in the assemblage makes it impossible to ignore the signification of the idiom "to make a stand" beyond its literalist dimension. "To make a stand" is a determined effort to defend something or to stop something from happening. In its double entendre, "making a stand" therefore proposes two valid commentaries about such power relations. The first is a resignation to the impossibility of making a determined effort to defend, supposedly on ethical grounds, the value of the biopower relations at play in the human/animal relations inscribed. The second is a sense of resignation to the naturalization that such power relations have transhistorically acquired, thereby acknowledging that "it's hard to make a stand" against the pervasive powers that perpetrate the human/animal relations on display in this work. In this sense, *It's Hard to Make a Stand* is indeed like a defaced memorial, a sign that the values it represents are no longer supported and shared by parts of society. As an anthropogenic element of resistance, the piece equates to a refusal to comply with the power/knowledge relationships defining the transhistorical human/animal relations that it reveals.[62]

THE REENCHANTMENT OF ART

Perhaps with reason, it might seem that speculative taxidermy is characterized by a certain level of cynicism—the anthropogenic darkness herein

mentioned. Since speculative taxidermy has its feet firmly planted in the ground, its indexical matrix anchors readings in a carnal register of technocapitalist consumption. So it is no surprise that it might, in turn, appear somewhat dark.

In 1991, Suzi Gablik's controversial book *The Reenchantment of Art* laid the foundations of many essential artistic/political concerns that have become central to today's discourses. The book diagnoses the traits of a cultural crisis essentially caused by modernism, which, according to the author, substantially impoverished artistic discourses and art making in the second half of the twentieth century.[63] In opposition to an object-focused art system, Gablik advocates the need to overcome the artist/audience dichotomic relationship based on shock tactics (little did she know that the Young British Artists [YBAs] would be soon capturing the attention of the artworld with unprecedentedly intense and brutal shock strategies) for the purpose of establishing aesthetics of interaction and connection. But most importantly, Gablik argues that this new relation should be employed in light of the need to overcome the hegemony of technological and materialist views that have compromised any other possibilities to form connections between humans and nature. A reenchantment of art, however, has nothing to do with a return to religious art, but instead is centered around the possibility that new mythologies may arise in order to define new alternative realisms—realisms that are not defined by the empiricism of scientific thought.

Perhaps Gablik challenged the predominant sociocultural paradigm a little too soon, but in a sense, the excessive, obsessive, self-indulgent, and narcissistic gestures of the YBAs (and other commercial movements) might have heightened the desire for a different, quieter, slower, and more meditative aesthetic register. The disenchantment of art, a phenomenon partly caused by oppressive consumerist frameworks, was linked to scientific objectivity and to the Greenbergian/Friedian modernist emphasis on an art model in which the object is autonomous. Gablik acknowledges that Cartesian philosophies have "carried us away from a sense of wholeness by focusing only on individual experience" and thus advocates the importance of placing interconnectedness at the center of the picture.[64] For the purpose of defining new aesthetic models, emphasis should be placed on new concepts of communities and environments, a reenchantment capable of moving beyond "modern traditions of mechanism,

positivism, empiricism, rationalism, materialism, secularism and scientism—the whole objectifying consciousness of the Enlightenment— in a way that allows for a return of the soul."[65] This operation, Gablik argues, becomes an urgent necessity in the light of the need we have to remediate the "mess we have made of the world."[66] It is perhaps not surprising that at the beginning of the 1990s this argument was critiqued by some as "new-age obscurantism." But it is evident today that much of Gablik's argument was somewhat prophetic.

Since the publication of Gablik's book, two major sociocultural shifts have substantially shaped the western artistic scene. Environmental concern has become an omnipresent factor in everyday life. Global warming is the ever-present form of anxiety today's children live with, while the Internet has substantially reconfigured the concept of communities on micro and macro scales. These factors have substantially affected the art scene in ways that Gablik could have not foreseen. The massification of digital technologies, which has especially characterized the past twenty years, has also substantially altered our relationship with material objects.[67] Adding to Fudge's theorization of the recalcitrant materiality of the animal-made-object, it can be argued that the nonreducible materiality presented by animal fur in Bishop's work, and in the work of the other artists discussed in this book, has been substantially enhanced and problematized by the relentless dematerialization of analog technologies operated by the emergence of digital networks. As argued by Simon Reynolds in *Retromania*, the 2000s were generally characterized by a return of past stylistic genres in music and fashion. These revivals have coincided with a recuperation of the tangible materiality of media, such as vinyl records, printed books, and cassette tapes.[68]

The discourses that have demarcated the emergence of this renewed material interest in popular culture and in art practices are interrelated. As the editors of the volume *Visuality/Materiality* argue, visuality and materiality should be conceived as co-constituting—as caught in a reflexively productive relationship.[69] Akin to Shukin's double entendre of the mimetic, and sharing substantial preoccupations with Elkins's plea to pay attention to materials in art, the visuality/materiality paradigm proposes a problematized contemporary cultural economy of consumption in which materiality is nonreducible. In this context, the possible complications proposed by a fleeting and unremarkably ephemeral circulation of

images in contemporary media-saturated societies should also be taken into account.[70] The mode of inattentiveness in which images are generally consumed in our everyday lives constitutes a political problematization of ethical value as the material world is relentlessly compressed in immaterial file formats and exposed through flat screens inviting material indifference.[71] How will this shift away from materiality in popular culture affect human/animal relations and the aesthetics through which these approaches appear in contemporary art?

The recursivity with which this "immaterial condition of consumption" is informing media industries such as film and music results in a collective practice producing an apparent sameness, ultimately justifying the disinterestedness with which contemporary consumption is imbued. The new, high-speed technologies of the early twentieth century, such as film, radio, and telephone, those that Lippit linked to the disappearance of animals in everyday life (and that emerged at the same time as the surrealist assemblage), have all today been absorbed and made hyper by cyberspace.

It is within these practices and discourses producing increasingly affirmative experiences characterized by absolute sovereignty, and inscribed in the disembodied experience proposed by the contemporary technocapitalist conditions of consumption, that the appearance of animal skin in contemporary art (along with numerous other strategies) provides a material-based, charged problematizer—an alternative constructed register of realism. It is also within this paradigmatic set that a more demarcated human/animal studies context can enable the conception of the presence of animal skin in contemporary art as a gesture of resistance, rather than a simple sign of human domination over animals.

As proposed by Broglio, animal skin constitutes an entity of "contact and resistance,"[72] even and most importantly when the animal is no longer alive and therefore can no longer physically resist. There is a shock of physicality at play, Broglio claims, in the encounter with animal surfaces that "enlivens the surface of the animal body as something other than an object enframed by human desire."[73]

CODA

Toward New Mythologies—the Ritual,

the Sacrifice, the Interconnectedness

Haunting seems to happen where enchantment has been banned or suppressed. The gods are replaced by ghosts and they disturb us with hollow sounds. Ghosts are not the things they once were, but nagging forms of memory that refuse to let the past go away. They are unfinished business, terrifying proof that the past is not yet over.

—DAVID MORGAN, "ENCHANTMENT, DISENCHANTMENT, RE-ENCHANTMENT"

A life thus names a restless activeness, a destructive-creative force-presence that does not coincide fully with any specific body. A life tears the fabric of the actual without ever coming fully "out" in a person, place, or thing. A life points to what A Thousand Plateaus describes as "matter-movement" or "matter-energy," a "matter in variation that enters assemblages and leaves them." A life is a vitality proper not to any individual but to "pure immanence," or that protean swarm that is not actual though it is real: "A life contains only virtuals. It is made of virtualities."

—JANE BENNETT, *VIBRANT MATTER: A POLITICAL ECOLOGY OF THINGS*

n 2001, Jane Bennett's *The Enchantment of Modern Life: Attachments, Crossings, and Ethics* incorporated ideas similar to those explored by Gablik. Bennet's critique of the Anthropocene ultimately positioned it as a time in which secularization, rationalization, and scientization have re-

placed enchantment.[1] Her proposal considered the possibility of connecting enchantment to ethics. Thus far, speculative taxidermy has been contextualized as a critical interface in which scientific realism is relentlessly problematized, fragmented, and reconfigured. But in line with Gablik's original conception, speculative taxidermy can also subvert "modern traditions of mechanism, positivism, empiricism, rationalism, materialism, secularism and scientism—the whole objectifying consciousness of the Enlightenment."[2] Yet, it is important to face the fact that an enchantment involving taxidermy can only be a haunted one—one in which the animal absence/presence is central, always unstable, and relentlessly polysemic.

Contemporary art has not yet renounced (as Gablik might have hoped) the "affirmative art object" as a central catalyst, as the vanishing point of discourses, and as a sedimentation of practices. Donald Preziosi argued in 2011 that the contemporary art object is persistently haunted by its ancestral predecessor: the *religious relic*.[3] While it is important to clarify that Gablik's advocacy of reenchantment is not situated in Christianity or any other religious doctrine, it is also important to note that any enchantment of western art would most likely build upon preexisting notions of transcendence. Taxidermy is intrinsically aligned to the relic on the account of its indexicality. Like the relic, the taxidermy object is a sign, a symbol, and a trace that rests on institutionally constructed truth. However, this truth, in contemporary art, is characterized by an important fluidity that renders it unstable and precarious. This instability, as seen throughout the examples discussed in this book, is where the possibility of a nonanthropocentric positioning of the future can emerge. Therefore, as a relic, speculative taxidermy can be a site upon which the magical, the mythical, and the scientific might interplay without necessarily disavowing a political/ethical edge inscribed in its material register.

Krzysztof Pomian has argued that western collections of relics and cabinets of curiosities are associated with a substantial and undeniable link to the sacrificial, which he structurally outlines as the process of removing an object from the utilitarian sphere, for the purpose of entering a transcendental connection with an invisible spiritual dimension.[4] As such, the relic's charged indexicality, its material claims for truth, essentially is a connective agent between the immanent and the transcendent. In this sense, in all speculative taxidermy, the preserved animal skin constitutes the materialization of the abyss between human and animal. It is a surface thought out

and manipulated for the purpose of connecting us to a long-lost dimension: a prelinguistic relationship with other animals, environments, and ultimately ourselves. But of course its usefulness in this task its only illusory. In the oxymoronic aesthetic game that defines taxidermy animal skin, maximum visibility always equates to utter invisibility, closeness is the ultimate distance, and possession entails the deepest loss.

It is in this context that Cole Swanson's installation titled *Out of the Strong, Something Sweet* (2016) operates a series of ontological derailments designed to map the intermingling of multispecies relationships connected by mythical, transhistorical, and material connections. Sidestepping modern scientific models and incorporating a multimedia approach that involves taxidermy, sound, painting, drawing, and sculpture, Swanson constructs an "enchanted" epistemological space in which the body of the viewer is mobilized by multiple representational strategies. As a complex example apparatus incorporating speculative taxidermy, this installation centers on different notions of mimesis and indexicality, their potential ability to structure different registers of realism, and the indexical materiality through which realist narratives are implicitly validated.

Focusing on the deconstruction and reconfiguration of human/animal worldings, *Out of the Strong, Something Sweet* recovers an important triangulation of interdependency connecting humans, honeybees, and bovines. Both honeybees and bovines have long histories of transspecies becomings. Examples of Egyptian art show that the domestication of bees could have occurred almost 5,000 years ago,[5] whereas the domestication of bovines began roughly 10,500 years ago.[6] The entanglements of "becoming with" that have defined our relationships with these animals are many and are today naturalized enough to no longer be visible. As we know, both bovines and bees, for different reasons, play extremely important roles in our capitalist cycles of production and consumption and, by implication, in ecosystems. A tangible sign of anthropogenic environmental unbalances is, in fact, the current collapse of bee populations around the world. Suddenly, the interconnectedness between pollinators, meat production, and mass agricultural processes has been exposed as a fracture in the illusion that we might have successfully mechanized nature's process enough to get along without insects. Thus, the conflicts of interest between efforts to keep parasites off plants, the use of pesticides and neonicotinoids, and the need to allow bees to pollinate have become more and more pressing over the past ten years. It is in this context that

the current collapse of bee populations becomes emblematic of the current anthropogenic stage when it is aligned with the simultaneously worldwide increase in bovine farming caused by rising demand for meat and other animal derivates. These different and seemingly unrelated biotechnoecological economies are brought together in Swanson's installation through the notions of sacrifice, purification, and rebirth.

Lippit argued that sacrifice is "a melancholic ritual, replete with sadism and ambivalence, which repeats the origin of humanity."[7] The supporting principle of Swanson's *Out of the Strong, Something Sweet* is *bougonia*, an ancient ritual, recounted by Virgil in the *Georgics*, involving the miraculous rebirth of a bee swarm from the rotting carcass of a calf.[8] Losses in bee populations are not exclusive to the current stage of the Anthropocene, but occurred in ancient Egypt as well as in modern Europe. For centuries, until the 1700s, the *bougonia* ritual provided a sort of reparatory practice that was regularly included in beekeeping manuals.[9] Based on the prescientific theory of spontaneous generation, according to which insects could be born from animal carcasses, *bougonia* involved a sacrificial negotiation between visibility and invisibility.[10] And much of the enchantment toward which Swanson's installation thus rests on this nonaffirmative negotiation that the viewer is invited to engage. A case in point lies in the piece of the installation titled *Caulbearers*: a selection of preserved and modeled cattle stomachs, which leverages upon the allusive power of decontextualized animal matter gesturing to the materiality of beeswax and the structure of hive cells. Mimesis and resemblance are made to intertwine in order to crumble the order of taxonomy and to speculate about the possibility of alternative relational registers that could have formed the backbone of what became classical scientific knowledge. What would our world look like today if one of these analogical options had been seriously pursued?

The installation comprises six distinct, but interrelated, pieces in different media: *Out of the Strong, Something Sweet*; *Regina Mortem*; *Caulbearers*; *Swarms*; *Specimen Hides*; and *Bone Black*. All pieces allude to the absent presence of animal flesh through intriguing interplays of materiality involving animal skin, animal sounds, entrails, and bones. In *Regina Mortem*, viewers are implicitly invited by the setup to place their heads between two suspended bovine horns right where the animal skull would have been (fig. C.1). Once the participant's ears are aligned with the hollow cavities of the horns, a crinkly noise becomes audible. Through repeated listening,

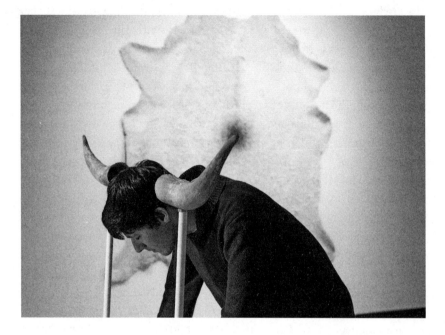

FIGURE C.1 Cole Swanson, *Regina Mortem*, 2016, from *Out of the Strong, Something Sweet*. Exhibition curator Dawn Owen, 2016, Art Gallery of Guelph, Canada. Dean Palmer Photography. © Cole Swanson.

this noise manifests itself as the call of a virgin queen bee. As is known, any given hive has space for only one queen, so the initial royal task of the first-emerging queen bee is to identify the other unborn queens that are still in their cells and to sting them to death. This stage in the installation proposes a curious overlay of human, bovine, and bee, for the sound of a queen bee hatching alludes to the essential step in the generation of a new swarm in *bougonia*. The sound is connected to a narrativization that bears substantial anthropomorphic traits: that of the deadly power disputes between royal heirs to the throne (and, by proxy, many other mundane power struggles we are all involved in), reminding us how important power also is in animal societies. This analogy is tightened further by the shadow cast on the ground, which visually fuses the horns to the head of the participant. This embodied experience, for a few moments, invites an immersion in the enchanted interconnectedness between human, bovine, and insect central to the installation—an experience far from the epistemic distancing of

scientific analysis, and one that instead unravels in a pseudomythical sacrificial ritual from thousands of years ago in order to derail modern ontologies of human/animal/environment relations. In this position, anthropomorphism and anthropocentrism are made to problematically intertwine in a web of new productivities.

While listening to the call of the firstborn queen bee, the viewer is strategically positioned so that twelve abstract images alluding to cow body parts appear in full view. *Bone Black* comprises bone char pigment drawings in which the animal body, as modern science would have it, is fragmented and abstracted (fig. C.2). Stark against the white background, the body fragments visualy oscillate between the scientific specimen and beef offcuts. The use of bone char pigment is for Swanson extremely important, for this specific material presence anchors *Out of the Strong, Something Sweet* in the undeniable workings of rendering and commodification that have been discussed in this book through Shukin's argument on the technocapitalist economies of consumption. Bone char has historically been used in three distinct circumstances. The tricalcium phosphate it contains has served as a water defluoridation agent because of its strong capacity for the absorption of heavy metals, arsenic, and lead.[11] Its intrinsic filtering qualities have led to its use in the sugar refining industry as a

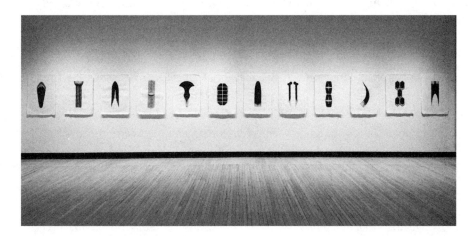

FIGURE C.2 Cole Swanson, *Bone Black*, 2015, from *Out of the Strong, Something Sweet*. Exhibition curator Dawn Owen, 2016, Art Gallery of Guelph, Canada. Dean Palmer Photography. © Cole Swanson.

decolorizing and de-ashing agent.[12] Lastly, the same material also has a long history as an artist's pigment: the famous bone black or ivory black used since the Baroque period is derived from bone char. These levels of interconnectedness between animal renderings, artistic practices, and technocapitalist economies of visibility are regularly lost in the narrativizations of modernity through which animal sacrifices and ritualized renderings have been incorporated, disavowed, and disenchanted.

The industrial purifying qualities of bone char are reenchanted in *Bone Black* through an emphasis on the blackness that constitutes it, the whiteness that it can impart, and the cleansing effect it can have on water and sugar. Thus, purification is the magical essence of the ritualistic element in this installation. However, its inscription is ambivalent and ambiguous, substantially positive but equally ominous. This ambivalence is inscribed in the drawings' black-and-white rendering; as the essential noncolors in art, they simplify, synthesize, and purify the world into distilled images. However, what is being reenchanted in Swanson's installation, both representationally and materially, is the offcut of bovine meat the drawings idealize: they stand for consumption and waste. This reenchantment is haunted—for, as Shukin argues, the rendering industry, by efficiently and productively disposing of the by-product, formulates "itself as the redeemer of the animal carnage of mass capitalism."[13] This operation constitutes a radicalization of the nature of capitalism, its systematic consumption of animals, and its seemingly endless ability to unravel capital gain from different forms of rendering.[14]

In this context, the bed of white sugar upon which some of the bovine skulls rest becomes a problematic field of forces in which colonialist narratives of exploitation, connecting the agential capacities of humans, bovines, bees, and the devastating deforestation required to grow sugar cane, are sedimented. Like desert sand, the expanse of sugar looks inert, but it contains potential. Although in the installation sugar appears embroiled within chains of devastation and death, it simultaneously is the food given to bees by beekeepers during the cold winters. The feedback loop of dark ecologies starts again here. It is obvious at this point that a western preoccupation with whiteness pervades the whole installation—the notions of purity and sacrifice inscribed in many components of *Out of the Strong, Something Sweet* are suddenly problematized further. The blackness and whiteness of materialities, and their essentially othering agencies, imply ideological positionings and dynamics that still pervade today's societies.

Swanson's critique of human/animal/environment relations and the different epistemic avenues through which we make sense of interconnectedness through the rediscovery of *bougonia*, and the biological registers of animal rendering, are further problematized in this installation by two other pieces featuring ten miniature simulacra of cowhides and two preserved, full-size ones. *Specimen Hides* and *Swarms* deliberately refer to the ontologies of natural history, the positivist realism able to reduce animals to surfaces. As seen in chapter 2, anthropologist Levi-Strauss argued that the miniature is effectively a dedicated power/knowledge operation: a deliberate reduction of the object of study aiming at more easily grasping its element and essence. Through the reconfiguration of this essential natural history totalization, Swanson points to objectification through three symbolic gestures of reduction. Not only are the miniature skins displayed by Swanson much smaller than the originals, but they actually are small and intricately detailed paintings shaped like hides (fig. C.3). Each measures three by two inches and

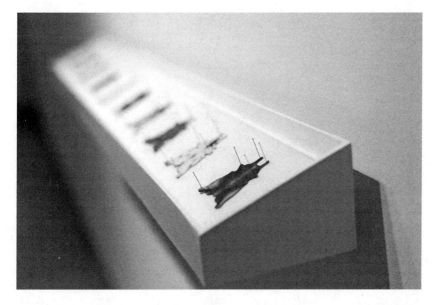

FIGURE C.3 Cole Swanson, *Specimen Hides*, 2015, from *Out of the Strong, Something Sweet*. Exhibition curator Dawn Owen, 2016, Art Gallery of Guelph, Canada. Dean Palmer Photography. © Cole Swanson.

faithfully reproduces a cowhide, using only bone black and earth pigments. Although the skin patterns look entirely natural, closer inspection reveals that colonialist trade routes have been inscribed on their surfaces.

To heighten the sense of objectification that disenchanted animals through the classical age, Swanson operates a strategy typical of speculative taxidermy: he conflates two different institutional practices for the purpose of heightening the discursive incongruities that lie beneath the surface of epistemology. The miniature skins are set flat using entomological pins, thus gesturing toward the outermost level of objectification in modern natural history (fig. C.4). This is a peculiar sight in which the intrinsic absurdity of taxonomical practices is exposed by the miniature skins' collapse of mammal and entomological display modalities. This simple gesture poses ontological questions about animal lives and the value we attribute to them in relation to their assigned group and species of membership—what was the essential difference between the life of

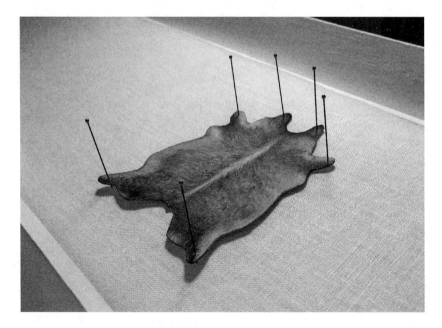

FIGURE C.4 Cole Swanson, *Specimen Hides*, 2015, from *Out of the Strong, Something Sweet*. Exhibition curator Dawn Owen, 2016, Art Gallery of Guelph, Canada. Dean Palmer Photography. © Cole Swanson.

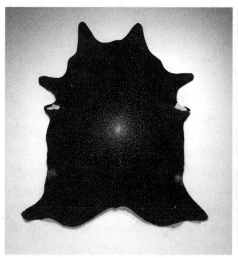

FIGURE C.5 Cole Swanson, *Star Swarm*, 2015, from *Out of the Strong, Something Sweet*. Exhibition curator Dawn Owen, 2016, Art Gallery of Guelph, Canada. Dean Palmer Photography. © Cole Swanson.

a bovine and that of an insect to the natural history scientist of the eighteenth century and, by extension, to the scientists of today? But if at one moment *Specimen Hides* paradoxically casts us as giants in charge of ordering the world, in the next moment *Swarms* rapidly dwarfs us by presenting the undeniable material presence of two preserved cowhides, one black and one white, this time fully life-size. The skins are once again flattened, a symbolic gesture that nonetheless alludes to seemingly unrelated practices of skin tanning (in the production of clothing) and taxonomic collecting. But in this sense, Swanson's skins are substantially different from those encountered in the work of Snæbjörnsdóttir/Wilson, Galanin, or Mntambo. Suspended in their ambiguous, headless flatness, these skins are transfixed by entomological pins whose purpose, this time, is purely aesthetic. The pins are not positioned methodically as they would be in a natural history display; they cluster at the center of the hide, dispersing toward the outer edges. Carolyne Topdjian has noted that the pins "puncture the skin again and again, denoting a repeated act that borders on violence. With each prick, a blemish forms on the otherwise pure fur, creating a sense of pain and disgust. The skin's borders

are spoiled, violated."[15] This operation evokes physical pain in a site in which the animal body that could experience such feeling has been made absent. The impossibility of an empathic relationship is thus inscribed in a connection that returns us to a notion of distance, one that takes the viewer to an aesthetic dimension in which the life-size taxidermy surface bursts into a vast expanse. Too close to ignore in its material presence and simultaneously too far away to be fully comprehended, the pins derail the viewer's sense of scale and dimensionality by simultaneously posing as stars, bees, ants, gnats, or bacteria. This deliberate disorientation alludes to the metasublime challenges of the Anthropocene, in which notions of deep time push the impact of human activity on this planet to the very surface of a depth we cannot possibly comprehend. Thus, unorthodoxically inserted, the pins are evidenced as tools of power, order, determination, and identification marking a new and intrinsic impossibility of being. Might these abstract swarms represent the possibility to reconnect us with the nonscientific, mythological dimension of the ritual *bougonia* as a portal through which we can rewind time for the purpose of considering human/bovine/bee relationships outside of the contemporary capitalist scale of interest that relentlessly reduces human, animal, insect, and vegetal lives into the flatness of data, figures, and graphs?

With its poetic and sharply symbolic proposal for a sacrificial antidote to ecosystemic collapse, *Out of the Strong, Something Sweet* (plate 12) situates itself at the heart of the current anthropogenic crisis: on the symbolic register, the materialities it incorporates harness notions of propitiation, loss, purification, transmutation, regeneration, consumption, domestication, objectification and exploitation. In the face of ultimate life-threats, the means through which propitiation could be secured entails the rather cunning proposal of sacrificing cows to resuscitating bees: a plea for a sustainable human/animal/environmental coexistence. Thus, *Bougonia* metaphorically functions as a precapitalist, speculative tool; it derails registers of scientific and optical realism to questions our scientific certainties built on an ultimately destructive distancing from the natural world. Simultaneously, it gestures toward alternative registers of perceptual realism and empathic identification that could support future, sustainable ecological models. As scientific knowledge develops its analytical tools and shifts its goals according to contemporary capitalist discourses, what cannot be thought by science that might bear important repercussions? *Out*

of the Strong, Something Sweet does not answer such questions directly, but it nonetheless maps models for registering human/animal interconnectedness beyond scientific/capitalist optics, while still productively incorporating very real histories of human-animal becomings. Marrying these with a kind of prescientific enchantment capable of focusing our attention on ecosystems and interspecies existence from new perspectives might generate a new awareness, giving way to an ontological mobility capable of shaping different and more sustainable futures.

APPENDIX

Some Notes Toward a Manifesto for Artists Working With and About Taxidermy Animals

MARK DION AND ROBERT MARBURY

1 Artists should follow and respect local, national, and international laws designed to protect and foster wildlife. There should be no trafficking in protected species. Abiding by these laws promotes wildlife conservation and breaking these laws can result in the promotion of poaching or stiff fines, and even jail time.

2 It is the responsibility of the artist to know the respective laws pertaining to animals, not just where the artist lives but wherever the artwork may subsequently be shown. This obligation is not superseded by the gallery, art broker, or art buyer.

3 A death is a terrible thing to waste. Whenever possible (and legal) use animal bodies that are already dead—from roadkill incidents or farm deaths, or from euthanization at animal shelters. Needless to say, the use of antique taxidermy is preferable if it serves the artist's aesthetic goals.

4 Art, as a practice, can be a wasteful endeavor. When working with dead animals, strive to use or find use for all parts of the animal. Since taxidermy refers strictly to the preservation of an animal's skin, the carcass, organs and bones are often discarded. Look for creative uses for these parts, and handle and dispose of any toxic or nonorganic material with care.

5 Find creative solutions to producing animals that are unavailable because of their protected status. Goat skins make excellent polar bears and alpaca skin can substitute for grizzly bear skin, for example.

6 Preserved specimens, particularly those improperly prepared, are often subject to infestation by insect pests. Be careful not to spread infestation to the institutions and individuals hosting exhibitions. When preparing specimens or treating infested mounts, parasites and pests can often be dealt with by freezing the specimens.

7 Nothing is permanent. Taxidermy has a list of talented enemies (fire, sunlight, insects, improper care, and time). Understand the limitations of preservation, and work with individuals and institutions to develop maintenance guidelines.

8 There are health concerns when working with dead animals and antique taxidermy. Stay informed about these issues and protect yourself. Take precautions such as wearing gloves and a mask when necessary, and stay up-to-date on your immunizations. Vintage taxidermy was often prepared with arsenic and other poisons, and must be handled with care.

9 Although we are making art, the material we use remains a dead animal. People have very strong reactions to seeing dead animals, no matter how they are presented. Understand that people might have recently lost a pet or chosen to abstain from industrialized farming for the welfare of the animals, or simply are sensitive to thoughts of death. Acknowledge that this artwork will be upsetting to some people.

10 Become knowledgeable about the materials that you are using: animals. Be curious and inquisitive about their classification, habitat, and biology. The audience should assume that you have chosen to use a specific animal and all that goes along with that animal in the context of the artwork: for example, a whitetail deer brings very different meaning to a piece than does a kudu (North American vs. African, hunting season vs. safari, etc.).

11 Because every taxidermy animal was once alive and an individual, recognize the oneness of each specimen. The process of learning about that specific animal, its injuries, symmetry or asymmetry, loss of fur, and unique characteristics give clues to how the animal can be used in art, informing the creation of flow, line, and lifelike qualities. Even if the goal is not mimesis, the process of skinning and fleshing an animal is an intimate act and deserves respect.

12 Ethics are constantly evolving. It is not enough to say either that an artwork is created in an ethical manner or that no animals were killed in the making of an artwork. Artists working with dead animals need to

be able to speak about the death of the animal and must be willing to struggle regularly with the ethical choices we make.

13 Participate in and encourage a dialogue about animals—not limited to animal-human relations, conservation, species protection, animals as pets, animals as food, and greater understanding of the nonhuman world. This is especially important when the dialogue is challenging or even hostile.

NOTES

PROLOGUE

D. Coole 2015, "From Within the Midst of Things: New Sensibility, New Alchemy, and the Renewal of Critical Theory," in C. Cox, J. Jaskey, and S. Malik, eds., *Realism Materialism Art* (Berlin: Sternberg), 41; G. Harman 2015, "Art and Objecthood," in C. Cox, J. Jaskey, and S. Malik, eds., *Realism Materialism Art* (Berlin: Sternberg), 108.

1. R. Kendall 1998, *Degas and the Little Dancer* (New Haven: Yale University Press), 45.
2. C. Millard 1976, *The Sculpture of Edgar Degas* (Princeton: Princeton University Press), 47.
3. At this time, theories of eugenics advocated that one's likelihood to commit crimes could be seen in recurring facial traits.
4. Kendall 1998:7.
5. A.Vollard, "Degas: An Intimate Portrait," cited in R. Kendall, ed. 1994, *Degas by Himself: Drawings, Prints, Paintings, Writings* (New York: Chartwell), 21.
6. The original wax sculpture of *Little Dancer* is exhibited at the National Gallery in Washington, DC.
7. Kendall 1998:32.
8. J. Claretie, cited in Charles S. Moffett, ed., 1986, *The New Painting: Impressionism 1874–1886* (San Francisco: Fine Arts Museum of San Francisco), 341.
9. Kendall 1998:45. Kendall reports that in Joris-Karl Huyusmans's essay "L'exposition des independants en 1881," in *L'art Moderne* (Paris, 1883), 225–257, the wig might have been made of horse or unidentified animal hair.
10. Kendall 1998:41.
11. Ibid., 87.
12. Ignotus, "Le bilan du crime," *Le Figaro*, August 18, 1880, 1, quoted ibid.
13. Hegel, quoted in L. Nochlin 1971, *Realism* (London: Penguin), 14.

INTRODUCTION

M. Foucault 1964, *Madness and Civilization: A History of Insanity in the Age of Reason* (New York: Vintage, 1988), 288; H. Hoch, 1929, *Hannah Hoch* [exhibition catalog] (Berlin: Kunstzaal De Bron).

1. Deyrolle, accessed October 5, 2014, http://www.deyrolle.fr/magazine/spip.php ?rubrique93.
2. Princess Olga of Greece 2008, "Animal House," *Vanity Fair*, September, http://www .vanityfair.com/culture/features/2008/09/deyrolle200809.
3. Ibid.
4. K. Knorovsky 2008, "Behind the Lens: Paris' Deyrolle Taxidermy Shop," *National Geographic Online*, February 21, http://intelligenttravel.nationalgeographic.com/2008/02 /21/behind_the_lens_paris_deyrolle/; M. Blume 2008, "Rescuing Deyrolle, a Beloved Parisian Shop," *New York Times*, March 28, http://www.nytimes.com/2008/03/28/arts /28iht-blume.html?pagewanted=all&_r=0; Drawbridge, 2009, "Martin d'Orgeval: Touched by Fire," *Telegraph*, November 6, http://www.telegraph.co.uk/culture/6455166 /Martin-dOrgeval-Touched-by-Fire.html; E. Biétry-Rivierre 2008, "Comment sauver la maison-musée Deyrolle," *Le Figaro*, February 4, 29; Princess Olga of Greece, "Animal House"; C. Bagley 2009, "Deyrolle: Up from the Ashes," *Wmagazine*, October 9, http://www.wmagazine.com/fashion/2009/10/1000c-deyrolle/.
5. R. Poliquin 2012, *The Breathless Zoo: Taxidermy and the Cultures of Longing* (University Park: Pennsylvania State University Press), 222; Z. Bellel 2009, "Deyrolle: Where the Wild Things Are (Again)," *Paris by Appointment Only* [blog], October 21, http:// www.parisbao.com/art/deyrolle-where-the-wild-things-are-again/.
6. B. McKay 2011, "The Return of Taxidermy," *The Art of Manliness Trunk* [blog], http:// www.artofmanliness.com/trunk/1647/the-return-of-taxidermy/; Jury, L., 2014, "Stuff It! Taxidermy Is the Latest Craze," *Evening Standard*, January 7, 3.
7. L. Secorun Palet 2014, "Taxidermy: The New Hipster Hobby," *Ozy*, August 9, http:// www.ozy.com/fast-forward/taxidermy-the-new-hipster-hobby/32756.
8. G.. Morris 2013, "Taxidermy: Art of Stuffing Animals Dead Trendy," *Sky News*, October 19, http://news.sky.com/story/1156652/taxidermy-art-of-stuffing-animals-dead -trendy.
9. P. Assouline 2008, *Deyrolle—Pour l'avenir* (Paris: Gallimard); L. Bochet and L. A. de Broglie 2009, *1000 Degrees C. Deyrolle* (Paris: Assouline).
10. Princess Olga of Greece 2008; Poliquin 2012:222–223.
11. M. d'Orgeval 2009, "Still Life," *Drawbridge*, no. 14 (Autumn): 16.
12. Throughout this book, the term *naturecultures* is adopted from Donna Haraway's own conception of an impossibility to talk or think of nature as separate from culture. The collapse of the nature/culture dichotomy thus emphasizes an indivisible bond between materiality and semiosis. D. J. Haraway and T. Goodeve 1999, *How Like a Leaf* (London: Routledge).
13. P. A. Morris 2010, *A History of Taxidermy: Art, Science and Bad Taste* (Ascot: MPM), 353.

14. Poliquin 2012:78–79; G. Kavanagh 1989, "Objects as Evidence, or Not?" in S. Pearce, ed., *Museum Studies in Material Culture* (Leicester: Leicester University Press), 125–138; M. Patchett 2010, "Putting Animals on Display: Geographies of Taxidermy Practice," PhD diss., University of Glasgow, 12–20.

15. Kavanagh 1989:137–138.

16. R. Poliquin 2008, "The Matter and Meaning of Museum Taxidermy," *Museum and Society* 6, no. 2 (July): 123–134, quote on 123.

17. Ibid., 123.

18. J. Berger 1980, "Why Look at Animals?" in *About Looking* (London: Vintage, 1993), 3–28.

19. Poliquin 2012:96.

20. L. Barber 1980, *The Heyday of Natural History, 1820–1870* (London: Jonathan Cope), 40–42.

21. Poliquin 2012:96.

22. P. Wakeham 2008, *Taxidermic Signs: Reconstructing Aboriginality* (Minneapolis: University of Minnesota Press), 5–6.

23. M. Simpson 1999, "Immaculate Trophies," *Essays on Canadian Writing*, no. 67 (Summer): 77–106.

24. Ibid., 77.

25. J. M. MacKenzie 1988, *The Empire of Nature: Hunting, Conservation, and British Imperialism* (Manchester: Manchester University Press), 35.

26. D. J. Haraway 1984, "Teddy Bear Patriarchy: Taxidermy in the Garden of Eden," *Social Text*, no. 11 (Winter): 20–64.

27. J. Niesel 1994, "The Horror of Everyday Life: Taxidermy, Aesthetics, and Consumption in Horror Films," *Journal of Criminal Justice and Popular Culture* 2, no. 4: 61–80.

28. A. Hitchcock, dir., 1960, *Psycho* [film] (Shamley Productions); T. Hooper, dir., 1986, *The Texas Chainsaw Massacre 2* [film] (Cannon Films); J. Demme, dir., 1991, *The Silence of the Lambs* [film] (Orion Pictures).

29. Niesel 1994:61.

30. David Shrigley, Jake and Dinos Chapman, Noble and Webster, Damien Hirst, Zhang Huan, Banksy, Paul McCarthy, Jane Edden, Peter Gronquist, Jochem Hendricks, Iris Schieferstein, Paola Pivi, Christiane Mobus, Huang Yong Ping, Jeroen Diepenmaat, and Rod McRae.

31. Dune Varela, Nicolas Lamas, Danielle van Ark, and Mark Fairnington.

32. Berger 1980; S. Baker 1993, *Picturing the Beast: Animals, Identity, and Representation* (Urbana: University of Illinois Press).

33. S. Baker 2000, *The Postmodern Animal* (London: Reaktion).

34. S. Baker 2001, "Where the Wild Things Are: An Interview with Steve Baker," *Cabinet*, no. 4 (Fall), http://www.cabinetmagazine.org/issues/4/SteveBaker.php.

35. Baker 2000:55–56.

36. Ibid., 50, 52, 81.

37. Ibid., 14, 20, 54, 62, 135, 165.

38. Ibid., 56–61.

39. M. H. Marcyliena 2014, *Speech Communities* (Cambridge: Cambridge University Press), 15.

40. Q. Meillassoux 2006, *Après la finitude: Essai sur la nécessité de la contingence*, L'ordre philosophique (Paris: Seuil).

41. G. Harman 2011b, *The Quadruple Object* (Ropley: Zero).

42. Baker 2000:50, 52, 81.

43. K. Barad 2003, "Posthumanist Performativity: Toward an Understanding of How Matter Comes to Matter," *Signs: Journal of Women in Culture and Society* 28, no. 3: 808.

44. The notion of intra-activity used here is borrowed from Karen Barad's conception of agential realism, according to which performativity is linked to the formation of the subject and simultaneously to the production of the matter of bodies. Barad expands Foucault's understanding of the productivity of power for the purpose of incorporating "important material and discursive, social and scientific, human and non-human, and natural and cultural factors." Ibid., 811.

45. This book subscribes to the proposed beginning of the Anthropocene in the 1950s as evidenced by the appearance of radioactive elements dispersed across the planet (Anthropocene Working Group, https://theanthropocene.org/topics/anthropocene -working-group/).

46. T. Morton 2016, *Dark Ecology: For a Logic of Future Coexistence* (New York: Columbia University Press).

47. T. Morton 2010, *The Ecological Thought* (Cambridge: Harvard University Press), 16.

48. D. J. Haraway 2008, *When Species Meet* (Minneapolis: University of Minnesota Press), 41.

49. G. Harman 2011a, *Heidegger Explained: From Phenomenology to Thing* (Chicago: Open Court), 44.

50. A. Appadurai, ed. 1988, *The Social Life of Things: Commodities in Cultural Perspective* (Cambridge: Cambridge University Press).

51. B. Brown 2001, "Thing Theory," *Critical Inquiry* 28, no. 1: 1–22.

52. Harman 2011b:63.

53. Ibid., 5.

54. T. Lemke 2015, "New Materialisms: Foucault and the 'Government of Things,'" *Theory, Culture, and Society* 32, no. 4: 3–25.

55. D. Coole and S. Frost 2010, "Introducing the New Materialism," in D. Coole and S. Frost, eds., *New Materialism: Ontology, Agency, and Politics* (Durham: Duke University Press), 5.

56. Ibid., 8.

57. Ibid., 9.

58. Ibid., 23.

59. L. Dufresne 1803, "Taxidermie," in *Nouveau dictionnaire d'histoire naturelle, appliquée aux arts, principalement à l'agriculture, et à l'economie rurale et domestique par une société de naturalistes et d'agriculture*, vol. 21 (Paris: Déterville), 507–565.

60. D. J. Haraway 2004, "The Promises of Monsters: A Regenerative Politics for Inappropriate/d Others," in *The Haraway Reader* (Abingdon: Psychology), 86.

61. L. Daston and P. Galison 2007, *Objectivity* (New York: Zone).

62. Ibid., 142.

63. M. Foucault and N. Bourriaud 1971/2009, *Manet and the Object of Painting* (London: Tate, 2011), 16; and M. Foucault 1983, *This Is Not a Pipe* (Berkeley: University of California Press), 43–52.

64. R. Broglio 2011, *Surface Encounters: Thinking with Animals and Art* (Minneapolis: University of Minnesota Press), xvi.

65. M. Foucault 1966, *The Order of Things: An Archaeology of the Human Science* (London: Routledge, 1970, 2003), 244 and 408.

66. A. M. Lippit 2000, *Electric Animal: Toward a Rhetoric of Wildlife* (Minneapolis: University of Minnesota Press), 8.

67. Berger 1980:16.

68. N. Shukin 2009, *Animal Capital: Rendering Life in Biopolitical Times* (Minneapolis: University of Minnesota Press); Broglio 2011; J. Malt 2004, *Obscure Objects of Desire: Surrealism, Fetishism, and Politics* (Oxford: Oxford University Press).

69. A. Breton 1924, "First Manifesto of Surrealism," in R. Seaver and H. R. Lane, trans., *Manifestoes of Surrealism* (Ann Arbor: University of Michigan Press, 1969), 34.

70. M. Foucault 1977, *Power/Knowledge: Selected Interviews and Other Writings, 1972–1977,* ed. C. Gordon (New York: Pantheon), 93–94.

71. Ibid., 23; and Foucault 1966:xix.

72. S. Thierman 2010, "Apparatuses of Animality: Foucault Goes to the Slaughterhouse." *Foucault Studies*, no. 9: 89–110; C. Palmer 2001, "'Taming the Wild Profusion of Existing Things'? A Study of Foucault, Power, and Human-Animal Relations?" *Environmental Ethics* 23, no. 4 (Winter): 345.

73. S. Gablik 1991, *The Reenchantment of Art* (New York: Thames and Hudson), 11.

74. Lippit 2000:18.

75. T. Habinek 1990, "Sacrifice, Society, and Vergil's Ox-Born Bees," in *Cabinet of the Muses* (Atlanta: Scholars), 209–233.

76. G. Aloi 2015, "Animal Studies and Art: Elephants in the Room," *Antennae: The Journal of Nature in Visual Culture*, 7, http://www.antennae.org.uk/back-issues-2015/4589877799.

77. M. Foucault 1969a, *The Archaeology of Knowledge*, trans A. M. S. Smith (London: Routledge, 2006); M. Foucault 1976a, *The History of Sexuality 1: The Will to Knowledge* (London: Penguin, 1978); M. Foucault 1975b, *Discipline and Punish: The Birth of the Prison* (London: Penguin, 1991); M. Foucault 1974–1975, *Abnormal* (London: Verso, 1999).

78. See note 79.

79. Foucault 1975b; Foucault 1964; M. Foucault 1963, *The Birth of the Clinic: An Archaeology of Medical Perception* (London: Routledge, 1973, 2003).

80. P. Cavalieri 2008, "A Missed Opportunity: Humanism, Anti-Humanism and the Animal Question," in J. Castricano, ed., *Animal Subjects: An Ethical Reader in a Posthuman World* (Waterloo: Wilfrid Laurie University Press), 97–123; M. Chrulew 2012, "Animals in Biopolitical Theory: Between Agamben and Negri," *New Formations*, no. 76 (Winter): 53–67; L. Johnson 2012, *Power, Knowledge, Animals* (Basingstoke: Palgrave Macmillan); Palmer 2001; Taylor 2013, "Foucault and Critical Animal Studies: Genealogies of Agricultural Power," *Philosophy Compass* 8, no. 6: 539–551; E. Castanò and L. Fab-

bri, eds., 2013, "Gli animali di Foucault," *Animal Studies: Rivista italiana di antispe-cismo* 2, no. 4 (July).

81. Cavalieri 2008:97–123.

82. Y. Greslé 2006, "Foucault's *Las Meninas* and Art-Historical Methods," *Journal of Literary Studies* 22, nos. 3–4 (December): 211–228.

83. C. M. Soussloff 2009, "Foucault and the Point of Painting," *Art History* 32, no. 4: 734–753.

84. Foucault 1966:3–18.

85. Greslé 2006:212.

86. Among others, Svetlana Alpers's and Norman Brison's positive reception of Foucault's analysis of Las Meninas has had much resonance in art historical discourses. Ibid., 214; S. Alpers 1983, "Interpretation Without Representation, or the Viewing of *Las Meninas*," *Representations* 1, no. 1 (February): 31–42; N. Bryson 1988, *Calligram: Essays in New Art History from France* (Cambridge: Cambridge University Press), xiv, xv, and 91–105.

87. E. Fernie 1995, *Art History and Its Methods* (London: Phaidon), 19–20; J. J. Tanke 2009, *Foucault's Philosophy of Art: A Genealogy of Modernity* (London: Continuum); G. Shapiro 2003, *Archaeologies of Vision: Foucault and Nietzsche on Seeing and Saying* (Chicago: University of Chicago Press).

88. Foucault and Bourriaud 1971/2009; Foucault 1983; Foucault 1975a, "Photogenic Paint-ing," in G. Deleuze and M. Foucault, *Gérard Fromanger: La Peinture Photogénique* (London: Black Dog, 1999); M. Foucault 1973, "The Force of Flight," in J. W. Crampton and S. Elden, eds., *Space, Knowledge, and Power: Foucault and Geography* (Aldershot: Ashgate, 2007), 169–173.

89. Foucault 1966:xvi.

90. Ibid., xxiii.

91. Ibid., xix; on the fictitiousness of this passage, see K. Windschutll, 1997, *The Killing of History: How Literary Critics and Social Theorists Are Murdering Our Past* (New York: Free Press), 255.

1. RECONFIGURING ANIMAL SKINS

A. Drummond 2008, *Elephantina: An Account of the Accidental Death of an Elephant in Dundee in the Year 1706, Described by an Engraver Resident in That Town* (Edinburgh: Poly-gon), 168; O. Davie 1894, *Methods in the Art of Taxidermy* (Philadelphia: David McKay), 122.

1. M. Milgrom 2010, *Still Life: Adventures in Taxidermy* (Boston: Houghton Mifflin Har-court); and D. Madden 2011, *The Authentic Animal: Inside the Odd and Obsessive World of Taxidermy* (New York: St. Martin's).

2. J. Easton 2012, *The Art of Taxidermy* (London: Pavilion); A. Turner 2013, *Taxidermy* (London: Thames and Hudson); R. Marbury 2014, *Taxidermy Art* (New York: Artisan).

3. P. A. Morris 2010, *A History of Taxidermy: Art, Science and Bad Taste* (Ascot: MPM); R. Poliquin 2012, *The Breathless Zoo: Taxidermy and the Cultures of Longing* (University Park: Pennsylvania State University Press); A. R. Rader and V. E. Cain 2014, *Life on Display: Revolutionizing U.S. Museums of Science and Natural History in the Twentieth Century* (Chicago: University of Chicago Press).

4. B. Snæbjörnsdóttir and M. Wilson 2006, *Nanoq: Flat Out and Bluesome: A Cultural Life of Polar Bears* (London: Black Dog); B. Snæbjörnsdóttir 2009, *Spaces of Encounter: Art and Revision in Human-Animal Relations* (Gothenburg: University of Gothenburg).

5. *Antennae: The Journal of Nature in Visual Culture*, nos. 6 and 7, 2008.

6. L. E. Thorsen, K. A. Rader, and A. Dodd, 2013, *Animals on Display: The Creaturely in Museums, Zoos, and Natural History* (University Park: Pennsylvania State University Press); S. M. M. J. Alberti 2011, *The Afterlives of Animals: A Museum Menagerie* (Charlottesville: University of Virginia Press).

7. Morris 2010:20.

8. M. Foucault 1969a, *The Archaeology of Knowledge*, trans A. M. S. Smith (London: Routledge, 2006, 3–19.

9. M. Browne 1896, *Artistic and Scientific Taxidermy and Modelling* (London: A. & C. Black), 2.

10. Davie 1894:2.

11. Ibid.

12. Morris 2010:8–9.

13. Poliquin 2012:23.

14. Foucault 1969a:35.

15. S. Ikram 2005, "The Loved Ones: Egyptian Animal Mummies as Cultural and Environmental Indicators," in H. Huitenhuis, A. M. Choyke, L. Martin, L. Bartosiewicz, and M. Mashkour, eds., *Archaeozoology of the Near East, Proceedings of the Sixth International Symposium on the Archaeology of Southwestern Asia and Adjacent Areas* (Groningen: ARC).

16. M. Rice 2006, *Swifter Than the Arrow: The Golden Hunting Hounds of Ancient Egypt* (London: I. B. Tauris), 73.

17. Catalog number and name of the object in question: CG29836. S. Ikram 2005.

18. Browne 1896:3.

19. S. Pearce and K. Arnold 2000, *The Collector's Voice: Critical Readings in the Practice of Collecting*, vol. 2 (Burlington: Ashgate), 111.

20. S. T. Asma 2001, *Stuffed Animals and Pickled Heads: The Culture and Evolution of Natural History Museums* (Oxford: Oxford University Press); Milgrom 2010; Madden 2011; Alberti 2011; Turner 2013.

21. Poliquin 2012:6.

22. Foucault 1969a:23.

23. The archaeological method of inquiry was retrospectively theorized by Foucault in *The Archaeology of Knowledge*, published in 1969. Ibid., 6–9.

24. Ibid., 7.

25. Archaeology places emphasis on the *document*, in opposition to the approach of classical historiography, which relentlessly looks for what the document may *say*; archaeology excavates deeper into the past from which the document *emanates*. Ibid., 6 and 17–18.

26. Ibid., 41.

27. Archaeology is essentially comparative. As demonstrated in *The Order of Things*, its full analytical potential is employed when parallelisms between contemporary but seemingly nonrelated disciplines are considered. Nonetheless, it is possible to extrapolate specific archaeological tools for the analysis of epistemological strata.

28. M. Foucault 1966, *The Order of Things: An Archaeology of the Human Science* (London: Routledge, 1970, 2003), 31.

29. Foucault 1969a:31.

30. L. Dufresne 1803, "Taxidermie," in *Nouveau dictionnaire d'histoire naturelle, appliquée aux arts, principalement à l'agriculture, et à l'economie rurale et domestique par une société de naturalistes et d'agriculture*, vol. 21 (Paris: Déterville), 507–565.

31. M. Melguen 2005, "French Voyages of Exploration and Science in the Age of Enlightenment: An Ocean of Discovery Throughout the Pacific Ocean," in J. W. Markham and A. L. Duda, eds., *Voyages of Discovery: Parting the Seas of Information Technology: Proceedings of the 30th Annual Conference of the International Association of Aquatic and Marine Science Libraries and Information Centers* (Fort Pierce: IAMSLIC), 31–59.

32. *The New Oxford Dictionary of English*, 1998, vol. 1 (Oxford: Clarendon), 1808.

33. J. P. Mouton-Fontenille 1811, *Traité Elémentaire d'Ornithologie, Suivi de l'Art d'Empailler les Oiseaux* (Lyon: Yvernault & Cabin).

34. A. D. Manesse 1787, *Traité sur la Manière d'Empailler et de Conserver les Animaux, les Pelleteries et les Laines* (Paris: Guillot).

35. In England, the "stuffing" of chairs and benches began during the reign of Queen Elizabeth I (1558–1603) and gradually gained professional momentum through the eighteenth and nineteenth centuries, when a person involved in the production of furniture padded with materials ranging from straw and sawdust to feathers was referred to as a *stuffer*. S. Creegan, ed. 1984, *Upholstery, the Inside Story* (London: Chapman).

36. Foucault 1969a:4.

37. In English the title would be *Taxidermy, or, the Art of Preparing and Preserving Hides of all Animals, for Museums and Cabinets of Natural History*.

38. L. Dufresne 1820, *Taxidermie, ou, l'Art de Préparer et de Conserver la Dépouille de tous les Animaux, pour les Musées, les Cabinets d'Histoire Naturelle* (Paris: Chez Deterville).

39. R. Griffiths and G. E. Griffiths 1820, "Taxidermy," *Monthly Review or Literary Journal* 93: 103–105.

40. Ibid.

41. Ibid., 104.

42. T. F. Stuessy 2009, *Plant Taxonomy: The Systematic Evolution of Comparative Data* (New York: Columbia University Press), 6.

43. Foucault 1966:136–179.

44. Dufresne 1803:509.

45. T. E. Bowditch 1820, *Taxidermy or, the Art of Collecting, Preparing and Mounting Objects of Natural History for the Use of Museums and Travellers* (London: Longman, Hurst, Rees, Orme, and Brown), 4.

46. Morris 2010:78.

47. R. W. Shufeldt 1892, "Scientific Taxidermy for Museums," *Report of National Museum*, 373.

48. Morris 2010:108–109.

49. Ibid., 5. Also M. Patchett 2006, "Animal as Object: Taxidermy and the Charting of Afterlives," paper presented at Making Animal Afterlives, Hunterian Zoology Museum, University of Glasgow, November.

50. G. Marvin 2006, "Perpetuating Polar Bears: The Cultural Life of Dead Animals," in B. Snæbjörnsdóttir and M. Wilson 2006, *Nanoq: Flat Out and Bluesome: A Cultural Life of Polar Bears* (London: Black Dog), 157. His argument is substantially informed by that of K. Verdery 1999, *The Political Lives of Dead Bodies: Reburial and Postsocialist Change* (New York: Columbia University Press).

51. Marvin 2006.

52. A. Appadurai, ed. 1988, *The Social Life of Things: Commodities in Cultural Perspective* (Cambridge: Cambridge University Press).

53. Ibid., 3–63.

54. M. Heidegger 1927, *Being and Time* (New York: State University of New York Press, 1996), 70.

55. L. Stein 1927, *The A-B-C of Aesthetics* (New York: Boni and Liveright), 72, referenced in B. Brown 2001, "Thing Theory," *Critical Inquiry* 28, no. 1 (Autumn): 3.

56. Brown 2001:4.

57. K. Marx 1867, *Capital: A Critique of Political Economy*, vol. 1 (Moscow: Progress, 2010), 26.

58. Ibid., 125.

59. Ibid., 258.

60. Ibid., 125.

61. M. Foucault 1981, "The Order of Discourse," in R. Young, ed., *Untying the Text: A Post-Structuralist Reader* (London: Routledge, 2006), 70–71.

62. M. Foucault 1980, "Two Lectures," in C. Gordon, ed., *Power/Knowledge: Selected Interviews and Other Writings, 1972–1977* (Brighton: Harvester), 85.

63. Foucault 1966:77.

64. Morris 2010:25.

65. J. Petiver 1696, "Brief Instructions for the Easy Making and Preserving Collections of All Natural Curiosities," appendix in J. Petiver, *Musei Petiveriani Centuria Secunda & Tertia Rariora Naturae Continens* (London).

66. R. A. F. de Réaumur 1748, "Divers Means for Preserving from Corruption Dead Birds, Intended to Be Sent to Remote Countries, So That They May Arrive There in a Good Condition. Some of the Same Means May Be Employed for Preserving Quadrupeds, Reptiles, Fishes, and Insects," *Philosophical Transactions of the Royal Society of London* 45, 304–320.

67. Morris 2010:8–33; J. Easton 2012, *The Art of Taxidermy* (London: Pavilion); Turner 2013; Marbury 2014.

68. G. B. Vai and W. G. E. Caldwell 2006, *The Origins of Geology in Italy* (Boulder: Geological Society of America), 43.

69. Ibid.

70. For a detailed biography of the Boboli hippopotamus, see L. E. Thorsen 2006, "The Hippopotamus in Florentine Zoological Museum 'La Specola': A Discussion of Stuffed Animals as Sources of Cultural History," *Museologia Scientifica* 21, no. 2: 269–281.

71. P. Findlen 2002, "Inventing Nature," in P. H. Smith and P. Findlen, eds., *Merchants & Marvels: Commerce, Science, and Art in Early Modern Europe* (London: Routledge), 304.

72. Findlen 2002:301–302.

73. M. P. Ciccarese 1999, "Bibbia, bestie e bestiari: L'interpretazione Cristiana degli animali dalle origini al Medioevo," in G. Schianchi, ed., *Il Bestiario di Parma: Iconografia, Iconologia, Fonti Letterarie* (Milan: Vita e Pensiero), 400.

74. Ibid., 385.

75. Fr. G. R. A. Aquaro 2004, *Death by Envy: The Evil Eye and Envy in the Christian Tradition* (Bloomington: IUniverse), 98.

76. U. Cordier 1986, *Guida ai Draghi e Mostri in Italia* (Milan: Sugar), 34.

77. A. Bena 2010, *Racconto della Nascita di Ponte Nossa* (TipoLito: Valeriana); M. Foucault 1975b, *Discipline and Punish: The Birth of the Prison*, trans. A. Sheridan (London: Penguin, 1991), 32–62.

78. Foucault 1975b:27.

79. D. J. Haraway 2004, "The Promises of Monsters: A Regenerative Politics for Inappropriate/d Others," in *The Haraway Reader* (Abingdon: Psychology), 86.

80. B. Snæbjörnsdóttir and M. Wilson 2010, "The Empty Wilderness: Seals and Animal Representation," in K. Benediktsson and K. Lund, eds., *Conversations with Landscape: Anthropological Studies of Creativity and Perception* (Farnham: Ashgate), 211–226.

81. B. Snæbjörnsdóttir 2009, *Spaces of Encounter: Art and Revision in Human-Animal Relations* (Gothenburg: University of Gothenburg), 6.

82. Ibid., 2–3.

83. A. M. Lippit 2000, *Electric Animal: Toward a Rhetoric of Wildlife* (Minneapolis: University of Minnesota Press), 34–35.

84. Ibid., 193–194.

85. Foucault 1966:146.

2. A NATURAL HISTORY PANOPTICON

M. Foucault 1975b, *Discipline and Punish: The Birth of the Prison*, trans. A. Sheridan (London: Penguin, 1991), 200; R. Broglio 2011, *Surface Encounters: Thinking with Animals and Art* (Minneapolis: University of Minnesota Press), xvi–xvii.

1. M. Fairnington 2008, "The Specimen," *Antennae: The Journal of Nature in Visual Culture*, no. 6 (Summer): 61.

2. In Foucault's reconfiguration of historic periodization, the episteme is the historical a priori that in any given culture, and at any given time, defines "the conditions and possibility of knowledge" through implicit cultural limitations and constraints imposed on discourses and practices of truth.

3. M. Foucault, 1966, *The Order of Things: An Archaeology of the Human Science* (London: Routledge, 1970, 2003), 193.

4. In this book I adopt Foucault's own historical periodization—one that partially disregards traditional historiographical approaches to focuses on epistemes. The three main periodizations Foucault discusses in *The Order of Things* are the Renaissance (1400–1650), the Classical age (1650–1800), and the Modern age (1800–1950). In a 1967 interview with Raymond Bellour, Foucault explained: "I can . . . define the Classical age in its own configuration through the double difference that opposes it to the 16th century on the one hand and to the 19th on the other. On the other hand, I can define the Modern age in its singularity only by opposing it to the 17th century on the one hand and to us on the other. . . . From this Modern age which begins around 1790–1810 and goes to around 1950, it's a matter of detaching oneself, whereas for the Classical age it's only a matter of describing it." M. Foucault 1989, *Foucault Live (Interviews 1966–84)* (New York: Semitoext(e)), 30.

5. Ibid., xxiv.

6. Foucault 1966:142.

7. Ibid., 143.

8. R. J. Hoage and W. A. Deiss, eds., 1996, *New Worlds, New Animals: From Menagerie to Zoological Park in the Nineteenth Century* (Baltimore: Johns Hopkins University Press), 14–15.

9. Foucault 1966:143–144.

10. Ibid., 144–145.

11. Ibid., 145.

12. C. Lévi-Strauss 1962, *The Savage Mind*, trans. G. Weidenfield and Nicolson (Chicago: University of Chicago Press, 1972), 23.

13. Ibid., 23.

14. Ibid.

15. Ibid., 22.

16. Ibid., 24.

17. Ibid., 23.

18. Foucault 1966:40.

19. Ibid., 149.

20. Foucault 1967, "Les mots et les images," in D. Defert and F. Ewald, eds., *Dits et écrits, 1954–1988* (Paris: Gallimard, 1994), 620–623.

21. Foucault 1966:149.

22. Ibid.

23. Ibid.

24. M. Foucault 1964, *Madness and Civilization: A History of Insanity in the Age of Reason* (New York: Vintage, 1967, 1988).

25. M. J. Curley 2009, *Physiologus: A Medieval Book of Nature Lore* (Chicago: University of Chicago Press), ix.

26. Ibid.

27. M. R. James 1931, "The Bestiary," *History: The Quarterly Journal of the Historical Association* 16, no. 61 (April): 1–11 and 3.

28. Ibid., 141.

29. F. Klingender 1971, *Animals in Art and Thought to the End of the Middle Ages* (Cambridge: MIT Press), 341.

30. Ibid., 4.

31. R. J. Allen 1887, *Lecture VI: The Medieval Bestiaries—The Rhind Lectures in Archaeology for 1885* (London: Whiting).

32. Ibid., 18.

33. As argued by art historian John Richards, Christianity appropriated artistic production for funerary purposes, and "the selective use of the naturalistic modes of antiquity in Early Christian and Byzantine art reflects a profound shift in the understanding of art. Representation of the material world was embraced where appropriate, but the overall purpose of images . . . was directed at an experience transcending nature and the world of appearances." J. Richards 2000, "Early Christian Art," in M. Kemp, ed., *The Oxford History of Western Art* (Oxford: Oxford University Press), 70–75, ref. on 71.

34. According to Klingender, the impact of these new cultural optics produced representations of animals "whose distorted forms at best do no more than suggest the character of some living species, while more often they depart from nature altogether to shape some awe-inspiring monster." Klingender 1971:117.

35. W. Worringer 1953, *Abstraction and Empathy: A Contribution to the Psychology of Style* (Chicago: Ivan R. Dee, 1997), 44.

36. W. B. Ashworth 1996, "Emblematic Natural History in the Renaissance," in J. Jardine, A. Secord, and E. C. Spary, eds., *Cultures of Natural History* (Cambridge: Cambridge University Press), 17–37, ref. on 17.

37. Ibid.

38. W. B. Ashworth 2003, "The Revolution in Natural History," in M. Hellyer, ed., *The Scientific Revolution* (London: Blackwell), 130–156, ref. on 142.

39. C. Gesner 1551, *Historia Animalium*, I, g1 v, as quoted in S. Kusukawa 2010, "The Sources of Gessner's Pictures for the Historia Animalium," *Annals of Science* 76, no. 3: 303–328, quote on 307.

40. Ashworth 1996:27.

41. Foucault 1966:140–141.

42. H. Wölfflin 1932, *Principles of Art History: The Problem of the Development of Style in Later Art*, trans. M. D. Hottinger (New York: Dover), 18–19.

43. Ibid., 73.

44. Ibid., 124, 155, 196.

45. Broglio 2011:xvii.

46. Ibid., xvi.

47. Ibid., xv–xxxii.

48. Ibid., xvii.

49. G. Savi and G. Andres 1840, *Istituzioni Botaniche* (Loreto: Tipografia Rossi), x–xii.

50. Ibid., xiv–xxiv.

51. P. Dioscoridis AD 50–70, *De Materia Medica* (Lugdunum: Apud Balthazarem Arnolletum).

52. Pseudo-Apuleius, fourth century CE, *Herbarium of Pseudo Apuleius* (Oxford: Bodleian Library), Ashmole 1431 (7523).

53. H. J. de Vriend, ed. 1984, *The Old English Herbarium and Medicina de Quadrupedibus* (London: Oxford University Press).

54. O. Brunfels 1532–1536, *Herbarum Vivae Eicones* (Strasburg: Argentorati, Apud Joannem Schottum); L. Fuchs 1547, *De Historia Stirpium Commentarii Insignes* (Leipzig: Kurt Wolff).

55. P. Findlen 1994, *Possessing Nature: Museums, Collecting, and Scientific Culture in Early Modern Italy* (Berkeley: University of California Press), 166.

56. T. Tomasi 2013, "Gherardo Cibo: un percorso tra arte e scienza," in *Gherardo Cibo: Dilettante di Botanica e Pittore di Paesi* (Ancona: Il Lavoro).

57. Aldrovandi, quoted in C. Swan 2005, *Art, Science and Witchcraft* (Cambridge: Cambridge University Press), 41.

58. Ibid.

59. Kusukawa 2010:312.

60. For Foucault's analysis of the spatializations in hospitals, see M. Foucault 1963, *The Birth of the Clinic: An Archaeology of Medical Perception* (London: Routledge, 1973, 2003); for prisons, see Foucault 1975b; for the asylum, see M. Foucault 1961, *History of Madness* (London: Routledge, 2006, 2009). A famous interview from 1976 titled "Questions of Geography" is also considered to be one of his most important texts on spatialization in general. M. Foucault 1976b, "Questions of Geography," in C. Gordon, ed., *Power/Knowledge: Selected Interviews and Other Writings, 1972–1977* (Brighton: Harvester, 1980), 63–77.

61. Ibid.

62. Foucault 1975b:147–149.

63. Foucault 1966:139–143.

64. Foucault 1975b:148–149.

65. Ibid., 200.

66. Ibid., 195–228, and M. Foucault 1972, "The Eye of Power," in *Power/Knowledge: Selected Interviews and Other Writings, 1972–1977* (Brighton: Harvester), 146–147.

67. Foucault 1975b:201.

68. Ibid., 143.

69. Findlen 1994:223. It was in this epistemological context that light emerged as the preponderant, signifying, epistemic source of the classical age—full lighting facilitated the all-seeing ambition of the eye of the observer, aiding the production of knowledge

shaped by power relations that configured animal bodies as quelled in their representational, objectified status. Foucault 1975b:203.

70. R. Descartes 1637, *Discourse on the Method* (New York: Cosimo, 2008).

71. Findlen 1994:23.

72. It was in this epistemological context that light emerged as the preponderant, signifying, epistemic source of the classical age—full lighting facilitated the all-seeing ambition of the eye of the observer, aiding the production of knowledge shaped by power relations that configured animal bodies as quelled in their representational, objectified status. M. Foucault 1966, *The Order of Things: An Archaeology of the Human Science* (London: Routledge, 1970, 2003), 20.

73. Ibid., 146.

74. Ibid., 30.

75. Ibid., 20.

76. Ibid., 22–24.

77. Ibid., 26.

78. L. Daston and K. Park 2001, *Wonders and the Order of Nature* (New York: Zone), 260.

79. J. Derrida 2008, *The Animal That Therefore I Am* (New York: Fordham University Press), 54.

80. Ibid., 147–148.

81. Descartes 1637:45.

82. S. Gensini and M. Fusco 2010, *Animal Loquens: Linguaggio e Conoscenza Negli Animali Non Umani da Aristotele a Chomsky* (Roma: Carocci), 58–114.

83. Broglio 2011:xvii.

84. R. Descartes 1629, *Treatise of Man* (Amherst: Prometheus, 2003).

85. Ibid., xxix.

86. Descartes 1637:44.

87. R. Malbert 2013, "Foreword," in B. Dillon and M. Warner, *Curiosity: Art and the Pleasures of Knowing* (London: Hayward), 9.

88. C. Sheehy, ed. 2006, *Cabinets of Curiosities: Mark Dion and the University as Installation* (Minneapolis: University of Minnesota Press), xiii.

89. P. Hoare 2014, "Museum and Gallery Curators Reopen the Cabinet of Curiosities Concept," *Guardian*, January 13.

90. L. G. Corrin, M. Know, and N. Bryson, 1997, *Mark Dion* (London: Phaidon), 48.

91. Daston and Park 2001:110.

92. Augustine 397–398, *Confessions* (Oxford: Oxford University Press, 1992), 211.

93. Ibid., 110–116.

94. J. Locke 1693, *Some Thoughts Concerning Education* (London: A. and J. Churchill), 134.

95. C. Renfrew 2003, *Figuring It Out* (London: Thames and Hudson), 90–91.

96. J. Locke 1689, *An Essay Concerning Human Understanding* (New York: Oxford University Press, 1975); and J.-J. Rousseau 2012, *The Basic Political Writings* (Indianapolis: Hackett, 1987).

97. S. Greenblatt 1991, *Marvelous Possessions: The Wonder of the New World* (Chicago: University of Chicago Press), 14.

3. DIORAMAS

O. Davie 1894, *Methods in the Art of Taxidermy* (Philadelphia: David McKay), 129; M. Milgrom 2010, *Still Life: Adventures in Taxidermy* (Boston: Houghton Mifflin Harcourt), 54.

1. N. Mirzoeff 2014, "Visualizing the Anthropocene," *Public Culture* 26, no. 2: 73, 213–232.
2. S. Žižek 2011, *Living in the End of Times* (London: Verso).
3. R. Bach 1970, *Jonathan Livingston Seagull* (New York: MacMillan).
4. Ultimately, in its antiheroic aesthetic and its embedded narratives of destruction, survival, gratuitous spoilage, *Landfill* also proposes a broader critique of past histories of representation. Landscape painting, a genre renowned for its tendency to beautify and idealize, was traditionally defined by bourgeois taste, the same taste rejected by the historical avant-gardes and by the neo-avant-gardes of the 1950s and 1960s. The objects presented as trash in Dion's diorama are derivative of Duchampian readymades or, more appropriately, of Kurt Schwitters's found objects—both of which are artistic responses to the unquestioned preponderance of bourgeois taste in mainstream culture.
5. R. MacKay, L. Pendrell, and J. Trafford, 2014, *Speculative Aesthetics* (Falmouth: Urbanomic), 3.
6. H. Putnam 2016, *Naturalism, Realism, and Normativity* (Cambridge: Harvard University Press).
7. D. Outram 1996, "New Spaces in Natural History," in N. Jardine, J. A. Secord, and E. C. Spary, eds., *Cultures of Natural History* (Cambridge: Cambridge University Press), 251, ref. on 249.
8. T. Bennett 1988, "The Exhibitionary Complex," *New Formations*, no. 4 (Spring): 73–102.
9. Ibid., 79.
10. Ibid., 86.
11. D. J. Haraway 1984, "Teddy Bear Patriarchy: Taxidermy in the Garden of Eden, New York City, 1908–1936," *Social Text*, no. 11 (Winter): 20–64, ref. on 40.
12. T. Bennett 1995, *The Birth of the Museum: History, Theory, Politics* (London: Routledge), 59–88.
13. B. T. Gates 2007, "Introduction: Why Victorian Natural History?" *Victorian Literature and Culture* 35, no. 2: 539.
14. Ibid., 540.
15. K. Wonders 1993, *Habitat Dioramas: Illusions of Wilderness in Museums of Natural History* (Uppsala: Acta Universitatis Upsaliensis).
16. A. Stefanucci 1944, *Storia del Presepio* (Roma: Autocultura).
17. I. Margulies 2003, *Rites of Realism: Essays on Corporeal Cinema* (New York: Duke University Press).
18. G. Batchen 1999, *Burning with Desire: The Conception of Photography* (Cambridge: MIT Press), 139–143.
19. C. Kamcke and R. Hutterer 2015, *Natural History Dioramas* (Berlin: Springer), 10.

20. M. Andrews 1999, *Landscape and Western Art* (Oxford: Oxford University Press), 141.

21. Daguerre, quoted in K. Wonders 1990, "The Illusionary Art of Background Painting in Habitat Dioramas," *Curator: The Museum Journal* 33, no. 2 (June): 90–118.

22. M. W. Marien 2006, *Photography: A Cultural History* (London: Laurence King), 11.

23. A. Scharf 1968, *Art and Photography* (London: Penguin, 1983), 13.

24. M. Foucault 1975a, "Photogenic Painting," in G. Deleuze and M. Foucault, *Gerard Fromanger: La Peinture Photogénique* (London: Black Dog, 1999), 88.

25. Scharf 1968:13.

26. L. Daston and P. Galison 2007, *Objectivity* (New York: Zone), 121.

27. J. Ryan 1997, *Picturing Empire: Photography and the Visualization of the British Empire* (London: Reaktion), 132.

28. S. L. Star 1992, "Craft vs. Commodity, Mess vs. Transcendence: How the Right Tool Became the Wrong One in the Case of Taxidermy and Natural History," in A. E. Clark and J. H. Fujimura, eds., *The Right Tools for the Job: At Work in Twentieth-Century Life Sciences* (Princeton: Princeton University Press), 257–286.

29. Haraway 1984:24.

30. Ibid., 40.

31. Daston and Galison 2007:131.

32. M. Browne 1896, *Artistic and Scientific Taxidermy and Modelling* (London: A. & C. Black), 10.

33. Ibid., 11.

34. C. Metz 1985, "Photography and Fetish," in *October* 34 (Autumn): 81–90, quote on 84.

35. S. Sontag 1977, *On Photography* (London: Allen Lane), 1978, 14–15.

36. Ibid., 38–43.

37. Haraway 1984:24.

38. Akeley to Osborn, March 29, 1911, in J. M. Kennedy 1968, "Philanthropy and Science in New York City: The American Museum of Natural History, 1868–1968," PhD diss., Yale University, 186.

39. C. Fisher 1927, "Carl Akeley and His Work," in *Scientific Monthly* 24, no. 2: 97–118, ref. on 101.

40. R. W. Shufeldt 1892, "Scientific Taxidermy for Museums," *Report of National Museum*, s.l., s.n., 369–382, 383.

41. Browne 1896:11.

42. Haraway 1984:37–38.

43. Ibid., 34.

44. Ibid., 34, 35, and 57.

45. Ibid., 63.

46. Scharf 1968:13.

47. M. Kemp 2000, *The Oxford History of Western Art* (Oxford: Oxford University Press), 66 and 218.

48. D. Getsy 2014, "Acts of Stillness: Statues, Performativity, and Passive Resistance," *Criticism* 56, no. 1 (Winter): 1–20.

49. Ibid., 8.

50. Ibid.

51. L. Nochlin 1971, *Realism* (London: Penguin), 13–15.

52. B. Prendeville 2000, *Realism in Twentieth-Century Painting* (London: Thames and Hudson), 7–12.

53. Ibid., 7.

54. L. J. Freeman 1901, *Italian Sculpture of the Renaissance* (Whitefish: Kessinger), 12–13.

55. A. D. Stokes 1955, *Michelangelo: a Study in the Nature of Art* (London: Routledge), 75.

56. C. Pedretti 1973, *Leonardo: A Study in Chronology and Style* (Berkeley: University of California Press), 97.

57. Kemp 2000:61.

58. Browne 1896:5.

59. J. S. Memes 1825, *Memories of Antonio Canova: With a Critical Analysis of His Works and Historical Views of Modern Sculpture* (Edinburgh: Archibald Constable), 223.

60. J. J. Winckelmann 1755, "Reflections on the Imitation of Greek Works in Painting and Sculpture," in D. Preziosi, ed., *The Art of Art History: A Critical Anthology* (Oxford: Oxford University Press, 1998), 31.

61. D. K. Holt 2001, *The Search for Aesthetic Meaning in the Visual Arts: The Need for the Aesthetic Tradition in Contemporary Art Theory and Education* (Chicago: Greenwood), 51.

62. Winckelmann 1755:35.

63. J. Harrell, C. Barrett, and D. Petsch, eds., 2006, *History of Aesthetics* (London: Continuum), 48–74.

64. Winckelmann 1755:35.

65. Holt 2001:51.

66. G. P. R. Métraux 1995, *Sculptures and Physicians in Fifth-Century Greece: A Preliminary Study* (Montreal: McGill-Queen's University Press).

67. Ibid., 53.

68. Aristotle, n.d., "The Nature of Poetic Imitation: From the Poetics," in G. Dickie, R. Sclafani, and R. Roblin, eds., 1989, *Aesthetics: A Critical Anthology* (New York: St. Martin's), 44–45.

69. Ibid.

70. Harrell, Barrett, and Petsch 2006:189.

71. E. Chapman 2012, *Prove It on Me: New Negroes, Sex, and Popular Culture in the 1920s* (Oxford: Oxford University Press), 9.

72. Ibid., 190.

73. Haraway 1984:24.

74. Hegel, cited in Nochlin 1971:14.

75. Haraway 1984:53–58.

76. M. Foucault 1961, *History of Madness* (London: Routledge, 2006, 2009), 569 and 457.

77. U. Eco 1995, *Travels in Hyperreality* (San Diego: Harcourt), 8–9.

78. C. Avery 2002, "Forms in Space, c. 1700–1770," in M. Kemp, ed., *The Oxford History of Western Art* (Oxford: Oxford University Press), 280–281.

79. K. Barzman 2002, "Academies, Theories, and Critics," in M. Kemp, ed., *The Oxford History of Western Art* (Oxford: Oxford University Press), 290–293.

80. H. W. Jason 1985, *Nineteenth-Century Sculpture* (New York: Abrams).

81. In this instance, the term *Realist* is employed to define the Realist movement in art that developed in France starting in the 1840s as a challenge to Romanticism and History painting. Nochlin 1971:13–57.

82. J. Goodman 2002, "Pictures and Public," in M.p, ed., *The Oxford History of Western Art* (Oxford: Oxford University Press), 304–311, ref. on 304.

83. Jason 1985.

84. T. Richardson 1990, *The Commodity Culture of Victorian England: Advertising and Spectacle, 1851–1914* (Stanford: Stanford University Press), 3–4.

85. C. Frost 1981, *Victorian Taxidermy: Its History and Finest Exponents* (Long Melford: Privately published by the author), 7.

86. P. A. Morris 2010, *A History of Taxidermy: Art, Science and Bad Taste* (Ascot: MPM), 54.

87. Frost 1981:7.

88. L. Vergine and G. Verzotti 2004, *Il Bello e la Bestia: Metamorfosi, Artifici e Ibridi dal Mito all'Immaginario Scientifico* (Milano: Skira), 202.

89. D. Fox 2008, "Constructed Reality: The Diorama as Art," *Antennae: The Journal of Nature in Visual Culture*, no. 6 (Summer): 13–20.

4. THE END OF THE DAYDREAM

S. Sontag, 1977, *On Photography* (London: Allen Lane), 15; J. R. Ryan 2000, "Hunting with the Camera: Photography, Wildlife and Colonialism in Africa," in C. Philo and C. Wilbert, eds., *Animal Spaces, Beastly Places: New Geographies of Human-Animal Relations* (London: Routledge), 214.

1. K. Barad 2012, "What Is the Measure of Nothingness? Infinity, Virtuality, Justice," part of the series *100 Notes, 100 Thoughts: dOCUMENTA* (Berlin: Hatje Cantz).

2. G. Harman 2012, "Third Table," part of the series *100 Notes, 100 Thoughts: dOCUMENTA* (Berlin: Hatje Cantz).

3. C. Pentecost 2012, "Notes from Underground," part of the series *100 Notes, 100 Thoughts: dOCUMENTA* (Berlin: Hatje Cantz).

4. D. Abram 1997, *The Spell of the Sensuous: Perception and Language in a More-Than-Human-World* (London: Vintage).

5. G. Deleuze and F. Guattari 1998, *A Thousand Plateaus: Capitalism and Schizophrenia* (London: Continuum, 2003).

6. Q. Meillassoux 2008, *After Finitude: An Essay on the Necessity of Contingency* (New York: Continuum), 5.

7. L. Bryant, N. Srnicek, and G. Harman, 2011, *The Speculative Turn* (Melbourne: Re-Press), 4.

8. D. Coole and S. Frost, eds., 2010, *New Materialisms: Ontology, Agency, and Politics* (Durham: Duke University Press), 5.

9. R. Broglio 2011, *Surface Encounters: Thinking with Animals and Art* (Minneapolis: University of Minnesota Press), xvi.

10. M. Foucault 1966, *The Order of Things: An Archaeology of the Human Science* (London: Routledge, 1970, 2003), 332.

11. Ibid., 330–374; M. Foucault and N. Bourriaud 1971/2009, *Manet and the Object of Painting* (London: Tate, 2011).

12. Foucault 1966:273.

13. Ibid., 330–374.

14. Ibid., 369.

15. C. Baudelaire 1863, "The Painter of Modern Life," in *The Painter of Modern Life and Other Essays* (London: Phaidon), 1964.

16. Ibid.

17. The germ of a speculative attitude toward realism can be indeed found in Foucault's work, especially as he claims that at this point "natural things become more than natural," that is, they transcend the crystallized ontology of realism, which classical art relied upon in the uttering of *affirmation*. M. Foucault 1984b, "What Is Enlightenment?" in P. Rainbow, ed., *The Foucault Reader* (New York: Pantheon), 32–50.

18. The germ of a speculative attitude toward realism can be indeed found in Foucault's work, especially as he claims that at this point "'natural' things become 'more than natural'" (ibid., 41); that is, they transcend the crystallized ontology of realism, which classical art relied upon in the uttering of affirmation.

19. Foucault 1966:314.

20. Ibid., 142.

21. M. Brower 2011, *Developing Animals: Wildlife and Early American Photography* Minneapolis: University of Minnesota Press), xvii.

22. Ibid., 25–82.

23. J. R. Ryan 1997, *Picturing Empire: Photography and the Visualization of the British Empire* (London: Reaktion), 110–112.

24. Ibid., 100–101.

25. J. Berger 1980, "Why Look at Animals?" In *About Looking* (London, Vintage, 1993), 16.

26. Ibid., 17.

27. Ibid.

28. Although Berger made no mention of taxidermy in his text, it is possible to argue that taxidermy dioramas also operated according to economies of representation and consumption very similar to those of wildlife photography.

29. R. Horn, "Roni Horn aka Roni Horn: Explore the Exhibition, Themes, Pairs," Tate Online, http://www.tate.org.uk/whats-on/tate-modern/exhibition/roni-horn-aka-roni-horn/roni-horn-aka-roni-horn-explore-exhibition-3.

30. These concepts had considerably shifted since their formulation in *The Order of Things*, also through Magritte's own argumentation of the subject. M. Jay 1986, "In the Empire of the Gaze: Foucault and the Denigration of Vision in Twentieth-Century French Thought," in D. Hoy, ed., *Foucault: A Critical Reader* (London: Wiley-Blackwell), 175–204.

31. M. Foucault 1983, *This Is Not a Pipe* (Berkeley: University of California Press), 43–52.

32. Ibid., 46.

33. Foucault 1966:176–177.

34. Ibid., 177.

35. Foucault 1983:44.

36. Foucault formulated these separately, but in this chapter they are linked for the purpose of mapping the work of aesthetic economies of nonaffirmation in rethinking our modes of perception

37. Foucault 1983:29.

38. Ibid., 17.

39. Ibid., 30.

40. Foucault and Bourriaud 1971/2009:92.

41. Ibid., 93.

42. M. Foucault 1975a, "Photogenic Painting," in G. Deleuze and M. Foucault, *Gerard Fromanger: La Peinture Photogénique* (London: Black Dog, 1999), 93.

43. Foucault outlined four fundamental categories of ways in which a photograph can propose nonaffirmation: (1) by applying paint on the photographic surface, (2) by capturing out-of-focus, disappearing objects, (3) by writing words on the photographic surface, and (4) by employing irony, which entails the frustration of linear narrative (ibid., vi.). *Dead Owl* by Roni Horn markedly belongs to the category of irony. Horn does not blur her images in an attempt to defy the affirmative work of quattrocento painting. In essence, *Dead Owl*, like many of her other diptychs, enacts nonaffirmative and challenging relationships with the viewer through an exacerbation of the intermingling of similitude and resemblance within the photographic idiom.

44. R. Horn 2008, *Bird* (Zurich: Steidl Hauser & Wirth).

45. R. Barthes 1980, *Camera Lucida* (New York: Hill and Wang), 89.

46. Sontag 1977.

47. Foucault 1983.

48. Ibid., 30.

49. Foucault 1983:49.

50. Ibid., 10.

51. Ibid.

52. H. B. Werness 2006, *The Continuum Encyclopaedia of Animal Symbolism in Art* (New York: Continuum).

53. Berger 1980:28.

54. B. Viola, dir., 1986, *I Do Not Know What It Is I Am Like* [film] (Quantum Leap).

55. C. Hourihane, ed., 2012, *The Grove Encyclopedia of Medieval Art and Architecture*, vol. 2 (Oxford: Oxford University Press), 298–299.

56. N. Armstrong 2010, "Realism Before and After Photography," in M. Beaumont, ed., *A Concise Companion to Realism* (London: Wiley-Blackwell), 102–120, ref. on 109.

57. J. Akeley 1929, *Carl Akeley's Africa* (New York: Blue Ribbon), 37.

58. Besides the very influential section of his text dedicated to Magritte's *The Treachery of Images*, Foucault focused on a number of works by the artist in which the same image

is repeated twice or multiple times within the same painting, such as *Representation* (1962) or *The Two Mysteries* (1966). What is of fundamental importance in Magritte's approach to the image, according to Foucault, is the artist's ability to deliberately derail the work of affirmative representation by manipulating the relationship between similitude and resemblance. This manipulation, Foucault argued, culminates by bringing similitude into play against resemblance itself. Foucault 1983:43 and 44.

59. K. Hauser 1999, "Coming Apart at the Seams: Taxidermy and Contemporary Photography," in *Make: The Magazine of Women's Art*, no. 82, 8–11, quote on 9.

60. Ibid., 29–31.

61. Ibid., 17 and 29, ref. on 17.

62. K. Shapiro 1989, "The Death of the Animal: Ontological Vulnerability," *Between the Species* 5, no. 4 (Fall): 183–195.

63. Ibid., 184.

64. Ibid., 185.

65. Ibid.

66. Ibid., 186.

5. FOLLOWING MATERIALITY

D. Coole 2015, "From Within the Midst of Things: New Sensibility, New Alchemy, and the Renewal of Critical Theory," in C. Cox, J. Jaskey, and S. Malik, eds., *Realism Materialism Art* (Berlin: Sternberg), 41; J. Rebentisch, in J. Bryson-Wilson, G. Kester, and J. Elkins, 2009, "Answers to Questionnaire on the Contemporary," *October* 130 (Fall): 101.

1. J. Withers 1977, "The Famous Fur-Lined Teacup and the Anonymous Meret Oppenheim," *New York: Arts Magazine* 52 (November): 88–93.

2. A. Breton 2002, *Surrealism and Painting* (Boston: MFA).

3. A. Breton 1936, "Crisis of the Object," ibid., 275–281.

4. G. Harman 2002, *Tool-Being: Heidegger and the Metaphysics of Objects* (Peru: Open Court), 2–3.

5. C. Greenberg 1952, "*Cézanne:* Gateway to Contemporary Painting," *American Mercury*, June, 69–73, reference on 72.

6. M. Merleau-Ponty 1945, *Sense and Non-Sense* (Evanston: Northwestern University Press, 1992), 12.

7. C. Greenberg 1961, *Art and Culture: Critical Essays* (Boston: Beacon), 57.

8. Mentions of Cézanne's influence on cubism can be found in Picasso's interviews. P. Picasso 1935, *Conversation*, in H. B. Chipp, 1968, *Theories of Modern Art: A Source Book by Artists and Critics* (Berkeley: University of California Press), 266–273.

9. Merleau-Ponty 1945:12.

10. T. J. Clark 2011, "Phenomenality and Materiality in *Cézanne*," in T. Cohen et al., *Material Events: Paul de Man and the Afterlife of Theory* (Minneapolis: University of Minnesota Press), 106.

11. M. Foucault 1966, *The Order of Things: An Archaeology of the Human Science* (London: Routledge, 1970, 2003), 340–346.

12. Ibid., 244.

13. Ibid., 408.

14. A. M. Lippit 2000, *Electric Animal: Toward a Rhetoric of Wildlife* (Minneapolis: University of Minnesota Press), 8.

15. Ibid., 2–3.

16. Ibid., 187.

17. S. Platzman 2001, *Cézanne: The Self-Portraits* (Berkeley: University of California Press), 29.

18. J. Bignell 2007, *Postmodern Media Culture* (Delhi: Aakar), 100.

19. Foucault 1966:346.

20. N. Shukin 2009, *Animal Capital: Rendering Life in Biopolitical Times* (Minneapolis: University of Minnesota Press), 87–130.

21. Ibid., 87.

22. Ibid., 92.

23. Ibid., 20.

24. See page 108 for Shukin's addressing of Lippit's lack of consideration for the materiality of film (a derivate of animal materials) and therefore its "pathological relationship to animal life."

25. Shukin 2009:108.

26. T. Morton 2016, *Dark Ecology: For a Logic of Future Coexistence* (New York: Columbia University Press), 6.

27. Shukin 2009:20.

28. Ibid., 127.

29. Ibid., 21.

30. Aristotle, "Poetics," and Plato, "Book X of the Republic," in D. H. Richter, ed., *The Critical Tradition: Classic Texts and Contemporary Trends* (New York: St. Martin's, 1989).

31. J. Elkins 2008, "On Some Limits of Materiality in Art History," in S. Neuner and J. Gelshorn, eds., "Taktilität: Sinneserfahrung als Grenzerfahrung," special issue, *31: Das Magazin des Instituts fur Theorie* 12:25–30.

32. Ibid.

33. J. Elkins 2000, *What Painting Is* (Abingdon: Taylor and Francis).

34. Ibid.

35. J. A. D. Ingres 1870, "Notes, 1813–27," in H. Delaborde, *Ingres, Sa Vie, Ses Travaux, Sa Doctrine* (Paris: Plon), 93–177.

36. Elkins 2008:27.

37. Ibid., 28.

38. T. Ingold 2012, "Toward an Ecology of Materials," *Annual Review of Anthropology* 41:427–442.

39. T. de Duve 1984, *Pictorial Nominalism: On Marcel Duchamp's Passage from Painting to the Readymade* (Minneapolis: University of Minnesota Press), 78.

40. D. Cottington 2004, *Cubism and Its Histories* (Manchester: Manchester University Press), 186.

41. T. P. Brockelman 2001, *The Frame and the Mirror: On Collage and the Postmodern* (Evanston: Northwestern University Press), 1–16.

42. C. Poggi 1993, *In Defiance of Painting: Cubism, Futurism and the Invention of Collage* (London: Yale University Press).

43. de Duve 1984.

44. Ibid., 107.

45. Ibid., 110.

46. R. Broglio 2011, *Surface Encounters: Thinking with Animals and Art* (Minneapolis: University of Minnesota Press).

47. Ibid., xvi.

48. R. Descartes 1637, *Discourse on the Method* (New York: Cosimo, 2008).

49. Broglio 2011:xvii.

50. Ibid.

51. H. Foster 1996, *The Return of the Real* (Cambridge: MIT Press), 11.

52. Ibid., 4.

53. J. Malt 2004, *Obscure Objects of Desire: Surrealism, Fetishism, and Politics* (Oxford: Oxford University Press), 2.

54. Ibid., 6.

55. Ibid., 8.

56. Ibid., 6.

57. W. Benjamin 1982, *The Arcades Project* (Cambridge: Harvard University Press, 1999), 391.

58. Malt 2004:55.

59. Ibid., 56–57.

60. Foucault 1966:407–420.

61. K. Oliver 2013, *Animal Lessons: How They Teach Us to Be Human* (New York: Columbia University Press), 14.

62. Malt 2004:86.

63. Ibid., 104.

64. Ibid., 119.

65. Ibid.

66. Ibid., 138.

67. S. Baker 2000, *The Postmodern Animal* (London: Reaktion), 51.

68. Baker's theorization of the postmodern animal substantially relied on Michael Fried's 1967 influential essay "Art and Objecthood," which predominantly revolves around minimal art's relationship to abstract painting and sculpture. On these grounds, Baker configures the encounter with the postmodern animal as a confrontation between animal body and observer's body, thus urging a negotiation between bodies that in their awkwardness transcends the solemnity of modernist phenomenology. Although interesting, this configuration of the human/animal encounter in the gallery space is limiting.

69. Baker 2000:53.

70. Ibid., 52.

71. L. Steinberg and R. Rauschenberg 2000, *Encounters with Rauschenberg* (Chicago: University of Chicago Press).

72. Ibid., 54–57.

73. R. Hughes 1981, *The Shock of the New* (London: Thames and Hudson), 335.

74. J. Saltz 2005, "Our Picasso?" *Artnet*, http://www.artnet.com/magazineus/features/saltz/saltz1-11-06.asp.

75. Steinberg and Rauschenberg 2000:57.

76. A. Danto 1997, "Robert Rauschenberg," *Nation*, November 17, 32.

77. R. Krauss 1997, "Perpetual Inventory," in W. Hopps and S. Davidson, *Robert Rauschenberg: A Retrospective* [exhibit catalog] (New York: Guggenheim Museum), 125.

78. R. Cranshaw and A. Lewis 1981, "Re-reading Rauschenberg," *Artscribe*, no. 29 (June): 47.

79. In this context the western viewer has been trained to treat this utopianist distancing from the real object as an invitation to the gateway of symbolism. Thus the body of a naked woman sculpted in marble or painted in oil no longer is the body of a naked woman per se; it has been already transformed into an idea. And if the historical/cultural context is precisely outlined, we are confronted by a nude, most likely a Venus—the naked female body leaves its materiality behind to stand in as the emblem of pure love. In line with this trajectory, the prologue of this book focuses on the unconventional and shocking realism of Degas's *Little Dancer Aged Fourteen*. This artistic paradigm has been constructed and explored by artists since then, yet art historians persevere in ignoring its ability to link what is visible in the gallery space with what is invisible outside of it.

80. D. J. Haraway 1991, *Simians, Cyborgs, and Women: The Reinvention of Nature* (London: Routledge).

81. R. Rauschenberg and B. Rose 1987, *An Interview with Robert Rauschenberg* (New York: Avedon), 58.

82. L. Bryant 2011, *The Democracy of Objects* (Ann Arbor: Open Humanity).

83. Steinberg and Rauschenberg 2000, 58.

84. M. Fried 1967, *Art and Objecthood: Essays and Reviews* (Chicago: University of Chicago Press, 1998), 125.

85. H. Foster 1996, *The Return of the Real* (Cambridge: MIT Press), 163.

6. THE ALLURE OF THE VENEER

W. J. T. Mitchell 2005, *What to Do with Pictures? The Lives and Loves of Images* (Chicago: University of Chicago Press), 112; G. Harman 2005, *Guerrilla Metaphysics: Phenomenology and the Carpentry of Things* (Chicago: Open Court), 54.

1. D. Ziogos 2015, "Reminiscence of an Unprocessed Leather Technician," in *Agrimiká: Why Look at Animals?* (Milan: Postmedia), 91.

2. G. Harman 2011b, *The Quadruple Object* (Ropley: Zero), 38.

3. Ibid., 43–44.

4. Ibid., 46.

5. B. Latour 2005, *Reassembling the Social: An Introduction to Actor-Network-Theory* (Oxford: Oxford University Press).

6. Ibid., 79.

7. J. Bennett 2010, *Vibrant Matter: A Political Ecology of Things* (Durham: Duke University Press), ix.

8. Ibid., xiii.

9. Ibid., 117.

10. Ibid., viii.

11. Ibid., 4.

12. Ibid., 6.

13. Ibid., 17–18.

14. Ibid., ix.

15. Ibid., xiii.

16. E. Fudge 2002, "A Left Hand Blow: Writing the History of Animals," in N. Rothfels, ed., *Representing Animals* (Bloomington: Indiana University Press).

17. Bennett 2010:4.

18. Harman 2011b:16–19.

19. Ibid., 8–13.

20. G. Harman 2002, *Tool-Being: Heidegger and the Metaphysics of Objects* (Chicago: Open Court), 42.

21. H. D.Thoreau, *Journal*, 2:313, quoted ibid., 126.

22. Harman 2011b:24–25.

23. H. Wölfflin 1896, "How One Should Photograph Sculpture," trans. G. A. Johnson, *Art History* 36 (February 2013): 52–71.

24. Ibid., 52–53.

25. Ibid., 53–54.

26. Ibid., 54.

27. Ibid., 57–58.

28. Ibid., 58.

29. Ibid., 59.

30. Harman 2011b:24.

31. M. Foucault 1969a, *The Archaeology of Knowledge*, trans A. M. S. Smith (London: Routledge, 2006), 64.

32. Ibid.

33. J. Derrida 2008, *The Beast and the Sovereign*, vol. 1, trans. G. Bennington (Chicago: University of Chicago Press, 2009), 280.

34. B. Latour 1991, *We Have Never Been Modern* (Cambridge: Harvard University Press), 89.

35. R. Broglio 2011, *Surface Encounters: Thinking with Animals and Art* (Minneapolis: University of Minnesota Press), xvii. In his discussion of Damien Hirst's work *Mother and*

Child Divided, Broglio drew from Heraclitus's notion that "Nature loves to hide," simultaneously referring to the tendency animals have to hide from humans and to our impossibility of accessing the deepest workings of nature itself. Francis Bacon's cutting open of the animal therefore constituted a forceful attempt at "lifting the veil" through "torture" (F. Bacon 1620, *The New Organon*, quoted in Broglio 2011:5), a totalizing violence that epistemologically compensated for our lost ability to otherwise "see deeply inside" the animal—a gift Adam originally possessed, enabling him to name all animals (the signature of affirmation). D. J. Haraway 1990, *Simians, Cyborgs and Women: The Reinvention of Nature* (London: Routledge), 81.

36. G. Harman 2007, "On Vicarious Causation," *Collapse* 2:187–221, 195.

37. G. Harman 2010, "A Larger Sense of Beauty," *Indieoma*, April 11, http://dialogicafantastica.wordpress.com/2011/02/01/a-larger-sense-of-beauty/.

38. Ibid.

39. Harman 2007:215.

40. J. Derrida 1987, *The Truth in Painting* (Chicago: University of Chicago Press), 15–148.

41. G. Deleuze and F. Guattari 1980, *A Thousand Plateaus: Capitalism and Schizophrenia* (London: Continuum, 1987, 2003), 36.

42. Ibid., 31.

43. Ibid., 32.

44. N. Galanin 2014, "Inert," http://galan.in/post/13976734736/by-combining-two-pre-taxidermied-wolves-into-one.

45. S. Baker 2000, *The Postmodern Animal* (London: Reaktion), 82.

46. J. Coleman 2004, *Vicious: Wolves and Men in America* (New Haven: Yale University Press), 43–46.

47. Deleuze and Guattari 1987:30.

48. Baker 2000:56.

49. Ibid., 22.

50. R. Poliquin 2012, *The Breathless Zoo: Taxidermy and the Cultures of Longing* (University Park: Pennsylvania State University Press), 156.

51. "Standard Bank Young Artist Awards 2011 – Visual Art" [YouTube video], 2010, posted by "National Arts Festival," October 28, https://www.youtube.com/watch?v=7VvBiUYuqV8.

52. N. Maradzika 2012, "Nandipha Mntambo: Hide and Seek," *Another Africa*, December 11. http://www.anotherafrica.net/art-culture/nandipha-mntambo-hide-seek.

53. Harman 2007:211.

54. Ibid., 215.

55. Maradzika 2012.

56. N. Mntambo 2007, "Locating Me in Order to See You," MA thesis, University of Cape Town, 5.

57. Ibid., 4.

58. Ibid., 5.

59. Ibid., 37.

60. C. J. Adams 1990, *The Sexual Politics of Meat: A Feminist-Vegetarian Critical Theory*, 20th anniv. ed. (New York: Continuum, 2010), 13.

61. R. Cassidy 2002, *The Sport of Kings: Kinship, Class and Thoroughbred Breeding in New-market* (Cambridge: Cambridge University Press), 140–160.

62. Ibid.

63. Ibid., 168.

64. Ibid., 160.

65. V. Despret 2004, "The Body We Care For: Figures of Anthropo-zoo-genesis," *Body and Society* 10, no. 2: 121, quoted in D. J. Haraway 2008, *When Species Meet* (Minneapolis: University of Minnesota Press), 229.

66. K. Barad 2003, "Posthumanist Performativity: Towards an Understanding of How Matter Comes to Matter," *Signs: Journal of Women in Culture and Society* 28, no. 3: 801–831.

67. Ibid., 808.

68. Ibid., 811.

69. Ibid., 814.

70. Ibid., 815.

71. Ibid., 821.

7. THIS IS NOT A HORSE

M. Kundera 1984, *The Unbearable Lightness of Being* (New York: Harper and Row), 290; S. Bishop 2009, "It's Hard to Make a Stand," Saatchi Gallery website, http://www.saatchigallery.com/artists/steve_bishop.htm.

1. H. Foster 1996, *The Return of the Real* (Cambridge: MIT Press), 108–109.

2. The term *commodity sculpture* is here appropriated from Foster's discussion of the art produced in the World War II period. Ibid., 107.

3. T. de Duve 1984, *Pictorial Nominalism: On Marcel Duchamp's Passage from Painting to the Readymade* (Minneapolis: University of Minnesota Press), 88.

4. I. Kant 1914, *Critique of Judgement* (New York: Cosimo, 2007), 27–57.

5. A. Breton 1924, "First Manifesto of Surrealism," in R. Seaver and H. R. Lane, trans., *Manifestoes of Surrealism* (Ann Arbor: University of Michigan Press, 1969), 34.

6. U. Lehmann 2011, "The Surrealist Object and Subject in Materialism: Notes on the Understanding of the Object in Surrealism," in I. Pfeiffer and M. Hollein, eds., *Surreal Objects: Three-Dimensional Works of Art from Dali to Man Ray* (Ostfildern: Hatje Cantz), 129–135, quote on 134–135.

7. E. Fudge 2012, "Renaissance Animal Things," *New Formations*, no. 76 (Autumn): 86–100.

8. Ibid., 89.

9. Ibid., 87.

10. Ibid., 86.

11. B. Brown 2001, "Thing Theory," *Critical Inquiry* 28, no. 1: 4.

12. T. de Duve 1990, "Resonance of Duchamp's visit to Munich" in R. E. Kuenzli and F. M. Naumann, eds., *Marcel Duchamp: Artist of the Century* (Cambridge: MIT Press), 41–63.

13. Ibid., 58.

14. The term was first used by Foucault in a 1977 interview titled "The Confessions of the Flesh." M. Foucault 1977, *Power/Knowledge: Selected Interviews and Other Writings, 1972–1977*, ed. C. Gordon (New York: Pantheon), 194–228.

15. Ibid.

16. Ibid., 193.

17. M. Foucault 1966, *The Order of Things: An Archaeology of the Human Science* (London: Routledge, 1970, 2003), xviii–xxii; and M. Foucault 1984a, "Of Other Spaces," *Diacritics* (Spring 1986): 22–27.

18. Foucault 1984a:23; Foucault 1966:xix.

19. Foucault 1984a:25–26.

20. Foucault 1966:xvi and xix.

21. Ibid., xviii.

22. Ibid., xix.

23. The artist does not know what animal the fur coat is made of, but he confirmed that the coat is a secondhand, vintage item bought in a thrift store.

24. Taxidermy mannequins, tools, and many more items for display of mounts can be purchased from many suppliers. One of the most renowned is Van Dyke's Taxidermy Supply, http://www.vandykestaxidermy.com/.

25. D. Preziosi 1989, *Rethinking Art History: Meditations on a Coy Science* (New Haven: Yale University Press), 56–57.

26. Ibid., 57. As is well articulated by Rudolf Arnheim in *The Power of the Center*, "Perceptually a person is a viewer, who sees himself at the center of the world surrounding him. As he moves, the center of the world stays with him. Considering himself the primary center, he sees the world populated with secondary objects, eccentric to him." What Arnheim's statement brings to the surface is the implicit ontologization provided by the anthropocentric vision that quattrocento painting has for centuries reproduced and crystallized; the one Wölfflin felt the need to impose on the three-dimensional nature of sculpture. However, the multiple viewpoints of anamorphism are structured around the same concepts of possession, mastering, and control that produce affirmation. R. Arnheim 1988, *The Power of the Center* (Berkeley: University of California Press), 37.

27. Bishop 2009.

28. M. Foucault 1976a, *The History of Sexuality 1: The Will to Knowledge* (London: Penguin, 1998), 133–160.

29. Ibid., 139.

30. M. Foucault 1982a, "Technologies of the Self," in P. Rainbow, ed., *Ethics: Subjectivity and Truth—Essential Works of Foucault 1954-1984*, vol. 1 (New York: New Press, 1994).

31. Foucault 1976a:138.

32. Ibid., 140–141.

33. S. Thierman 2010, "Apparatuses of Animality: Foucault Goes to the Slaughterhouse," *Foucault Studies*, no. 9: 89–110; and C. Palmer 2001, "'Taming the Wild Profusion of Existing Things'? A Study of Foucault, Power, and Human-Animal Relations?" *Environmental Ethics* 23, no. 4: 345.

34. M. Foucault 1975b, *Discipline and Punish: The Birth of the Prison*, trans. A. Sheridan (London: Penguin, 1991), 138–139.

35. Ibid., 139.

36. Ibid.

37. Ibid.

38. M. Foucault 1982b, "The Subject and Power," *Critical Inquiry* 8, no. 4 (Summer): 777–795, reference on 786.

39. Ibid., 789.

40. It is important to note that a valuable connection between Foucault's biopower and concentration camps as localized entities in which law, territories, and the power of absolute sovereign are operated is drawn by Giorgio Agamben in *Homo Sacer: Sovereign Life and Bare Life* (Stanford: Stanford University Press, 1998). A meaningful connection between this conception of biopolitics and animal life is drawn in Agamben's *The Open: Man and Animal* (Stanford: Stanford University Press, 2004).

41. Preziosi 1989:39–40, 56–57.

42. Foucault 1977:93–94.

43. C. Wolfe 2010, *What Is Posthumanism?* (Minneapolis: University of Minnesota Press), xxv.

44. S. McHugh 2004, *Dog* (London: Reaktion), 16.

45. C. R. Sanders 2000, "The Impact of Guide Dogs on the Identity of People with Visual Impairments," *Anthrozoos* 13, no. 3: 134–137, quote on 136.

46. McHugh 2004:203–204.

47. P. Patton 2003, "Language, Power, and the Training of Horses," in C. Wolfe, ed., *Zoontologies: The Question of the Animal* (Minneapolis: University of Minnesota Press), 83–100, 84.

48. S. Bowers and M. Steward 2006, *Farming with Horses* (London: Voyageur), 150.

49. G. Lim 2011, "'A Stede Gode and Lel': Valuing Arondel in Bevis of Hampton," in *Postmedieval: A Journal of Medieval Cultural Studies* 2, no. 1: 50–68.

50. McHugh 2004:100.

51. Ibid., 102–123.

52. Patton 2003:93.

53. Ibid., 4; N. Shukin 2009, *Animal Capital: Rendering Life in Biopolitical Times* (Minneapolis: University of Minnesota Press), 13.

54. J. V. Emberly 1997, *The Cultural Politics of Fur* (New York: Cornell University Press), 53.

55. Ibid., 2.

56. T. Porter 2013, "Global Fur Sales Soar Due to High Demand in China," *International Business Times*, May 4, http://www.ibtimes.co.uk/articles/464467/20130504/china-fur -sales-increase.htm.

57. M. Foucault 1973, "The Force of Flight," in J. W. Crampton and S. Elden, *Space, Knowledge and Power: Foucault and Geography*, (Aldershot: Ashgate, 2007), pp. 169–173.

58. M. Foucault 1975a, "Photogenic Painting," in G. Deleuze and M. Foucault, *Gerard Fromanger: La Peinture Photogénique* (London: Black Dog, 1999), 93.

59. Bishop 2009.

60. Malt 2004:142.

61. Ibid., 143.

62. Bishop 2009.

63. S. Gablik 1991, *The Reenchantment of Art* (New York: Thames and Hudson).

64. Ibid., 7.

65. Ibid., 11.

66. Ibid., 12.

67. G. Rose and D. P. Tolia-Kelly, eds. 2012, *Visuality/Materiality: Images, Objects and Practices* (Farnham: Ashgate).

68. S. Reynolds 2011, *Retromania: Pop Culture's Addiction to Its Own Past* (London: Faber and Faber).

69. Ibid., 1–12.

70. P. Frosh 2012, "Indifferent Looks: Visual Inattention and the Composition of Strangers," in Rose and Tolia-Kelly 2012:171–191.

71. Ibid., 175.

72. R. Broglio 2011, *Surface Encounters: Thinking with Animals and Art* (Minneapolis: University of Minnesota Press), 73.

73. R. Broglio 2008, "Living Flesh: Animal-Human Surfaces," *Journal of Visual Culture* 7, no. 1: 103–121.

CODA

D. Morgan 2009, "Enchantment, Disenchantment, Re-Enchantment," in J. Elkins and D. Morgan, eds., *Re-Enchantment* (London: Routledge), 5; J. Bennett 2010, *Vibrant Matter: A Political Ecology of Things* (Durham: Duke University Press), 54.

1. J. Bennett 2001, *The Enchantment of Modern Life: Attachments, Crossings, and Ethics* (Princeton: Princeton University Press).

2. S. Gablik 1991, *The Reenchantment of Art* (New York: Thames and Hudson), 11.

3. D. Preziosi and C. Fargo 2011, *Art Is Not What You Think It Is* (Blackwell: Chichester).

4. K. Pomian 2004, *Dalle Sacre Reliquie All'Arte Moderna* (Milan: Il Saggiatore), 9–19.

5. C. Abivardi 2001, *Iranian Entomology: An Introduction*, 2 vols. (Berlin: Springer), 458.

6. R. Bollongino, J. Burger, A. Powel, M. Mashkour, J.-D. Vigne, and M. J. Thomas, 2012, "Modern Taurine Cattle Descended from Small Number of Near-Eastern Founders," *Molecular Biology and Evolution* 29, no. 9: 2101–2104.

7. A. M. Lippit 2000, *Electric Animal: Toward a Rhetoric of Wildlife* (Minneapolis: University of Minnesota Press), 18.

8. T. Habinek 1990, "Sacrifice, Society, and Vergil's Ox-Born Bees," in *Cabinet of the Muses* (Atlanta: Scholars), 209–233.

9. J. Worlidge 1698, *The Complete Bee Master* (London: G. Conyers).

10. Although it is not clear how the belief that bees could originate from animal carcasses arose, it is assumed that beekeepers might have confused hoverflies (Eristalis tenax) with honeybees. Hoverflies' larvae, like those of all flies, feed on carcasses, but the adults look strikingly similar to bees and feed on nectar and pollen.

11. Y.-N. Chen, L.-Y. Chai, and Y.-D. Shu 2008, "Study of Arsenic Adsorption on Bone Char from Aqueous Solution," *Journal of Hazardous Materials* 160, no. 1 (December): 168–172.

12. C. C. Chou 2000, *Handbook of Sugar Refining: A Manual for the Design and Operation of Sugar Refining Facilities* (Hoboken: Wiley).

13. N. Shukin 2009, *Animal Capital: Rendering Life in Biopolitical Times* (Minneapolis: University of Minnesota Press), 66–67.

14. Ibid., 68.

15. C. Topdjian 2016, "Posthumanism and Body Politics in the Work of Cole Swanson," in C. Swanson, *Out of the Strong, Something Sweet* [exhibition catalog] (Toronto: Art Gallery of Guelph), 20.

APPENDIX

This appendix was originally published as a pamphlet produced in support of the exhibition "Dead Animals, or The Curious Occurrence of Taxidermy in Contemporary Art," held at the David Winton Bell Gallery in Providence, Rhode Island, between January 23 and March 27, 2016. It is reproduced here with permission of the authors.

BIBLIOGRAPHY

Abivardi, C. 2001. *Iranian Entomology: An Introduction*. 2 vols. Berlin: Springer.

Abram, D. 1997. *The Spell of the Sensuous: Perception and Language in a More-Than-Human-World*. London: Vintage.

Adams, C. J. 1990. *The Sexual Politics of Meat: A Feminist-Vegetarian Critical Theory*. 20th anniv. ed. New York: Continuum, 2010.

Agamben, G. 2004. *The Open: Man and Animal*. Stanford: Stanford University Press.

Agnes, A. 1912. *Herbals: Their Origins and Evolution, a Chapter in the History of Botany, 1470–1670*. Cambridge: Cambridge University Press.

Akeley, J. 1929. *Carl Akeley's Africa*. New York: Blue Ribbon.

Albera, F., and M. Tartajada. 2010. "The 1900 Episteme." In F. Albera and M. Tartajada, eds., *Cinema Beyond Film: Media Epistemology in the Modern Era*, 25–44. Amsterdam: Amsterdam University Press.

Alberti, S. J. M. M., ed. 2011. *The Afterlives of Animals*. Charlottesville: University of Virginia Press.

Allen, R. J. 1887. *Lecture VI: The Medieval Bestiaries—the Rhind Lectures in Archaeology for 1885*. London: Whiting.

Aloi, G. 2007. "Marcus Coates: Becoming Animal." *Antennae: The Journal of Nature in Visual Culture*, no. 4 (Winter): 18–20. http://www.antennae.org.uk/back-issues-2007/4583449287.

Aloi, G. 2008. "Oleg Kulik: Artificial Paradise." *Antennae: The Journal of Nature in Visual Culture*, no. 8.2: 31–39. http://www.antennae.org.uk/back-issues-2008/4583459061.

Aloi, G. 2011a. *Art & Animals*. London: I. B. Tauris.

Aloi, G. 2011b. "Different Becomings." *Art and Research: A Journal of Ideas, Contexts and Methods* 4, no. 1 (Summer). http://www.artandresearch.org.uk/v4n1/pdfs/aloi.pdf.

Aloi, G. 2015. "Animal Studies and Art: Elephants in the Room." *Antennae: The Journal of Nature in Visual Culture*. http://www.antennae.org.uk/back-issues-2015/4589877799.

Alpers, S. 1983. "Interpretation without Representation, or the Viewing of *Las Meninas.*" *Representations* 1, no. 1 (February): 31–42.

Andrews, M. 1999. *Landscape and Western Art.* Oxford: Oxford University Press.

Anonymous. 1968. "Objets Surréalistes." 1931. In A. Breton, ed., *Le Surréalisme au Service de la Revolution*, 16–20. Paris: Ayer.

Appadurai, A., ed. 1988. *The Social Life of Things: Commodities in Cultural Perspective.* Cambridge: Cambridge University Press.

Aquaro, G. R. A. 2004. *Death by Envy: The Evil Eye and Envy in the Christian Tradition.* Bloomington: IUniverse.

Aristotle. n.d. *History of Animals.* Vol. 10. Edited by G. P. Goold. Cambridge: Harvard University Press, Loeb Classical Library, 1965.

Aristotle. n.d. "The Nature of Poetic Imitation: From the Poetics." In G. Dickie, R. Sclafani, and R. Roblin, eds., *Aesthetics: A Critical Anthology.* New York: St. Martin's Press, 1989.

Aristotle. n.d. "Poetics." In D. H. Richter, ed., *The Critical Tradition: Classic Texts and Contemporary Trends.* New York: St. Martin's Press, 1989.

Armstrong, N. 2010. "Realism Before and After Photography." In M. Beaumont, ed., *A Concise Companion to Realism*, 102–120. London: Wiley-Blackwell.

Ashworth, W. B. 1996. "Emblematic Natural History in the Renaissance." In J. Jardine, A. Secord, and E. C. Spary, eds., *Cultures of Natural History*, 17–37. Cambridge: Cambridge University Press.

Ashworth, W. B. 2003. "The Revolution in Natural History." In M. Hellyer, ed., *The Scientific Revolution*, 130–156. London: Blackwell.

Asma, S. T. 2001. *Stuffed Animals and Pickled Heads: The Culture and Evolution of Natural History Museums.* Oxford: Oxford University Press.

Assouline, P. 2008. *Deyrolle—Pour L'Avenir.* Paris: Editions Gallimard.

Augustine. 1992. *Confessions.* Oxford: Oxford University Press.

Avery, C. 2002. "Forms in Space, c.1700–1770." In M. Kemp, ed., *The Oxford History of Western Art*, 280–281. Oxford: Oxford University Press.

Bach, R. 1970. *Jonathan Livingston Seagull.* New York: MacMillan.

Bacon, F. 1620. *The New Organon.* Cambridge: Cambridge University Press, 2000.

Bagley, C. 2009. "Deyrolle: Up from the Ashes." *W Magazine*, October 9. http://www.wmagazine.com/fashion/2009/10/1000c-deyrolle/.

Baker, S. 1993. *Picturing the Beast: Animals, Identity, and Representation.* Urbana: University of Illinois Press.

Baker, S. 2000. *The Postmodern Animal.* London: Reaktion.

Baker, S. 2001. "Where the Wild Things Are: An Interview with Steve Baker." *Cabinet*, no. 4 (Fall). http://www.cabinetmagazine.org/issues/4/stevebaker.php.

Baker, S. 2008. "Something's Gone Wrong Again." *Antennae: The Journal of Nature in Visual Culture*, no. 7 (Autumn): 4–9. http://www.antennae.org.uk/back-issues-2008/4583459061.

Baker, S. 2013. *Artist | Animal.* Minneapolis: University of Minnesota Press.

Balbus, I. 1988. "Disciplining Women." In J. Arac, ed., *After Foucault: Humanistic Knowledge, Postmodern Challenges.* New Brunswick: Rutgers University Press.

Bann, S. 2013. *Ways Around Modernism.* London: Routledge.

Barad, K. 2003. "Posthumanist Performativity: Toward an Understanding of How Matter Comes to Matter." *Signs: Journal of Women in Culture and Society* 28, no. 3: 801–831.

Barad, K. 2007. *Meeting the Universe Halfway: Quantum Physics and the Entanglement of Matter and Meaning.* Durham: Duke University Press.

Barad, K. 2012. "What Is the Measure of Nothingness? Infinity, Virtuality, Justice." Part of the series *100 Notes, 100 Thoughts: dOCUMENTA.* Berlin: Hatje Cantz.

Barber, L. 1980. *The Heyday of Natural History, 1820–1870.* London: Jonathan Cope.

Barthes, R. 1980. *Camera Lucida.* New York: Hill and Wang.

Bartky, S. 1988. "Foucault, Femininity and the Modernization of Patriarchal Power." In I. Diamond and L. Quinby, eds., *Feminism and Foucault: Reflections on Resistance.* Boston: Northeastern University Press.

Barzman, K. 2002. "Academies, Theories, and Critics." In M. Kemp, ed., *The Oxford History of Western Art,* 290–293. Oxford: Oxford University Press.

Batchen, G. 1999. *Burning with Desire: The Conception of Photography.* Cambridge: MIT Press.

Baudelaire, C. 1863. "The Painter of Modern Life." In *The Painter of Modern Life and Other Essays.* London: Phaidon, 1964.

Bell, J. 2007. *Mirror of the World: A New History of Art.* London: Thames & Hudson.

Bellel, Z. 2009. "Deyrolle: Where the Wild Things Are (Again)." *Paris by Appointment Only* [blog]. October 21. http://www.parisbao.com/art/deyrolle-where-the-wild-things-are -again/.

Bena, A. 2010. *Racconto della Nascita di Ponte Nossa.* TipoLito: Valeriana.

Bennett, J. 2001. *The Enchantment of Modern Life: Attachments, Crossings, and Ethics.* Princeton: Princeton University Press.

Bennett, J. 2010. *Vibrant Matter: A Political Ecology of Things.* Durham: Duke University Press.

Bennett, T. 1988. "The Exhibitionary Complex." *New Formations,* no. 4 (Spring): 73–102.

Bennett, T. 1995. *The Birth of the Museum: History, Theory, Politics.* London: Routledge.

Bentham, J. 1791. *The Works of Jeremy Bentham.* Vol. 4. Edinburgh: William Tait, 1843.

Berger, J. 1980. "Why Look at Animals?" In *About Looking,* 3–28. London, Vintage, 1993.

Best, S. 2009. "The Rise of Critical Animal Studies: Putting Theory into Action and Animal Liberation into Higher Education." *JCAS: Journal for Critical Animal Studies* 7, no. 1: 9–52.

Best, S., and D. Kellner. 1991. *Postmodern Theory: Critical Interrogations.* New York: Guilford Press.

Biétry-Rivierre, E. 2008. "Comment sauver la maison-musée Deyrolle." *Le Figaro,* February 4.

Bignell, J. 2007. *Postmodern Media Culture.* Delhi: Aakar.

Blume M. 2008. "Rescuing Deyrolle, a Beloved Parisian Shop." *New York Times,* March 28. http://www.nytimes.com/2008/03/28/arts/28iht-blume.html?pagewanted=all&_r=0.

Bochet, L., and L. A. de Broglie. 2009. *1000 Degrees C. Deyrolle.* Paris: Editions Assouline.

Bollongino, R., J. Burger, A. Powel, M. Mashkour, J.-D. Vigne, and M. J. Thomas. 2012. "Modern Taurine Cattle Descended from Small Number of Near-Eastern Founders." *Molecular Biology and Evolution* 29, no. 9: 2101–2104.

Bolnest, E. 1672. *Aurora Chymica, or, a Rational Way of Preparing Animals, Vegetables, and Minerals for a Physical Use.* Charleston: BiblioBazaar, 2011.

Bowditch, T. E. 1820. *Taxidermy or, the Art of Collecting, Preparing and Mounting Objects of Natural History for the Use of Museums and Travellers.* London: Longman, Hurst, Rees, Orme, and Brown.

Bowers, S., and M. Steward. 2006. *Farming with Horses.* London: Voyageur Press.

Breton, A. 1924. "First Manifesto of Surrealism." In R. Seaver and H. R. Lane, trans., *Manifestoes of Surrealism,* 1–38. Ann Arbor: University of Michigan Press, 1969.

Breton, A. 2002. *Surrealism and Painting.* Boston: MFA Publications.

Brockelman, T. P. 2001. *The Frame and the Mirror: On Collage and the Postmodern.* Evanston: Northwestern University Press.

Broglio, R. 2008. "Living Flesh: Animal-Human Surfaces." *Journal of Visual Culture* 7, no. 1: 103–121.

Broglio, R. 2011. *Surface Encounters: Thinking with Animals and Art.* Minneapolis: University of Minnesota Press.

Browder, C. 1967. *Andre Breton: Arbiter of Surrealism.* Geneva: Librairie Droz.

Brower, M. 2011. *Developing Animals: Wildlife and Early American Photography.* Minneapolis: University of Minnesota Press.

Brown, B. 2001. "Thing Theory." *Critical Inquiry* 28, no. 1: 1–22.

Browne, M. 1884. *Practical Taxidermy: A Manual of Instruction to the Amateur in Collecting, Preserving, and Setting Up Natural History Specimens of All Kinds.* Alcester: Read Country Book, 2005.

Browne, M. 1896. *Artistic and Scientific Taxidermy and Modelling.* London: A. & C. Black.

Brunfels, O. 1532–1536. *Herbarum Vivae Eicones.* Strasburg: Argentorati, Apud Joannem Schottum.

Bryant, L. 2011. *The Democracy of Objects.* Ann Arbor: Open Humanity Press.

Bryant, L., N. Srnicek, and G. Harman. 2011. *The Speculative Turn.* Melbourne: RePress.

Bryson, N. 1988. *Calligram: Essays in New Art History from France.* Cambridge: Cambridge University Press.

Bryson, N. 1990. *Looking at the Overlooked: Four Essays on Still Life Painting.* London: Reaktion.

Burt, J. 2002. *Animals in Film.* London: Reaktion.

Burt, J. 2007. "Animals in Visual Art from 1900 to the Present." In R. Malamud, ed., *A Cultural History of Animals in the Modern Age,* 163–194. Oxford: Berg.

Calarco, M. 2008. *Zoographies: The Question of the Animal from Heidegger to Derrida.* New York: Columbia University Press.

Carroll, N. 1999. *Philosophy of Art.* London: Routledge.

Cassidy, R. 2002. *The Sport of Kings: Kinship, Class and Thoroughbred Breeding in Newmarket.* Cambridge: Cambridge University Press.

Castanò, E., and L. Fabbri, eds. 2013. "Gli animali di Foucault." *Animal Studies: Rivista italiana di antispecismo* 2, no. 4 (July).

Castricano, J., ed. 2008. *Animal Subjects: An Ethical Reader in a Posthuman World.* Waterloo: Wilfrid Laurie University Press.

Cavalieri, P., ed. 1988–1998. *Etica & Animali.* Milan: Animus.

Cavalieri, P. 2004. *The Animal Question: Why Nonhuman Animals Deserve Human Rights.* Oxford: Oxford University Press.

Cavalieri, P. 2008. "A Missed Opportunity: Humanism, Anti-Humanism and the Animal Question." In J. Castricano, ed., *Animal Subjects: An Ethical Reader in a Posthuman World,* 97–123. Waterloo: Wilfrid Laurie University Press.

Chapman, E. 2012. *Prove It on Me: New Negroes, Sex, and Popular Culture in the 1920s.* Oxford: Oxford University Press.

Chipp, H. B. 1968. *Theories of Modern Art: A Source Book by Artists and Critics.* Berkeley: University of California Press.

Clark, T. J. 2011. "Phenomenality and Materiality in Cézanne." In T. Cohen et al., *Material Events: Paul de Man and the Afterlife of Theory,* 93–113. Minneapolis: University of Minnesota Press.

Ciccarese, M. P. 1999. "Bibbia, bestie e bestiari: L'interpretazione Cristiana degli animali dalle origini al Medioevo." In G. Schianchi, ed., *Il Bestiario di Parma: Iconografia, Iconologia, Fonti Letterarie.* Milano: Vita e Pensiero.

Coates, P. *Nature.* 1998. Berkeley: University of California Press.

Coleman, Jon T. 2004. *Vicious: Wolves and Men in America.* New Haven: Yale University Press.

Connor, S. 2002. "Seeing Sound: The Displaying of Marsyas." Lecture marking the inauguration of the MA in Text and Image, University of Nottingham. http://www.stevenconnor.com/marsyas/.

Coole, D. 2015. "From within the Midst of Things: New Sensibility, New Alchemy, and the Renewal of Critical Theory." In C. Cox, J. Jaskey, and S. Malik, eds., *Realism Materialism Art,* 41–46. Berlin: Sternberg Press.

Coole, D., and S. Frost, 2010. "Introducing the New Materialism." In D. Coole and S. Frost, eds., *New Materialisms: Ontology, Agency, and Politics,* 1–46. Durham: Duke University Press.

Cordier, U. 1986. *Guida ai Draghi e Mostri in Italia.* Milan: Sugar.

Corrin, L. G., M. Know, and N. Bryson. 1997. *Mark Dion.* London: Phaidon Press.

Cottington, D. 2004. *Cubism and Its Histories.* Manchester: Manchester University Press.

Cranshaw, R., and A. Lewis. 1981. "Re-reading Rauschenberg." *Artscribe,* no. 29 (June): 47.

Creegan, S., ed. 1984. *Upholstery, the Inside Story.* London: Chapman.

Curley, M. J. 2009. *Physiologus: A Medieval Book of Nature Lore.* Chicago: University of Chicago Press.

Danto, A. 1997. "Robert Rauschenberg." *The Nation,* November 17, 32.

Daston, L., and P. Galison. 2007. *Objectivity.* New York: Zone.

Daston, L., and K. Park. 2001. *Wonders and the Order of Nature.* New York: Zone.

Davie, O. 1894. *Methods in the Art of Taxidermy.* Philadelphia: David McKay.

de Duve, T. 1984. *Pictorial Nominalism: On Marcel Duchamp's Passage from Painting to the Readymade.* Minneapolis: University of Minnesota Press.

de Duve, T. 1990. "Resonance of Duchamp's Visit to Munich." In R. E. Kuenzli and F. M. Naumann, eds., *Marcel Duchamp: Artist of the Century,* 41–63. Boston: MIT Press.

Deleuze, G. 1981. *Francis Bacon: Logic of Sensation.* London: Continuum.

Deleuze, G., and F. Guattari. 1980. *A Thousand Plateaus: Capitalism and Schizophrenia.* London: Continuum, 1987, 2003.

DeMello, M. 2013. *Animals and Society: An Introduction to Human-Animal Studies*. New York: Columbia University Press.

Demme, J., dir. 1991. *The Silence of the Lambs* [film]. Orion Pictures.

de Réaumur, R. A. F.. 1748. "Divers Means for Preserving from Corruption Dead Birds, Intended to Be Sent to Remote Countries, So That They May Arrive There in a Good Condition. Some of the Same Means May Be Employed for Preserving Quadrupeds, Reptiles, Fishes, and Insects." *Philosophical Transactions of the Royal Society of London* 45, 304–320.

Derrida, J. 1987. *The Truth in Painting*. Chicago: University of Chicago Press.

Derrida, J. 1989. *Of Spirit: Heidegger and the Question*. Chicago: University of Chicago Press.

Derrida, J. 1997. "The Animal That Therefore I Am (More to Follow)." *Critical Inquiry* 28, no. 2 (2002): 369–418.

Derrida, J. 2006. *The Animal That Therefore I Am*. Ed. M. L. Mallet. New York: Fordham University Press.

Derrida, J. 2008. *The Beast and the Sovereign*. Vol. 1. Trans. G. Bennington. Chicago: University of Chicago Press, 2009.

Descartes, R. 1629. *Treatise of Man*. Amherst: Prometheus, 2003.

Descartes, R. 1637. *Discourse on the Method*. New York: Cosimo, 2008.

De Vriend, H. J., ed. 1984. *The Old English Herbarium and Medicina de Quadrupedibus*. London: Oxford University Press.

Dewes, P. 1987. *Logics of Disintegration: Post-structuralist Thought and the Claims of Critical Theory*. New York: Verso.

Dioscoridis, P. AD 50–70. *De Materia Medica*. Lugdunum: Apud Balthazarem Arnolletum.

Donald, D. 2007. *Picturing Animals in Britain 1750–1850*. New Haven: Yale University Press.

d'Orgeval, M. 2009a. "Still Life." *The Drawbridge*, no. 14. http://thedrawbridge.org.uk/issue_14/still_life/.

d'Orgeval, M. 2009b. *Touched by Fire*. Gottingen: Steidl Photography International.

Douglas, N. 1928. *Birds and Beasts of the Greek Anthology*. London: Chapman and Hall.

Drawbridge. 2009. "Martin d'Orgeval: Touched by Fire." *The Telegraph*, November 6. http://www.telegraph.co.uk/culture/6455166/Martin-dOrgeval-Touched-by-Fire.html.

Drummond, A. 2008. *Elephantina: An Account of the Accidental Death of an Elephant in Dundee in the Year 1706, Described by an Engraver Resident in That Town*. Edinburgh: Polygon.

Dufresne, L. 1803. "Taxidermie." In *Nouveau dictionnaire d'histoire naturelle, appliquée aux arts, principalement à l'agriculture, et à l'economie rurale et domestique par une société de naturalistes et d'agriculture*, vol. 21, 507–565. Paris: Déterville.

Dufresne, L. 1820. *Taxidermie, ou, l'Art de Préparer et de Conserver la Dépouille de tous les Animaux, pour les Musées, les Cabinets d'Histoire Naturelle*. Paris: Chez Deterville.

Dumbadze, A., and S. Hudson. 2012. *Contemporary Art: 1989 to the Present*. Chichester: Wiley.

Dumbadze, P. 2011. *Avian Architecture: How Birds Design, Engineer, and Build*. Princeton: Princeton University Press.

Easton, J. 2012. *The Art of Taxidermy*. London: Pavilion.

Eco, U. 1995. *Travels in Hyperreality*. San Diego: Harcourt.

Edwards, S., and P. Woods, eds. 2013. *Art and Visual Culture 1850–2010: Modernity to Globalisation*. London: Tate.

Elkins, J. 2000. *What Painting Is*. Abingdon: Taylor and Francis.

Elkins, J. 2008. "On Some Limits of Materiality in Art History." In S. Neuner and J. Gelshorn, eds., "Taktilität: Sinneserfahrung als Grenzerfahrung," special issue, *31: Das Magazin des Instituts fur Theorie* 12: 25–30.

Emberly, J. V. 1997. *The Cultural Politics of Fur*. New York: Cornell University Press.

Fairnington, M. 2008. "The Specimen." *Antennae: The Journal of Nature in Visual Culture*, no. 6 (Summer): 60–65.

Faubion, J. D. 2014. *Foucault Now: Current Perspectives in Foucault Studies*. Cambridge: Polity Press.

Fernie, E. 1995. *Art History and Its Methods*. London: Phaidon.

Findlen, P. 1994. *Possessing Nature: Museums, Collecting, and Scientific Culture in Early Modern Italy*. Berkeley: University of California Press.

Findlen, P. 2002. "Inventing Nature." In P. H. Smith and P. Findlen, eds. *Merchants & Marvels: Commerce, Science, and Art in Early Modern Europe*, 297–323. London: Routledge.

Fisher. C. 1927. "Carl Akeley and His Work." *Scientific Monthly* 24, no. 2: 97–118.

Foster, H. 1996. *The Return of the Real*. Cambridge: MIT Press.

Foucault, M. 1961. *History of Madness*. London: Routledge, 2006, 2009.

Foucault, M. 1963. *The Birth of the Clinic: An Archaeology of Medical Perception*. London: Routledge, 1973, 2003.

Foucault, M. 1964. *Madness and Civilization: A History of Insanity in the Age of Reason*. New York: Vintage, 1967, 1988.

Foucault, M. 1966. *The Order of Things: An Archaeology of the Human Science*. London: Routledge, 1970, 2003.

Foucault, M. 1967. "Les mots et les images." In D. Defert and F. Ewald, eds., *Dits et écrits, 1954–1988*, 620–623. Paris: Gallimard, 1994.

Foucault, M. 1969a. *The Archaeology of Knowledge*. Trans. A. M. S. Smith. London: Routledge, 2006.

Foucault, M. 1969b. "What Is an Author?" In D. F. Bouchard, ed., *Language, Counter-Memory, Practice: Selected Essays and Interviews by Michel Foucault*. Ithaca: Cornell University Press, 1980.

Foucault, M. 1972. "The Eye of Power." In *Power/Knowledge: Selected Interviews and Other Writings, 1972–1977*, 146–165. Brighton: Harvester Press.

Foucault, M. 1973. "The Force of Flight." In J. W. Crampton and S. Elden, eds., *Space, Knowledge and Power: Foucault and Geography*, 169–173. Aldershot: Ashgate, 2007.

Foucault, M. 1974. "'A quoi revent les philosophes?" In D. Defert, F. Ewald, and J. Lagrange, eds., *Foucault: Dits et ecrits I, 1954–1975*. Paris: Editions Gallimard, 2001.

Foucault, M. 1974–1975. *Abnormal*. London: Verso, 1999, 2003.

Foucault, M. 1975a. "Photogenic Painting." In G. Deleuze and M. Foucault. *Gerard Fromanger: La Peinture Photogénique*. London: Black Dog, 1999.

Foucault, M. 1975b. *Discipline and Punish: The Birth of the Prison*. Trans. A. Sheridan. London: Penguin, 1991.

Foucault, M. 1976a. *The History of Sexuality 1: The Will to Knowledge.* London: Penguin, 1998.

Foucault, M. 1976b. '"Questions of Geography." In C. Gordon, ed., *Power/Knowledge: Selected Interviews and Other Writings, 1972–1977,* 63–78. Brighton: Harvester, 1980.

Foucault, M. 1977. *Power/Knowledge: Selected Interviews and Other Writings, 1972–1977,* ed. C. Gordon. New York: Pantheon.

Foucault, M. 1980. "Two Lectures." In C. Gordon, ed., *Power/Knowledge: Selected Interviews and Other Writings, 1972–1977,* 78–108. Brighton: Harvester.

Foucault, M. 1981. "The Order of Discourse." In R. Young, ed., *Untying the Text: A Post-Structuralist Reader,* 48–78. London: Routledge, 2006.

Foucault, M. 1982a. "Technologies of the Self." In P. Rainbow, ed., *Ethics: Subjectivity and Truth—Essential Works of Foucault 1954–1984,* vol. 1, 223–252. New York: New Press, 1994.

Foucault, M. 1982b. "The Subject and Power." *Critical Inquiry* 8, no. 4 (Summer): 777–795.

Foucault, M. 1982c. "Thought, Emotion." In D. Michals, *Duane Michals: Photographie de 1958 à 1982,* iii–vii. Paris: Musée d'Art Moderne de la Ville de Paris.

Foucault, M. 1983. *This Is Not a Pipe.* Berkeley: University of California Press.

Foucault, M. 1984a. "Of Other Spaces." *Diacritics* (Spring 1986): 22–27.

Foucault, M. 1984b. "What Is Enlightenment?" In P. Rainbow, ed., *The Foucault Reader,* 32–50. New York: Pantheon.

Foucault, M. 1989. *Foucault Live (Interviews 1966–84).* New York: Semitoext(e).

Foucault, M., and N. Bourriaud. 1971/2009. *Manet and the Object of Painting.* London: Tate, 2011.

Fox, D. 2008. "Constructed Reality: The Diorama as Art." *Antennae: The Journal of Nature in Visual Culture,* no. 6 (Summer): 13–20.

Fraser, N. 1989. *Unruly Practices: Power, Discourse and Gender in Contemporary Social Theory.* Minneapolis: University of Minnesota Press.

Freeman, C., and Leane, E. 2011. "Introduction." In C. Freeman, E. Leane, and L. J. Freeman. *Italian Sculpture of the Renaissance,* 1–20. Whitefish: Kessinger, 1901.

Fried, M. 1967. "Art and Objecthood." In *Art and Objecthood: Essays and Reviews,* 148–172. Chicago: University of Chicago Press, 1998.

Frosh, P. 2012. "Indifferent Looks: Visual Inattention and the Composition of Strangers." In G. Rose and D. P. Tolia-Kelly, eds., *Visuality/Materiality: Images, Objects and Practices,* 171–191. Farnham: Ashgate.

Frost, C. 1981. *Victorian Taxidermy: Its History and Finest Exponents.* Long Melford: Privately published by the author.

Fuchs, L. 1547. *De Historia Stirpium Commentarii Insignes.* Leipzig: Kurt Wolff Verlag.

Fudge, E. 2008. *Pets.* Durham: Acumen.

Fudge, E. 2012. "Renaissance Animal Things." *New Formations,* no. 76 (Autumn): 86–100.

Gablik, S. 1991. *The Reenchantment of Art.* New York: Thames and Hudson.

Gates, B. T. 2007. "Introduction: Why Victorian Natural History?" *Victorian Literature and Culture* 35, no. 2: 539–549.

Gensini, S., and M. Fusco. 2010. *Animal Loquens: Linguaggio e Conoscenza Negli Animali Non Umani da Aristotele a Chomsky.* Roma: Carocci.

Getsy, D. 2014. "Acts of Stillness: Statues, Performativity, and Passive Resistance." *Criticism* 56, no. 1 (Winter): 1–20.

Glaister, D. 2013. "The Artist Who Tried to Capture Death." *The Guardian*, May 29. http://www
.theguardian.com/artanddesign/2013/may/29/jordan-baseman-artist-deadness
-interview.

Gombrich, E. H. 1950. *The Story of Art*. London: Phaidon, 2006.

Goodman, J. 2002. "Pictures and Public." In M. Kemp, ed., *The Oxford History of Western Art*,
304–311. Oxford: Oxford University Press.

Greenberg, C. 1952. "*Cézanne*: Gateway to Contemporary Painting." *The American Mercury*,
June, 69–73.

Greenberg, C. 1959. "The Case for Abstract Art." *Saturday Evening Post*, August 1.

Greenberg, C. 1961. *Art and Culture: Critical Essays*. Boston: Beacon Press.

Greenberg, C. 1963. "Modernist Painting." In S. Everett, ed., *Art Theory and Criticism: An An-
thology of Formalist, Avant-Garde, Contextualist and Post-Modernist Thought*, 110–118.
Jefferson: McFarland, 1991.

Greenblatt, S. 1991. *Marvelous Possessions: The Wonder of the New World*. Chicago: University
of Chicago Press.

Greslé, Y. 2006. "Foucault's *Las Meninas* and Art-Historical Methods." *Journal of Literary
Studies* 22, nos. 3–4 (December): 211–228.

Griffiths, R., and G. E. Griffiths. 1820. "Taxidermy." *Monthly Review or Literary Journal* 93.
Charleston: Nabu Press, 2010.

Gupta, S. 2005. "Approaching Modernism/Modernisms." In S. Gupta and R. D. Brown, eds.,
Aestheticism and Modernism: Debating Twentieth-Century Literature 1900–1960, 221–229.
Hove: Psychology Press.

Habinek, T. 1990. "Sacrifice, Society, and Vergil's Ox-Born Bees." In *Cabinet of the Muses*, 209–
233. Atlanta: Scholars Press.

Hamel, F. 1969. *Human Animals: Werewolves and Other Transformations*. New Hyde Park:
New York University Press, 2010.

Haraway, D. J. 1984. "Teddy Bear Patriarchy: Taxidermy in the Garden of Eden, New York City,
1908–1936." *Social Text*, no. 11 (Winter): 20–64.

Haraway, D. J. 1991. *Simians, Cyborgs, and Women: The Reinvention of Nature*. London:
Routledge.

Haraway, D. J. 2004. "The Promises of Monsters: A Regenerative Politics for Inappropriate/d
Others." In *The Haraway Reader*, 63–124. Abingdon: Psychology Press.

Haraway, D. J. 2008. *When Species Meet*. Minneapolis: University of Minnesota Press.

Haraway, D. J., and T. Goodeve. 1999. *How Like a Leaf*. London: Routledge.

Harman, G. 2002. *Tool-Being: Heidegger and the Metaphysics of Objects*. Chicago: Open
Court.

Harman, G. 2005. *Guerrilla Metaphysics: Phenomenology and the Carpentry of Things*. Chi-
cago: Open Court.

Harman, G. 2007. "On Vicarious Causation." *Collapse* 2: 187–221.

Harman, G. 2010. "A Larger Sense of Beauty." *Indieoma*, April 11. http://dialogicafantastica.
wordpress.com/2011/02/01/a-larger-sense-of-beauty/.

Harman, G. 2011a. *Heidegger Explained: From Phenomenology to Thing*. Chicago: Open Court.

Harman, G. 2011b. *The Quadruple Object*. Ropley: Zero.

Harman, G. 2012. "Third Table." Part of the series *100 Notes, 100 Thoughts: dOCUMENTA*. Berlin: Hatje Cantz.

Harman, G. 2015. "Art and OOObjecthood." In C. Cox, J. Jaskey, and S. Malik, eds., *Realism Materialism Art*, 97–122. Berlin: Sternberg.

Harrell, J., C. Barrett, and D. Petsch, eds. 2006. *History of Aesthetics*. London: Continuum.

Hartmann, C. H. 1924. *La Belle Stuart: Memoirs of Court and Society in the Times of Frances Teresa Stuart, Duchess of Richmond and Lennox*. London: Routledge.

Hauser, K. 1999. "Coming Apart at the Seams: Taxidermy and Contemporary Photography." *Make: The Magazine of Women's Art*, no. 82: 8–11.

Heidegger, M. 1927. *Being and Time*. New York: State University of New York Press, 1996.

Heidegger, M. 1950. "The Origin of the Work of Art." In *Basic Writings*, 2nd ed. New York: HarperCollins, 2008.

Henning, M. 2006. "Skins of the Real: Taxidermy and Photography." In B. Snæbjörnsdóttir and M. Wilson, *Nanoq: Flat Out and Bluesome: A Cultural Life of Polar Bears*, 136–147. London: Black Dog.

Hitchcock, A., dir. 1960. *Psycho* [film]. Shamley Productions.

Hoage, R. J., and W. A. Deiss, eds. 1996. *New Worlds, New Animals: From Menagerie to Zoological Park in the Nineteenth Century*. Baltimore: Johns Hopkins University Press.

Hoch, H. 1929. *Hannah Hoch* [exhibition catalog]. Berlin: Kunstzaal De Bron.

Holt, D. K. 2001. *The Search for Aesthetic Meaning in the Visual Arts: The Need for the Aesthetic Tradition in Contemporary Art Theory and Education*. Chicago: Greenwood.

Hooper, T., dir. 1986. *The Texas Chainsaw Massacre 2* [film]. Cannon Films.

Horn, R. 2008. *Bird*. Zurich: Steidl Hauser & Wirth.

Hornaday, W. 1891. *Taxidermy and Zoological Collecting*. New York: Scribner.

Hourihane, C., ed. 2012. *The Grove Encyclopedia of Medieval Art and Architecture*. Vol. 2. Oxford: Oxford University Press.

Howells, R., and J. Negreiros. 2011. *Visual Culture*. Stafford: Polity.

Hughes, R. 1981. *The Shock of the New*. London: Thames and Hudson.

Huyusmans, J.-K. 1883. "L'exposition des independants en 1881." *L'art Moderne*, 225–257. Paris.

Ikram, S. 2005. "The Loved Ones: Egyptian Animal Mummies as Cultural and Environmental Indicators." In H. Huitenhuis, A. M. Choyke, L. Martin, L. Bartosiewicz, and M. Mashkour, eds., *Archaeozoology of the Near East, Proceedings of the Sixth International Symposium on the Archaeology of Southwestern Asia and Adjacent Areas*. Groningen: ARC Publications.

Ingold, T. 2000. "From Trust to Domination: An Alternative History of Human-Animal Relations." In T. Ingold, ed., *The Perception of the Environment. Essays in Livelihood, Dwelling and Skill*, 61–76. London: Routledge.

Ingold, T. 2012. "Toward an Ecology of Materials." *Annual Review of Anthropology* 41: 427–442.

Ingres, J. A. D. 1870. "Notes, 1813–27." In H. Delaborde, *Ingres, Sa Vie, Ses Travaux, Sa Doctrine*, 93–177. Paris: Plon.

Iversen, M., and S. Melville. 2010. *Writing Art History: Disciplinary Departures*. Chicago: University of Chicago Press.

James, M. R. 1931. "The Bestiary." *History: The Quarterly Journal of the Historical Association* 16, no. 61 (April): 1–11.

Jason, H. W. 1985. *Nineteenth-Century Sculpture*. New York: Abrams.

Jay, M. 1986. "In the Empire of the Gaze: Foucault and the Denigration of Vision in Twentieth-Century French Thought." In D. Hoy, ed., *Foucault: A Critical Reader*, 175–204. London: Wiley-Blackwell.

Johnson, L. 2012. *Power, Knowledge, Animals*. Basingstoke: Palgrave Macmillan.

Jones, A. 1994. *Postmodernism and the En-gendering of Marcel Duchamp*. Cambridge: Cambridge University Press.

Jovanovsky, T. 2008. *Aesthetics Transformation: Taking Nietzsche At His Word*. New York: Peter Lang.

Jury, L. 2014. "Stuff It! Taxidermy Is the Latest Craze." *The Evening Standard*, January 7, 3.

Kac, E. 2005. *Telepresence and Bio Art: Networking Humans, Rabbits and Robots*. Ann Arbor: University of Michigan Press.

Kamcke, C., and R. Hutterer. 2015. *Natural History Dioramas*. Berlin: Springer.

Kant, I. 1914. *Critique of Judgement*. New York: Cosimo, 2007.

Kavanagh, G. 1989. "Objects as Evidence, or Not?" In S. Pearce, ed., *Museum Studies in Material Culture*, 125–138. Leicester: Leicester University Press.

Kean, H. 1998. *Animal Rights: Political and Social Change in Britain since 1800*. London: Reaktion.

Kemp, M. 2000. *The Oxford History of Western Art*. Oxford: Oxford University Press.

Kendall, R., ed. 1994. *Degas by Himself: Drawings, Prints, Paintings, Writings*. New York: Chartwell.

Kendall, R. 1998. *Degas and the Little Dancer*. New Haven: Yale University Press.

Kennedy, J. M. 1968. "Philanthropy and Science in New York City: The American Museum of Natural History, 1868–1968." PhD diss., Yale University.

Keulartz, J. J. 1998. *The Struggle for Nature*. London: Routledge.

Kimbell, L. 2013. "The Object Strikes Back: An Interview with Graham Harman." *Design and Culture* 5, no. 1: 8.

Klingender, F. 1971. *Animals in Art and Thought to the End of the Middle Ages*. Cambridge: MIT Press.

Knorovsky, K. 2008. "Behind the Lens: Paris' Deyrolle Taxidermy Shop." *National Geographic Online*, February 21. http://intelligenttravel.nationalgeographic.com/2008/02/21/behind_the_lens_paris_deyrolle/.

Kosuth, J. 1991. *Art After Philosophy and After: Collected Writings, 1996–1990*. Cambridge: MIT Press.

Krauss, R. 1977. "Notes on the Index: Seventies Art in America." *October* 3 (Spring): 68–81.

Krauss, R. 1997. "Perpetual Inventory." In W. Hopps and S. Davidson, *Robert Rauschenberg: A Retrospective* [exhibit catalog]. New York: Guggenheim Museum.

Krysa, J. 2006. *Curating Immateriality: The Work of the Curator in the Age of Network System*. New York: Autonomedia.

Kundera, M. 1984. *The Unbearable Lightness of Being*. New York: Harper and Row.

Kusukawa, S. 2010. "The Sources of Gessner's Pictures for the Historia Animalium." *Annals of Science* 76, no. 3: 303–328.

Latour, B. 1991. *We Have Never Been Modern*. Cambridge: Harvard University Press.

Latour, B. 2005. *Reassembling the Social: An Introduction to Actor-Network-Theory*. Oxford: Oxford University Press.

Lehmann, U. 2011. "The Surrealist Object and Subject in Materialism: Notes on the Understanding of the Object in Surrealism." In I. Pfeiffer and M. Hollein, eds., *Surreal Objects: Three-Dimensional Works of Art from Dali to Man Ray*, 129–135. Ostfildern: Hatje Cantz Verlag.

Lemke, T. 2015. "New Materialisms: Foucault and the 'Government of Things.'" *Theory, Culture and Society* 32, no. 4: 3–25.

Lemm, V. 2009. *Nietzsche's Animal Philosophy: Culture, Politics, and the Animality of the Human Being*. New York: Fordham University Press.

Lévi-Strauss, C. 1962. *The Savage Mind*. Trans. G. Weidenfeld and Nicolson Ltd. Chicago: University of Chicago Press, 1972.

Lim, G. 2011. "'A Stede Gode and Lel': Valuing Arondel in Bevis of Hampton." *Postmedieval: A Journal of Medieval Cultural Studies* 2, no. 1: 50–68.

Lippit, A. M. 2000. *Electric Animal: Toward a Rhetoric of Wildlife*. Minneapolis: University of Minnesota Press.

Locke, J. 1689. *An Essay Concerning Human Understanding*. New York: Oxford University Press, 1975.

Locke, J. 1693. *Some Thoughts Concerning Education*. London: A. and J. Churchill.

MacKay, R., L. Pendrell, and J. Trafford. 2014. *Speculative Aesthetics*. Falmouth: Urbanomic.

MacKenzie, J. M. 1988. *The Empire of Nature: Hunting, Conservation and British Imperialism*. Manchester: Manchester University Press.

Madden, D. 2011. *The Authentic Animal: Inside the Odd and Obsessive World of Taxidermy*. New York: St. Martin's Press.

Malt, J. 2004. *Obscure Objects of Desire: Surrealism, Fetishism, and Politics*. Oxford: Oxford University Press.

Manesse, A. D. 1787. *Traité sur la Manière d'Empailler et de Conserver les Animaux, les Pelleteries et les Laines*. Paris: Guillot.

Maradzika, N. 2012. "Nandipha Mntambo: Hide and Seek." *Another Africa*, December 11. http://www.anotherafrica.net/art-culture/nandipha-mntambo-hide-seek.

Marbury, R. 2014. *Taxidermy Art*. New York: Artisan.

Marcyliena, M. H. 2014. *Speech Communities*. Cambridge: Cambridge University Press.

Marien, M. W. 2006. *Photography: A Cultural History*. London: Laurence King.

Marvin, G. 2002. "Unspeakability, Inedibility, and the Structures of Pursuit in the English Foxhunt." In N. Rothfels, ed., *Representing Animals*, 139–158. Bloomington: Indiana University Press.

Marvin, G. 2006. "Perpetuating Polar Bears: The Cultural Life of Dead Animals." In B. Snæbjörnsdóttir and M. Wilson, *Nanoq: Flat Out and Bluesome: A Cultural Life of Polar Bears*. London: Black Dog.

Marvin, G. 2010. "Challenging Animals: Purpose and Process in Hunting." In S. Pilgrim and J. Pretty, eds., *Nature and Culture: Rebuilding Lost Connections*, 145–162. London: Earthscan.

Mauriès, P. 2002. *Cabinets of Curiosities*. London: Thames and Hudson.

McHugh, S. 2004. *Dog.* London: Reaktion.

McHugh, S. 2011. *Animal Stories: Narrating across Species Lines.* Minneapolis: University of Minnesota Press.

McKay, B. 2011. "The Return of Taxidermy." *The Art of Manliness Trunk* [blog]. http://www.artofmanliness.com/trunk/1647/the-return-of-taxidermy/.

Meillassoux, Q. 2006. *Après la finitude: Essai sur la nécessité de la contingence.* L'ordre philosophique. Paris: Seuil.

Meillassoux, Q. 2008. *After Finitude: An Essay on the Necessity of Contingency.* Trans. Ray Brassier. London: Continuum.

Melguen, M. 2005. "French Voyages of Exploration and Science in the Age of Enlightenment: An Ocean of Discovery throughout the Pacific Ocean." In J.W. Markham and A. L. Duda, eds., *Voyages of Discovery: Parting the Seas of Information Technology: Proceedings of the 30th Annual Conference of the International Association of Aquatic and Marine Science Libraries and Information Centers,* 31–59. Fort Pierce: IAMSLIC.

Memes, J. S. 1825. *Memories of Antonio Canova: With a Critical Analysis of His Works and Historical Views of Modern Sculpture.* Edinburgh: Archibald Constable.

Merleau-Ponty, M. 1945. *Sense and Non-Sense.* Evanston: Northwestern University Press. 1992.

Merleau-Ponty, M. 1948. *Phenomenology of Perception.* London: Routledge. 2013.

Métraux, G. P. R. 1995. *Sculptures and Physicians in Fifth-Century Greece: A Preliminary Study.* Montreal: McGill-Queen's University Press.

Metz, C. 1985. "Photography and Fetish." *October* 34 (Autumn): 81–90.

Mileaf, J. 2010. *Please Touch: Dada and Surrealist Objects after the Readymade.* Hanover: Dartmouth College Press.

Milgrom, M. 2010. *Still Life: Adventures in Taxidermy.* Boston: Houghton Mifflin Harcourt.

Millard, C. 1976. *The Sculpture of Edgar Degas.* Princeton: Princeton University Press.

Mirzoeff, N. 2014. "Visualizing the Anthropocene." *Public Culture* 26, no. 2: 73, 213–232.

Mitchell, W. J. T. 2005. *What to Do with Pictures? The Lives and Loves of Images.* Chicago: University of Chicago Press.

Mntambo, N. 2007. "Locating Me in Order to See You." MA thesis, University of Cape Town.

Moffett, C. S. ed. 1986. *The New Painting: Impressionism 1874–1886.* San Francisco: Fine Arts Museum of San Francisco.

Molesworth, H. 2005. "Eros and the Readymade." In S. Melville, ed., *The Lure of the Object,* 193–202. New Haven: Yale University Press.

Morgan, D. 2009. "Enchantment, Disenchantment, Re-Enchantment." In J. Elkins and D. Morgan, eds., *Re-Enchantment,* 3–22. London: Routledge.

Morris, P. A. 2010. *A History of Taxidermy: Art, Science and Bad Taste.* Ascot: MPM.

Morton, T. 2010. *The Ecological Thought.* Cambridge: Harvard University Press.

Morton, T. 2016. *Dark Ecology: For a Logic of Future Coexistence.* New York: Columbia University Press.

Mouton-Fontenille, J. P. 1811. *Traité Elémentaire d'Ornithologie, Suivi de l'Art d'Empailler les Oiseaux.* Lyon: Yvernault & Cabin.

Munster, H. 2006. *Materializing New Media: Embodiment in Information Aesthetics.* Lebanon: Dartmouth College Press.

Muybridge, F. 1887. *Animal Locomotion: The Muybridge Work at the University of Pennsylvania*. Philadelphia: Lippincott.

Nayar, P. K. 2010. *An Introduction to New Media and Cybercultures*. Malden: Wiley-Blackwell.

Niesel, J. 1994. "The Horror of Everyday Life: Taxidermy, Aesthetics, and Consumption in Horror Films." *Journal of Criminal Justice and Popular Culture* 2, no. 4: 61–80.

Nietzsche, F. 1872. *The Birth of Tragedy and Other Writings*. Ed. R. Guess and R. Speirs. Cambridge: Cambridge University Press, 1999.

Nietzsche, F. 1873–1876. *Untimely Meditations*. Cambridge: Cambridge University Press, 1997.

Nietzsche, F. 1878. *Human All Too Human: A Book for Free Spirits*. Cambridge: Cambridge University Press, 1996.

Nietzsche, N. 1887. *The Genealogy of Morals*. Trans. H. B. Samuel. Oxford: Oxford University Press, 1913, 1997.

Nochlin, L. 1971. *Realism*. London: Penguin.

Oliver, K. 2013. *Animal Lessons: How They Teach Us to Be Human*. New York: Columbia University Press.

Outram, D. 1996. "New Spaces in Natural History." In N. Jardine, J. A. Secord, and E. C. Spary, eds., *Cultures of Natural History*, 249–265. Cambridge: Cambridge University Press.

Ovid. n.d. *Metamorphoses*. Trans. M. M. Innes. London: Penguin, 1955.

Palmer, C. 2001. "'Taming the Wild Profusion of Existing Things'? A Study of Foucault, Power, and Human-Animal Relations?" *Environmental Ethics* 23, no. 4: 339–358.

Panofsky, E. 1939. *Studies in Iconology: Humanistic Themes in the Art of the Renaissance*. Boulder: Westview, 1972.

Patchett, M. 2006. "Animal as Object: Taxidermy and the Charting of Afterlives." Paper presented at Making Animal Afterlives, Hunterian Zoology Museum, University of Glasgow.

Patchett, M. 2010. "Putting Animals on Display: Geographies of Taxidermy Practice." PhD diss., University of Glasgow.

Patton, P. 2003. "Language, Power, and the Training of Horses." In C. Wolfe, ed., *Zoontologies: The Question of the Animal*. Minneapolis: University of Minnesota Press.

Pearce, S., and K. Arnold. 2000. *The Collector's Voice: Critical Readings in the Practice of Collecting*. Vol. 2. Burlington: Ashgate.

Pedretti, C. 1973. *Leonardo: A Study in Chronology and Style*. Berkeley: University of California Press.

Pentecost, C. 2012. "Notes from Underground." Part of the series *100 Notes, 100 Thoughts: dOCUMENTA*. Berlin: Hatje Cantz.

Petiver, J. 1696. "Brief Instructions for the Easy Making and Preserving Collections of All Natural Curiosities." Appendix in J. Petiver, *Musei Petiveriani Centuria Secunda & Tertia Rariora Naturae Continens*. London.

Platzman, S. 2001. *Cézanne: The Self-Portraits*. Berkeley: University of California Press.

Poggi, C. 1993. *In Defiance of Painting: Cubism, Futurism and the Invention of Collage*. London: Yale University Press.

Poliquin, R. 2008. "The Matter and Meaning of Museum Taxidermy." *Museum and Society* 6, no. 2 (July): 123–134.

Poliquin, R. 2012. *The Breathless Zoo: Taxidermy and the Cultures of Longing*. University Park: Pennsylvania State University Press.

Pomian, K. 2004. *Dalle Sacre Reliquie All'Arte Moderna*. Milan: Il Saggiatore.

Prendeville, B. 2000. *Realism in Twentieth-Century Painting*. London: Thames and Hudson.

Preziosi, D. 1989. *Rethinking Art History: Meditations on a Coy Science*. New Haven: Yale University Press.

Preziosi, D., and C. Fargo. 2011. *Art Is Not What You Think It Is*. Chichester: Blackwell.

Pseudo-Apuleius. Fourth century CE. *Herbarium of Pseudo Apuleius*. Oxford: Bodleian Library, Ashmole 1431 (7523).

Putnam, H. 2016. *Naturalism, Realism, and Normativity*. Cambridge: Harvard University Press.

Rader, A. R., and V. E. Cain. 2014. *Life on Display: Revolutionizing U.S. Museums of Science and Natural History in the Twentieth Century*. Chicago: University of Chicago Press.

Rauschenberg, R., and B. Rose. 1987. *An Interview with Robert Rauschenberg*. New York: Avedon.

Reynolds, S. 2011. *Retromania: Pop Culture's Addiction to Its Own Past*. London: Faber and Faber.

Rice, M. *Swifter than the Arrow: The Golden Hunting Hounds of Ancient Egypt*. London: I. B. Tauris.

Richards, J. 2000. "Early Christian Art." In M. Kemp, ed., *The Oxford History of Western Art*, 70–75. Oxford: Oxford University Press.

Richardson, T. 1990. *The Commodity Culture of Victorian England: Advertising and Spectacle, 1851–1914*. Stanford: Stanford University Press.

Ritvo, H. 1987. *Animal Estate: The English and Other Creatures in the Victorian Age*. Cambridge: Harvard University Press.

Rony, F., T. 1996. *The Third Eye: Race, Cinema, and Ethnographic Spectacle*. Durham: Duke University Press.

Rose, G., and D. P. Tolia-Kelly, eds. 2012. *Visuality/Materiality: Images, Objects and Practices*. Farnham: Ashgate.

Rothfels, N., ed. 2002. *Representing Animals*. Bloomington: Indiana University Press.

Rousseau, J.-J. 2012. *The Basic Political Writings*. Indianapolis: Hackett, 1987.

Ryan, J. R. 1997. *Picturing Empire: Photography and the Visualization of the British Empire*. London: Reaktion.

Ryan, J. R. 2000. "Hunting with the Camera: Photography, Wildlife and Colonialism in Africa." In C. Philo and C. Wilbert, eds., *Animal Spaces, Beastly Places: New Geographies of Human-Animal Relations*, 205–222. London: Routledge.

Sanders, C. R. 2000. "The Impact of Guide Dogs on the Identity of People with Visual Impairments." *Anthrozoos* 13, no. 3: 134–137.

Savi, G., and G. Andres. 1840. *Istituzioni Botaniche*. Loreto: Tipografia Rossi.

Scharf, A. 1968. *Art and Photography*. London: Penguin, 1983.

Shapiro, G. 2003. *Archaeologies of Vision: Foucault and Nietzsche on Seeing and Saying*. Chicago: University of Chicago Press.

Shapiro, K. 1989. "The Death of the Animal: Ontological Vulnerability." *Between Species* 5, no. 4 (Fall): 183–195.

Sheehy, C., ed. 2006. *Cabinets of Curiosities: Mark Dion and the University as Installation*. Minneapolis: University of Minnesota Press.

Shell, H. R. 2004. "Skin Deep: Taxidermy, Embodiment and Extinction in W. T. Hornaday's Buffalo Group." *Proceedings of the California Academy of Sciences* 55 : 83–108.

Shufeldt, R. W. 1892. "Scientific Taxidermy for Museums." *Report of National Museum*, 369–382, s.l., s.n.

Shukin, N. 2009. *Animal Capital: Rendering Life in Biopolitical Times*. Minneapolis: University of Minnesota Press.

Simpson, M. 1999. "Immaculate Trophies." *Essays on Canadian Writing*, no. 67 (Summer): 77–106.

Singer, P. 1975. *Animal Liberation*. New York: HarperCollins.

Snæbjörnsdóttir, B. 2009. *Spaces of Encounter: Art and Revision in Human-Animal Relations*. Gothenburg: University of Gothenburg.

Snæbjörnsdóttir, B., and M. Wilson. 2006. *Nanoq: Flat Out and Bluesome: A Cultural Life of Polar Bears*. London: Black Dog.

Snæbjörnsdóttir, B. and M. Wilson. 2010a. "The Empty Wilderness: Seals and Animal Representation." In K. Benediktsson and K. Lund, eds., *Conversations with Landscape: Anthropological Studies of Creativity and Perception*, 211–226. Farnham: Ashgate.

Snæbjörnsdóttir, B., and M. Wilson. 2010b. "Falling Asleep with a Pig." *Antennae: The Journal of Nature in Visual Culture* 13: 38–40. http://www.antennae.org.uk/back-issues-2010/4583475279.

Sontag, S. 1977. *On Photography*. London: Allen Lane.

Stefanucci, A. 1944. *Storia del Presepio*. Roma: Autocultura.

Steinberg, L., and R. Rauschenberg. 2000. *Encounters with Rauschenberg*. Chicago: University of Chicago Press.

Stokes, A. D. 1955. *Michelangelo: A Study in the Nature of Art*. London: Routledge.

Stuessy, T. F. 2009. *Plant Taxonomy: The Systematic Evolution of Comparative Data*. New York: Columbia University Press.

Tanke, J. J. 2009. *Foucault's Philosophy of Art: A Genealogy of Modernity*. London: Continuum.

Thierman, S. 2010. "Apparatuses of Animality: Foucault Goes to the Slaughterhouse." *Foucault Studies*, no. 9: 89–110.

Thorsen, L. E. 2006. "The Hippopotamus in Florentine Zoological Museum 'La Specola': A Discussion of Stuffed Animals as Sources of Cultural History." *Museologia Scientifica* 21, no. 2: 269–281.

Thorsen, L. E., K. A. Rader, and A. Dodd. 2013. *Animals on Display: The Creaturly in Museums, Zoos, and Natural History*. University Park: Pennsylvania State University Press.

Topdjian, C. 2016. "Posthumanism and Body Politics in the Work of Cole Swanson." In C. Swanson, *Out of the Strong, Something Sweet* [exhibition catalog]. Toronto: Art Gallery of Guelph.

Tuan, Y. F. 1984. *Dominance and Affection: The Making of Pets*. New Haven: Yale University Press.

Turner, A. 2013. *Taxidermy*. London: Thames and Hudson.

Tyler, T., and M. Rossini, eds. 2009. *Animal Encounters*. Leiden: Brill.

Vai, G. B., and W. G. E. Caldwell. 2006. *The Origins of Geology in Italy*. Boulder: Geological Society of America.

Verdery, K. 1999. *The Political Lives of Dead Bodies: Reburial and Postsocialist Change*. New York: Columbia University Press.

Vergine, L., and G. Verzotti. 2004. *Il Bello e la Bestia: Metamorfosi, Artifici e Ibridi dal Mito all'Immaginario Scientifico*. Milano: Skira.

Viola, B., dir. 1986. *I Do Not Know What It Is I Am Like* [film]. Quantum Leap.

Wakeham, P. 2008. *Taxidermic Signs: Reconstructing Aboriginality*. Minneapolis: University of Minnesota Press.

Weil, K. 2012. *Why Animal Studies Now?* New York: Columbia University Press.

Werness, H. B. 2006. *The Continuum Encyclopaedia of Animal Symbolism in Art*. New York: Continuum.

Winckelmann, J. J. 1755. "Reflections on the Imitation of Greek Works in Painting and Sculpture." In D. Preziosi, ed., *The Art of Art History: A Critical Anthology*, 27–34. Oxford: Oxford University Press, 1998.

Windschutlle, K. 1997. *The Killing of History: How Literary Critics and Social Theorists Are Murdering Our Past*. New York: Free Press.

Withers, J. 1977. "The Famous Fur-Lined Teacup and the Anonymous Meret Oppenheim." *New York: Arts Magazine* 52 (November): 88–93.

Wolfe, C., ed. 2003. *Zoontologies: The Question of the Animal*. Minneapolis: University of Minnesota Press.

Wolfe, C. 2010. *What Is Posthumanism?* Minneapolis: University of Minnesota Press.

Wölfflin, H. 1896. "How One Should Photograph Sculpture." Trans. G. A. Johnson. *Art History* 36 (February 2013): 52–71.

Wölfflin, H. 1932. *Principles of Art History: The Problem of the Development of Style in Later Art*. Trans. M. D. Hottinger. New York: Dover.

Wonders, K. 1990. "The Illusionary Art of Background Painting in Habitat Dioramas." *Curator: The Museum Journal* 33, no. 2 (June): 90–118.

Wonders, K. 1993. *Habitat Dioramas: Illusions of Wilderness in Museums of Natural History*. Uppsala: Acta Universitatis Upsaliensis.

Young, J. 1994. *Nietzsche's Philosophy of Art*. Cambridge: Cambridge University Press.

Ziogos, D. 2015. "Reminiscence of an Unprocessed Leather Technician." In *Agrimiká: Why Look at Animals?* Milan: Postmedia.

INDEX

aesthetic disinterest, 35–36, 222

affirmation, 72, 99, 165, 173, 199–203, 224; classical, 152, 165, 175, 322; Foucault's conception of, 147–148; in photography, 155–156; of viewer, 144–146, 201. *See also* nonaffirmation

agency, 4, 10, 30–31, 47–49, 72, 140–141, 144, 149, 179–181, 192, 196–197, 201–202, 223; of Anthropocene, 22, 24–30, 35, 101, 106–107, 139, 164–165, 172, 175, 223, 237, 244, 247, 254; in Cezanne's paintings, 165–167; linguistic, 53–54, 56–57; of the *tableau objet*, 150–151

anthropocentrism, 16, 21, 29, 31, 153, 158, 175–177, 194, 196, 224, 249; and Cezanne, 165–167; and new materialism, 199–200

anthropomorphism, 158, 249

Appadurai, Arjun, 2, 32, 54–55, 137

archaeology (Foucault), 47–49, 57; taxidermy as, 208–209

Audubon, John James, 73–74

automaton, 67, 95–97

Baker, Steve, 7, 22–23, 25, 178, 182–183, 207

Barad, Karen, 137, 175, 198, 219–220

Barthes, Roland, 151

Baudelaire, Charles Pierre, 116, 142

Bécœur, Jean-Baptiste, 58–59

bees, 37, 246–247, 254–255

Benjamin, Walter, 179–180

Bennett, Jane, 175, 196–200, 244

Bennett, Tony, 110–111

Bentham, Jeremy, 93–94

Berger, John, 34–35, 143–144

Bestiarium, 79–88

biopolitics, 24–28, 38–39, 237

Bishop, Steve, 21, 36, 221, 225, 233–234, 238–239, 242

botanical illustration, 89–90. *See also* herbarium

botched taxidermy, 22–25, 178, 183, 209

Bougonia, 37, 247–248, 251, 254

Braque, George, 166, 175, 184, 187

Breton, Andre, 36, 163, 223

Broglio, Ron, 7, 34, 71, 87, 177, 205, 224, 243

Brown, Bill, 55, 224

Browne, Montagu, 45–47, 118–119, 121, 123–125, 130, 202

Buonarroti, Michelangelo, 123